G000068237

TOUCHED BODIES

TOUCHED BODIES

The Performative Turn in Latin American Art

MARA POLGOVSKY EZCURRA

RUTGERS UNIVERSITY PRESS

New Brunswick, Camden, and Newark, New Jersey, and London

Library of Congress Cataloging-in-Publication Data

Names: Polgovsky Ezcurra, Mara, author.
Title: Touched bodies : the performative turn in Latin American art / Mara
 Polgovsky Ezcurra.
Description: New Brunswick, New Jersey : Rutgers University Press, [2019] |
 Includes bibliographical references and index.
Identifiers: LCCN 2018057616 | ISBN 9781978802025 (pbk. : alk. paper) |
 ISBN 9781978802032 (cloth : alk. paper)
Subjects: LCSH: Performance art—Latin America. | Body art—Latin America. |
 Arts, Latin American—20th century. | Arts and society—Latin America—History—
 20th century. | Arts—Political aspects—Latin America—History—20th century.
Classification: LCC NX456.5.P38 P65 2019 | DDC 709.04/0752—dc23
LC record available at https://lccn.loc.gov/2018057616

A British Cataloging-in-Publication record for this book is available from
the British Library.

Copyright © 2019 by Mara Polgovsky Ezcurra

All rights reserved

No part of this book may be reproduced or utilized in any form or by any means,
electronic or mechanical, or by any information storage and retrieval system, without
written permission from the publisher. Please contact Rutgers University Press,
106 Somerset Street, New Brunswick, NJ 08901. The only exception to this prohibition
is "fair use" as defined by U.S. copyright law.

♾ The paper used in this publication meets the requirements of the American National
Standard for Information Sciences—Permanence of Paper for Printed Library
Materials, ANSI Z39.48-1992.

www.rutgersuniversitypress.org

Manufactured in the United States of America

To Demetrio and Eugenio,
lovingly

CONTENTS

FIGURES

TOUCHED BODIES

INTRODUCTION

The subject is of flesh and blood, one who hungers and eats, entrails in a skin, and is thus capable of giving the bread out of their mouth, or giving their skin.[1]

—Emmanuel Levinas, *Otherwise than Being or Beyond Essence*

In October 1981 the Argentine artist Antonio Berni died in Buenos Aires at the age of seventy-six. In his three-floor workshop, situated in the heart of the city's historic center, the painting of a naked woman lying on the sand of a moonlit coastline was left unfinished on his easel (Figure I.1). The woman's wide-open eyes face the sky, seeming to hover between life and death; her legs are tightly crossed, and her right hand is carefully positioned to cover her pubis. The posture suggests a willingness to expose the woman's fragility while masking her sexuality. At some distance from her, a large aircraft painted in tones of gray is suspended in an overcast sky; its presence evokes more than sheer chance. This was a time of dictatorship in Argentina. For years, death-flights had been throwing people alive into the River Plate to disappear them in the anonymity of its waters. Is the solitary and frail body of the woman one of these "disappeared" people returning from the death?[2]

Nicknamed by Berni "Graciela Amor," the woman who posed for this painting remembers that both her slender profile and the ominous airplane were part of the original composition. Yet the colors of the image changed substantially over the course of a week, following Berni's premonition of his own passing, which he announced to Amor.[3] During this spell, the contours of Amor's bare silhouette went from receiving the warm tones of painted daylight to being covered by a silver palette, as night began to fall on the picture, and only the moon was left to illuminate it. Allegedly, Berni had the presentiment that he would not finish this work. He was certainly unaware that his passing would become the symbol of the closure of an era in the politics of art in Argentina and in other Latin American countries.

Roberto Amigo parallels Berni's life with Eric Hobsbawm's tripartite division of the "short twentieth century" into the Age of Catastrophe (1914–1945), with the rising levels of unemployment in Argentina in the 1930s, populist leader Juan

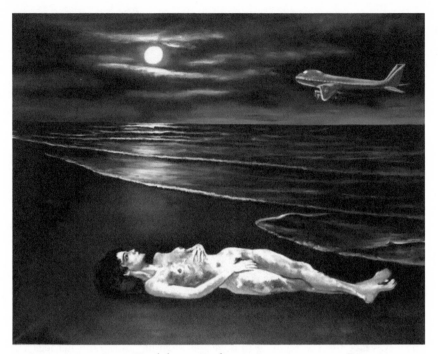

FIGURE I.1. Antonio Berni, *Untitled*, 1981. Acrylic on canvas, 160 × 200 cm. Private collection. Courtesy of Inés Berni.

Domingo Perón's contested rise to power, and Berni's embrace of communism; the Golden Age (1947–1973), during which the artist received increased recognition in his country and abroad while supporting a politics of Latin American solidarity; and the Landslide (1973–1991), with the rise of civilian and state violence in Argentina, accompanied by Berni's refusal to speak about politics, even while acknowledging his commitment to portraying "the idea of human suffering" (Amigo 2010, 56). Berni did not live long enough to see the world fully lose "its bearings and slid[e] into instability, [uncertainty,] and crisis," as Hobsbawm (1995, 403) describes the twenty years after 1973 that brought the short twentieth century to a close; nonetheless he appears to have foreseen the coming of the Landslide. During the last years of his life, the artist created a number of works evoking the brutal marks that authoritarian power was leaving on human bodies. The portrait of Amor is indeed reminiscent of the thousands of people the Argentine military threw alive into the River Plate, and who often reappeared, lifeless, on the coastline. The painting features Berni's New Realist style, with his expressive treatment of seemingly everyday situations, yet it also departs from it by representing a subject that instead of primarily symbolizing a social class—like the archetypical New Realist subject[4]—embodies a form of human, and in this case also female, vulnerability. In Amor's portrait, exposure, Eros, and terror become enmeshed in

the indecipherability of the woman's fortunes, an indecipherability that also stems from the absence of a clear political message on the canvas. It is in this sense that this work speaks for a transformation in the politics of art triggered by the ways in which authoritarian regimes in Latin America inscribed their power on human bodies.

Christ in the Garage (Cristo en el garage) from 1981 is similarly illustrative of this shift in Berni's work and in the relationship between art and politics in Argentina more broadly. This painting depicts the crucifixion of an emaciated, young, and arguably effeminate man who had endured torture in a small, luminous garage. The room has a roof window pointing toward the sky that suggests a certain resemblance with a chapel, but it is otherwise empty, except for a parked motorcycle and a puddle of blood below the cross in which the man is hanging (Figure I.2). Secularizing the fundamental Christian symbol of sacrifice, this work reflects the brutality of Argentine reality at the time of its making, when the country's youth were being tortured and killed in large numbers. Yet, unlike some of Berni's earlier paintings, the work resists a transparent interpretation according to a revolutionary or emancipatory program. Well beyond the transmission of any given message of liberation or revolution, the piece prompts the spectator to recognize this subject's incarnated suffering and the use of his body as the ground in which ideology becomes (brutally) inscribed. An industrial landscape is visible from a side window, suggesting that this specific form of human sacrifice was driven by an accelerated politics of modernization, or arguably, by the crisis of this model. The contradictions of capital become perceptible at the level of its corporeal costs.

In 1983, two years after Berni painted this scene, and right when the seven-year dictatorship was coming to an end, sculptor Liliana Maresca and photographer Marcos López agreed to meet at Maresca's studio, located in road "United States" in San Telmo, Buenos Aires, in order to carry out a photo shoot in which both would be undressed. The nudity of the photographer remains an anecdote, yet that of the sculptor was powerfully captured by López's Rollei camera with the sheer use of natural light. In this series of black and white pictures, Maresca, performing for the lens, adopts postures that refrain from erotic allure while expanding and resculpting her body. In each one of them her live body and the objects of her art become assembled, both prosthetically augmenting her corporeality and giving "flesh" to the objects. In Figure I.3 she lies still in the corner of a room, disaffectedly looking away from the camera. Unlike the bare woman in Berni's *Untitled* painting, Maresca's posture resists any sense of puritanism toward female sexuality. Rather than veiling her pubis, the artist displaces the corporeal situatedness of sex, by cradling with her arms a large wooden sculpture evocative of female genitalia (*Carozo deurazno* [Peach Pit], 1982), and enclosing another similar piece between her legs.

Maresca's photo-performance, Amor's *Untitled* painting, and Berni's *Christ in the Garage* reflect the extent to which the late 1970s and early 1980s saw major

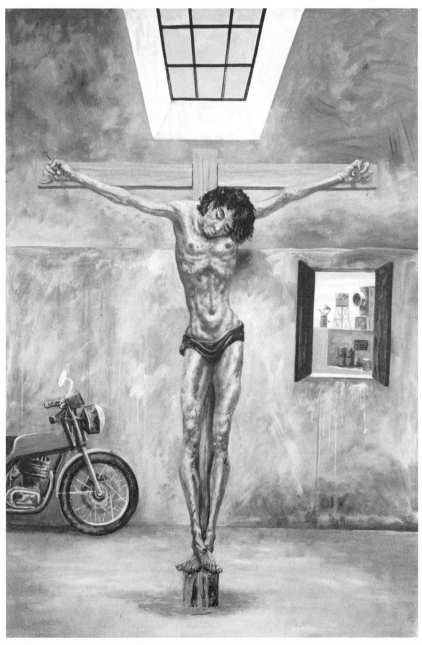

FIGURE I.2. Antonio Berni, *Cristo en el garage*, 1981. Oil on canvas, 200 × 135 cm. Courtesy of Inés Berni. Stolen, Interpol search ongoing.

changes in political as well as artistic sensibilities. This was certainly the case in Argentina, and similar transformations took place in other Latin American counties that suffered from the violence of authoritarianism. Such transformations resulted from the posthumous return of those bodies that had been clandestinely murdered and disappeared by authoritarian regimes in the preceding years, and from the lack of a collective utopia capable of replacing the decaying dreams of a social revolution. In the midst of an atmosphere of political disenchantment, in which the languages of an era—or, as I shall suggest on the basis of Jacques Rancière's theory of aesthetics, the prevailing *partage du sensible* (distribution of the sensible) (2009a, 25)—appeared to disintegrate, socially committed artists began to explore a politics of art that would leave behind the revolutionary projects and models of artistic avant-gardism of the 1960s. As critic Daniel Link metonymically wrote, artists confronted the question, "How to make political art after Berni?" (Link 2012, 12).

This book takes Link's question as its starting point to understand the changes in the relationship between art and politics that emerged during the late 1970s and 1980s in Argentina, Chile, and Mexico. I argue that midway through the authoritarian regimes that eclipsed the conditions of life and creation in the region during the 1960s and early 1970s, the politics of art began to adopt new forms, new meanings, and new strategies. In them, the live body and the body's vulnerability to injury, illness, and death took center stage. I study this re-elaboration of the politics of art by looking at the role of performativity in this shifting vision of the political. In particular, I identify and theorize a performative turn in Latin American artistic production driven by intermedial artistic projects focused on the politics of corporeality. This performative turn stemmed from the diversification of live art and participatory practices in earlier years. Yet it is in the little-studied period of what I describe as "the long 1980s" (lasting from the mid-1970s to the early 1990s) that one can fully grasp the extent to which performativity recast the artistic field as a whole: by refiguring the relationships between object-based practices, live art, exhibition spaces, and publics, and imbuing them with a new sense of the political.

The centrality of the body in these intermedial practices signals the direction of change in the politics of art in the late 1970s. While the political art of the 1960s, with experiences like the group exhibition *Tucumán Arde* in Argentina[5] and the graphic art of Grupo Mira[6] in Mexico, focused on Latin America's pervasive class inequalities and the perceived need to forge the conditions for a major social transformation to take place, the art of the late 1970s and 1980s left behind the idea of the grand political project, concentrating instead on the embodied experience of power. This transformation of the languages and imaginaries of the political in artistic practice was deeply influenced by the rise of a global feminist movement, which brought to public discussion the fact that politics are not only a matter of sovereign control but are also intrinsic to the domain of the sexed body.[7]

Before proceeding further, I should clarify that my objective in exploring this artistic tendency is not to provide a comprehensive account of performance art in the Americas in the 1970s and 1980s through an overview of a large number of artists. Instead, my study is an in-depth engagement with a small number of artists whose work illustrates the performative turn that I seek to discuss. The work of these artists is telling and theoretically insightful rather than being representative. Some of them remain little known despite the breath, originality, and considerable influence of their practices on younger artists. Working with personal archives, interviews, and other materials, this study therefore seeks to deepen the cursory knowledge that we have of the work of Diamela Eltit (b. 1949), Raúl Zurita (b. 1950), and the CADA artists' collective from Chile; León Ferrari (1920–2013) and Liliana Maresca (1951–1994) from Argentina; and Marcos Kurtycz (1934–1996) and the Proceso Pentágono and No Grupo collectives from Mexico. I constellate the work of these artists on the basis of the relevance of performativity in the highly varied set of practices in which they engaged. Moreover, I argue that these artists' unique—yet interconnected—strategies of resituating the living body in artistic practice is symptomatic of a larger shift in the politics of art, where the vulnerability of the subject takes center stage.[8]

Comparisons with artists from other Latin American countries escape the scope of this research. Yet a number of recent studies on performance and performativity throughout the region share my interest in establishing the late 1970s and early 1980s as a key moment in the development and consolidation of a critical sense of performativity in the arts—rather than seeing it as a time limited to the marketization of conceptualist practices, as has been suggested in previous scholarship (see Ramírez 1999, 55). Notable among these recent studies is Coco Fusco's *Dangerous Moves*, which looks at the relationship between performance and politics in Cuba. Fusco argues that "during the island's [. . .] visual arts renaissance of the 1980s, performance art had become the aesthetic strategy of choice for serving up irreverent critiques of [. . .] the state's power over artists and the perceived hypocrisies of socialist officials" (Fusco 2015, 22). She situates the critique of biopower, and the forms of pleasure, knowledge, and compliance that it produces, as being key to understanding performance art in Cuba from the 1980s until today; yet she moves beyond a reading of performance as a mere art of resistance against state power.[9] As Fusco puts it, "Cuban performance art's intersection with the political sphere has varied in character from conflict to collusion, from strategic evasion to tactical confrontation" (35). Fusco's study, alongside similar research initiatives on performance in Chile, Colombia, Argentina, Mexico, and Peru in the 1970s and 1980s,[10] corroborate a palpable synchronicity in artistic and political developments across various Latin American countries. Despite the prevalence of national approaches to the study of art, this synchronicity should not surprise us, as these countries were jointly influenced by a number of inescapably transnational processes, such as the Cold War, the femi-

nist and gay movements, and the weakening of socialist ideology in the 1980s. However, this growing interest in the long 1980s is not intended to establish this decade as the starting point of performativity or performance in the region or to deny that certain artists and countries came first. An anxiety about origins and originality has been at the heart of the scholarship on conceptualism in Latin America.[11] This book focuses less on origins and more on understanding the performative and semiotic strategies of artistic practices that sought to reimagine the politics of the live body in art. Many of these strategies date back to the 1960s or much before.

CORPOREAL CALLIGRAPHIES

The era that drew to a close with the rise of authoritarian and dictatorial regimes in Latin America during the late 1960s and early 1970s is one in which the artistic avant-garde joined forces with the political vanguard, as militancy became "the true test of the authentic [artist and] intellectual" (Franco 2002, 88).[12] During these years, a number of artists throughout the subcontinent hoped a social revolution would take place to fight imperialism and capitalist exploitation, and they believed this to be increasingly possible after the Cuban Revolution in 1959 and the electoral triumph of socialist Salvador Allende in 1970. Artists committed themselves in large numbers to working for this impending social transformation, and some willingly abandoned their artistic practice to join the armed struggle (Longoni and Mestman 2000, 227; Longoni 2014a, 2). Cold War antagonisms, societal polarization, and the state persecution of "the Communist enemy" effectively obliged artists and intellectuals "to define themselves in no uncertain terms" by having to choose not just between capitalism and a Soviet/Maoist idea of revolution, but also between bourgeois passivity and the active engagement in a societal change (Terán 2004, 265). Among those who opted for change, the ideal of a "new revolutionary man"—characteristically masculine, bold, and austere— became the desired model of political subjectivity (Vezzetti 2009, 104–105).[13] Moreover, under the aegis of a revolutionary ideal, politics came to be understood in terms of not just resisting but indeed overthrowing economic and cultural forms of domination—by violent means if necessary. In the sphere of art this expression of the political reached its apogee with experiences such as the exhibition project *Tucumán arde* (1968) in Argentina, and the Ramona Parra muralist brigades of the communist youth in Chile.[14] These collective projects posed a serious challenge to received artistic languages by directly working with organized workers and voicing their cries of emancipation. To quote Jaime Vindel and Ana Longoni, during these years art "found itself permeated by a Hegelian conception of historic time, in which revolution was represented as an imminent future which would consummate the vision of history articulated by the political subject" (Vindel and Longoni 2010, 312).[15]

This understanding of the instrumental role of art in shaping a new revolutionary man and a new society reached a point of exhaustion in the mid-1970s, when the dreams of an upcoming social revolution were crushed by fierce repression. The experiences of dictatorship in Chile (1973–1990) and Argentina (1976–1983), as well as the "Dirty War" in Mexico (1960s–1980s),[16] transformed a horizon of social change into what Nelly Richard describes as a *zona de catástrofe* (zone of catastrophe), marked by the rupture of "every remaining covenant of symbolic and social legitimation" (Richard 2007, 16). The prevalence of torture and police brutality throughout these countries led, at a corporeal level, to the disciplining of bodies by both inflicting pain and mobilizing fear.[17] Throughout the Americas, authoritarian regimes often proclaimed a need to sacrifice people for the health of the nation, asserting that certain individuals and social groups had to be extirpated as cancerous tumors from the social body (O'Donnell 1999, 53). A politics of mass murder ensued, with more than 3,000 people killed and disappeared in Chile, between 9,000 and 30,000 in Argentina,[18] and a lesser but still highly significant—and poorly researched—number of victims in Mexico (a country that managed to mask its human rights abuses with a veil of democracy).[19] In each of these countries many more people were subjected to torture. The biopolitics of authoritarianism in Latin America resulted in the mass production of vulnerable and broken bodies, while enforcing a traumatic rupture with prior conceptions of political subjectivity. In the following chapters I describe how critical artists in the late 1970s and 1980s reclaimed and resignified these vulnerable bodies by turning their scars into the signs of new, appropriated calligraphies, their cries of pain into poetic laments, and their fragile, finite, and mutilated bodies into posthuman corporealities. These practices took political art in Latin America in a new direction, drifting away from past imaginaries of utopia and revolution. In the late 1970s and 1980s, the politics of embodiment, and the subjective renegotiation of acceptable forms of pain and desire, came first.

In looking at this new articulation of politics and art my focus is primarily on how the body became "a problem" for artists in Argentina, Chile, and Mexico during the 1970s, and how these artists (re)presented and refigured human and non-human bodies, turning the corporeal into a vehicle for "thought and action" (Osborne 1997, 192) as well as into a point of encounter between sense and matter (Nancy 1993, 194). I do not argue that the artists discussed were the first to approach the body in this manner, as the genealogy of the intimate politics of live performance dates further back in history (see Bishop 2012; Goldberg 1988; Jones 1998). Yet in these decades I observe the liveness of performative practices rapidly spilling over into other art forms and bestowing them with a performative sense of the political. My focus on performativity has led me to move away from common oppositions between body and discourse, gesture and language. Instead, I pay special attention to the singular relationship between discourse, corporeality, and subjectivity. In this sense, I approach the body not only as a site of discur-

sive inscription but also as something that may resist signification as it becomes ex-scripted in the act of writing (see Nancy 1993, 338). In taking this approach, I refrain from looking at the body in strictly material or biological terms or reducing it to a repository of pleasure and pain. Instead, I understand the body as both a site of desire and a site of vulnerability. I contend that those performative bodies that became visible and perceptible through artistic practice in Latin America during the 1970s and 1980s were at once assertive, dissensual,[20] and vulnerably exposed. Furthermore, I suggest that during these decades artists in Chile, Argentina, and Mexico situated the body's vulnerability to pain and injury as an ethical basis to reimagine the politics of art.

THE LONG 1980S

The developments that I discuss in this book date back at least to the 1960s.[21] Yet they only fully began to flourish and become popularized in the late 1970s. I therefore situate them in a long decade lasting from the mid-1970s to the early 1990s, and encompassing, in Argentina, Chile, and Mexico, years of authoritarian rule followed by contested transitions to neoliberal democracy. I identify the long 1980s as characterized by a recoiling of modernity's utopian imagination. This process was triggered by the rise of military regimes and the use of state violence to crush revolutionary projects of social transformation. Under these circumstances, political groups aligned with Left-wing positions were not only decimated and often felt to be defeated but also questioned their previous identification with "really existing" socialist regimes in the USSR, China, or Cuba—together with the models of agency and subjectivity that they entailed. Moreover, the long 1980s lacks an overarching *relato* or account that would situate it within a larger unfolding of History, Modernity, or Spirit (García Canclini 2010, 19), hit as it was by what Jean-François Lyotard describes as late modernity's crisis of grand narratives (Lyotard 1984, 15). As notions such as "revolutionary consciousness" and the "proletariat" (or "the subject of History") were being reshaped by a new organization of labor and capital in increasingly postindustrial societies, teleological accounts of revolutionary emancipation waned. And, according to Néstor García Canclini, the arts were the sphere where "the agony of emancipatory utopias" was most visibly dramatized (García Canclini 2010, 10). The violence accompanying this process was such that most of this history remains fragmented and haunted by the specter of irretrievable loss.

What one could figuratively describe as the 1980s' lack of History also reflects deficiencies in scholarly production, as scholars have given little attention to the range of artistic practices that developed in Latin America during this decade. Inadvertently, this has led to their alignment with European movements, a process that Carlos Basualdo (1999) calls "mimetic internationalism." One of the consequences of this tendency is the deceptive association of this decade with the

"return" or "rescue" (*rescate*) of figurative representation in painting, which is often linked to the rise of the Italian Transavantgarde and German Neoexpressionism (Buchloh 1981, 40; Garza Usabiaga 2011, 179). These movements were largely conceived in opposition to conceptual art (including performance), so one of the problematic consequences of their transposition to a Latin American context is that instances of productive dialogue between strategies of representation on the two-dimensional canvas and live art were neglected. Moreover, this view focuses almost exclusively on artistic developments within museums and other established art institutions and therefore fails to attend to artistic practices unfolding at the margins of mainstream art circles. More significantly, the representation of the 1980s as a "return to painting" dismisses, by way of omission, the historical relationship between the popularization of performance art and an international feminist avant-garde, together with the HIV-AIDS activism movement, that developed during this period.

RE-DECENTERING CONCEPTUALISM

Accounts of the rise of conceptualism in Latin America have forged a similarly disheartened view of Latin American art during the long 1980s (Ramírez 1999, 55). To appreciate the bleak framing of this decade by historians of conceptual art, a brief description of what Puerto Rican curator Mari Carmen Ramírez (following Spanish historian Simón Marchán Fiz) describes as Latin American or "ideological conceptualism" is in order. With Luis Camnitzer (2007) and others, Ramírez has developed an enriched view of conceptualism that goes beyond an exclusively metropolitan narrative of this artistic tendency and takes into account not just the propositional and linguistic understanding of conceptual art developed in the United States and Europe, but also a series of political manifestations of conceptualism in Latin America. For these authors, the category of "conceptualism," as opposed to the more restricted notion of "conceptual art," cannot be reduced to a movement or style—nor can it be defined strictly on the basis of the "dematerialization" of the art object, as Lucy R. Lippard and John Chandler suggest in their seminal 1968 essay, which provided for many a lens with which to understand this tendency in artistic practice. Ramírez argues that for conceptualism to be understood in the context of Latin American art, it ought to be seen as "a strategy of antidiscourses whose evasive tactics call into question both the fetishization of art and its systems of production and distribution in late capitalist societies" (Ramírez 1999, 53). From this angle, conceptualism had both material and dematerialized expressions in a multiplicity of media, and it performed a shift from the traditional focus on art's formal elements to the processes involved in its making. The politics of conceptualist art in Latin America furthermore entailed not so much the effective communication of political messages through art but the strategic intervention of "ideological circuits."

Ramírez's reading of the global leverage of Latin American conceptualism centers on the 1960s and 1970s and is primarily concerned with a search for origins—arguing that artists from Argentina and Brazil expressed conceptualist propositions earlier than better known artists from the United States and Europe. Moreover, she identifies three moments in the development of Latin American conceptualism, stressing its diachronic expansion throughout the region. From 1960 to 1974 Ramírez sees conceptualism as restricted to Brazil (Rio de Janeiro), Argentina (Rosario and Buenos Aires), and a community of South American artists living in New York. During this period, idea-based art, as she refers to it, took part in the critique of authoritarian governments, often by way of coining "anti-discourses" and intervening surreptitiously in networks of power with works such as Cildo Meireles's inscriptions of political messages on Coca-Cola bottles (*Insertions into Ideological Circuits: Coca-Cola Project*, 1970). The second moment in this chronology roughly spans a five-year period after 1975, a date set somewhat arbitrarily. During this time span artists from Chile, Mexico, Colombia, and Venezuela began participating more actively in the production of idea-based art, this time by trying to appropriate urban space and involve popular audiences (Ramírez 1999, 55). At this point, the rise of a series of art collectives in Mexico, known as Los Grupos, came to enact the critique of individual authorship by way of collective practice and street performance. The third and last period of this chronology—the late 1980s and 1990s—interests me the most, because it is defined with even less precision. For Ramírez, conceptualism in Latin America during this last phase became increasingly institutionalized and commercial, leading to the dying out of its radical possibilities. She writes, "With notable exceptions, this last stage corresponds to the institutionalization of conceptualism as both a high-priced commodity and lingua franca of global artistic circuits" (55). Yet this vision collapses the 1980s and the 1990s all too quickly. And while it might be valid for certain artists and certain countries, it oversees immensely significant critical developments in the field of live, participatory, and performance art in the 1980s. In this book I am less concerned with origins than with the trajectories of the politics of aesthetics, and I argue that the closure of the critical or "political" era of Latin American conceptualism at the end of the 1970s suffers from a limited idea of the political that leaves aside artists' full-fledged critical engagement in the politics of intimacy and the politics of mourning during the 1980s. Such a limited genealogy of conceptualism in Latin America pays insufficient attention to the role of feminism and of other forms of sexual and religious dissidence in the shaping of not just a conceptualist but also a performative turn in artistic practice.

FROM CURATORIAL TO HISTORICAL REVISIONISM

The revisionist perspective that I develop in this book follows in the steps of recent curatorial practices that have shifted the national and temporal boundaries of art

in Latin America and have made available extensive archival documentation of artworks and artists that had fallen into oblivion. I refer specifically to two major exhibitions: *La era de la discrepancia: Arte y cultura visual en México 1968–1997* (The Age of Discrepancy: Art and Visual Culture in Mexico 1968–1997), held at Museo Universitario de Ciencias y Artes (MUCA-Campus) in Mexico City in 2007, and *Perder la forma humana: una imagen sísmica de los años ochenta en América Latina* (Losing the Human Form: A Seismic Image of the Eighties in Latin America), organized at Museo Reina Sofía in Madrid in 2012. Describing the aims of the first of these projects, curators Olivier Debroise and Cuauhtémoc Medina wrote: "One of our principal commitments was to revise the conventional representation of the 'art of the eighties' in Mexico [. . .]. Instead of lamenting the existence of so-called 'neo-Mexicanism,' or revisiting the historicist style of painting dominant in Mexico City, we understood this decade to be a moment of public display of a variety of discourses concerning identity [. . .]. The eighties that interest us are those that challenged 'normality' and redefined the 'political' to distance it from the party-political, proletarian, and labor-unionist model of the left" (Debroise and Medina 2006a, 22).

I share Debroise and Medina's approach to the art of the 1980s in Mexico, which foregrounds, on the one hand, the crisis of the notion of national identity and, on the other, a reconfiguration of the idea of the political in the arts. Moreover, *La era de la discrepancia* can be viewed as the trigger that set in motion a sudden increase of interest in the 1980s, as well as the emergence of a number of public and private libraries and archives seeking to rescue the history of this forgotten decade—the erasure or amnesia of which was institutionalized by an official disregard for artistic practices that did not engage with well-established national traditions. In the writing of this book, I benefited from having access to several of these private archives, which were often built precariously by the artists' relatives or by the artists themselves, as was the case of the archive of Polish-Mexican artist Marcos Kurtycz, and, in Chile, of Colectivo Acciones de Arte (CADA). These multifarious and often intimate archives are not only repositories of a little-known past, but they are also "generative systems" that put into crisis received narratives on the workings of power in bodies of flesh as much as bodies of knowledge (Edwards 2009, 7).

The second exhibition that influenced my historiographical approach, *Perder la forma humana*, was curated by a network of Latin American artists, writers, and academics known as Red Conceptualismos del Sur. This show established a synchronic and comparative reading of Latin American art in the 1980s. Aware of the risks of cultural homogenization resulting from espousing a regional perspective, the curators avoided presupposing any sort of unique cultural identity spanning the subcontinent. They focused, instead, on regional affinities, dialogues, and parallel developments. These affinities, they claimed, called for a regional periodization of artistic movements and the forging of a conceptual apparatus coming from

the South (Carvajal et al. 2013, 11–12). I, too, embrace such a view in this book, while understanding the "South" as a primarily relational category. A reading of Latin American art from the South does not entail positing a radical disconnection from artistic developments in Europe and the United States. On the contrary, it foregrounds the importance of North-South relationships and conceives of them as a complex and bidirectional flow of people, knowledge, and ideas, where histories of coloniality, imperialism, and Northern dominion have been traversed and interrupted by what Brazilian poet Oswald de Andrade described in 1928 as Latin Americans' anthropophagic disposition to devour, engulf, and appropriate foreign cultures (De Andrade [1928] 1991). North-South relationships have similarly been influenced by exchanges between East and West, a dynamic that appears most clearly in chapters 5 and 6, in which I discuss the work of Polish-born artist Marcos Kurtycz.

In the shaping of a regional perspective, the points of departure of *Perder la forma humana* were a series of geopolitical, economic, and political processes that affected the whole of Latin America during the last decades of the twentieth century. These involved, as I suggest at the beginning of this introduction, the rise of authoritarian governments—both civilian and military—in a Cold War context in which the elimination of leftist and *guerrilla* organizations received direct moral and economic support from the United States (Carvajal et al. 2013, 13).[22] A number of these governments seized power by means of military coups, including coups in Brazil in 1964, Argentina in 1966 and 1976, and Uruguay and Chile in 1973. From the late 1970s onward, authoritarian regimes dismantled the welfare systems of *desarrollista* states and implemented major reforms to promote a shift toward a neoliberal economic model. Those reforms led to the privatization of public services, the rise of foreign investment in domestic markets, and the formation of tertiary, service-driven economies with diminishing labor rights (Harvey 2006, 11). This model heightened inequality in the region and fostered dependence on speculative financial markets—conditions that, combined with a history of political repression, set a somber scenario for the transitions from authoritarian to democratic rule that took place in the late 1980s and 1990s (see Svampa 2001, 39; Winn 2004, 56). Stressing this shared history of authoritarianism, a dismal record of human rights violations, and the synchronic adoption of neoliberal policies, the curators of *Perder la forma humana* point out that "during the eighties in Latin America, the systematic use of torture, forced disappearance and mass murder readied the terrain for the introduction of a series of social changes which supported, in the nineties, the introduction of restricted and corrupt democracies, jollily celebrating their own existence with a cocktail of false consensus, modernization, and collective amnesia" (Carvajal et al. 2013, 13). In view of this convulsive and rapidly deteriorating political and economic situation, critical artists in the 1980s were confronted with challenges that were very different from those faced by artists of previous generations. As the technologies of

power changed, the very idea of political art needed revising. Therefore, just as in *La era de la discrepancia*, *Perder la forma humana* describes Latin American artists in the 1980s as reimagining the notion of "the political" on the basis of "the emergence of a broad, complex spectrum of practices and subjectivities which permeate[d] the 'underground scene' and the movement of sexual dissent" (Carvajal et al. 2013, 14). In these practices, the body became a "chief artistic support and ground for political action" (11).

Perder la forma humana suffers from some of the limitations of a survey exhibition, such as the brevity with which each artist is discussed. Yet I dialogue with some of the premises of this show by focusing on the politics of corporeality in art, paying attention to a number of relatively little-known artists, and adopting a cross-national perspective. Moreover, I work with an expanded temporal frame of the 1980s that echoes the one used in that curatorial project. *Perder la forma humana* sets the 1980s' symbolic beginning at the moment of Augusto Pinochet's 1973 military coup in Chile, understood as a "landmark inaugurating a genocidal politics, continental in scope, which brutally cut off a cycle of revolutionary expectations, while leading to a forced transformation of the modes of action and languages of politics" (Carvajal et al. 2013, 11). Seen from this angle, Pinochet's coup represents a moment of historical rupture and radical discontinuity, which brought about unseen transformations in the practice of both politics and art and had visible resonances at a regional scale once other military regimes rose to power. The show closes the 1980s with the Zapatista rebellion in Chiapas on January 1, 1994, an indigenous anti-capitalist uprising that coincided with the launch of the North American Free Trade Agreement (NAFTA) between Mexico, the United States, and Canada. This event not only symbolizes the beginning of a new era of capitalism in Latin America but also inaugurates "a new cycle of mobilizations, which relaunches activism at an international level," after a decade in which politics had not been conceived in these terms (Carvajal et al. 2013, 12).

In my study, 1994 also takes on symbolic importance in relation to the lives and careers of the artists under discussion. This year marks a major retrospective at Centro Cultural Recoleta in Buenos Aires of the Argentine artist Liliana Maresca, whose work I discuss in chapter 4. This exhibition signaled the growing recognition of her erotic and subversive mixed-media creations. It was also in 1994 that, soon after the exhibition opening, Maresca died of AIDS. Mexico City–based artist Marcos Kurtycz, to whom I devote part of chapter 5 and chapter 6, died two years later. The long 1980s, spanning roughly from Pinochet's coup to the Zapatista uprising, can therefore be seen as an extended decade that witnessed years of murderous repression, the disarticulation of the welfare state, and the devastation of emancipatory utopias. Yet alongside and in close relationship to that deployment of political violence, this period also saw the proliferation of artistic practices that turned the vulnerability of the subject into an ethical and political basis for an art of "dissensus."

BEYOND THE ART OF DICTATORSHIP
AND POST-DICTATORSHIP

Previous scholarship on a number of the artistic practices that I discuss in this book has associated those practices with categories such as the art of dictatorship (Brito 1990), the art of transition (Masiello 2001), or the art of post-dictatorship (Bell 2014). Although I originally started to write this book with a similar intention, the more I got to know the artists, the less I found myself able to endorse this stark dependency of the artistic on the political. In other words, I came to realize that, while both the contents and the forms of artistic practice are profoundly influenced by political processes, the temporalities of art are never the sheer mirror image of those of politics: at times art moves lethargically behind political change, revealing the paralyzing effects of trauma; at other times, it situates itself—or so imagines—as the avant-garde of social change, staging different versions of projected futures. The time of political change and that of artistic change are often out of joint, and one must, in consequence, refrain from too-readily associating certain art forms with certain political eras, as is so commonly done. The problem with these types of associations is the risk of sacrificing the nuances and productive contradictions resulting from the close visual, formal, and material analysis of discrete artworks for the sake of the bigger political picture—a view that tends to disregard anachronistic disruptions in the flow of historical change (see Didi-Huberman 2005). In other words, I understand the temporalities of art and politics as immanently interlocked and prone to affecting one another, yet also capable of experiencing a-synchronic dislocations. This enables me to discuss the importance of temporal disturbance or asynchrony in the distribution of political and aesthetic sensoria. Indeed, it is my contention that the syncopated movement between art and politics opens possibilities for artistic practice to intervene in the existing forms of organization of political communities and thus reshape prevalent understandings of political subjectivity and agency.

THE (FEMINIST) ART OF BORDER CROSSING

Adopting a cross-national approach to the study of the art of the long 1980s, as I do in this book, is atypical in the historiography of Latin American art. My reading challenges claims of national exceptionalism and advocates, instead, the analysis of specific, constellated practices. I describe each of these practices as developing in complex political, economic, cultural, and technological conditions, influenced not only by national events but also by local and global processes.[23] In this respect, I endorse Cuban art critic Gerardo Mosquera's observation that "more than representing contexts," contemporary artists have been "constructing their works from within them" (Mosquera 2010, 22). I also take into account

Mosquera's emphasis on the need to think transnationally about "art in Latin America"—his term to avoid the homogenizing notion of "Latin American art"[24]—to approach the global from "positions of difference" that are not just "demarcated by the limits of the nation-state" (22). That perspective has allowed me to structure this book as a series of in-depth case studies of individual artists and artists' collectives, all working within specific national contexts and intuitional formations, yet synchronically linked with artists beyond their vicinity.

My historiographical approach is also influenced by Griselda Pollock's conceptualization of an avant-garde moment "in, of, and from the feminine" (Pollock 2010, 795) during the 1980s, and by the major 2007 exhibition (curated by Cornelia Butler for the Museum of Contemporary Art in Los Angeles) called *WACK! Art and the Feminist Revolution*—the catalogue of which stresses the need to explore "affinities between diverse geographical positions" when tracing transnational feminist activity (Butler 2007, 325). While my focus is not exclusively on feminist art, I nevertheless discuss the work of two feminist artists (Eltit and Maresca) and other artists who arguably supported and were influenced by the feminist movement, including Raúl Zurita and León Ferrari. Moreover, I address a series of questions that could not have reached the research agenda of visual and cultural studies without the influence of second- and third-way feminist thought, and that have been most cogently explored by feminist thinkers themselves. Central among these issues is the relationship between the (gendered) body and the organization and distribution of power, together with the role of semiotic and embodied practices in the performative critique and subversion of forms of biopolitical control. In the following chapters I establish a close dialogue with the writings of Judith Butler, Elizabeth Grosz, Griselda Pollock, Susan Sontag, Donna Haraway, and Julia Kristeva. And I highlight the ways in which they entwine the signifying practices of literature and art with a performative understanding of subjectivity and a politics of corporeality.

PERFORMATIVITY AND THE PERFORMATIVE ARCHIVE

The scholarship on performance and performativity often mobilizes a division between the study of "literary and historical documents" and the study of a nonarchival repertoire of embodied and performed behaviors (Taylor 2003, xviii).[25] This position is rooted in the need to look beyond what Ángel Rama (1984) describes as the "lettered city," that is, the works of the lettered elites that have dominated the politics and the cultural memory of Latin America. This scholarship also searches to understand a range of political practices and identity conflicts on the basis of embodied forms of knowledge, power, and resistance rather than looking at strictly linguistic inscriptions. In *The Archive and the Repertoire*, Diana Taylor (2003) brilliantly develops this methodological stand, which she describes as a personal intervention in the fields of performance studies and

Latin/o American studies. Her performative look at cultural memory in the Americas dates back to Mesoamerican times. This positions performance as a "methodological lens" that can be directed at a range of practices and time periods broader and more varied than that which pertains just to the spheres of performance art, theater, or dance (Taylor 2003, 3). Although this vision has expanded the scope of performance studies, it relies on an unyielding distinction between discourse and corporeality that needs to be revisited in order fully to grasp the complexity of the artistic practices that I examine in this book.

By bridging discussions from performance studies, Latino American studies, critical theory, and art history, I move from a media-specific approach to the politics of artistic practice to an intermedial vision of the politics of performativity. This methodological approach has led me to renounce Taylor's invitation to move beyond the study of historical and literary documents and has instead motivated me to position myself in critical proximity to the remaining archives of relatively unknown, minor, and arguably marginal artists. However, in adopting this perspective, I have carefully considered Taylor's view that various elements of embodied behavior resist their incorporation into the archive, and are effectively rendered invisible by the epistemological logics that organize it (Taylor 2003, 37). Accordingly, I have attempted to address these omissions indexically, by discussing the significance of the traces of the body in the archive and arguing for the need to read these traces performatively to give a more inclusive account of performance and live art in Latin America.

THE PERFORMATIVE TURN

My use of the notion of performance art encompasses various forms of live art, body art, art action, happening, video-performance, photo-performance, and even occasional artistic scandals. This broad approach is crucial to attend to the multiple expressions of—and names given to—live art during the historical period under scrutiny. The artists under consideration did not consistently stick to any one of these notions but often gave their practices local names, which they sporadically paralleled with better known Anglicisms. Crucially, in Latin America in the 1970s and 1980s, the word "performance" was not as common as it has become today, and it was often thought of as a US import. The term itself does not exist in the Spanish language, so its adoption by speakers of Spanish and Portuguese has lent itself to acts of "political and artistic translation" (Taylor 2016, 7). Increasingly, the word has gained currency as both a masculine and a feminine noun; this linguistic ambiguity resonates with the generative possibilities opened up by the practice.

In lieu of performance, in the late 1970s Chilean artists proposed the notion of *acción de arte* (art action), while Marcos Kurytcz spoke about *artefactos* and "art-i-facts" (in English) to reference his embodied ritual actions. Peruvian art

critic Juan Acha (2012), in turn, singularly described performance art as part of a series of what he called "non-objectual" practices, in which the art object came to matter less than the processes and social relations that it mobilized. In the following chapters I engage closely with each one of these notions. None of them, however, encompasses the larger performative turn that I seek to discuss. Accordingly, for the purposes of this book, the classification of the works under discussion as performance art or as something else is less significant than the fact that embodied practices in the long 1980s had visible effects on the production and reception of other, more traditional, artistic media. When I speak of a performative turn, I refer to this process of intermedial affectation generated by the rise and popularization of live art. Moreover, I point to the politics of this process and look at the forms of agency and subjectivity that it entailed.

The first dimension of the performative turn invites us to reflect on the idea of "contagion" (from the Latin *contāgiŏn em*, a touching or contact) between different media. The underlying logic of this phenomenon becomes visible when we think of other moments in which the emergence of a new media technology, such as cinema or, more recently, the World Wide Web, transformed the languages and forms of circulation of previously existing media—that which, referring to computer technologies, Lev Manovich describes as the "computer media revolution [affecting] all stages of communication [. . .] and all types of media" (Manovich 2002, 19). It would, of course, be naive to claim that performance art emerged as an artistic technology in the second half of the twentieth century, for its origins date back, as RoseLee Goldberg suggests, at least to Futurism and Dada (Goldberg 1988, 14). Nonetheless, this same pioneering scholar in this field argues that performance only came to be recognized as an art form in its own right in the 1970s, and as I discuss in the following chapters, this process saw significant resistance in Latin America. The performative turn in the art of the region can be seen, in this sense, as an agonistic process set in motion during years of authoritarian politics that heightened the presence of live actions in the field of art and led to the intermedial diversification of artistic expressions. Understanding this process involves coming to terms with how the rise of live art affected the strategies of production, reception, and circulation of other art forms, including collage, painting, photography, video, and poetry. My use of this notion to denote a process and a tendency in the sphere of art is in dialogue with what Jeffrey Geiger and Karin Littau have described as "cinematicity" in media studies, which refers to the relationship between cinema and a host of other media, often expressed through "mimetic traces" of the cinematic in works of literature, paintings, photography, and video games (Geiger and Littau 2013, 2). Both the concepts of the performative turn in art and that of cinematicity move beyond a formalist and medium-specific approach to performance art and cinema, respectively. They reflect the entwinement of media histories and the ways in which media cross

historical, cultural, and physical borders; they also attend to how the new shapes the old, whereas the old resists disappearance as it goes through cycles of renewal and reinvention. In Latin America in the late 1970s and 1980s this crossing of boundaries was earnestly longed for and primarily advanced through live performance. As Maresca claimed (referring to how these developments affected her sculptural practice), artists were searching to "desacralize all that history in which sculpture is simply made to be placed in the gallery and nothing happens. We wanted to give movement to the work and the public to be part of it all" (quoted by Sequeiro 1987, 56). Such attitude is vividly expressed in López's photograph of Maresca sitting in the corner of her studio surrounded by two of her sculptures as they prosthetically extend her bare body. In other words, this one shot is a powerful synthesis of the place of intermediality in the performative turn (Figure I.3).

The second dimension of the performative turn points toward a different but related problem, one stemming from philosophical and linguistic discussion on the performativity of language. In linking the study of performance art with the concepts of subjectivity and agency, I draw on J. L. Austin's *How to Do Things With Words* (1962) and Judith Butler's restaging of Austin's speech acts theory in order to reflect on how the performativity of language bears upon subjectivity and embodiment (Butler 1990, 1993a). For Austin, a performative utterance "brings

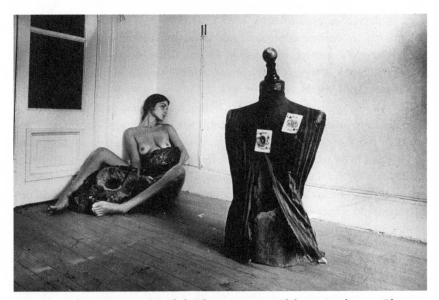

FIGURE I.3. Liliana Maresca, *Untitled: Liliana Maresca with her Artworks*, 1983. Photo-performance photographed by Marcos López. Gelatin silver print, 22 × 33.5 cm. Courtesy of Rolf Art, Almendra Vilela and Marcos López.

what it states into being (illocutionary) or makes a set of events happen as a consequence of the utterance being made (perlocutionary)" (Butler 2015, 28). Along similar lines, Butler suggests that "performativity is a way of naming a power language has to bring about a new situation or to set into motion a set of effects" (28). This power of language is also present in nonlinguistic communicative acts, including certain gestures and forms of visual expression (Langton 1993). Yet the performativity of communicative acts should not be taken lightly—by claiming that the performative effects of language might be shaped at will. This agency of language is strictly dependent on a society's existing institutions and conventions. A classic example of a performative utterance would be, for instance, the words "I do" voiced by bride and groom during a marriage ceremony when they are asked whether they will take each other as husband and wife. These words produce the marital bond. For these utterances to have any effect, however, they must be made in a society in which marriage, as a social institution, exists in the first place; moreover, the priest or civil servant who phrases the question must also have the requisite authority. In other words, speech acts to the extent that its actions may derive meaning and effect change in given contexts. This precondition is similarly present in performance art. Here, the effects of certain forms of embodied communication—that is, their capacity to affect publics and passersby, their transformation of space and time, and their potential to disrupt an existing fabric of sensory experience—depend on the social conventions of a given time and place. Therefore, one of the tasks of this book is to outline strategies by which artists in Chile, Argentina, and Mexico developed performative forms of critique against conventions that in their time were deemed oppressive. And to suggest that they did so without necessarily having a message, or "referent" to communicate, beyond a self-reflexive and embodied awareness of power abuses and the kinds of individual and collective injury that those abuses generate.[26]

How, then, as Butler questions, "do bodily acts become performative" (2015, 29)? This interrogation speaks more broadly to the meaning of embodiment and the codification of corporeal movement and gesture. For Butler, speech acts always "animate us in an embodied way" (63); language, in turn, has profound consequences on the shaping of gendered bodies. Gender does not precede but indeed succeeds the linguistic interpellation. In other words, the body is interpellated performatively to reiterate the gender norm, which is construed linguistically in the first place. However, by means of repetition, the body may also fail to repeat fully or indeed "embody" this norm, as the organization of desire and sexuality often slips outside or exceeds the (binary) possibilities to name sex. In other words, bodies are at once linguistically and institutionally supported as well as capable of resisting the constrictions resulting from the various networks of support upon which they rely. Moreover, according to Butler, "The body is less an entity than a living set of relations; the body cannot be fully dissociated from the infrastructural

and environmental conditions of its living and acting. Its acting is always conditioned acting, which is one sense of the historical character of the body. Moreover, the dependency of human and other creatures on infrastructural support exposes a specific vulnerability that we have when we are unsupported" (Butler 2015, 68). The history of performance art has been tied to this constitutive ambiguity at the origin of embodied action. Performance plays and experiments with the subversion of identity and the "appropriation" of one's body; yet performance artists inevitably work with bodies that are always already political, that is, bodies that are bounded by a series of norms and social relations. By rendering the body as medium, performance artists situate embodiment at the center of the relationship between aesthetics and politics. Their exploration of agency is not based on any sort of methodological individualism but rather enacts the extent to which agency is always radically conditioned and intersubjective. In performance, the "individual body"—a term that, for the reasons already mentioned, is nothing but a fiction that dissociates the subject from both the community and the norm—is allegorical of the political body, but also something else: affect, matter, the index of a subject's finitude, and the possibility of ethical agency.

THE AESTHETICS OF DISSENSUS

A seemingly fixed or denotative vision of the political often accompanies the categories of political art and "artistic resistance." My analysis seeks to go beyond this vision to explore Jacques Rancière's notion of "dissensus" (2013a, 139) as a conceptual framework that, although not without its own faults, may be better equipped to account for the challenges posed by a self-reflexive and performative critique of power in the face of experiences of authoritarianism and political violence. Rancière's English translator, Steven Corcoran, proposes a succinct definition of the meaning of "dissensus," arguing that it differs substantially from the overturning of political or institutional power—which falls under the category of resistance.[27] Dissensus is the primary force through which the politics of aesthetics unfolds: "it is an activity that cuts across forms of cultural and identity belongings and hierarchies between discourses and genres, working to introduce new subjects and heterogeneous objects into the field of perception" (Corcoran 2013, 2). The term derives from an idea of domination that posits the invisibility of the oppressed and in which the political demands of the *sans-part*, that is, "those who have no 'share' in that which is common" (Davis 2013, 157), are both imperceptible and seen to be illegitimate. Furthermore, Rancière's understanding of possible forms of aesthetic disruption of the perceptual and symbolic organization of the political presupposes an idea of the aesthetic that abandons its modern association with the realm of beauty to return it to its classic origins. That is, the philosopher's definition of aesthetics goes back to the Greek root of the word *aisthesis*

(αἴσθησις), referring to "the system of *a priori* forms determining what presents itself to sense experience" (Rancière 2013b, 8). This conceptualization of the aesthetic proves to be particularly meaningful for my study, in view of the possibilities that it opens: first, to leave aside the centrality of beauty; second, to ascribe primacy to sense perception in the discussion of art (thus largely rooting aesthetic experience in the body); and third, to expand the conceivable forms of political action. Framed in this light, politics becomes a way of selecting, classifying, and distributing that which can be sensed. It entails, too, the act of tracing relations between these domains and establishing areas of invisibility, silence, and exclusion. Correspondingly, political processes of subjectivation are defined as encompassing a certain ordering of time and space, a division between the visible and the invisible, and the creation of institutions that may sustain this aesthetic distribution. To quote Rancière: "The political is [...] first of all the debate over what is given sensibly, on what is seen, on the way what is seen is sayable and over who can see and say it" (Rancière 2011, 10). The relationship between politics and aesthetics therefore dwells on what he calls *le partage du sensible*, a phrase translated as the "division" or "distribution of the sensible" (even though this translation relies on a linguistic "false friend"; the concept refers to neither reason nor prudence, but to what can and cannot be sensed or felt). The distribution of the sensible, a phrase I use frequently in the following pages, "is a delimitation of spaces and times, of the visible and the invisible, of speech and noise, that simultaneously determines the place and the stakes of politics as a form of experience" (Rancière 2013b, 8).

In line with Theodor Adorno's (2004) attention to the politics of form, but breaking away from Adorno's aversion to the commodification of art, and his exclusive belief in the political potential of (certain) modernist languages, Rancière's understanding of the politics of aesthetics leads us to consider the political effects of works of art—be they objects, practices, or conceptual propositions—as resulting from the (performative) disruption or disorganization of given relations between objects and actions, of the ways these relations are perceived, and of their attributed meanings. Oliver Davis speaks of this politics of aesthetics as an "education in the contingency of domination," based on an immanent "contingency in objects and institutions" that stems from their embeddedness in an iterative "fabric of sensible experience" (Davis 2013, 156, 159). By being constitutive of this fabric of experience, and by recognizing that it is discursively and materially mutable, artistic practices have the potential to affect its composition, organization, and affective dimensions.

Rancière's observations largely disregard the economic sphere (see Žižek 2005, 75); they also suggest a certain universal approach to the meaning of aesthetic experience that is almost strictly centered on the study of Western art. This has led critics like Hal Foster to argue that the French theorist "gives art an agency that it does not possess at present," weakened as it has been by the power of the

culture and information industries and the mass media (Foster 2013, 15). From a truly Rancièrian perspective, however, the aesthetic exists only in relation to "ordinary forms of sensory experience" in a given time and place (Rancière 2013a, 179). The politics of aesthetics, therefore, cannot be limited to blanket statements such as Foster's, in which a universal and unbridgeable distinction between art and the information industry is already presupposed. Instead, one must identify the political potentiality of artistic practice and aesthetic dissensus "case by case, step by step, in the singular strategies of artists" (179). This case-specific approach guides my discussion of the politics of aesthetics in the following chapters and allows me to overcome both Foster's and Rancière's constrainedly Eurocentric views. In other words, I seek to understand how certain forms of embodied artistic practice intervened in the fabric of sensory experience within specific urban contexts in Argentina, Chile, and Mexico during the long 1980s. My focus on embodiment and performance, based on a conceptualization of aesthetics as that which presents itself to sense experience, will facilitate an approach to the politics of art that goes beyond the exclusive terrain of vision, reflecting specifically on the importance of what Erin Manning describes as a "politics of touch" under authoritarianism (Manning 2007, xiii). *Touched Bodies* is a study of performative practices in the South that does not assume the distant position of the gaze but the proximity of the touching hand and its relationship with other forms of perceptual experience in situated contexts.

THE ETHICS OF PERFORMANCE

Early scholarship on performance art, such as Peggy Phelan's *Unmarked* (1993), described the ontology of performance in terms of an economy of presences that resists an economy of reproduction. Performance is, in Phelan's view, "representation without reproduction" (Phelan 1993, 146). For Phelan performance can neither be saved nor recorded; its "only life is in the present" (146). From this perspective, performance art is not only an art of presence but also an art that becomes itself through disappearance and haunting. Moreover, performance art comes to be understood as antithetical to marketable art, and this believed impossibility of inserting performance in circuits of market exchange is described as a consequence of its purported immateriality.[28] Further still, Phelan ties the demand for embodied presence to the ethics of this practice. Largely literalizing Emmanuel Levinas's writings on the ethics of the face, which I discuss in further detail in chapter 6, Phelan writes: "If Levinas is right, and the face-to-face encounter is the most crucial arena in which the ethical bond we share becomes manifest, then live theatre and performance might speak to philosophy with renewed vigor" (Levinas 2004, 577).

Phelan's influential writings on the ontology and ethics of performance art can be contested from various perspectives. Delving into this debate is beyond the aims

of this introduction, but two of the central problems at stake are, first, the limited role ascribed to the relationship between performance and its "documentation" in Phelan's work; and second, the restricted idea of ethics she deploys. As I address these questions in the context of 1970s and 1980s Latin America, I find myself in agreement with Philip Auslander's rereading of the ontology of performance through the notion of "liveness." Moving away from Phelan's "reductive binary opposition" between live and mediatized art, Auslander posits that the very category of live art can exist only *within* an economy of reproduction" (Auslander 2008, 54). Therefore, he claims, it is the relationship between live and mediatized events within this economy that one must place under scrutiny, always taking the historicity of their phenomenal antagonism into account. For Auslander liveness ought to be ultimately conceived of as falling in the realm of contingency rather than ontology.

Auslander's perspective opens rich possibilities to research the relationship between performativity and intermediality, looking at the role of reproduction in the synchronic and diachronic (re)production of the live event. Moreover, this view illuminates the significance of "the performativity of performance documentation"—that is, the capacity of documents to produce meaning and affect audiences, together with the political consequences of this performativity (Auslander 2006, 1). The artistic practices that I bring together in this book were conceived of not only to be directly experienced but also documented. I, in turn, accessed them through this documentation, as well as through a multiplicity of communicative strategies that the artists used to remediate their live acts. Each of these mediations entailed new affectations and generative acts of meaning-production. Therefore, in writing this book I have aimed to move beyond a demand for presence or immediacy in the study of performance to reanimate the politics of art through our (belated) contact with extant traces of the live body in performative media.

Auslander's position relates more broadly to the history of performance art in Latin America, which is a history that has for the most part remained in oblivion. My own form of entry into this splintered past has not been through the live encounter with performative acts but through often dusty, moldy, and creased documents, intimate family archives, and blurred footage in VHS format that awaits digitalization. So many of the performances that I discuss in this book took place in either private spaces or completely anonymous and busy roads—where spectators were either nonexistent or transient—that situating the ethics of these practices in the live encounter with the artist, as Phelan suggests, would automatically foreclose their ethical significance, together with the value of their study and memorialization. My intention here is to assert the contrary. For already from the mid-1960s onward, with the onset of conceptualism in the region, the documentation of performance and its recirculation in different media at various points

in time proved to be a key strategy of artistic and ethical intervention in the field of politics. Moreover, the cyclical processes through which live performances and their documentation have been remediated fully determined the conditions for the writing of this book, and led me to consider the forces driving these cycles, their social effects, and the performative potential of archival documents. I wish to situate this study as yet another cycle in the performative activation of the traces left by past practices. I also wish to lay open new possibilities to imagine their political significance in the face of new forms of authoritarianism today.

OVERVIEW OF CHAPTERS

The following chapters constitute a series of case studies on artists from Chile, Argentina, and Mexico who worked either under conditions of authoritarianism or in the wake of military regimes. Each chapter focuses on the relationship between performance and an assemblage of different media, including video, poetry, collage, photography, painting, and mail art. Chapters 1 and 2 are devoted to Chilean artists and discuss a process of encounter and mutual affectation between performance and writing, looking first at Diamela Eltit's experimental narrative and then at Raúl Zurita's ritualized poetry. Chapter 1 opens with a discussion of the ways in which the body became a site for critical artistic practice in Chile during the years of military rule (1973–1990) and reflects on the arguably ephemeral character of live art, despite "art actions" having circulated mostly as experimental videos. My analysis centers on the interplay between pain and critical agency in Eltit's video-performance *Zona de dolor* (Zone of Pain) (1980), which combines still photographs of the artist's self-lacerated body with digital footage of a live reading of *Lumpérica* (her then-novel-in-progress) in an impoverished brothel in the outskirts of Santiago. An iconic work within the neo-avant-garde art scene that flourished in Chile during the dictatorship, this piece has often been discussed as a self-martyrizing allegory of the disciplining of bodies by the dictatorial regime. By revisiting this video-performance, I argue that rather than embodying the imaginaries of women and artists as sacrificial victims of the regime, the work constructs a broader critique of the social uses of suffering. Likewise, as the title of the piece suggests, the work destabilizes the accepted territory for the public expression of pain, making visible the political dimension of individual or "private" suffering. I pay special attention to Eltit's use of parodic ambiguity to critique dominant political and religious discourses at the time of Pinochet's dictatorship. In the closing section I examine painter Gonzalo Díaz's rereading of *Zona de dolor* toward the end the 1980s, thus shedding light on the interplay between live art, narrative, and painting during this decade.

In Chapter 2 I address the work of Raúl Zurita throughout the years of military rule in Chile and during the early days of the country's subsequent democratic

transition. I focus on the poet's enactment of corporeal vulnerability and mourning, in the form of poems of lamentation, and on the political significance of the public expression of grief in the context of Chile's experience of state violence. The main works under discussion are Zurita's prayer-poems *Purgatorio* (Purgatory) (1979) and *Canto a su amor desaparecido* (Song for His/Her Disappeared Love) (1985),[29] together with Zurita's self-blinding performance, *La vida nueva* (The New Life) (1982), and his work of land art, *Ni pena ni miedo* (Neither Sorrow Nor Fear) (1993). Taking into account the importance of Walter Benjamin's writings on mourning in the scholarship on the so-called art of post-dictatorship in Latin America, I propose a rereading of Zurita's work in the light of S. Brent Plate's (2005) call to "rescue lamentation from mourning" in the study of Benjamin's allegorical aesthetics. Linked to the public, performative, and often politically destabilizing dimensions of mortuary ceremonies, lamentations allow grief to be articulated through the body and through the sounds of language. Zurita's prayer-poems and live performances are not only evocative of vulnerable corporealities, but they also construct a fragmented and heteroglossic poetic voice that is both masculine and feminine, holy and profane. They express fragility, but they also resist it with a ritualized and public cry. It is my contention that the poet's construction of mirrored, confused, and corrupted subjectivities grounds the capacity of his poetic acts to shatter received social dichotomies and to assert the ethical significance of allegorical other-speaking in a time of social crisis.

The next two chapters focus on Argentine artists, moving from the preceding discussion of performative practices involving acts of wounding and linguistic fragmentation to an analysis of artistic explorations of corporeal proximity and touch. In chapter 3 I look at León Ferrari's series of collages entitled *Nunca más* (Never Again) (1995–1996) and *Brailles* (1996–c. 1998). Contrasting these works with the politically motivated practice of collage in Argentina during the 1960s, I posit that Ferrari's Braille-inscribed late collages do not seek to reveal a given political message but aim instead at offering the participant spectator a caressing, affective, and often ambiguous sensation. Haptic communication in Ferrari's art will refer me back to a series of writings on the "unrepresentability"—or untouchability—of historical traumas, writings that will lead me to examine the ways in which the artist contested this notion in his illustrated version of the 1984 human rights report *Nunca Más*. On the basis of the joint analysis of both series of collages, and the reflection on the participant role that they seek to provoke in the viewer, I suggest that Ferrari's late collages speak for a renewed and performative approach to this medium, where the meaning and range of the political becomes "touchable" and open for dissensus.

In chapter 4 I analyze the place of nudity in Ferrari's erotic collages and appropriated mannequins, which I compare with a series of performative sculptures by HIV-afflicted artist Liliana Maresca. These works intersect the "politics of Eros"

(Mahon 2005) and the politics of the ailing body with a critique of the biopolitical repression of corporeality by church and state. Ferrari's approach to the erotic contests the repressive deployment of an acutely conservative understanding of Catholicism by the last military regime in Argentina, and questions the persistence of a repressive sexual culture in the aftermath of this regime. I therefore situate the artist's interest in erotica within the larger context of the emergence of various forms of "sexual disobedience"—including second- and third-wave feminism and HIV-AIDS activism—toward the end of the dictatorship, and I position Maresca as a leading figure within this underground and disobedient cultural scene. This chapter brings together two figures that have been seen as embracing different visions of the political in art: Ferrari standing for a message-driven politics close to the early work of Antonio Berni, and Maresca for a (nonreferential) politics of embodiment (see Pineau 2012). Moving away from this scholarship, I describe Ferrari's and Maresca's mutual interest in developing an artistic practice that not only enunciates but also embodies and performs a politics of Eros. The intermedial encounter between performance art, collage, assemblage, and photography facilitated this full-fledged reorganization of the aesthetic in 1980s Argentina.

The final two chapters are organized around images of exposure and faciality.[30] They discuss artists working in Mexico, a country with a well-documented history of authoritarianism in the 1970s and 1980s, yet one rarely compared to other countries that experienced dictatorship in the same decades. In suggesting this comparison, I am not just interested in questioning the presumed exceptionalism of the Mexican case. I also seek to establish fruitful dialogues between areas of artistic practice that have remained obstinately separated as a result of a rigidly national organization of artistic debate. Seeking to doubly rupture this nationalist determinism, while continuing to pay close attention to the relationship between art and social context, these chapters focus on émigré artist Marcos Kurtycz, whose work was of crucial significance in the early conceptualist scene in Mexico. In chapter 5 I revisit the relationship between performance art, ritual, and (the critique of) painting by examining Kurtycz's *Potlatch* (1979), an art action in which the artist gate-crashed an exhibition opening and publicly destroyed one of his own paintings with acid. Inspired by Georges Bataille's notion of ritual "expenditure" (Bataille 1988), this both provocative and sacrificial act opens up questions of aesthetic and material value in a heavily iconophilic and regimented context. I consider Kurtycz's action in the light of different understandings of the role of violence in art, including destruction, war, terror, ritual, and self-critique. In doing so, I draw a series of comparisons between Kurtycz's performative use of violence and the staging of terrorist tactics by Mexican artists' collectives known as No Grupo, which self-defined as a parodic *guerrilla* organization, and Proceso Pentágono. Revisiting Luis Camnitzer's (2007) thesis on the role of left-wing terror in

the development of "ideological conceptualism" in Latin America, I suggest that the singularity of Kurtycz's art lies not in the communicational effects of his spectacular use of violence but in the ways in which he entwined political and (intimate) ritual violence while intersecting critical embodied acts with self-affirming acts of destruction. This is the linchpin of what feminist artist Mónica Mayer identified as the strange combination of vulnerability and violence that characterized Kurcyz's ritualized performances.[31]

Chapter 6 moves toward a reflection on the possibilities and limits of a post-human politics in 1980s performance and mail art and looks at the encounter of live art with technologies capable of expanding, deforming, and reshaping the body and its multiple masks. In this chapter I examine Kurtycz's early career as a cybernetic engineer in Poland and describe the ways his knowledge of cybernetics influenced the development of cybernetic assemblages, interactive sculptures, mail art systems, and live performances once he moved to Mexico in 1968. My focus is on the preeminence and meaning of faciality in a series of works influenced by first-wave cybernetics. I identify three conceptions of faciality in Kurtycz's art—the mask, the interface, and the trace—and argue that in his work the face is not a "mastering machine" acquiring primacy by becoming detached from the body, as Deleuze and Guattari would claim (2004, 197). Rather, it is a contingent mechanism of encounter and mediation between self and Other, and a site in which the vulnerability of the self is exposed, opening and multiplying the possibilities for linguistic and nonlinguistic communication. Linking Kurtycz's performances from the early 1990s to his early works, I also examine how the artist's knowledge of cybernetics, and the development of this "soft-science" in the Soviet world, influenced his interest in devising posthuman bodies as well as immersive and interactive environments. Yet, by distancing himself from the technophilia of those who celebrate virtual communication and cyberculture as the new terrain of politics, Kurtycz located the value of his practice in a search for face-to-face encounter and the construction of direct forms of interaction between the artwork (or performer) and the public—even as this search gave rise to new mediations, such as the traces of the artist's gestures and movements in the documentation of his live acts—which he sent to friends and enemies through the post.

The book closes with a reflection on the place of vulnerability in the work of each of the artists discussed. I describe these artists as having developed a poetics exploring the ambiguous boundaries of pleasure and pain as a means to contest what Levinas (1988) calls the "social utility of suffering" or its pedagogic function. Moreover, I argue that a number of artists from Chile, Argentina, and Mexico during the 1970s and 1980s situated the affective indeterminacy of corporeal experience as a terrain of aesthetic dissensus. Here the body as a medium, site of ethical encounter, substratum of pain, and index of the subject's iterative

identities allowed the appropriation and resignification of disciplinary models of subjectivity, feeling, and behavior that had stemmed from the rigid biopolitics of authoritarianism. In the art of the long 1980s pain and pleasure become ambiguous, disorganized, paradoxical. This aesthetic disorganization of "correct" feeling grounds the politics of the performative turn, a politics of proximity, vulnerability, subjective indeterminacy, and heteroglossia.

1 · WRITING THE BODY

Y así la quemada le dará nueva cicatriz que le forjará el cuerpo a voluntad.
(And then the burns will give her a new scar that shall shape her body at will.)
—Diamela Eltit, *Lumpérica*

"The least one can say about suffering," the French philosopher Emmanuel Levinas wrote, "is that in its own phenomenality, intrinsically, it is useless, 'for nothing'" (1988, 157–158). For the philosopher, the gratuitous and unassumable quiddity of suffering can only be given a signification in the light of an idea of history capable to subsume it, that is, in the light of a theodicy. Theodicy makes suffering comprehensible; in doing so, it also turns it into a function of power. However, the nature of suffering in relation to ethics is different. For Levinas, the recognition of the "unjustifiable character of suffering in the other person" is the necessary basis of a corporeal ethics, namely, an ethics that precedes the morality of the law, and posits no other foundation beyond the attention to the other's vulnerability to pain and injury (163). In this chapter I suggest that this distinction between theodicy and ethics is particularly telling when reflecting on the suffering that results from political violence, and from politically motivated attempts to render suffering "assumable"—by presenting it as a historical necessity for the coming of a greater good.

On September 11, 1973, the three branches of the Chilean military toppled the democratically elected socialist government of Salvador Allende by means of a violent coup. On that day, the bombing of the Moneda Palace in Santiago, a symbol of the long institutional history of Chilean democracy, announced the years of fierce repression that would follow. Estimates by the 1993 Chilean National Commission on Truth and Reconciliation and other more recent investigations account for 3,500–4,500 deaths and disappearances by state agents and 40,000 cases of torture.[1] Political arrests exceeded 82,000, and at least 200,000 people were driven into exile (Stern 2006, xxi). In a country of 10 million at the time of the coup, these figures "translate into pervasiveness": "a majority of families, including supporters and sympathizers of the military regime, had a relative, a friend, or an acquaintance touched by one or another form of repression" (xxi). In view of this situation, and given that at least during the first five years of the

dictatorship the violation of human rights became a state policy, critics have described dictatorial Chile as a society characterized by widespread fear (Silva 1999, 78; Lechner 1992, 26–27). This feeling was rooted in complex personal and collective experiences; yet it is most telling to observe the extent to which repressive strategies were invested in the production of a generalized perception of a sense of threat and in the justification of state violence as a purported means to "prevent" greater violence. Official denial and active obfuscation of illegal yet informally institutionalized repressive practices, such as forced disappearance, played a central role in spreading this feeling during the first years of military rule. Fear and ensuing distrust were also enhanced by the passing of a series of edicts (*bandos*) that dictated extreme repressive measures against loosely defined as enemies of the Chilean nation. These fast-track laws released during the state of exception reveal that the Chilean military saw the use of violence against its own citizens as a form of just war.[2] "Violence as salvation from violence," Stern argues, "provided political cover for the rapid building of a police state—a state that could quell criticism, dismantle resistance, and eventually render ambiguity a moot point" (Stern 2006, 36).

The military's self-perceived messianic deployment of violence was accompanied by the prescription of acceptable and unacceptable forms of suffering, casting the latter to invisibility. From the day of the coup, the military junta, claiming to act in the name of morality, the Fatherland, and religion (Government Junta 2014, 452), issued a public declaration describing the Allende government as illegal. All dissidence was thus deemed immoral, antipatriotic, and fueled by a purportedly irrational belief in a "demonstrably unsuccessful" model that was leading to a "fratricidal and blind struggle" (450). Shielded by this all-too-frail veil of righteousness and legitimacy, the military dehumanized its chosen "enemies," while also subjecting them to extreme physical and psychological torments. In 2011, the National Commission on Political Imprisonment and Torture (also known as the Valech Commission) not only documented 38,254 cases of political detention between 1973 and 1990—most of which involved torture—but also described torture and detention as widespread and systematic practices of political control with explicit gender components that were often covered up or directly supported by the judiciary. Despite the demonstrably generalized character of these practices, the military government went to great lengths to convince people that torture was a justifiable exception performed against a handful of dangerous criminals. Those who experienced this form of political violence were thus left to deal with their pain in solitude, and were largely excluded from public visibility and public debate, even during the less repressive later years of the regime (Vidal 2000, 9).

These strategies to rationalize and "manage" acceptable forms of suffering had enormous consequences in the shaping of a political and aesthetic culture in Chile. According to Norbert Lechner, the dictatorial state domesticated and infantilized

society, while giving rise to a self-punitive and self-contained idea of citizenship in which the fear of politically motivated suffering led to "self-inflicted subjection." Under these conditions power was "sanctified as a redemptive agent," while "citizens [did] not have to be excluded from the political realm; they exclude[d] themselves": "Desperately, dying of fear, people deliver themselves over to a superior agent that will decide for them. It is an act of faith based on the hope of winning salvation through self-abnegation" (Lechner 1992, 31).

It is in this sense that, returning to my initial discussion of Levinas, suffering may be said to have a "social utility" that goes beyond the intimate and often isolating experience of pain. As Levinas suggests, visible, embodied, and rationalized suffering is "necessary to the pedagogic function of Power in education, discipline and repression" (Levinas 1988, 160). Useless pain, by contrast, resists theodicy: the "gratuitous non-sense of pain [. . .] pierces beneath the reasonable forms which the social 'uses' of suffering assume" (160). Moreover, Lechner's reflections on the self-punitive idea of citizenship that prevailed in Chile during the military regime shed light on various rituals of self-inflicted pain that populated cultural production in the country during the dictatorship, particularly in the realm of live art and its intersection with writing.

Recognized by some Christian traditions as a form of redemptive suffering, practices of self-directed pain traverse Western history but inhabit an uneasy place in what Mark Seltzer describes as a "wound culture" or a "pathological public sphere" characteristic of highly mediatized societies that collectively gather around spectacles of horror, pain, and victimization (Seltzer 1997, 3). Such uneasiness derives from the various positionings of the onlookers. Indeed, the constitution of a visual culture around disaster and suffering does not mean that those who view them feel the same or interpret them univocally: "No 'we' should be taken for granted, when the subject is looking at other people's pain," as Susan Sontag argues (2003, 6). Even in a wound culture, not all forms of suffering and injuring are either visible or acceptable; and the role of the unacceptable is significant because—as Judith Butler suggests as she pushes Seltzer's argument into dialectical movement—that which cannot be said and cannot be shown negatively constitutes the public sphere, having major consequences for the forms of recognition and participation that it allows (Butler 2004, xvii).

Focusing on Chilean artist Diamela Eltit's practice of intermedial performance during the Pinochet regime, this chapter discusses an unconcealed, yet highly experimental and subjective, self-inflicted "zone of pain" during the years of dictatorial rule in Chile. Here, the notion of a "zone of pain" has multiple layers of meaning. In the first place, Zonas de dolor (in the plural) is the title of a series of three experimental video-performances filmed by Eltit and her collaborators in the early 1980s. My reference to pain or dolor is also thematic, since the video-performances interrogate the relationship between pain and language, the

representation of the wounded, sacrificial body, and the correspondences between poverty, asceticism, and martyrdom. One of the three videos—itself entitled *Zona de dolor* (1980), in the singular—brings together footage of an art action Eltit carried out in a brothel and photographic images of an act of self-wounding.[3] Both the pictures of Eltit's self-lacerated forearms and the footage of her presence in the brothel have circulated extensively as documentation of early performance art in Chile and exemplars of the flourishing of this practice as a form of artistic activism during the Pinochet regime. It has been repeatedly argued that in Eltit's video-performance the motifs of torture and bodily pain emerge as allegories contesting Chile's state of turmoil under military rule (Brito 1990; Neustadt 2003). The semiotic interplay through which this critical discourse emerges, however, has not received sufficiently careful consideration, nor has the intricate relationship between performance, video, and writing in Eltit's work.

Some of the most complex approaches to Eltit's arguably allegorical aesthetics come from important literary critics Francine Masiello (2001, 66–69) and Jean Franco (2002). Both interpret Eltit's literary and visual work during the late 1970s and early 1980s as a form of political resistance through aesthetic means, giving what Franco calls the Latin American "aesthetic turn" a singular tone (Franco 2002, 216). Such singularity results from the fact that the strategies of fragmentation that characterize postmodern aesthetics become politicized through the incorporation of those residues that have been overlooked by modernity's "cosmetic gaze" (217). However, in these critics' writings the discussion of intermediality in Eltit's work, together with the artist's use of contradiction and subjective indeterminacy as critical strategies, become entirely sidelined. Power is rendered hierarchically, in a top-down manner wherein the experimental writer resists a situation of oppression without in any way participating in its conditions of possibility. Moreover, these critics do not touch on Eltit's thematization of self-inflicted pain and her engagement with religion and eroticism in her early performances. Revisiting Eltit's *Zona de dolor* will allow me to problematize these views and further interrogate the artist's attempt to situate a private act of self-wounding in the public domain. In my reading, the dissident Christian tradition of mysticism, together with a feminist and self-reflexive approach to embodiment, pain, and vulnerability, occupy center stage in Eltit's performative poetics. The significance of religion in Eltit's critique of the state's management of pain, in turn, derives not only from the Chilean dictatorship's self-proclaimed Christian worldview but also from the broader identification of religion with theodicy, "the attempt to make sense of suffering" (Seeman 2004, 56). I consider Eltit's public performance of a painful ritual, and its intermedial recirculation in the form of both a novel and a piece of video art, as means to render perceptible the dictatorship's complex repressive logic, which sought to "sacrifice" certain presumed dissidents and justify their suffering in the name of the nation's general well-being.

Conservative Catholicism was one of the founding ideologies of Pinochet's dictatorship, despite the major role played by less-conservative Catholic groups and organizations, such as the Vicariate of Solidarity, in supporting victims of state repression.[4] According to literary critic Idelber Avelar, three basic sources fed off this ideology: "1) the geopolitics of the Doctrine of National Security: Chilean society suffered from a disease and some body parts had to be 'amputated' to cure it, 2) conservative Catholicism: Chile, in its 'essence,' belonged among Western Christian nations and social egalitarianism equalled blasphemous atheism, 3) nationalist populism: Chilean people were by nature peace-loving, quiet, and so on" (Avelar 1999, 46). The medicalized, moralizing, and nationalist tenets of this ideology were central to the self-repressive effects of state violence that Lechner evokes so vividly. Self-punishment, self-censorship, and self-disappearance (from public visibility and political engagement) were, in this sense, the ultimate forms of authoritarian repression, and this is what Eltit brings to light in her self-sacrificial performances. In other words, one could argue that the witness of a state crime who decides to remain silent, the political prisoner carrying a suicide pill, the activist burning his or her own library, and the militant who betrays his or her comrades can all be critically thought through the image of Eltit's mortified, self-mutilated body.

In the following sections I undertake a close examination of Eltit's *Zona de dolor*, tracing its relationship to the novel *Lumpérica* ([1983] 1998) and to other artistic evocations of self-inflicted pain in Pinochet's Chile. I discuss Eltit's appropriation of suffering in relation to the problem of subjectivation, understood as a double mechanism that not only involves the disciplining of the subject but also founds the possibility of agency. I also examine the mystical symbolism that traverses Eltit's video-performance, and relate these seemingly religious elements to a tradition of feminist contestation of power relations, grounded in bodily gesture and the use of a fractured, "disorganized," and polluted speech. Finally, I reflect on the extent to which Eltit's video-performance succeeds in articulating a critique of disciplinary and perceptual dynamics imposed by the military regime or, conversely, collapses back into the body, leading to a libidinization of suffering that reinforces those same disciplinary mechanisms. I argue that Eltit's approach to self-punishment is not primarily an ascetic gesture. Rather, she strives to bring a repressive and conservative morality to a terrain of parody and excess that challenges this ethical order and enables the affirmation of agency within a highly oppressive and controlling power structure. This discussion will ultimately lead me to dwell on (the limits and possibilities of) the body as a site of aesthetico-political dissensus in the context of disciplinary structures, and the consequences that this approach to corporeality entails for critically understanding the politics of intermedial performance.

A PRECARIOUS AESTHETIC

Today Diamela Eltit is known as a prolific avant-garde writer and one of the most important living literary figures in Chile. Despite Eltit's primary identification with the written word, during the years of the dictatorship she participated in a number of live and often collective artistic practices that were performed in public space as a means to oppose the regime. Between 1979 and 1985, Eltit belonged to the Colectivo Acciones de Arte (Art Actions' Collective, most commonly known as CADA), an interdisciplinary artists' collective that staged numerous live performances—known as "art actions" (*acciones de arte*)—in the streets and working-class neighborhoods (*poblaciones*) of Santiago. Those actions were minutely documented by the artists, and this documentation circulated within Chile's small artistic scene during the military regime.

CADA was born out of a desire for creative collaboration among two visual artists (Lotty Rosenfeld and Juan Castillo), two writers (Eltit and Raúl Zurita), and a sociologist (Fernando Balcells). Critics have argued that this collaboration sought to resist the impoverishment of artistic practice caused by state censorship, self-censorship, budgetary cuts, and the exile of artists and intellectuals that came with the coup (Neustadt 2001, 15). In my own archival research on CADA's work, I have also been struck by their concern over the social consequences of individualism, which they call "the system of the moment," and a sense of growing "disarticulation of the community."[5] The emergence of CADA coincided with the drafting of a new and highly repressive constitution in 1980, which ratified Pinochet as Chile's president and strengthened his powers (Huneeus 2000, 243).[6] Largely authored by ultra-conservative lawyer Jaime Guzmán Errázuriz, the constitution turned the rapid privatization of public services in the country into law, and it severely constrained opportunities for civilians to participate in public decision making.[7] The constitution reflected the views of two groups of Pinochet supporters: Catholic nationalists influenced by authoritarian leaders such as Chilean Diego Portales (1793–1837) and Spanish General Francisco Franco (1892–1975), and a younger generation of well-off professionals, the so-called Chicago Boys, who were educated primarily at the University of Chicago under the aegis of Milton Friedman. The latter became the ideologues of the "shock therapy" policies involving the sudden withdrawal of state subsidies and other guarantees of social welfare, including guaranteed access to health care and education, as well as the protection of labor rights (Huneeus 2000, 246–247). Both groups of Pinochet supporters expressed their interest in "the common good," engaging in what Michael J. Lazzara describes as different forms of complicity and complacency with the regime's violations of human rights, all for the sake of the country's imagined modernization (Lazzara 2018, 7). According to Lazzara, they also endorsed a discourse of "self-sacrifice," which "resonated perfectly with that of the military crusaders

who had 'saved' the nation from the toxic grip of Marxist ideology and who now, to protect their epic story, also needed to free the economy from the grip of socialist policies" (74).

Yet the early 1980s also saw the fragmentary reappearance of popular and artistic movements reclaiming the possibility to occupy and participate in public space. According to Vidal, in 1978, after five years under Pinochet's rule, the active persecution of intellectuals and artists lost intensity, and the censorship system gained a degree of predictability (Vidal 1987, 136). This led to the formation of spaces for intellectual and artistic dialogue aimed at resisting the ideological and sociopolitical project of the dictatorship from within the realm of culture. Among such spaces were literary workshops, experimental theater groups, and folk clubs. New art galleries, such as Sur, CAL, and Chrome (directed by cultural critic Nelly Richard), were also opened, and all supported experimental and dissident projects. In these semi-clandestine spaces, which were relatively isolated from the public eye, Vidal identifies a sense of "camaraderie" (136) that produced favorable conditions to reflect on the consequences of the dictatorial regime's violent disruption of the country's intellectual and cultural life. These micro-circuits of discussion and artistic creation also witnessed avid disputes, wherein different political and aesthetic projects directly conflicted with one another. Rather than leading to sterile purges, these tensions motivated the proliferation and intensification of new artistic initiatives, one of which was CADA.[8]

Members of CADA saw the city as the principal stage for a number of art actions that aimed to contest those symbols that produce, divide, and distribute hierarchies in (urban) space ("the syntax of civil order," in Richard's words [2007, 15]). CADA also placed a particular emphasis on the notion of "marginality," seeking to redefine the limits or margins of the city and of citizenship, while making visible those who had been excluded from official notions of "community" and "nation." During those years, all public forms of political opposition, especially those that critiqued the ideological foundations of the regime, were de facto illegal.[9] CADA's strategy of political and aesthetic dissensus therefore centered upon allegorizing the relationships between power structures and linguistic, corporeal, and urban signifying systems. In one of the earliest and most influential critical discussions of the group, Nelly Richard argues that CADA aimed at the "reformulation of signs" and the "unstructuring of the frames that compartmentalize genres and disciplines" (Richard [1986] 2007, 16–17). This entailed a commitment to destabilizing the symbolic basis upon which the authoritarian regime was erected, and to doing so by elaborating alternative languages in the arts, questioning the imagined boundaries of certain discursive formations, and exploring new technologies for cultural mediation. Among these languages, live performance, with its emphasis on the vulnerability and finitude of the human body, played a fundamental role.

Richard describes the larger nonofficial art scene to which CADA belonged as the Avanzada art scene (*la escena de avanzada*) or the Chilean neo-avant-garde. "Participants in this scene," writes Richard, "formulated, from the end of the seventies, strategies of creative production which cross the boundaries between genres (visual arts, literature, poetry, video, cinema, critical writing) and broaden the technical pillars of art to the processual dynamics of the living body and the city (2007, 15)."[10] Those artists that Richard conceives of as belonging to the Avanzada—including Eugenio Dittborn, Carlos Leppe, Carlos Altamirano, the members of CADA (as a collective and as individual artists), Elías Adasme, and Catalina Parra, among others—developed creative languages characterized by intermediality and transdisciplinarity. That is to say, not only did they cross divisions between artistic genres and media, but they also contested the "narrow borders of artistic and academic specialization" (Richard 2007, 17). In doing so, they saw their critique of the country's authoritarianism as closely entwined with a larger reflection on the disciplinary histories of art and literature.

CADA was particularly vocal in its disavowal of prevailing forms of artistic representation, and active in its search for dissident strategies and technologies for creating, displaying, and reproducing art. Eltit's use of video in her solo performances follows CADA's programmatic definition of "La función del video" (The Function of Video), published as a manifesto in 1980 in order to position themselves within a series of local debates in Santiago regarding the appropriate place of new technologies in artistic practice (cf. Galaz and Ivelić 1988, 235–236).[11] In this text, CADA rejects the posture of affording video an intrinsical aesthetic value, describing it as a medium that ought to be used strictly as a strategy of documentation. Significantly, despite this manifesto's endorsement of a certain realism in the use of video, this was not an attempt to return to the sort of socialist aesthetics that one could align with Allende's government,[12] for the group also emphasized the mediated and constructed character of those artworks attempting to represent social reality. They wrote: "Video does not document reality but a form or version of reality constructed beforehand" (CADA 1982). Moreover, in this same manifesto they describe video, and the video recording of art actions, as simultaneously capable of enabling and inhibiting the act of memory—allowing past images to be reappropriated, but failing to capture any form of authenticity. In the context of CADA's performative politics, video therefore becomes a means of registering art actions, circulating this documentation in various contexts, and favoring the combination of different media. As such, video becomes entrenched in what the artists referred to as a Latin American culture of reuse, rather than (consumerist and spectacular) waste.

In line with this program, Eltit's *Zona de dolor* mobilizes the austere aesthetic of the historical document, while relying on the use of montage to interrupt any sense of narrative totality. The work combines the footage of Eltit's live performance at a brothel with pictures taken at a different time and place. It also significantly

alters the real duration of the live event, leaving only fragments of a much longer piece. The interaction of the performer (Eltit) with her original audience is largely lost in the recording, a loss that nevertheless opens space for spectators not present at the brothel to experience a sense of proximity with the action. This new spectator may feel alienated by the poor technical quality of the video, in which the sound is not only difficult to hear, but is also out of sync with the image.

Eltit likewise used video to record a number of other art actions in some of Santiago's most disadvantaged neighborhoods. Rather than focusing on the portrayal of poverty and the critique of the political conditions leading to mass-scale marginalization, these intimate videos explore eroticism, femininity, and abjection in the urban margins. In one of them, filmed in 1982 and often referred to as *El beso* or *Kissing the Tramp*, Eltit kissed a homeless man walking with a crutch. This brief erotic encounter is marked by sexual and class tensions. Both bodies consciously perform the act of kissing before the camera, which makes them look stiff and moderately ashamed. Eltit is fashionably dressed in a leather jacket, a pair of sleek black trousers, and high-heels. The man wears a ragged vest. Although they approach each other projecting a feeling of curiosity and desire, when he starts kissing her more intensely, she leans back and rapidly distances herself from him.

According to Eltit, this video-performance attempted to de-ideologize what she calls "the Hollywood kiss," namely, a fetishistic version of love trapped in a consumerist and narcissistic logic. To a form of eroticism at the service of consumption, she opposed an anonymous eroticism belonging to the city and its margins (interview with Morales 1998, 168–169). She also saw this gesture as the exploration of an "archaic erotic," which, in Jean Franco's words, "cannot be identified with 'backwardness' or 'underdevelopment' but rather signals the traces of the presocial that cannot be processed by categories such as class" (Franco 2002, 217). Yet the different reactions to the kiss (Eltit's recoil and the vagabond's intensification of kissing), as well as the looks and gestures on show, reveal the inescapability of the socioeconomic and cultural divide.

A MONSTROUS SCENE

Eltit's video-performance *Zona de dolor* intersects her larger interest in eroticism and marginality with a reflection on self-punishment and the ideological management of pain. This video originated in a public reading of the artist's first novel—then unpublished and called *Por la patria*, but later published as *Lumpérica*[13]—which took place in a brothel located in an impoverished *población* on the outskirts of Santiago.[14] The reading was filmed, and Eltit later decided to edit the footage to combine it with a series of photographic shots showing her performing a private act of self-injury; these same pictures had been projected outside the brothel while she was carrying out her reading.[15]

The fifteen-minute video-performance begins with a series of still images depicting Eltit's act of having burned and lacerated her arms with a razor blade. She is sitting on a step while her body bleeds, and the gesture of corporeal muti-lation is repeated by the camera lens, which portrays a disassembled body, rather than a smooth totality: we first see the face and torso from the eyebrows down to the shoulders, then some wounds and bruises on the arms, one hand, both feet, the nose, a heavily wounded arm interrupted at the wrist, a shoulder. This corporeal collage emerges from the dark and dissolves back into it again. Eltit, as character, exhibits no pain. On the contrary, she appears serious and inex-pressive (Figure 1.1).

As I suggest at the opening of this chapter, these scenes have become iconic within the corpus of Chilean art under dictatorship, and they have often been read as representing the difficult sociopolitical conditions under which performance art developed in this country (Mosquera 2006, 296). One of the photographs of Eltit's act of self-mutilation opens the chapter entitled "Ensayo General" (Dress Rehearsal) in her first and highly experimental novel, *Lumpérica*. As Neustadt points out, the insertion of this picture in the text implies "a concatenate continuity between the novel and Eltit's corporeal 'art action'" (Neustadt 2003, 124). At the narrative level, Eltit develops this continuity by providing a meticulous, yet cold and fragmentary, description of an act of mutilation. Furthermore, she elaborates on the themes of cutting and wounding by shedding and disarticulating language:

E.G. 1 Muger/r/apa y su mano se nutre final-mente el verde des-ata y maya y se erige y vac/a-nal su forma.
E.G. 2 Anal'iza la trama = dura de la piel; la mano prende y la fobia d es/garra [. . .] Horizontal sentido acusa la primera línea o corte del brazo izquierdo.
(Eltit 1998, 162–165)

(D.R. 1 She moo/s/hears and her hand feeds mind-fully the green disentangles and maya she erects herself sha/m-an and vac/a-nal her shape.
D.R. 2 She anal-izes the plot = thickens the skin: the hand catches = fire and the phobia *d* is/members. [. . .] Horizontal direction betrays the first line or cut on the left arm.) (Trans. by Ronald Christ [Eltit 2003, 110])

These fragmentary lines draw a correspondence between the act of writing and that of wounding or mutilating. The narrator breaks language in the process of describing self-laceration. This physical intervention in the written word pro-foundly affects the sound and meaning of words, disrupting the semantic asso-ciations that emerge in the process of reading. Language performs the world-destroying effects of pain; and the difficulty of expressing this pain is vividly evoked by a narrative that focuses on the geometry of the wound, rather than on the sensations that arise during an act of self-harm. Moreover, the text unfolds by

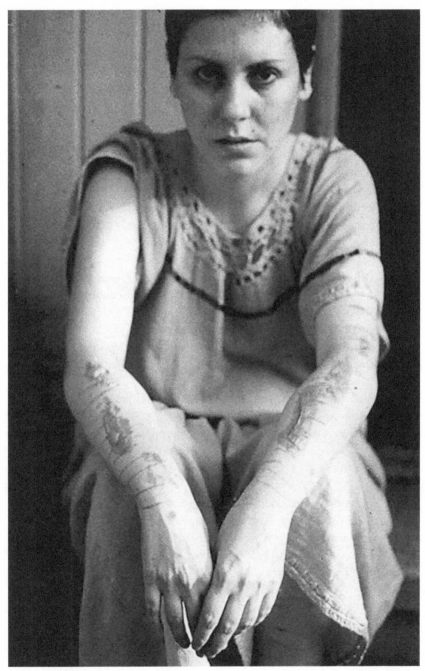

FIGURE 1.1. Diamela Eltit, *Zona de dolor*, 1980. Gelatin silver print. Photographer unknown. Courtesy of the artist.

depicting each line traced by the razor blade in relation to the others, giving rise to a microsystem of difference and repetition that resembles a primordial or primitive language—as if with pain language returned to its origins. This process is accompanied by syntactic fragmentation and pollution, leading to a sense of excess and impurity in the written word, which is also characteristic of the (neo-)Baroque literary tradition in Latin America, with figures such as Cuban poet Severo Sarduy.[16]

Understanding Eltit's treatment of language in *Lumpérica* is crucial for the discussion of *Zona de dolor*. From beginning to end, the soundtrack of the video-performance is the voice of the writer reading excerpts of her novel-in-progress. Her high-pitched and monotonous voice emulates a strident cry or a prayer. Soon after the first minute, the video transitions from the still photographs to the footage of the brothel, where one sees a small public surrounding the seated artist dressed in black. Despite being a space devoted to the commercialization of desire, the atmosphere of the brothel is casual and unsophisticated.[17] The prostitutes and the other spectators wear everyday clothes; people smoke and chat; some are watching Eltit's action with interest, but others do not seem to be paying much attention. The public is mixed, including what seem to be the brothel's clients, regular workers, and Eltit's friends. The passage from the first to the second section of the video is mediated by a careful intertwining of image and text. The wounded, sacrificial body that opened the film now appears in the form of a narrative voice describing the processes of identification and coming together of two feminine, suffering beings. The first of these is the narrator, who speaks in the first person. The second could be a female vagrant or any impoverished woman. The text enunciates their commonalities by focusing on minimal fragments:

> Sus uñas de los pies son al igual de mis uñas, cortezas.
> Sus dedos de los pies son a mis dedos gemelos en cada articulación que otorga la movilidad necesaria para ser mostrados en la extrema delgadez que los define.
> [...]
> Sus ojos son a mis ojos sufrientes de la mirada, por eso son el escaso nexo que priva del abandono.
> [...]
> Sus manos son a las mías gemelas en la ausencia de sortijas. Desnudas, entreabren los dedos como los rayos del sol cuando la luz eléctrica no ilumina el oscurecer precoz de la plaza pública.
> [...]
> Su cintura es a mi cintura gemela en su desgaste, diversa en su medida. En todo caso irreductible, su cintura se establece provocadora al demarcar zonas erógenas en el balanceo que da cabida al torso y al desplazamiento de los muslos.
> (Eltit 1998, 93–96)[18]

(Her toenails are just like my nails, crusts.

The toes of her feet are to my toes twins in each joint that provides the mobility necessary for their being shown with the extreme slimness that defines them [. . .]

Her eyes are to my eyes sufferers from the gaze, that's why they are the slight nexus that staves off abandonment [. . .]

Her hands are to mine twins in their absence of rings. Naked, the fingers half open like the sun's rays when electric light does not illuminate the premature darkness in the public square [. . .]

Her waist is to my waist the twin in its wearing away, different in its measurement. In any case irreducible, her waist becomes provocative in demarcating erogenous zones in the balancing that makes room for the torso and the shifting of the thighs.)

(Trans. by Ronald Christ [Eltit 2003, 107–109])

The third and final element of Eltit's action is a long sequence in which she walks out of the brothel and begins to mop the street's sidewalk, embodying the female subaltern of Chilean society. Again, the character undertakes the task of cleaning without showing any outward sign of grief or melancholy, as if the deepest wounds of the human body were, in reality, not so easily accessible to the naked eye, since they have already been incorporated into everyday gestures. This mute, servile subject contrasts with the one who has just led an avant-garde recitation. Yet Eltit's high-pitched voice continues over the new sequence of images, and she interrupts the foregoing text with the following manifesto:

> Me asumo como el sujeto de la producción sirviendo de puente entre el sistema real-socializado y el sistema textual [. . .] mostrando los mecanismos y la metodología mediante los que he codificado el espacio pluridimensional real y el espacio bidimensional ilimitado que moviliza tanto una concepción de punto como una concepción de texto [. . .] me erijo tanto como una instancia arquitectónica, pero sin olvidar el sufrimiento y el desamparo mental de los que están privados de ejercer su pensamiento [. . .] privilegiando por ello el panfleto, los *actos místicos*, el deseo de la creación corporal como modo de impotencia, el alcoholismo, ciertas formas de la delincuencia, cualquier clase de locura.[19]

(I assume the role of the subject of production, acting as a bridge between the real, social system and the textual system [. . .], showing the mechanisms and the methodology through which I have codified real, multidimensional space and the unlimited, two-dimensional space which mobilizes both a conception of the pause and a conception of text [. . .] I become an instance of architecture, but I do not forget the suffering and mental anguish of those who are denied the right to practice thought [. . .]; for that reason, I privilege the pamphlet, *mystical acts*, the desire for corporeal creation as a form of impotence, alcoholism, certain types of crime, any kind of madness.)

This disruption of the video-performance with such an explicit act of political self-positioning recalls Brechtian techniques of interruption that strive to shock or "estrange" the spectator (Esslin 1960, 144). Eltit breaks open the illusory continuity of the piece by asserting, first, her role as a cultural mediator or "bridge" between reality and text, and second, her willingness to expose representational strategies of codification while also emphasizing marginalized and silenced voices. This textual distancing of the spectator from the make-believe conventions of spectacle is accompanied by Eltit's presented identity as a mirage of sorts, capable of sliding from the position of narrator to that of character, performer, politically engaged writer, and photographic image. Despite these multiple transmutations, the spectral, suffering figure that introduces the video remains uncannily present throughout the work. In the following sections I suggest a possible reading of this performance of self-wounding devoid of visible signs of pain or exteriorized anguish.

TERRITORIES OF EXCESS

In *The Psychic Life of Power*, Butler (1997b) discusses the aporetic structure of self-sacrifice in her analysis of Hegel's passage on "The Unhappy Consciousness" in the *Phenomenology of Spirit* (1977, 119–138). The unhappy consciousness is structured as a duality between an "unchangeable" or "essential" domain and a "changeable" or "inessential" one. "Implicit in this dual structuring of the subject," says Butler, is the "relation between thought and corporeality" (1997b, 46), where the latter (despite representing the inescapable condition of the subject's existence) is reduced to an inessential aspect of being. In order to overcome this duality, the unhappy consciousness adopts a moral (religious) law by means of devotional, self-sacrificial practices, subordinating the body to the purity of the unchangeable spirit. For Hegel, this rejection of the body, and the construction of a moral law to control it and negate it, emerge out of the subject's fear of his or her own finitude. In other words: "The flight from [. . .] [the] fear of death, vacates the thing-like character of the subject. This entails vacating the body and clinging to what appears to be most disembodied: thought" (43). Nevertheless, this self-willed renunciation of the body in search of absolute transcendence inevitably collapses into "matter," as the "inessential" domain of the subject reemerges as a form of negative narcissism—centered on "the bodily feeling that it seeks to transcend" and "unable to furnish knowledge of anything other than itself" (47). As Butler observes, "Every effort to reduce itself to inaction or to nothing, to subordinate or mortify its own body, culminates inadvertently in the *production* of self-consciousness, as a pleasure-seeking and self-aggrandizing agent. Every effort to overcome the body, pleasure, and agency proves to be nothing other than the assertion of precisely those features of the subject" (53). This reading of Hegel is unusual, not only because it reconfigures Hegel's own argument, where the

dialectical movement of consciousness leads to its ultimate "resolution into Spirit" (34), but also because it situates his thought as prefiguring Nietzsche's and Foucault's critical discourses on the ethics of sacrifice. Thus, while Butler's reading of Hegel posits a relationship between self-abnegation and a pleasure-seeking self-consciousness, in *On the Genealogy of Morals*, Nietzsche emphasizes that the ascetic's "will to nothingness" fails to obliterate the very aspect of life that is will itself. Nietzsche writes: "This hatred of the human, and even more of the animal, and more still of the material, this horror of the senses, of reason itself, this fear of happiness and beauty, this longing to get away from all appearance, change, becoming, death, wishing, from longing itself—all this means—let us dare to grasp it—a *will to nothingness*, an aversion to life, a rebellion against the most fundamental presupposition of life; but it is and remains a will" (Nietzsche 1989, 162–163). And although Hegel's "inchoate body" and Nietzsche's will are not "strictly equivalent," they "circumscribe a kind of dialectical reversal which centers on the impossibility of a full or final reflexive suppression of what we might loosely call 'the body' within the confines of life" (Butler 1997b, 57).[20]

This idea of the (inescapable) body is also at the core of Foucault's description of the human soul as the instrument of a political anatomy. Foucault's "microphysics" of power in *Discipline and Punish* establish a relationship between self-consciousness, state discipline, and bodily life by arguing that the soul forms the body, limits its contours, and brings it into being (Foucault 1979, 29). For Foucault, power dynamics not only produce human souls—and ultimately produce "bodies"—but also, and above all, produce subjects. That is to say, power generates the subject that it subjects, while it also produces the mechanisms to resist subjection. The process of *assujetissment* is inevitably both "the process of becoming subordinated by power as well as the process of becoming a subject" (Butler 1997b, 2). In turn, Foucault's work seeks to understand the mutual interdependence between subjectivity and state-imposed disciplinary structures. His relationship to Hegel lies precisely in the fact that he does not see moral norms as external to the subject but as profoundly entrenched in his or her consciousness, corporeality, and sense of selfhood. This provocative idea brings about both challenges and possibilities to a reflection on the body as a space for political and aesthetic dissensus. That is, if power is not simply static and oppressive, and if embodied agency cannot be merely conceived of as exterior to power, then the subjective appropriation of moral/ideological imperatives may not only strengthen self-awareness but also become the site of a parodic critique of power.

The use of parody in *Zona de dolor* is fully rooted in this strategy. That is, Eltit's work entails to a complex and self-reflexive interrogation of subjectivity, which does not fall into assuming a naive critical exteriority with respect to the authoritarian and moralizing order that she derides. "Parody," writes Butler, "requires a certain ability to identify, approximate, and draw near; it engages an intimacy with

the position it approximates that troubles the voice, the bearing, the performativity of the subject such that the audience or the reader does not quite know where it is you stand, whether you have gone over the other side, whether you remain on your side, whether you can rehearse that other position without falling prey to it in the midst of the performance" (1997a, 266). The subversive intimacy of parody is at work in Eltit's video-performance on two closely related levels: first, through a corporeal rhetoric in which that which is deemed most intimate, such as the feeling of pain produced by a scarred epidermis, becomes symbolized as a territory where power is contested and negotiated (i.e., the subject can "feel otherwise"); second, by means of the use of seemingly religious words and gestures, which, instead of being directed toward a Christian idea of sacrifice, redemption, or transcendence, become mechanisms to express the voice or the cry of subjectivity in the face of historical catastrophe.

SACRIFICIAL BODIES

The use of the body as artistic support was rare in Chilean art before the practices of the Avanzada (Richard 2007, 78). Yet with the rapid dissemination of art actions and street performances in the mid-1970s, the live body became a prominent artistic "device" and began to be seen as a border zone—between biology and society—that could either subscribe to the recognized boundaries of action, affectivity, and gesture, or "smash itself against them" (78). Therefore, during the years in which the dictatorial state sought to impose not only an authoritarian and neoliberal regime but also a model of subjectivity,[21] the body—as a potentially alienated territory to be reappropriated—became a powerful agent with which to contest power relations. Richard points out that "the body, in the art of performance, acted as a trans-semiotic axis of pulsional energies which, in times of censorship, liberated margins of rebel subjectivity" (15). Similarly, Gaspar Galaz and Milan Ivelić suggest that "using the body as an artistic support and a signifier at the same time profoundly altered artistic practice, its materials and processes of creation, its meaning and purpose. The artist abandoned the emphasis of mediation to reaffirm the immediacy of a live support" (Galaz and Ivelić 1988, 191).

There were at least two different tendencies in the Avanzada's approach to corporeality. The visual artist Carlos Leppe explored gender and sexuality by embodying transvestite identities and exhibiting the body as a site of camouflage and simulacrum (Richard 2007, 77–78). Eltit and Raúl Zurita gave their performative practices a very different orientation by using the body as a means to inhabit and recognize a marginalized and sacrificial subjectivity. Indeed, Eltit was not the only Chilean artist to practice self-injuring performances during the first few years of the military dictatorship. In 1975, the poet Raúl Zurita, Eltit's partner at the time, burned his cheek with a piece of scorching metal. A picture of the scar left by this

wound was featured on the front cover of his book *Purgatorio* (1979), and thus this performance of self-wounding was transformed from a private act into a spectacle of abjection. Zurita saw his gesture as "an act of love and despair" (Neustadt 2001, 82); he also described it as the origin of all of his poetic work, which was marked by an attempt to erode the limits between art and life and by evocations of ritual fall and rebirth. "It is at that moment that I begin to express myself, to communicate," Zurita says in an interview. "I see the act of laceration as my first sentence, a newborn's first cry" (quoted in Pellegrini 2001, 49). As I discuss in greater detail in the next chapter, Zurita did not limit the practice of sacrifice to the genesis of his work. Some years later, he tried to blind himself by throwing ammonia into his eyes, and he elaborated on this topic in *Anteparaíso* (1982), where the themes of sight and blindness become prominent.[22]

Purgatorio opens with a transvestized reference to the poet's act of self-wounding: "Mis amigos creen que / estoy muy mala / porque me quemé mi mejilla" (My friends think / I'm a sick woman / because I burned my cheek) (Zurita 2009b, 2–3).[23] Zurita then dedicates his work to "Diamela Eltit: la santísima trinidad y la pornografía." (To Diamela Eltit: the holy trinity and pornography) (4–5). With these words the author initiates a resignifying operation whereby he queers identity signs by becoming, according to one of his translators, "poet, female prostitute, saint and superstar" (Jacobson 1983, 85). For critic Eugenia Brito, the first sentence of the book—"semiotized in feminine"—"presents a complex thematic nexus" (Brito 1990, 54). On the one hand, Brito states, "The wound, the facial 'burn,' invites us onto the signifying territory of a subject which rebels against a given order." On the other, it evokes a "Christian reference *par excellence*": "if someone strikes you on the cheek, turn the other to them" (54). Thus, Zurita's wound and its poetic rendering "is a signifier which allows us to constellate various meanings around it" (54), some of which are sharply opposed to one another.

As I mention in my opening remarks, Jean Franco interprets Zurita's and Eltit's acts of self-injury as codified references to other tortured bodies mortified in Chile as a result of the political situation; the artists, Franco states, were "drawing attention to the disciplining of bodies by the military regime" (Franco 2002, 180). Masiello proposes a similar interpretation when she writes:

> Zurita mutilated his face in defiance of the norms of citizenship in Chile, thereby protesting the physical violations that had been enacted against individuals and national landscape. His *Purgatorio* is a testament to this experience of anguish. Deformed and mutilated, the skin of his body registers pain. He is doubled into masculine and feminine, human and deified figure; he is both a totality and atomized parts. These metonymies are linked to a perceived fragmentation of his native Chile, which suffers similar violations under military rule. In this respect, the self-inflicted wound is an allegory of a nation in turmoil. (Masiello 2001, 66)

Franco's and Masiello's exegeses are marked by the memories of the dictatorship that have been forged after the transition to democracy. They bear the signs of testimonial literature written by political prisoners in all of the Southern Cone as well as post-coup film, theater, and photography. Although their interpretations rightfully give prominence to the widespread practice of torture in dictatorial Chile, they fail to take into account the ascetic or self-punitive logic traversing Eltit's and Zurita's performative acts of writing. By contrast, Richard and other scholars who began discussing the work of these artists while the dictatorship was still in place interpret their meaning precisely by analyzing the relationship between individual sacrifice and a search for collective redemption (or communion), posited by certain theological discourses. Echoing the parable of Christ's sacrifice for collective salvation, Richard claims: "The expurgatory value of bodily self-punishment is linked to a mystic identity that allows the self to exceed its boundaries and thus achieve transcendence. This reference to the sacred, particularly present in Zurita's corporeal rhetoric, certainly explains the fascination the author inspired in Chile" (Richard 2007, 84).

Richard's analysis stresses the centrality of religious references and embodied self-sacrifice in Zurita's work and its positive reception in avant-garde circles but also among the wider public and, most tellingly, among ultra-conservative literary critics. I suggest that these mystical and ritualized religious references play a critical function within the structure of Zurita's and Eltit's work. Consideration of Eltit's use of religious motifs makes visible the extent to which her work engages in acts of parodic dissensus from within a system of subjection. At the heart of Eltit's performances of self-sacrifice lies a complex inquiry into whether acts of parodic self-mortification may indeed become an effective means of contesting an oppressive regime.

Before entering this discussion, we must ask why the publication of *Lumpérica* was authorized, if, by all accounts, it proved to be so visibly critical of Chile's dictatorship. This puzzle is often solved by humorously affirming that the censors were unable to understand a word of the text (Green 2007, 13). An experimental novel, lavish in its disruptions of language and form, *Lumpérica* presents an interrupted plot and a fragmentary structure, which fluctuates between poetic prose, excerpts from an imaginary film script, and prayer-like stanzas. Indeed, it is likely that the regime's cultural bureaucrats were unable to understand this text, and that they allowed its release without recognizing its implicit critique of the patriarchal and oppressive politics of the dictatorship. Did they also allow the publication of *Purgatorio* and *Anteparaíso* in a state of indolent distraction?

I tend to view these explanations with suspicion—not because I believe in the omniscient power of Latin American censors, but because a text as complex as *Lumpérica* cannot be reduced to a single interpretation and even less to the reading of its own author. Within this novel there are elements that, if read inattentively, are not necessarily at odds with the universalist and sacrificial Catholic aesthetic

supported by the regime. The eulogistic reception of Zurita's work by the most important Chilean literary critic at the time, a priest and member of the Opus Dei movement, offers a strong case for this argument. In 1979, after the publication of *Purgatorio*, Ignacio Valente[24] (pseudonym of José Miguel Ibáñez Langlois) wrote: "It is a geometric adventure that surpasses Euclides, a metaphysical adventure that surpasses Aristotle, a journey to another world that surpasses Dante: a ludic confusion of the planes of reality, time, and space, inside and outside, object and image, self and other" (Valente 1979, n.p.).

Valente understands Zurita's writing as being redemptive and nationalistic, yet fully disengaged from current history or politics—that is, as universal and metaphysical. Although Eltit's work was never received in this way, one may still use Zurita's case to reflect on the broader reception of Eltit's writing. For despite clear formal and thematic differences, Zurita's and Eltit's early works share a common incorporation of inter- and metatextual elements informed by mystical poetry. In the following sections I discuss some strategies through which Eltit puts these religious elements into play in order to articulate a critique of the military regime. Her intention, I claim, is to avoid merely situating the repressed subject (and his/her agency) fully outside the dominant, conservative ideology. With this argument, I perform an interpretative shift that moves from understanding Eltit's references to a tradition of Catholic self-abnegation as external to her dissenting discourse, to seeing them as inherent to this critique—and, therefore, as being significantly more elaborate and forceful.

NEONIC OBSCENITY

Lumpérica's central trope is that of light. L. Iluminada, the protagonist, is in constant relation and negotiation with what is referred to as the *luminoso*, a vaguely described neon sign located in the middle of a *plaza*. The *luminoso* is as almighty as God, as unreachable as the divine, and as feared as that which can penetrate the body and even tear it apart. L. Iluminada is constantly seen, surveyed, and subjugated by it. She is blinded and exhausted by its glare. She receives its message and allows herself to be dazzled, illuminated, possessed, and enlightened by it. But this communion with the *luminoso*, rather than leading to the elevation of the spirit, results in brutal falls and a feral desire. In the chapter entitled "Escenas múltiples de caídas" (Multiple Scenes of Falls), L. Iluminada weeps and hallucinates. Stigmata appear on her body. A fragmentary poetic prose travels through her bleeding nudity. Wounds and scabs interrupt her epidermis. She becomes fragment, residue, excess. All she can see are the beams of light coming from the *luminoso*. She howls and pants, blinded by the glare of this "procacidad neónica" (neonic obscenity) (Eltit 1998, 198).

This strained relationship of sexual domination/illumination between L. Iluminada and the *luminoso* takes different forms throughout the novel, but it is

pushed to its limits in chapter 3, when the female character becomes a slobbering, aroused mare neighing in the plaza before the gaze of *lumpen*, agitated *pálidos* (pale tramps), who surround her and attempt to mount her but fail. Despite their violence, she glances at them only briefly, fully projecting her desire toward the neon sign, that is, toward a fallen, commercial idol, unable to cast spiritual light.

Más, ¿quién la montara? ¿quién le clavará espuelas? ¿quién la doliera? ¿qué lumpen se tomará ese derecho? ¿qué piernas? ¿qué ancas se las pusiera sobre las suyas? [...] ¿Y si fuera la luz quién la gimiera? ¿si tan sólo la luz se la montara? De un golpe de energía plena le desollara el ijar y aunque perdiera el brillo de la plateada espuela, el penetrante metal se lo saltara por el corcoveo de ese golpe eléctrico, único/infalible que le corrigiera hasta el pensamiento por la efectividad de su asolada, que la tirara sobre el pavimento en espasmódicas muestras de encuentro. (Eltit 1998, 70–71)

(But, who will mount her? Who will spur her on? Who will hurt her? Which lumpen will claim that as their right? Which legs? Which haunches will place themselves over hers? And if the light were to groan for her? If it were the light that mounted her? If a burst of pure energy were to flay her sides and even if the silver spur lost its shine, the penetrating metal would leap out with the buck of this electric charge, so unique/infallible that it would correct even as far as thought with the effectiveness of its ravishing and throw her to the pavement with spasmodic signs of encounter.)[25]

This public display of intimacy, in which torture and desire become confused, parallels the scenes of *Zona de dolor*. The female body is turned into a wild yet docile territory—to be conquered—whose borders are traversed by the burning of the skin and the shedding of blood. If one were to read these scenes exclusively through the lens of political repression, the dictatorship would be allegorized as the practice of a dreadful biopolitics, the inscription of a phallogocentric discourse on the body through torture, and the mutilation of female desire by means of corporeal violence. This is indeed the context in which Eltit performed her art action and wrote her novel—over a seven-year period, starting in the early 1970s. Yet Eltit confesses that this is not what she immediately had in mind during her creative process.[26] She attempted to engage a more complex logic, in which fear and pain are interwoven with mystic ecstasy, and the act of self-harm leads to the inscription of subjectivity, rather than its complete sacrifice or erasure. From this perspective, Eltit's performance, display, and ultimately parodic rendering of a series of self-punitive acts were directed toward understanding their conditions of (im)possibility, and their relationship to the politics of embodiment, the shaping of subjectivity, and the political uses of pleasure and pain.

A MYSTICAL OCCASION

Eltit's ritual approach to female desire and her defiant appropriation of mortifying punishment bring to mind Franco's study of mystic women in seventeenth-century New Spain.[27] In *Plotting Women*, Franco describes the mystic's relationship with Christ as an essentially erotic one, "beginning with arousal, stimulated by obsessive fascination with the wounds and openings of the body" (Franco 1989, 19). Furthermore, she discusses the transfiguration of pain and self-flagellation into illumination and rapture, the escape from the punitive logic of (male) rationality through communion with "the divine," the blurred boundaries between bodily pain and sexual pleasure, and the transformation of mysticism into an exploration of the female body and feeling. "The mystic's life tended to be one of constant sensation," says Franco. God communicated secrets to her, which became visions and hallucinations; "she was transported to distant places" and, "when gratification was at its height," "only external signs—deep sighs, a trancelike state, and body marks—revealed to the outside world what was happening" (6).

This was a particular form of feminine *jouissance*, or enjoyment, which, according to Franco, became incorporated into the power system of seventeenth-century New Spain by legitimizing the separation between "male rationality and female feeling." Since mysticism was "essentially outside writing," it also meant "the exclusion of women from the public domain of discourse" (Franco 1989, xiv). However, while mystic women were concealed in convents, both L. Iluminada, in *Lumpérica*, and Eltit, in her performance of *Zona de dolor*, are widely exposed to the public gaze. We could even argue that they are overexposed and strive to be seen. In the case of L. Iluminada, her encounters with the *luminoso* take place in a public plaza, before the gaze of, on the one hand, penurious *pálidos* that ogle her lecherously, and on the other, the camera that films the spectacle, surgically capturing every detail of her body and visage.[28] The plaza thus becomes a space of both intimate ritual and public performance, where power is performatively imposed and negotiated and a religious semantics is transposed to the secularized terrain of politics as spectacle. When Eltit performed *Zona de dolor* and interrupted the daily routines of a brothel, she was similarly longing for the public gaze in dictatorial Chile. How could her provocative gestures not be noticed if she situated herself at the center of the brothel's main hall and then began to mop the outside pavement? How could her high-pitched cries be ignored? Even the solitary intimacy of Eltit's private ritual of self-laceration was interrupted by the presence of a photographer, whose images were later inserted into both her novel and her video. In fact, L. Iluminada and Eltit (as performer) bear an even stronger resemblance to the figure of the *ilusa*, or deluded woman, who "shared a common language with the mystical nuns," but "often 'performed' rapture and ecstasy in public" (Franco 1989, 55). Noticeably, if this affinity is to be underscored, it is not as an attempt to read contemporary Chile using categories of seventeenth-century

New Spain, but because the figure of the *ilusa* casts light on how the public display of acts deemed intimate may indeed defy power structures by destabilizing an accepted distribution of what is public or common. According to Franco, *ilusas* were particularly feared by the church "because they directly challenged the power of the clergy" through their self-conscious use of the body: "These women used their bodies in virtuoso fashion. They suckled the Child Jesus, regressed into infantile behavior, spoke baby language, and had to be fed as if they were infants: they daubed themselves in menstrual blood, thus *publicly* expressing women's sexuality and even appropriating exclusively male terrains such as the pulpit" (1989, xvii).

Ilusas were mostly uneducated and socially marginal women. Their capacity to contest the power relations of colonial society did not result from an erudite use of language, but from their "misplacement" in the authorized mapping of women's behavior. Their challenge to colonial morality came from an untamed or liberated gesturality, which has strong correspondences with Eltit's poetics. Through her embodiment of a wounded, broken body and her fragmentation of the narrative voice, Eltit renounces the aspiration to unity, closure, and linearity. She approaches language as a corrupt territory, fully penetrated by modern rationality and patriarchal/authoritarian dominion. This results in a fractured and twisted language, resembling the babble of mystical nuns. However, Eltit does not aspire to commune with the Divine, but to dislodge parodically the very logic that subjugates her. Jaime Donoso describes this linguistic operation as the breaking down of syntax, the dissection of words and their distribution in "a-syntagmatic order" (Donoso 2009, 258), the creation of images that are "in constant movement and mutation" (252). Richard, in turn, argues that the reliance on both gesture and "fractured speech" to contest and even shatter the linearity of linguistic discourses is one of the features that makes Eltit's work profoundly antiauthoritarian (Richard 2007, 85).

SOR TERESA, LA LUMPÉRICA

The troubling and subversive duality of Eltit's (re)presentation of the mortified female body, read from its evocation of religious imaginaries, has been depicted by the Chilean painter Gonzalo Díaz in three triptychs entitled *Sor Teresa, la lumpérica, Diamela Eltit, la degollada*, and *Zulema Morandé, la escritora* (all from 1988). These works deliberately intertwine the life stories and pictorial representations of three public and, to some degree, iconic, Chilean women: Sor Teresa de los Andes, the first Chilean female saint, beatified during the visit of John Paul II to Chile in 1987 and subsequently canonized; Zulema Morande, an aristocrat who was brutally beheaded by her husband in 1914; and Eltit, writer, activist, and video-performance artist. Technically developed through a combination of multiple media and dense layering, Díaz's works articulate an unusual feminine trinity in

which the characters are simultaneously distinct and "one," becoming confused as their relationship to eroticism, punishment, and the sacred is revealed.[29]

The triptych *Diamela Eltit, la degollada*, juxtaposes a series of close-ups of Eltit's face (taken from *Zonas de dolor*) with a purely schematic, almost cartoonish crimson silkscreen of a naked and mutilated female body (Figure 1.2). Each of the triptych's panels exhibits a different fragment of this silkscreen, all of them presenting an image of the figure's lacerated right forearm. The body's wounds are depicted as jittery, hand-traced parallel lines, thus construing an equivalence between the act of drawing and that of self-wounding. The first panel, divided into two halves by measuring tape, shows on the left side the young and delicate profile of the writer. At the center, falling on both sides of the measuring tape, the multilayered panel exhibits a vertically cut photograph of Chile's mountainous landscape, subtly inscribing Eltit's face into this barren scenery. This minimal picture acts in the work as an impression, a fragment to be completed by the viewer's unconscious, a detail interrupting an already discontinuous collage. The right side of the image is no less easy to decipher, for it is fully covered by handwritten text. Like the rest of the elements that constitute the panel, the text is a citation taken from *Lumpérica*'s chapter entitled "Ensayo general," which, as mentioned, opens with a picture of Eltit's self-lacerated forearms. The excerpt quoted in Díaz's rendering of this scene concentrates on the pathways followed by the razor blade during the act of self-wounding and underscores the geometry of the wounds over any description of feelings or sensations that may unfold as one traverses the skin:

> La cuarta línea, en cambio, es más reducida que las anteriores, pero vuelve a la dirección horizontal que había dibujado el primer y segundo corte del brazo izquierdo.
> El trazado de la cuarta línea está brevemente interrumpido por un fragmento de piel, lo que podría permitir el suponer que:
> a) La línea fue realizada en más de una etapa.
> b) La hoja que efectuó el corte se levantó levemente. (Eltit 1998, 172)

> (The fourth line, on the other hand, is shorter than the previous ones, but returns to the horizontal direction sketched by the first and second cut on the left arm.
> The track of the fourth line is briefly interrupted by a fragment of skin, which allows the supposition that:
> a) the line was created in more than one stage.
> b) the blade that made the cut was raised slightly.) (Eltit 2003, 114)

Díaz crosses out the last few sentences of his transcription, thereby obstructing reading and repeating in the body of the text the violent act of physical harm.

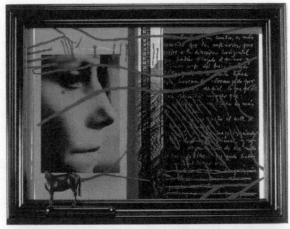

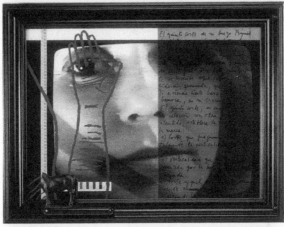

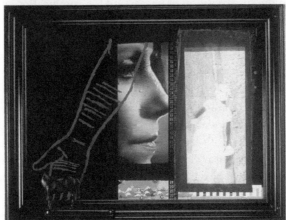

FIGURE 1.2. Gonzalo Díaz, *Diamela Eltit, la degollada*. Triptych, 1988. Mixed media (paint, photography, silkscreen, photomechanical process, and Mylar on mat board and Masonite). Each framed panel: 69 × 91.4 × 12.7 cm. Courtesy of Gonzalo Díaz.

He also traverses the entire panel, from the lower left corner (where one also spots the image of a beheaded donkey) to the upper right corner, with the silkscreen of a heavily wounded, headless, and nude female body bearing linear wounds on her arms and belly. The image produces a parallel between writing, as an act that unravels by way of carving or inscribing a surface, and the self-scarring of one's body, which combines an impetus toward self-control with a desire for self-definition. (As stated in this chapter's epigraph, "The burns will give her a new scar that shall shape her body at will"). In Díaz's work, however, this self-wounded body—ostensibly capable of liberating itself from its given materiality—becomes indistinct from the beheaded corpse of Zulema Morandé, who was killed in an act of masculinist violence. As such, Díaz purposefully confuses the act of inflicting violence upon the body of another with that of assertive self-harm.

In the triptych *Sor Teresa, la lumpérica*, Díaz juxtaposes a still photograph of Eltit's erotic encounter with a vagrant in *El beso* with the image of the Chilean saint *Sor Teresa*. Like the first panel of *Diamela Eltit, la degollada*, this one is also split into two, but this time the dividing element is a silkscreen image of a knife. To the left of the knife, Eltit, the avant-garde artist, kisses a vagrant, an anonymous figure of marginality and dispossession. Because of the solarization of the picture and the superposition of a film of turquoise Mylar paper over it, it becomes difficult to identify who is who. In their erotic desire, the masculine and the feminine, the vagrant and the artist become mirrors of one another. To the right of the knife, Sor Teresa's most iconic portrait is covered by a layer of red Maylar, almost fully obscuring her countenance and turning her face into a spectral contour. The boots of an upside-down aristocrat, possibly Morandé's husband, protrude over Sor Teresa's habit, thus crowning her with a set of horns. If it is difficult to decipher the identity of the inverted man, it is because Díaz constructs his work through the superposition of images and the combination of techniques; Eltit's and Sor Teresa's portraits are interrupted by all sorts of cut-out pictures, silkscreened sketch-like drawings, and writings. Among the various elements that constitute the first panel there is metric tape, the picture of a neoclassical baluster (ostensibly symbolizing the dismantling of the institution of the museum),[30] and a sort of phallic hopscotch filled with numbers.[31] In the two other panels, Díaz similarly intercalates, confronts, moves around, and alters the directionality of these portraits and their surrounding symbols, interweaving the prototype of Marianism (Sor Teresa) with Eltit's erotic textuality—which Richard describes as marked by the eroticism of a "violator of tongues [*violadora de lenguas*] and author of a textuality genitalized by rubbing the promiscuous signifier" (Richard 1988, 17).

Richard analyzes this series of triptychs from the perspective of the tensions between the categories of the masculine and the feminine, associating the feminine with the facial portraits, and the masculine with those technologies of measurement and classification that organize the panels: "The category of the feminine is translated to women-signifiers (the portraits) which iconize its

representation, while the category of the masculine operates as generally connected to apparatuses of production (the technique) or to networks of organization (the diagrammaticity of laws and phenomena) that make it function as a *syntactic regulator* and administrator of prevalences" (1988, 16, emphasis in original).

For Richard, "the Eltit-referent is interlinked with the Sor Teresa-referent because both sacrificially share self-punishment" (17). That is, those imaginaries associated with this practice are present both in the religious celebration of self-punishment and in an aesthetics of excess. Historically, Eltit, a transgressive writer, and Sor Teresa, "a model of evangelical life for the Chilean youth" (Bravo 2012, 37), have little in common. In Díaz's paintings, however, Eltit's self-affirmative self-mutilation becomes a form of punishment, whereas Sor Teresa's asceticism becomes infused with erotic desire. The painter therefore entwines, juxtaposes, overlaps, and refigures the Christian unconscious that shapes Eltit's early work, while proposing a multilayered and fragmentary reading of the relationship between power, embodiment, and the feminine.[32] This landscape of blurred signifiers that take part in multiple clashing discourses may be a better reflection of the ways in which rituals of excess shape Eltit's approach to bodily pain than would be a simple eulogy to her work as a form of resistance to authoritarianism. The latter vision would arguably leave no room for the parodic confusion between the "violator of tongues" and Marianism.

A CORPOREAL RHETORIC

The dialectics of self-sacrifice discussed by Butler unravel the deceiving nature of self-punishment as a means to suppress the body and thus become pure self, pure spirit, or pure thought. As I have argued, Eltit's treatment of self-inflicted pain in *Zona de dolor* and *Lumpérica* does not follow the misguided logic of a self-punitive subject who seeks transcendence or liberation through pain.[33] Its visuality refers us to a religious symbolism, but this symbolism evokes the parodic potential of public acts of self-punishment in the context of the imposition of an ultra-conservative government in Chile. Furthermore, the painless and eroticized image of Eltit's wounded body contests the forms of self-containment, self-repression, and self-sacrifice that became conditions of citizenship in Chilean society after the coup.

While the dictatorial regime tried to "remodel" social mores according to a punitive and disciplinary logic, in *Zona de dolor* and *Lumpérica* Eltit fashions rituals of self-punishment after this same moralistic vision, but she brings them to a territory of Dionysian excess—where every cut is described in minute detail, becoming a form of writing. This hyperbolic gesture gains force by being repeated at visual, corporeal, and linguistic levels, and by suspending the mortifying gestures often associated with physical pain. These are all possibilities for aesthetico-political

dissensus that the artist developed through her intermedial approach to live performance, an approach that entwined the live act with its documentation in the medium of digital video.

Rather than only denouncing the use of torture by the military authorities, Eltit's parodic version of the ascetic ideal casts a territory in which the imposed norm becomes productive for the self's own libidinal and political energies. "This subjection to the inner Law"—the law L. Iluminada posits when she "erects herself sha/m-an" (Eltit 2003, 110) in order to direct her mystical ritual—"does not simply 'extend' or 'internalize' external pressure" (Žižek 2008, 337). Rather, as Žižek points out, "it is correlative to the suspension of external pressure, to the withdrawal-into self" (337). This conception of selfhood is not artificially imagined outside of the law but constituted through a parodic relationship to an existing normativity. Therefore, it is contingent upon the space of possibility opened by the secularized ritual act. Furthermore, returning to Butler's discussion of the dual character of parody, the self here stands in intimate proximity to that Other that she opposes, to the point of feeling her voice and her bearing troubled by the Other, while "the audience or the reader does not quite know where it is [that she] stands" (Butler 1997a, 266).

THE IMPLICATED SELF

Eltit's *Zona de dolor* is one of the most iconic performances of the Chilean Avanzada. This work is a powerful example of the radically innovative and experimental artistic sensibility that emerged in an otherwise somber era. Yet Eltit's work has often been mistakenly reduced to a self-victimizing practice of resistance, which exclusively references the widespread use of torture in Pinochet's Chile. My focus on the role of religion and embodiment in Eltit's work, together with the importance she attributes to the performativity of gesture, image, and text, sheds new light on the treatment of self-inflicted pain in this experimental piece. *Zona de dolor* crafts a critique of sacrifice as being necessary for the formation and survival of community and pain as being fully available to serve the interests of a prevailing ideology. As the title of the piece suggests, the work destabilizes the accepted zone or territory for the public expression of pain, reclaiming the publicity of forms of suffering that are often confined to a purportedly private realm. Furthermore, along similar lines than the work of other artists belonging to the Avanzada, such as Zurita and Leppe, this video-performance situates the materiality of the body and the rupture of its accepted limits as opening up possibilities for political and aesthetic intervention in given discursive and sensuous regimes. Eltit's strategy of breaking or traversing corporeal boundaries takes place at various levels, going from the corporeality of the written word to the laceration of the body's skin. Likewise, her video-performance combines the live dynamics of an oral recitation with the use of photography and new technologies of image

reproduction such as video—thus introducing several layers of mediation to the mirage of self-presence, real-ness, and immediacy that have often been associated with performance art.

Existing scholarship on Eltit's early works suffers from a Manichean opposition of her writing to the discourses of the dictatorial regime. This oppositional reading conceives of Eltit's early artworks as practices of resistance entirely exterior to the field of power and the complex dynamics present in any process of subjection. By discussing the hitherto-ignored problem of the place of religion in Eltit's work, I question this vision and take into account the intimate proximity between Eltit's poetics and the sacrificial discourses mobilized by the dictatorship. My analysis suggests that such proximity, deployed as a form of parodic ambiguity, grounds Eltit's critical approach to state discipline and religious theodicy. Indeed, the artist's aesthetico-political strategies of dissensus "from within" refuse to partake in an aesthetic in which art is an access road to liberation. From her perspective, art's critical potential lies, by contrast, in its capacity to expose the contingency and fluidity of structures of power and meaning. Developed in the context of a murderous regime that proclaimed to be sacrificing human lives for the "health" of a unified political body, Eltit's art also offered a different idea of corporeality, in which bodies are rendered incomplete, vulnerable, and fragmented. The next chapter, which focuses on the work of Zurita, continues this reflection by examining how public enactments of self-vulnerability and mourning, in the form of poems of lamentation, may become performative acts of protest bearing strong corporeal and ritual elements. I discuss this problem in relation to Zurita's *Purgatorio* (1979) and *Canto a su amor desaparecido* (1985), poems that contain telling references to biblical laments where divine authority is either covertly or explicitly questioned. Chapter 2 therefore investigates the political and aesthetic significance of Zurita's poetic display of grief in 1980s Chile and its intersections with other forms of artistic practice, such as performance and land art.

2 · LAMENTATIONS

La ética de la poesía está en su sonido [...] ahí van las voces de nuestros muertos.
(The ethics of poetry lie in its sound [...]. The voices of our dead travel by
this sound.)
 —Raúl Zurita, interview with author, September 28, 2013, London

In *Precarious Life*, Judith Butler argues that the experience of grief has
often been considered depoliticizing, as it is said to "[return] the subject to a soli-
tary situation" (2004, 22). For the thinker, by contrast, grief "furnishes a sense of
political community of a complex order," since it cuts across ideological divisions
and makes visible the ethical basis of the social bond: "What grief displays [...] is
the thrall in which our relations with others hold us, in ways that we cannot always
recount or explain, in ways that [...] challenge the very notion of ourselves
as autonomous and in control [...]. The very 'I' is called into question by its rela-
tion to the Other, a relation that does not precisely reduce me to speechlessness,
but does nevertheless clutter my speech with signs of its undoing" (23).

A political understanding of grief posits that this feeling shatters the autono-
mous subject, exposing the being-in-common that underpins any claim to indi-
viduality. Moreover, it postulates that intense suffering, often perceived as physi-
cal pain, has destabilizing effects on cultural formations, beginning by undoing
the sounds of words and their communicative efficacy.[1] The cries and groans of
intense pain find public expression in laments for the dead, which are often con-
fined to women in what Veena Das calls "the division of labour of the work of
mourning" (1997, 68). Furthermore, according to Das, in "the genre of lamenta-
tion [...] grief is articulated through the body [...] 'objectifying' and making pre-
sent the inner state, and is finally given a home in language" (68). She also notes
that "pain, in this rendering, is not that inexpressible something that destroys com-
munication or marks an exit from one's existence in language. Instead, it makes a
claim asking for acknowledgement, which may be given or denied" (70).

The social significance of grief and its relationship to public mourning occupy
a prominent place in the scholarship on cultural production in dictatorship and
post-dictatorship Latin America. Macarena Gómez-Barris argues that experiences
of collective violence and grief "often only accrue social visibility and audibility

through cultural production," as transitional states tend to enforce amnesia as a way of producing political consensus (Gómez-Barris 2009, 18–19). Similarly, in *The Untimely Present*, Idelber Avelar considers "the imperative to mourn" as "the postdictatorial imperative par excellence" in the workings of literature (Avelar 1999, 3). According to Avelar, "mournful literature" is irrevocably tied to allegory and to the search "for those fragments and ruins [...] that can trigger the untimely eruption of the past."[2] Across much of the Southern Cone during the last quarter of the twentieth century, this creative search took place in the face of an emerging neoliberal rationality that acted (and continues to act) on the past by seeking to erase it. That is, the neoliberal market operates "according to a substitutive [...] logic in which the past must be relegated to obsolescence," so that the new may "replace the old without leaving a reminder" (2). Mourning therefore stands as an unassumable reminder in this substitutive logic.

As I began to discuss in the previous chapter, the combination of authoritarian rule and neoliberal economic reforms saw one of its most brutal expressions in Pinochet's Chile, particularly in the decade following the 1973 military coup. During this period, both political and economic reforms "were carried out in a framework of total deprivation of public liberties and citizens' rights" (Valdés 1995, 10). Looking at the work of Eltit and the Avanzada art scene, I argued that the process of mourning and critiquing the violence of the Chilean dictatorship began well before the end of this political regime, thus suggesting that the division between dictatorship and post-dictatorship cultural production provides only a partial account of the temporalities that organize the dissensual politics of art in this historical conjuncture. In this chapter I discuss a series of ritualized poetic acts and live performances by Chilean poet Raúl Zurita that were conceived of under Pinochet's dictatorship and during its immediate aftermath. These works showcase the shared history of intermedial performance art and of the critique of dictatorship in Chile. By discussing Zurita's poetry in light of the tradition of biblical and poetic lamentation, together with Walter Benjamin's approach to this tradition, I suggest that the series of works under analysis may be understood as cries of lamentation offered to those who were violently murdered and disappeared during the years of military rule. These works also make visible the extent to which live art in Chile burgeoned in its proximity with the poetic text—a question that has received little to no attention in the scholarship on performance in Latin America. Zurita's performative poems or poetic acts, however, resist becoming nostalgically regressive or backward looking. At no point do they seek to vindicate the political projects of the victims of dictatorial violence. By contrast, they are broadly addressed to victims and perpetrators of violence, as well as to the passive supporters of the dictatorial regime. This attempt to interpellate readers from different sides of the ideological spectrum by relying on allegorical techniques that instigate "awareness of otherness, flexible interpretation, and contradiction" (Hunter 2010, 267) has important ethical consequences, which are fully inscribed in the

differences between mourning and lamentation. While mourning is fundamentally an internal experience of grief, sadness, and "actively forgetting" (Avelar 1999, 1), the lament is a genre that externalizes grief. As Brent Plate suggests, laments—the "songs of despair"—must "be heard," which "[involves] connecting the inner experience into the outer world" (Plate 2005, 45). In Zurita's poetry, laments do not convey a single meaning or a message, they allow other-speaking to take place.[3] Likewise, the poet explores the limitations of language and what Lynette Hunter describes as "the complexities and difficulties of speaking about the not-said, or more interestingly, the not-yet-said" (Hunter 2010, 266). These performative and heteroglossic dimensions of Zurita's approach to the lamentation tradition grounds the potential for his poetic acts to destabilize received social dichotomies and assert the ethical significance of memory in a time of social crisis.

PRAYERFUL ACTS

When reading his poetry aloud, Zurita's striking style of recitation recalls that of a mystic who rolls his eyes as he proclaims the Word and breaks up his verses with the paramount Christian affirmation: "Amen." This may not seem particularly surprising, for in their mournful musicality and allegorical composition, poetry and prayer may become confused. Yet in Chile the lyrical tradition, which includes Vicente Huidobro, Pablo Neruda, and Nicanor Parra, has been strongly associated with secularism. Zurita, who is one of the best-known contemporary Chilean poets, therefore stands as a solitary figure, the subject of much curiosity. Copious amounts of ink have been spilled to discuss, critique, mock, and fictionalize Zurita's relationship to religion. Some affirm his belief in God, and others negate it, but an element of ambiguity in his work evades both of these conclusions. Ambiguity, put to productive, allegorical use, may be Zurita's aspiration.

Since the mid-1970s, when he published a selection of poems in *Manuscritos*, the legendary one-issue journal edited by the art critic Ronald Kay (1975), Zurita has been and remains a key figure for understanding the Chilean art scene, its relationship to politics, and its internal divisions. In recent years, however, Zurita's work has experienced a new wave of interest and criticism, propelled by Roberto Bolaño's novels *Estrella distante* (1999) and *La literatura nazi en América* (2005), in which, Bolaño, inspired by Zurita, constructs a fictional character that is both a poet and a serial killer enraptured by the aesthetics of violence. Controversies about Zurita's work go hand-in-hand with a discussion of the artistic avant-garde, its relationship to history and violence, and, above all, its Messianism.[4] Nelly Richard posits that it is impossible to read the works of the artists' collective Colectivo Acciones de Arte (CADA), to which he belonged, "without being suspicious of the messianic tone of the Zuritan voice, which served as propaganda for him" (1999, 32).[5] This alleged Messianism results from Zurita's attempt to universalize his own experience of pain and construct what Richard describes as a "sac-

rificial, even martyrical, subjectivity" (Richard 2007, 82). Along similar lines, other critics have argued that Zurita's frequent references to poetic resistance ultimately collapse in his self-presentation as society's redeemer (Soto Riveros and Bernaschina Schürmann 2011, 31–32, 47).

This treatment of Zurita as a fully-fledged aspirational Messiah, however, leaves significant questions unanswered—the most important being whether his prayer-poems indeed sustain a univocal relationship to sacrality (inscribed in a body of authorized Christian texts), or whether, alternatively, they are allegorical in nature, "simultaneously proffer[ring] and defer[ring] a promise of meaning," as Craig Owens describes the "allegorical impulse" (Owens 1980, 70). Moreover, given Zurita's palimpsestic approach to Dante in much of his work, it is important to bear in mind that, in their medieval use, "sacred and secular conceptions of allegory could be seen to co-exist in the same text" (Copeland and Struck 2010, 1). Let us recall that it was Dante who arguably "displace[d] into the domain of vernacular poetry an exegetical practice designed for exclusive application to Holy Scripture" (Ascoli 2010, 128).

Yet another problem of interpretation resulting from the association of Zurita's work with a cosmogony of salvation is that it sets him apart from the critical and transgressive Avanzada art scene, which I introduced in the previous chapter. That is, this vision does not account for the ways in which the poet's interest in metaphysics and in notions of divinity dialogue with the Avanzada's allegorical and performative aesthetic, which is clearly present in CADA's work. As I have mentioned, CADA was an interdisciplinary artists' collective formed in 1979 by visual artists Lotty Rosenfeld and Juan Castillo, writers Diamela Eltit and Zurita, and sociologist Fernando Balcells. During the darkest years of Pinochet's dictatorship, this collective carried out artistic interventions in urban space that involved both conceptual and embodied strategies to reimagine the relationship between art and politics in Chile. Those strategies embraced performativity and fragmentation over the realist representation—or denunciation—of an oppressive reality.

My reading of Zurita's poetic performances allows for crossover and continuity between CADA's allegorical aesthetics and Zurita's treatment of religious and gender categories, and posits that the latter's poetry was closely informed by his participation in this collective. This is most clearly evinced by the correspondences between the collective's art action entitled ¡Ay Sudamérica! (1981) and Zurita's performance La vida nueva (The New Life, 1982). In the following sections I compare and discuss these two works, together with Zurtia's Canto a su amor desaparecido (Song for His/Her Disappeared Love), Purgatorio (Purgatory), and Ni pena ni miedo (Neither Sorrow nor Fear). It is my contention that considering CADA's strategies of subverting discourses "from within"—following such allegorical procedures as the appropriation and depletion of meanings—alongside Zurita's work throws new light on our understanding of Zurita's performative poetics.[6]

While most of the scholarly literature on CADA and the art of the Avanzada endorses an ostensibly insurmountable divide between Zurita's individual and collective work, identifying possible continuities between these spheres of his creative practice brings to critical consideration the claim of his messianic religiosity. We must not underestimate the fact that Zurita has always considered himself a secular poet, and numerous elements in his writing substantiate this position. I therefore aim to fissure the stark binary between the religious and the secular domains in the study of Zurita's performative practice of writing, positing that the construction of an ambiguous relationship between them lies at the core of his aesthetic project. This ambiguity results from the way in which Zurita's prayer-poems, in dialogue with the ritually imbued tradition of religious lamentation, unfold into (secular) songs of protest against the military dictatorship. Zurita's poetic, prayerful voice is wavering and fragmentary, exhibiting the compulsively repetitive signs of traumatic experience. This voice also conveys a broader reflection on the contingency of subjectivity, which is expressed through unstable identifications with masculine and feminine subject positions. By producing areas of ambiguity between prayer and protest, cry and chant, masculine and feminine, scarring and writing, Zurita's writings not only take part in a critique of the Chilean dictatorship but also destabilize binary logics of classification and ordering that have shaped modernity's secular reason. In other words, his performative poetics illuminates the extent to which, as Bruno Latour suggests, modernity is a process that "renders the work of mediation that assembles hybrids invisible, unthinkable, unrepresentable," even while modern subjects are precisely those who can remain "secular and pious at the same time" (Latour 1993, 33–34).

SKY WRITING AND THE POETICS OF AMBIGUITY

On July 12, 1981, six airplanes (aligned in what may have been perceived from the ground as a military formation) flew over the city of Santiago, Chile, and dropped 400,000 leaflets on some of its poorest *poblaciones* (shanty towns). "We aren't artists," the fliers read, and repeated, "we aren't artists, but every man who works for the expansion, even if only mental, of the spaces of his life is an artist."[7] The country had been living under dictatorial rule since the bombing of the Moneda Palace on September 11, 1973, an attack (from above) by the Chilean military against its own people, monuments, and institutions. Despite the fierce governmental control of cultural activity and public space that followed the coup, when CADA requested authorization for this unusual form of leaflet distribution, the Air Force gave the nod. To mask the critical intentions of the action, CADA emphasized its aesthetic value, describing it as a work of land art, a "hot trend" in the United States and Europe. The artists also claimed to be attempting to create "a sculpture upon the city sky," and they called their action *¡Ay Sudamérica!* (Figure 2.1).[8] This fleeting "sculpture" of raining words was, however, briefly interrupted by the

FIGURE 2.1. CADA, ¡Ay Sudamérica!, 1981. Photo by Patricia Saavedra and Ana M. López. Courtesy of the artists.

sudden fall of a slightly heavier cargo. According to testimony, one of the packages of CADA's bundled leaflets was mistakenly thrown unopened and ended up falling, by chance, on the roof of a police station (Neustadt 2001, 88). The building suffered minor damage, so the artists feared investigation, if not arrest, knowing that their work was far from an expression of support for the regime. Lotty Rosenfeld points out that ¡Ay Sudamérica! was conceived of as a performative quotation of the bombing of Palacio de la Moneda "to reconstruct the political trauma of 1973" (quoted in Camnitzer 2007, 89).[9] That is, by embracing the allegorical possibilities of appropriation, ¡Ay Sudamérica! sought retrospectively to substitute words for bombs, thus acting on the memory of the recent past, and allowing the repetitive impulses of trauma to displace gradually the fear associated with the violence of the coup.[10] According to Fernando Balcells, another member of the collective, the action was also an invitation to "lift up one's gaze, unhunch one's body, and in the process look directly at the other, without fear or intimidation" (interviewed by Neustadt 2001, 75).

CADA's ¡Ay Sudamérica! may thus be understood as an attempt at decontextualizing and reappropriating an image that symbolized the crushing of Allende's democratic, socialist project, and the ideals that sustained it. The action interpellated those suddenly confronted with an unusual aerial formation in the Chilean sky, just as had happened on September 11, 1973. Yet this performance not only restaged the aerial images but also prompted those who got hold of the falling leaflets to recognize themselves in the surrounding landscape, heavily marked by

FIGURE 2.2. Raúl Zurita, *La vida nueva*, 1982. Photo by Leonel Cid. Courtesy of Raúl Zurita.

the traces of a violent history. The action was therefore not exclusively backward looking: it postulated that art was equally capable of acting on the mnemonic ruins of the past and of transforming the signifying possibilities of the present.

Given the uncanny similarities between this action and official strategies to distribute state propaganda—added to the unbridgeable distance between the artists riding the airplanes and the anonymous public—one may wonder whether the action did not further spread fear among its spectators, rather than assuage it. Along these lines, Hernán Vidal argues that "interpellating the populace with a squadron of six airplanes takes on the appearance of a military air raid, rather than the appearance of a friendly approach" (1987, 146).[11] I wish to argue that this simultaneously citational and provocative aspect of the work is unequivocally present, yet it does not result from a tradition of avant-gardism that would inscribe the performance in the genealogy of a Futurist celebration of warfare. Rather, *¡Ay Sudamérica!* deploys CADA's singular strategy of aesthetic dissensus, which combined techniques of fragmentation, iteration, embodiment, parody, and performative displacement in order to deploy a critique of power "from within." Thus, while

¡Ay Sudamérica! effectively mobilizes the imaginaries and technologies of war, it also brings them to another terrain: CADA's poetry-dropping airplanes provide an immediate and concrete illusion of suspending a relationship with the past that had been exclusively mediated by trauma.

In relation to previous experiences of political art in Chile, most notably the Ramona Parra muralist brigade, CADA's aesthetic strategies seem deliberately unorthodox. Muralist brigades originally emerged to support Salvador Allende's Frente de Acción Popular (Popular Action Front) 1958 and 1964 presidential campaigns. With Allende's presidential triumph in 1970 and the adherence of various professional artists (such as José Balmes, Gracia Barrios, Roberto Matta, Guillermo Núñez, and Alberto Pérez) to his cultural program, the Ramona Parra brigade of the communist youth developed what Richard describes as "a work of urban art which translated into images the revolutionary ideas of the program of the Popular Unity party" (Richard 2007, 63). The task of the brigade was to illustrate a given political message or rather to attempt "translating" it into a figurative language, thus using art in the service of revolution and producing a national-popular iconography. As such, the brigade's murals were imbued with aspirations to shape "a new Chile" and a "new man" (Oyarzún Robles 1988, 208). Following the Mexican postrevolutionary muralist aesthetic, the Chilean murals were also conceived of in accordance with a realist tradition that "illustratively subordinates the image to the contents of the ideological message" (Richard 2007, 64). Richard consequently argues that, in the art of the brigades, "the wall substitutes for the canvas, to portray—monumentally—the popular national myth through the pre-encrypted figures of 'the people' and 'the revolution'" (64). With the military coup, the diffusion of this aesthetic came to a sudden end, one that was brutally symbolized by the government's erasure of the murals.

On various occasions members of CADA referred to the Ramona Parra brigade of the communist youth as their predecessor. Yet the politics of art that sustained CADA's practices were visibly different. When CADA came into existence, the political function of art in shaping a new, revolutionary "man" had given way to an understanding of the political that was unlike anything Chilean art had seen in the preceding years. A text published by CADA in May 1982 accounts for this transformation when the collective argues that their main concern was not the representation of heroic and redemptive figures but an exploration of "the precarious and the painful, the waste ground [descampado] of concrete lives" (CADA 1982, 2).

Richard describes CADA's work, together with the art of the Avanzada, as having emerged in a post-catastrophic landscape in which the very meaning of words and symbols had been shattered. The coup overturned any sense of organic historical development, as well as long-held ideas of subjectivity, structured, for instance, around class or gender divides. Everything had to be reinvented, claims

Richard, "beginning with the intercommunicative texture of language which, having survived the catastrophe, no longer knows what to label the remains" (2007, 16). The context for an artistic "rebirth" after the initial paralysis that followed the coup was therefore highly restrictive, for not only did Avanzada artists have to face official attempts to curtail free speech, they also saw the need to circumvent government efforts to co-opt or institutionalize their practices (in a purportedly "new Chile" in great need of symbolic legitimization).[12] Richard suggests that these dual pressures also shaped the conditions under which the Avanzada developed its characteristically experimental and fragmentary aesthetics: "The necessity of misleading the censor meant that the works of the 'Avanzada' mastered the art of linguistic and symbolic disguise or cross-dressing [travestimiento] [. . .]. These works combined the operational rigor of their counter-institutional responses to the prohibitions of the censor with the rhetorical folding of meaning that obliquely marked their poetics of ambiguity" (Richard 2007, 19).

In my discussion of the strategies of co-optation of the Chilean state in the previous chapter, I mentioned how Ignacio Valente, one of the regime's official literary critics—writing for the right-wing newspaper El Mercurio—praised what he saw as the religious humanism of Zurita's work. From Valente's standpoint, Zurita's writings seemed to accompany, and even to legitimize, the official rhetoric, which endorsed "nation, family, and religion" as the basis of dictatorial culture. As Richard puts it, if one follows Valente's skewed interpretation of Zurita's writing, it "appears to speak the same language as official culture" (Richard 2007, 37). Yet the institutional appropriation of Zurita's poetic voice relied on the omission of those elements in his writing that question the very referentiality of language, using contradiction, ambiguity, and calligraphic fragmentation: "The constant quarrels between the official reading of the works and the counter-readings [. . .] made it clear that art always ran the risk of seeing its oppositional weight diminished. The way that the artists of the 'Avanzada' found to resist these official manipulations was by working on the hypothesis of a 'refractory art': an art that generates, inside the work, zones of resistance accommodating something unassimilable to order" (34).

Despite Richard's emphasis on the refractory character of the Avanzada, her own reading of this movement, particularly the reading that she develops in Márgenes e instituciones, tends toward an epic celebration of the ways in which it critiqued authoritarian power, often to the point of diluting those ambiguities that she originally highlights. By contrast, I seek to explore such ambiguities in greater depth and continue to dwell on their critical potential. Having discussed in chapter 1 the political significance of an ambiguous treatment of pain in Eltit's sacrificial poetics, in the following section I identify similarly troubling, performative, and paradoxical strategies of aesthetic critique in Zurita's prayer-poems and their lamenting resonances.

THE NEW LIFE

In 1982, the year after CADA's staging of ¡*Ay Sudamérica!*, Zurita traveled to New York to carry out an art action that was similarly performed from the sky. In this piece, entitled *La vida nueva* (The New Life), the artist etched poetry into the sky of the city's (then) impoverished borough of Queens, using water vapor blown out from five aircraft (Figure 2.2). His verses read:

Mi Dios es hambre
Mi Dios es nieve
Mi Dios es no
Mi Dios es desengaño
Mi Dios es carroña
Mi Dios es paraíso
Mi Dios es pampa
Mi Dios es chicano
Mi Dios es cáncer
Mi Dios es vacío
Mi Dios es herida
Mi Dios es ghetto
Mi Dios es dolor
Mi Dios es ... mi amor de Dios ...

(My God is hunger
My God is snow
My God is no
My God is disillusionment
My God is carrion
My God is paradise
My God is pampa
My God is Chicano
My God is cancer
My God is emptiness
My God is wound
My God is ghetto
My God is pain
My God is ... my love of God ...)[13]

Following the anaphoric structure of a litany, Zurita's sky poem describes, line after line, the multiple forms of his deeply personal rendering of G/god, double in nature, both holy and secular. Effectively, Zurita's action was monumental: the lines were between seven and eight kilometers in length and therefore visible from

a much greater distance than this. Yet this monumentality was also nothing but a fleeting gesture, since the movement of the wind almost immediately blurred the gigantic words. An evanescent ink, the water vapor soon regained its transparent humidity. However, the action did leave a number of traces, including a video recording by artist Juan Downey and several photographs of the vaporous poetic lines. Zurita included both the text and its visual rendering in his second poetry collection, entitled *Anteparaíso* (Anteparadise) (1982). In the numerous editions of this collection, the photographs of the sky poem occupy the totality of several pages, stretching beyond the book's margins as if they were trying to break loose from this medium and thus reenter the flux of the real and the contingent rhythms of the sky. The images also implicitly construe the world as a canvas, a space that can be written and drawn upon, where even the godly may be resignified and invested with new metaphors.

The photographs of *La vida nueva*, in combination with the printed text, render *Anteparaíso* a collage of sorts, which juxtaposes a performance with its script, a poetic and textual proposition with its visual representation. And the genealogical relationships between the scripted text and its performance are deeply altered by the workings of montage: the images of the verses in the boundless landscape undo the fixity of the written word, positing both its materiality and its meaning as fundamentally contingent. As the authority and stability of language comes undone, the poetry collection also enacts a refusal of a regime of vision in which opticality, too, partakes in the reification of ideas of truth and reality—the visual *a priori* of verifiable experience, or what Martin Jay describes as the ocularcentric orientation of modernity (1994). Yet this becomes clear only as the text comes to an end, when the collection seals its final lines with a brief text by Eltit, in which, in a direct, report-like style, she recounts that on March 18, 1980, Zurita tried to blind himself by pouring ammonia over his eyes. In doing this, the poet burned his eyelids and parts of his face, but he ended up with only minor injuries to his corneas, thus preserving his sense of sight (Zurita 2009a, 159). Eltit testifies to having seen Zurita cry as he renounced vision. She claims to have cried by his side, but she also adds that none of this matters, for "él" (he), referring to Zurita, "es el mismo que ha podido pensar toda esta maravilla" (is the same person who has been able to think up all of this wonder) (159).

By linking Zurita's "wondrous" creation to the negation of sight, Eltit establishes a possible dialogue with the Surrealist search to restore the "Edenic purity of the 'innocent eye,'" an idea that is also arguably present in Dalí and Buñuel's *Un chien andalou* (1929), and that appears in Bataille's fascination with the "violent termination of vision" in *Histoire de l'œil* (Story of the Eye, 1928) (Jay 1994, 220, 243). Eltit writes, on having realized that he had not lost the capacity to see, Zurita "me dijo entonces, llorando, que el comienzo del Paraíso ya no iría" (told me then, crying, that he would no longer go to the beginning of Paradise) (Zurita 2009a, 159). With these words Eltit invokes a notion of paradise that is not only a

way of seeing—cut off from the "corrupted, habitual vision of everyday life" (Jay 1994, 244), as the Surrealists would frame it—but also an idea imbued with religious meaning. The scene of the two tearful writers bears the echoes of the Christian parable of the Fall: the lovers, Eltit and Zurita, weep tears of remorse for the latter's failure to (re)enter Paradise; Zurita preserves his sight at the cost of a denied purity, just like Adam's expulsion from Paradise is accompanied by the "opening of his eyes" as he gains access to the knowledge of Good and Evil (Gen. 3:7).

Zurita's attack on his own vision is also a way of treating life itself as artistic terrain, whereupon the artist may shape, deform, and refashion the subject, and where art and life are seamless. The artist postulates the body and the senses as "artistic matter," spaces that can be modified, subjectively appropriated, and, to a certain degree, renounced. As such, Zurita's self-blinding performance is closely entangled with the act of mutilating his own cheek, an act that, as I mention in chapter 1, the poet describes as the origin of all his writing. Both acts of self-injury are means to write a narrative on the body by turning it into an artistic medium— similar to acts of tattooing and piercing that refashion the body, and often turn it into a mnemonic device.[14] Going back to Zurita's relationship with Surrealism, Matías Ayala claims that, like the Surrealists, Zurita "tried to blur the boundaries between art and life, the body and text, and the subject and the Other's gaze" (Ayala 2012, 184). Yet one must take notice of the strikingly visceral character of Zurita's idea of "life," as well as the religious references that permeate it—references that continuously bring to mind Catholic practices of self-immolation and the corresponding redemptive qualities of pain. Unlike the Surrealists, the Chilean poet does not confront the autonomy of art, nor does he ascribe to the association of life with the everyday. Instead, Zurita grounds his idea of life in the vulnerability of the suffering body. Therefore when Zurita seeks "to sublate" art and life, as Peter Bürger describes the signature of avant-gardism (1984, 36), the latter stands for the susceptibility to injury of that which is alive, and the vulnerability of the human body to painful experience. Moreover, Zurita explores how the feelings of grief that result from the finitude of corporeal life—feelings that dwell on the limits of language and take expressive form in the materiality of the written word—may critically disrupt the fundamentally modern division between the sacred and the profane. And as he unsettles this division, bringing together poetry and prayer, protest and lamentation, he points toward the extent to which the politics of pain dwell in an ambiguous terrain between an unnamable, unreachable transcendental, which allows only indirect evocation through traces and gestures, and concrete political projects.

SONG FOR HIS/HER DISAPPEARED LOVE

Ahora todos son caídos menos nosotros los caídos.
Ahora todo el universo somos tú y yo menos tú y yo.

Tras los golpes, ya idos, nos desplazamos un poco y destrozada yo
fui lo único que sentiste acercarse.
Nadie sabrá, porque tú eres el que busco, al que cuido. Llorona de
ti tal vez seamos todos una sola cosa.
(Zurita 2010, 14)

(Now everyone is fallen except for us, the fallen.
Now the entire universe is you and I minus you and I.
After the blows ended, we moved a bit and destroyed I was the
only one you felt come closer.
Now no one will know, but it's you I look for, who I care for.
Weeping for you perhaps we are all one thing.) (43)[15]

Zurita published the above lines in 1985. At this time, as I discuss in further detail
in the next chapter, the publication of the *Nunca Más* report of the Argentine
National Commission on the Disappearance of People, together with a number
of testimonial writings, cast the notion of "political disappearance" as a political
technology that had been widespread throughout the Latin American subconti-
nent at least since the 1960s, with the Brazilian 1964 military coup. The poet's lines,
therefore, refer not only to the human rights situation in Chile but "sing" to all
those who died as a result of this infamous experience, dedicating the poem
"—A la Paisa /—A las Madres de la Plaza de Mayo /—A la Agrupación de los
Familiares de los que no aparecen /—A todos los tortura, palomos de amor, países
chilenos y asesinos" (To the brothers and sisters / To the mothers of the Plaza de
Mayo / To the association of family members of the disappeared / To all of us,
we are tortured, pigeons of love, Chilean countries and murderers) (9, 50).[16] The
last words of this dedication can be read in two different forms: the first is the one
that I quote in the translation from Borzutzky, while the second would read "Chil-
ean and murderous countries." This syntactic ambiguity introduces an unex-
pected element in the way that the poem is positioned ideologically. I take the
first translation to suggest, polemically, that Zurita's song seeks to address not only
the victims of dictatorial violence, but also its perpetrators (the "murderers").
Indeed, as one reads the text one can sense that *Canto a su amor desaparecido* (1985)
effectively understands the task of mourning the disappeared as a problem that
does not pertain exclusively to the direct victims of these crimes. Rather, by way
of a series of often ambiguous and performative strategies, the text suggests that
this task ought to be understood as a shared burden that extends beyond levels
of involvement in the enactment of political violence. The poetic form that Zurita
deploys in order to produce this depersonalized understanding of mourning is
the lament.

In accordance with the historical association of lament rituals with the figure
of the weeping woman, Zurita initially resorts to a female poetic voice to sing

and cry for the disappeared. This female voice grieves for her disappeared love, who died during torture. Yet as one reads her lament, one realizes that the singing subject constantly shifts from the masculine to the feminine, and that both lovers had suffered the same fate. When the poetic voice becomes masculine, he equally mourns her absence. This lament therefore bears multiple, spectral echoes: it is nebulous, undefined, and loosely anchored to the subject and to the places where she/he dwells. As s/he sings, s/he wanders around the burial niches of entire countries that have fallen. For them, s/he sings as well. A penciled map of the nave in which they rest accompanies the poem: Bolivia was buried on its own; Chile and Argentina lie right next to one another. Mexico was buried under the sign of empire, together with Puerto Rico. Empires, however, were themselves unable to escape their own demise, and they received no glamorous burial. The United States of America lies next to Libya, Algeria, and Morocco. "Son noches las tumbas" (The graves are nights), reads the poem, "y es toda la noche la tumba americana" (and everything is night in the American grave) (19, 40).

In Zurita's necropolis, death is an equalizing force, regardless of a country's history and geopolitics. The hand-drawn rectangles that demarcate the niches for dead nations also symbolize the absurdly arbitrary nature of national borders and national hierarchies. The drawings offer the image of a sanitized edifice of piled-up national niches, as if the body politic, too, could reach finitude. Therefore, despite those interpretations of Zurita's writing that claim that his poetry seeks national redemption through writing (Pérez Villalobos 1995, 55), here Zurita leaves no space for a mythology of restitution. Instead, as William Rowe points out, "The clichéd patriotic narrative of dead human beings expressing the essence of a national territory is opposed by countries becoming violated human beings" (2000, 289). Argentina's epitaph describes a disappeared country, a country that became hollow. A wisp of wind flows over nonexistent pampas and, as massacred faces take their last breath, they look at one another:

> Nicho Argentina. Galpón 13, nave remitida bajo el país Perú y sobre el país Chile. De tortura en tortura, desaparecimiento y exterminio quedó hueca, como los países nombrados, y la noche no tuvo donde caer ni el día. País desaparecido del horror tras los cuarteles. Desde allí el viento sopló sobre la pampa inexistente y apagándose se vieron las masacradas caras, Amén. (19)

> (Argentinean Niche. Shed 13, a [nave][17] beneath the country of Peru and above the country of Chile. From torture to torture, disappearance to extermination, a hole was left and it was like the aforementioned countries and the night had nowhere to fall and neither did the day. Country disappeared from the horror behind the barracks. From there the wind blew across the inexistent pampas and as it settled the massacred faces became visible, Amen.) (40)

In Zurita's *Canto*, various epitaphs conclude with the word "amen," bestowing upon the text the resonances of prayer in a mortuary mass. The poem-prayer evokes the abused bodies of those who died in torture and identifies their traces in the landscape: "Miles de cruces llenaban hasta el fin el campo" (Thousands of crosses spread across the field) (11, 48). Yet the poet also distinguishes the land from the suffering subjects: the land is, according to Rowe, "the place that torture cannot penetrate" (2000, 288). Therefore, as the mourner signs her adieu, she endlessly repeats that her love "ha quedado pegado en las rocas, el mar y las montañas" ([remains sealed in] the rocks, the sea and the mountains) (Zurita 2010, 13, 46).[18] "Imagined as unviolated," the land stands for the unsignified, where memory and resistance can still be inscribed (Rowe 2000, 286). Landscape becomes, as Rowe suggests, "an alternative body, resistant to the repressive effects of pain" (286).

Zurita's poem is a polyvocal testimony of torture, loss, and affection. Alternating verse with poetic prose, it registers the agony leading to the lovers' final demise, but it also evokes their posthumous expressions of affection: "Te busqué entre los destrozados, hablé contigo. [...] Todo acabó [...]. Pero muerta te amo y nos amamos, aunque esto nadie pueda entenderlo" (I looked for you among the [corpses],[19] I spoke to you. [...]. Everything ends [...]. But dead I love you and we love each other even if no one understands this) (11, 48). The spectral condition of the poem's characters allows a nonlinear configuration of time and space. Images of the wrecked "galpones de concreto" (concrete sheds), which are filled with dozens of niches—"unos sobre otros" (one over the other)—are interrupted by images of the sea, the mountains, and the desert, where love has been sealed (*pegado*) (11, 48). The fluctuating qualities of this spatiotemporal configuration can be deciphered in light of what Gustavo Buntinx names the "posthumous condition" of the Latin American disappeared. This suggestively ambivalent category articulates "the confronted concepts of beginning and end, death and birth" (Buntinx 1995, 30). Its disputed Latin etymology links the soil or *humus* to "that which is born or comes to light after death" (30). Therefore, in this category, soil becomes a site of burial as well as rebirth, confusing the individual body, now corpse, with the collective body of the land. Buntinx therefore suggests that this liminal notion offers a particularly insightful description of the figure of the disappeared: "those neither living nor dead, but simply 'missing'" (32). Furthering this understanding of the posthumous condition, Zurita's text explores a liminal space between life and death, which could be linked to Aby Warburg's concept of *Nachleben* (afterlife). The poet also explores and blurs the tensions between the masculine and the feminine, the individual and the collective.

Canto a su amor desaparecido starts with a question about the whereabouts of the disappeared, directed by a mourning mother straight at Zurita ("Ahora Zurita [...] ¿tú puedes decirme dónde está mi hijo?" (Now Zurita [...] can you tell me where my son is?) [Zurita 2010, 7, 52]). Zurita's answer to this question is far from

univocal, and it can be better understood as a performative gesture than as a literal or referential message. He attempts to transcribe the voices of the dead; voices that come in fragmentary form, often blended with one another, and that can be heard only by being attentive to landscape. It is as if, for him, in the aftermath of catastrophe, only the vastness and anonymity of the landscape—in its (often sublime) resistance to being apprehended—could have an answer to the question of the whereabouts of the disappeared. Likewise, it is as if landscape—the sea, the soil, the mountains—bore a physical archive of their memory, including forensic remains and other expressive traces of love, anguish, and final surrender. The poem suggests, however, that finding this archive necessitates attending to muddy echoes, as the physical location of the disappeared remains unknown.

Amidst these echoes, in which masculine and feminine and individual and collective voices become entangled, we hear people—or fragments of people—singing and weeping for unidentifiable, broken, piled-up corpses, lying in half-empty and looted niches. These pillaged niches, in turn, bear no individual names, but only those of entire countries: "—En cada nicho hay un país, están ahí, son los países sudamericanos. /—Grandes glaciares vienen a recogerlos" (—In each niche there is a country, they are there, the South American countries. /—Great glaciers come to pick them up) (15, 44).[20]

Therefore while the poem opens like a journey in search of the disappeared, at no point does this journey have a clear direction. Traces of the dead are everywhere present in the ruinous landscape, and the search is continuously interrupted by flashbacks to their agony, flashbacks narrated in the first person and characterized by an emphasis on heightened sensations arising in moments of great danger. One of these "flashlights," or rather, vivid remembrances dwelling in the landscape, reads: "—El hombro cortado me sangraba y era olor raro la sangre" (—My disembodied shoulder bled and the strange smell was the blood) (13, 46). As the poem unfolds, those that are already dead become confused with those that are still dying, as if the process of dying were ceaseless, or continuously reenacted ("—La generación sudaca canta folk, baila rock, pero todos se están muriendo" (—The South American generation sings folk songs, dances to rock, but everyone is dying) (15, 44). The poem eschews providing an explanation for such an incessant loss of life, even suggesting that, from the victim's perspective, it is difficult to disentangle from pure chance ("es mi karma ¿no?" [it's my karma, right?]) (16, 41). Yet the poem also offers a more complex treatment of history and causality, for time moves back and forth as the past "flashes up." Read alongside Walter Benjamin's "Thesis on the Philosophy of History," these erratic "illuminations" evoke the possibility to "articulate the past historically" outside a linear and homogeneous conception of time, as the philosopher argues in his sixth thesis (Benjamin 1999, 247). Furthermore, in the tenor of Benjamin's notion of allegorical memory, the poetic voice in Canto a su amor desaparecido is discontinuous, nomadic, and transubstantial, allowing the confusion of identities

between victims of dictatorship in different Latin American countries, rather than exalting the singularities of the Chilean experience ("—Todos los países míos y natales se llaman del amor mío, es mi lindo y caído. /—Todos están allí, en los nichos flotan" [—All my countries and hometowns call to my love, my beautiful fallen boy /—They're all there, they float in the niches] [16, 41]). In these lines, as in other parts of the poem, floating, weightless identities become confused, as emotions shift swiftly from one subject position to another. This process is grammatically stressed by introducing each sentence with dashes, as if the lines were part of a dialogue, even while each conveys a single idea. At one point the *canto* alternates the plaintive memories of a single mourner with a collective voice that, like a chorus, repeats in the third person: "—Cantando, oh sí, cantando a su amor desaparecido" (—Singing, oh yes, singing for [his/her] disappeared love) (17, 42).[21] As the poem comes to an end, like in Huidobro's *Altazor* (1931), formal experimentation is heightened and words themselves begin to dissolve into mere sound. The mourning voice becomes entirely impersonal, merging with night itself, the absence of light, a time of darkness, a posthumous rendering of a feminine force which sings beneath the earth:

La noche canta, canta, canta, canta
Ella canta, canta, canta bajo la tierra

(The night sings, sings, sings, sings
She sings, sings, sings beneath the earth) (Zurita 2010, 26, 31)

THE POLITICS OF LAMENTATION

Beyond Zurita's treatment of ruins and time, there is another, less visible, connection between *Canto* and Benjamin's thought: an approach to the poetic lament as an aesthetico-political form of cultural critique. In order to understand Benjamin's politics of lamentation, a word must be said about his religiously imbued idea of the lament, as this topic has received little attention in the scholarship on his work. Brent Plate's study of Benjamin's text on the *Trauerspiel* argues for the need to "rescue lamentation from mourning" in the study of Benjamin's philosophy (Plate 2005, 44). Plate prepares the ground for this operation by suggesting a new reading of Benjamin's *Ursprung des deutschen Trauerspiels* (often translated as *The Origin of German Tragic Drama*) in which the notion of *Trauerspiel* is translated as "lament play," rather than the more commonly used concepts of "tragic drama" or "mourning play." According to Plate, although "mourning play" is linguistically more accurate, it fails to take into account "Benjamin's own interest in the relation between the *Trauerspiel* and certain traditions of Judaism" (44). In 1918, "in the midst of his reflections on the language of the *Trauerspiel*" (44), Benjamin wrote a letter to his friend Gershom Scholem, stating that he had come

to the realization that his concerns "must be asked on the basis of the Hebrew lament" (45). George Steiner's introduction to Benjamin's *Ursprungs* similarly posits that "*Trauer* signifies sorrow, lament, the ceremonies and memorabilia of grief. Lament and ceremony demand an audience. Literally and in spirit, the *Trauerspiel* is a 'play of sorrow,' playing at and displaying of human wretchedness" (Steiner 2009, 17).

Steiner's text elucidates Benjamin's interest in the ritual and public (therefore expressed and material) aspects of the mourning process. The critic also draws attention to the relationship between a Baroque and "sorrow-filled" rendering of nature in the *Trauerspiel* (Buck-Morss 1989, 229) and Benjamin's allegorical approach to history: the lament play "sees in historical events, in architecture, in the collateral edifice of the human body and of the body politick, properties for a grievous pageant" (Steiner 2009, 18).

The word *Spiel* compounds in German the double sense also present in its English equivalents: stage performance and game. This is significant for Benjamin, for he sees German Baroque drama as being sorrowful as much as it is ludic. "The Dance of the Death depicted in sixteenth- and seventeenth-century art and ritual," writes Steiner, "is the crowning episode of the game or play of lamentation" (18). Moreover, according to Benjamin, "The world of the mourning [lament] play is a special world that can assert its greatness and equality even in the face of tragedy" (1996b, 61).[22] This greatness does not depend on a final leap toward messianic redemption, as Benjamin's text has often been misinterpreted to mean, but on the emergence of an allegorical world of ruins and fragments that are filled with meaning despite their splintered and disjointed, fallen appearance (Plate 2005, 65). Furthermore, Benjamin grounds the lament's capacity to open up language, "hallow the word" (Steiner 2009, 14), and allow the multiplication of meaning in the shivering movement of its musical resonance: "Whereas in tragedy the eternal inflexibility of the spoken word is exalted," Benjamin writes, "the mourning play concentrates in itself the infinite resonance of its sound" (1996b, 61). Yet Benjamin also harbors doubts about the potency and complexity of laments. In his essay "On Language as Such and on the Language of Man," he writes that the "lament [. . .] is the most undifferentiated, impotent expression of language" (Benjamin 1996b, 72–73), being entirely dependent on the ear. He adds: "Only the most profoundly heard lament can become music" (61).[23]

Benjamin's conception of the primal, unelaborate nature of the lament, together with his exaltation of some laments for their mournful musicality, parallels revisionist biblical commentary on the book of *Lamentations* in the Old Testament, where Jeremiah weeps and laments the ravaging of Jerusalem and the destruction of its Temple by the Babylonians around the year 587.[24] According to Claus Westermann, the significance of these laments does not reside in their capacity to "explain or admonish" extreme suffering, but in the fact that "they allow the suffering of the afflicted to find expression" (Westermann 1994, 81). Likewise, Tod

Linafelt posits that *Lamentations* ought not to be read as a text that claims that "suffering is a punishment for sin or that a submissive spirit is more important than the voicing of pain and grief"—assertions he considers to be increasingly untenable in the aftermath of the "Holocaust and other twentieth-century acts of mass atrocity" (Linafelt 2000, 4).

Differing interpretations of *Lamentations* are often the result of which poems or chapters, out of the five that constitute the text, are given greatest emphasis. The third chapter, privileged in nineteenth- and twentieth-century scholarship, narrates the story of an unnamed man who "has suffered under the hand of God" but who, knowing that God's "will for man is not suffering," gathers hope to wait for God's mercy (Hillers 1992, 6). By contrast, in the book's largely overlooked first and second chapters, "Zion is personified as a widow and a mother lamenting her suffering and perishing children." She uses a rhetoric that addresses God with a feeling of urgency that "demands a response on behalf of her children" (Linafelt 2000, 2–3). A close reading of these two poems leads Linafelt to postulate that, contrary to the consensus of biblical scholars, the expression of suffering in *Lamentations* comes in the form of a questioning of authority, an argument that is crucial to my own understanding of Zurita's return to the lamentation tradition. That is, alongside a rich critical biblical scholarship, I see the lament form as belonging to a "literature of survival" that seeks to surpass a state of nostalgia and that also refuses to accept authoritarian power. As Michael D. Guinan points out, in *Lamentations* "Israel's enemies are mentioned on occasion," yet "more often they fade from sight." Instead, Yahweh becomes "Israel's main enemy," the one who brings about destruction (Guinan 1990, 559). This critical biblical scholarship is to be taken into account in the study of Benjamin's interest in lamentation too. Lamentation thus becomes "more than just mourning"; it is an "address to God"—the ultimate authority, the source of injustice—"to change the present circumstances" (Plate 2005, 45). Similarly, as Linafelt suggests, a lamentation is "more about *protest* as a religious posture than capitulation or confession" (Linafelt 2000, 4, emphasis in original). It "entails an interaction with God, an interaction that may be as much a protest as a prayer" (Plate 2005, 45).

Understood in this light, Benjamin's allegorical reading of the "lament play" has significant resonances in Zurita's *Canto*, the denunciatory politics of which are rooted in the evocation of torture as the primordial form of authoritarian repression. The multiple voices that constitute the text describe scenes of extreme physical abuse as well as bodies that continue to be brutalized after death (as if, in Benjamin's words, "even the dead will not be safe from the enemy if he wins" [1999, 247]). Torture not only breaks bodies down but also turns them into instruments for the punishment of others: "—De un bayonetazo me cercenaron el hombro y sentí mi brazo al caer al /—pasto /—Y luego con él golpearon a mis amigos" (They clipped off my shoulder with a bayonet-blow and I felt my arm as I fell to the/grass / Then they hit my friends with it) (Zurita 2010, 13, 46). As bod-

ies and voices become fragmented in the text, the condition of victimhood becomes dispersed, to the point of reaching a certain universality: "Llorona de ti tal vez seamos todos una sola cosa" (Weeping for you perhaps we are all one thing) (14, 45).

Gail Holst-Warhaft describes laments as expressions of passionate feeling that focus on mourning and loss, instead of praising the value of (heroic) death for the survival of community (Holst-Warhaft 2002, 3). As such, they have a history of prohibition by both religious and civil authorities that dates back to classical Greece. The "dangerous" nature of the poetic lament lies in its capacity to transform lived and potentially speechless pain into a shared embodied experience, which reclaims a forum for its public expression. This search for the voice simultaneously capable of expressing individual and communal feelings of loss is strongly felt in Zurita's writings, as well as in the embodied performance of his texts. To quote Matías Ayala: "Zurita used bodily pain [. . .] as the element of suture between the subjective and the collective" (Ayala 2012, 185). His poetic attempts to make pain publicly visible are therefore not to be understood as a celebration of messianic sacrifice and self-injury but rather in relation to the public expression of suffering as a ritualized political act. In this sense, they are reminiscent of Emmanuel Levinas's description of pain as the ultimate appeal to the Other. Groans of pain are signs of subjective exteriority, Levinas claims, and they may bring about an experience beyond useless suffering in the recognition of a sense of responsibility before the Other's pain. For Levinas, this recognition is tantamount to "the inter-human" (Levinas 1988, 158). He writes: "A radical difference develops between *suffering in the Other*, which for *me* is unpardonable and solicits me and calls me, and suffering *in me* [. . .] The only meaning to which suffering is susceptible [lies] in becoming a suffering for the suffering—be it inexorable—of someone else" (1988, 159, italics in original). This discussion brings us back to this chapter's opening lines. As Butler explores the collective consequences of the subject's inescapable vulnerability, her political rehabilitation of pain establishes a close dialogue with Levinasian ethics. In both thinkers, the subject's exposure to violence and his or her vulnerability to pain—resulting from the corporeal condition of being and the manifest finitude of the body—give rise to an idea of the ethical and the political that reclaims a nonidealist and nondiscursive sense of universality.[25] Butler writes: "Loss has made a tenuous 'we' of us all" (2004, 20).

PURGATORY

Zurita's 1979 poetry collection entitled *Purgatorio* is less clearly evocative of a lament than Zurita's *Canto*. Yet the treatment of image, body, and language in the text, together with its description of a deserted, biblical landscape, populated by words-turned-ruins, bring this poetry collection to a similarly painful, allegorical,

and lamenting terrain. *Purgatorio* is assembled like a collage of textual and visual elements in which the visual not only interrupts the succession of texts through the use of images but is also present as a dimension of language itself, through the incorporation of bulky and partially crossed-out, handwritten texts. The layout of the poems in the seventy-page book creates a sharp contrast between large areas of empty, white space, and short, heavily condensed stanzas, spread out in the pages as scattered ruins or *manchas* (stains). This unusual textual disposition situates the spatiality of the text, and its physical "body," as crucial to understanding remarkably abstruse poems and poetic sequences, which only rarely conform to syntactical rules.

Already from the title, the book resorts to a religious category that is primarily spatial, and evocative of in-betweenness or ambiguity: betwixt and between heaven and hell. According to Robin Kirkpatrick, in Dante, which is a key reference throughout Zurita's writings (particularly in his trilogy *Purgatorio, Anteparaíso,* and *La vida nueva*), Purgatory is "a transitional state, where [...] lives are still in motion, free from the icy constriction of Hell, yet still to arrive at the absolute peace of Paradise. There are no absolute conclusions here. We are concerned with lives as they are lived, and with virtues, or principles that are expressed in, and explored through, our sympathetic engagement in a process" (Kirkpatrick 2006, xxvii). This transitional condition, suspended between the white and mostly empty space of the page and the minimal, densely concentrated stanzas, not only organizes *Purgatorio*'s layout, but also invites us to read each stanza as a formless, disorganized *mancha* situated within the confined space of an animal body, a female body, a cow's epidermis: "Comprended las fúnebres manchas de la vaca" (Understand the funereal spots of the cow), writes Zurita, "I. Esta vaca es una insolubre paradoja [...] y sus manchas finitas son símbolos" (I. This cow is an insoluble paradox [...] and her finite spots are symbols) (Zurita [1979] 2009b, 64–65).[26] The disproportionally large white space surrounding the poems acts as a nonsignifying void that demarcates the limits of the written text and evokes that which lies beyond language.[27] This empty space also stands in relation to one of the poem's central themes: the Atacama Desert as an infinite and barren land, capable of becoming its other, a fertile grassland, by means of a process of crucifixion, expiation, and potential redemption (a form of redemption that is entirely earthly, as in Dante's writings).[28]

Zurita's third section of *Purgatorio* is a series of seven numbered and axiomatically organized poems, entitled "El Desierto de Atacama" (The Atacama Desert), in which the poet highlights the need to *see* the Atacama desert, which is successively symbolized as weightless, "suspendido sobre el cielo de Chile" (suspended over the sky of Chile), "áurico" (luminous) (40–41), and "maldito" (damned) (32–33). The first poem pleads for the sterility of the desert to come to an end, equating this sterility with infinitude or with a totality that never becomes concrete: "i. Dejemos pasar el infinito del Desierto de Atacama / ii. Dejemos pasar

la esterilidad de estos desiertos" (i. Let's allow the infinity of the Desert of Atacama to pass / ii. Let's allow the sterility of these deserts to pass) (38–39). For the poet, this totality is to be traversed by a rising prayer (*plegaria*) that would bring it to a point of encounter with "the singular" and thus make visible the infinite in the concrete. At that point the barren desert would become fertile and green: "vii. Entonces sobre el vacío del mundo se abrirá completamente el verdor infinito del Desierto de Atacama" (vii. Then over the world's emptiness the infinite green of the Desert of Atacama will open completely) (38–39). The prayer that cuts through infinity rises with the vapors of weeping, but then condenses into water droplets and leads to "la primera lluvia en el desierto" (the first rain of the desert). These waters emerge from a maternal, genital source, flowing, as the poet states: "desde las piernas abiertas de mi madre" (from the spread-open legs of my mother) (38–39). The genital liquids, turned tears, turned rain, effect a mobile, transitive connection between the intimacy of the female body and the anonymity of landscape. Furthermore, they lead to a progressive coming-together, to the point of indistinction, between above and below, high and low, the debased and the sacred. The barren desert eventually begins to rise, propelled by the wind: "Hasta que finalmente no haya cielo sino Desierto"—*cielo* written in lower case, as the "Atacama áurico" takes a capital letter (40–41).

> Helo allí Helo allí
> suspendido en el aire
> El Desierto de Atacama
> i. Suspendido sobre el cielo de Chile diluyéndose
> entre auras
> ii. Convirtiendo esta vida y la otra en el mismo
> Desierto de Atacama áurico perdiéndose en el
> aire.
>
> (There it is There
> suspended in the air
> The Desert of Atacama
> i. Suspended over the sky of Chile dissolving
> amid auras
> ii. Converting this life and the other into the same
> Desert of Atacama luminous losing itself in the
> air) (40–41)

Although the series of poems on the Desert is organized according to a numbered, axiomatic logical schema, its lines violate the principle of noncontradiction that stands as a condition of truth for any sequence of logical axioms. The third poem begins with the following mutually opposing statements: "i. Los

desiertos de atacama son azules / ii. Los desiertos de atacama no son azules ya ya dime lo que quieras" (i. The deserts of atacama are blue / ii. The deserts of atacama aren't blue, go ahead say what you will) (42–43). These lines not only posit the destabilization of truth as a poetic operation, but also directly associate this process with a critique of (religious) authority. The axiom that follows the above states: "iii. Los desiertos de atacama no son azules porque por allá no voló el espíritu de J. Cristo que era un perdido" (iii. The deserts of atacama aren't blue because out there J. Christ's spirit didn't fly he was lost) (42–43). In light of these words, it is clear that the poet's misgivings about the blueness or non-blueness of the deserts refer to the possibility of their fusion with the heavens. Thus, the third proposition starts by giving an explanation for the non-blueness of the deserts based on the idea that they would be un-heavenly as long as they are not touched by God's spirit. Yet the same stanza rapidly subverts this reasoning by provocatively stating that Jesus himself was someone who had got lost along the way. Crucially, the other person who is portrayed as being lost in Zurita's *Purgatorio* is Raquel, a prostitute who, in a brief handwritten note composed in the first person and juxtaposed with a picture of Zurita's face in the text's opening pages, claims to have been in the "oficio" (job/business) for many years, to be in the middle of her life, and to have lost her way (9, 11).[29] Like the ambiguous and contradictory category of the heaven/Desert, Christ/prostitute is a divided subject: masculine and feminine, sinful and holy. This broken subjectivity is what ends up defining the poetic voice throughout the text, leading Mario Rodríguez Fernández to understand *Purgatorio* as a confrontation between a fragmented subject and the totality of (religious) discourse. He also identifies in the text a paradoxical evocation of the sacred or the transcendental. His insightful analysis is worth quoting at length:

> The mutilated figure of the person writing is presented, in an ambiguous fashion, as inscribed in the figure of Christ, even if this Christ is an insane one. His double sexual condition would appear to stem from certain initiatory doctrines that propose a Christ combining the masculine with the feminine. From this transformation of religious maxims, one might infer that the writing of *Purgatorio* is profaning, and that it is realized in the degradation of the sacred, but evidently this is not the case. The text encourages an aspiration towards the transcendental, a desire to access a higher reality; it is just that this desire does not follow "the path of habitual perfection," but an inverse one: that of degradation, of the demons of madness, sickness, violence, and of the mutilation of one's own body. (Rodríguez Fernández 1985, 116)

This reading of *Purgatorio* entirely subverts Ignacio Valente's ultra-conservative interpretation of the text and approximates Zurita's writing to Bataille's conception of the sacred as a site of conflict and heterogeneity. Zurita's biblical numerology, corporeal disassembly, and axiomatic writing produce a complex distur-

bance of hierarchy and form—evoked by the formless *mancha*—where high and low become confused, the masculine is wounded and broken open, and Christ and a writer-prostitute "get lost" as they climb Mount Purgatory. Focusing on Zurita's construction of ambiguous subjectivities, both holy and corrupt, also undermines Avelar's criticisms of the poet's purported Messianism. *Purgatorio*'s critical and unsettling potentiality lies precisely in Zurita's continuous destabilization of the positionality of the poetic voice, disarticulating the idea of the stable subject, and refusing both corporeal and ontological fixity. As such, it constructs what Rodríguez Fernández calls a "mistaken, double subject, of uncertain status" (Rodríguez Fernández 1985, 115). When in the poem the individual is identified with the collective, it is not in the form of a redemptive, sacrificial figure but in the confrontation of "the presence of the subject with its loss in the heterogeneous" (Kristeva 1995, 252). In the last stanza of "El desierto de Atacama IV" (The Desert of Atacama IV), Zurita expresses this experience of loss as a series of bleating noises emanating from disembodied souls lost in a desolate desert:

> iv. Y si no se escucha a las ovejas balar en el Desierto
> de Atacama nosotros somos entonces los pastizales
> de Chile para que en todo el espacio en todo el mundo
> en toda la patria se escuche ahora el balar de nuestras
> propias almas sobre esos desolados desiertos miserables

> (iv. And if you don't listen to the sheep bleat in the
> Desert of Atacama then do we become the pastures
> of Chile so that everywhere all over the world
> all over the country you listen now to our own souls
> bleat throughout those miserable desolate deserts) (44–45)

NEITHER SORROW NOR FEAR

In 1993, only a few years after the end of the dictatorship, Zurita's verse *"ni pena ni miedo"* (neither sorrow nor fear), the closing line of *La vida nueva* (the last book of his trilogy) was inscribed with a bulldozer into the arid ground of the Atacama desert (Figure 2.3). Made of letters 250 meters high, this three-kilometer-long "geoglyph" is clearly discernible only if read from a distance above. Reminiscent of Robert Smithson's earthworks, which Owens discusses as allegorical ruins of the metaphysical aesthetic tradition (Owens 1980, 67; 1979, 130), Zurita's work turns landscape into a medium for poetic intervention, placing the aesthetic refashioning of nature into tension with the material resistance from "the land." *Ni pena ni miedo* deploys a surprisingly stylized calligraphy for a work of this genre, emphasizing its man-made, artificial nature. Likewise, the choice of the desert as

FIGURE 2.3. Raúl Zurita, *Ni pena ni miedo,* 1993. Photo by Guy Wenborne. Courtesy of Raúl Zurita.

material support for written verse seems to challenge the constant erasure of traces in this particular landscape, which is characterized by the mobility and enormity of its sand dunes.

In contrast to Patricio Guzmán's reflections in his documentary film *Nostalgia de la luz* (Nostalgia for the Light) (2010) on the difficulty of locating the traces of the past—more specifically, the remains of those forcibly disappeared during the dictatorship—in the vastness of this desert, Zurita seeks to produce a mark or an inscription that would effectively resist its own erasure. According to Richard, the work also aims to transcend the conflicting temporalities of past and future by collapsing them together: "The two time frames that the phrase conjoins speak about a past one need not lament and a future one need not fear" (Richard 2004, 36). She suggests that the reconciliation of these temporalities, adopting a position far removed from avant-garde aesthetics (where they are characterized by unbridgeable conflict) produces false homogeneity and consensus in the present: "past

and future finally have been harmonized here by the *mediation* of a conciliatory present that tranquilizes and reconciles, that ponders and controls, those excesses of a historic temporality that the avant-garde will to rupture sought to disrupt" (36, emphasis in original). Yet Zurita claims a different posture, whereby words, in poetry, "return" to what Jean Paul Sartre called a savage, undomesticated condition ([1948] 2008, 19). For Zurita, this allows the poetic word

> to evoke better the complexity of time than that which is possible through words domesticated by the necessity of communication. That dance of words in the poem collects more deeply these movements of time, whose simile is not a vector traveling from the past to the future, but is much closer to the indescribable simultaneous movement of waves in the sea [...] and imitates more profoundly the abstract sense of memory [...]. In language, all things happen simultaneously. There is no history that is not a contemporary history. (Zurita and Santini 2011, 261)

In light of this understanding of history as temporal simultaneity, one could argue that Zurita's *Ni pena ni miedo* affirms the now-time, where, as Benjamin suggests, "thinking suddenly stops in a configuration pregnant with tensions [and] it gives that configuration a shock, by which it crystallizes into a monad" (Benjamin 1999, 254). A double negation, lacking a subject or a defined action, the phrase does not harmonize the tensions between past and future but refigures them in an ever-changing present. To read the work as aiming for consensus, as Richard does, is to project onto it the questionable assumptions that withdrawal from fear necessarily involves reconciliation, and that reconciliation necessarily involves forgetting. Moreover, this interpretation fails to account for how, as discussed earlier in relation to his *Canto*, Zurita's poetry participates in a search for forms of reconciliation that do not entail consensual forgetting but which, by contrast, are enabled by conflicted memories and contingent subjectivities. Richard claims that the present in Zurita's work is "the quieted (calmed, satisfied) present of the institutional consecration of the 'great work' and not the rest-less present of the avant-garde" (Richard 2004, 36–37). Yet despite its monumentality, Zurita's verse suspends rather than dictates action, resisting the totalizing impulses that have so tirelessly corroded previous avant-garde experiences. Firm and monumental as his verses appear, they are still being slowly erased by the incessant movement of sand dunes.

(UN)GODLY FRAGMENTS

A close analysis of Zurita's aesthetic strategies to appropriate and reenact the tradition of biblical and poetic lamentation casts light on the ways that, rather than returning to religion or crafting an individual cult, Zurita's performative poetics search for possibilities to bring together cries of *protest* and *pain*. The writer's

poetico-political interventions need to be situated in a contemporary context in which these two forms of acting as a subject and being acted upon have been fundamentally separated, in the process of demarcating the political expression of disagreement from the private terrain of feeling. Zurita's biblical metaphors furthermore confront the individual with ideas of totality, and they unveil their doubly seductive and oppressive effects. This extends to the total or totalizing nature of language as the substrate of culture. The poet's interest in the *idea* of God is indeed determined by his incessant analysis of language. He describes "Dios" (God) as nothing but "a combination of four letters (in Spanish, three in English) which, when removed from language, de-structures everything."[30] When asked about his own belief, he replies: "I [. . .] don't believe in God; if he came to exist, what hope could remain? None [. . .]. But, despite everything, God is omnipresent. God exists because he exists in language. This word 'God' is extremely powerful because it has no other existence than in language. God does not exist in silence" (Zurita and Santini 2011, 259).

In these lines Zurita construes "God" as a signifier within a signifying chain—the signifier of an omnipresent signified, therefore of no particular signifier at all. This signifier's enigmatic character does not result from being "mere illusion" or from humanity's blindness or unwillingness to see. Rather, as a signifier without a signified, it occupies a structural position, in the form of a Lacanian "master-signifier," simultaneously empty and universal, able to supplement floating signifiers, while being unable to occupy a position of transparent equivalence in the chain. In this sense, God as master-signifier becomes, in Žižek's words, "the primordial encounter with the opacity of the Other" (2003, 72).

In Zurita's poetry, the naming of the sacred coexists with a critical politics. Just as in the case of Eltit's writing and video-performances, this mechanism occurs via a performative process leading to the fragmentation, doubling, and confusion of the subject in a state of relation with the Other. The sort of religiosity present in Zurita's work dialogues closely with the conservative, Catholic morality that Pinochet's regime was trying to impose on Chilean society. Yet Zurita turns this religious voice into a prayer or a song for the victims of the dictatorship, thus reappropriating the sacred as a space for protest, critique, and (political) denunciation. His writings do not enact a "return" to religion or aim at a complete sublation of the political into the ethical. Instead, they search for the (immediate) doubling and reversal of prayer into its presumed opposite: the questioning of authority.[31] Richard explains the fascination that Zurita's work inspired in Chile precisely on the basis of this complex "register of sanctity [. . .] in times in which the real seems to [have been] subject to prohibition" (Richard 2007, 84). She adds that the artist's sacrificial subjectivity is also a reference to the marginalized, those living on the fringes of society, the wounds of the social body, and the invisible residues of the process of modernization.

Zurita therefore grounds the notion of sacrality in a history of political vio-lence and social exclusion in the name of modernity. The fragmentary bodies that he evokes in *Canto*, whose posthumous voices are simultaneously singular and plural, stand as remnants of a failed absolute. But they also affirm the possibility of life, love, and community after catastrophe. By distancing itself from the "idea that militant realism is the only possible language for political art" (Valdés 2006, 592), Zurita's writing reaffirms the critical potentiality of dissensus once the organic character of history has been demystified. The poet's allegorical writing not only seeks to deconstruct the correspondence between signifiers and signifieds (by breaking apart the sound, meaning, and materiality of words), but it also aims to go beyond deconstruction and its accompanying sense of disenchantment and nostalgia. This "beyond" lies in the poet's commitment to render what Butler calls the "precariousness of life" as a kind of sound: "the sound of language evacuating its sense, the sonorous substratum of vocalization that precedes and limits the delivery of any semantic sense" (Butler 2004, 134). In this rendering, as Das sug-gests, pain does not stand as an "inexpressible something" marking an exit from the subject's existence in language (Das 1997, 70). Painful, lamenting words, which emerge from mutable and splintered subjects, "make a claim asking for [public] acknowledgement" (70). As such, they assert the social significance of expressed suffering, while positing the body's susceptibility to injury as a nondiscursive grounding for ethics. A similar exploration of corporeality as the basis of a renewed relationship between art and politics in 1980s Latin America is present in León Ferrari's approach to collage in the aftermath of the last Argentine dictatorship. To this self-proclaimed heretic, whom Tununa Mercado nevertheless considered "a humanist mystic [. . .] who denounces that there is no good God, nor good Christ, an ethical mystic, whose ministry is to unmask the tall tales of faith" (1994, n.p.), I devote the next chapter.

3 · TOUCH, ETHICS, AND HISTORY

> One quickly understands that […] every aesthetic choice invokes an ethical rule (and I do not mean a morality).
>
> —Georges Didi-Huberman, *The Site, Despite Everything*

WAITING FOR ARIEL

In *Psychostrategies of Avant-Garde Art,* Donald Kuspit describes avant-garde collage as tantamount to a "flayed skin, which exists in tatters" (2000, 137). From Kuspit's perspective, collage is "an attempt to stitch the tatters together into a new makeshift patchwork skin." Yet the "unstable, utterly erratic, haphazard character" of this practice also "makes it clear that they [the tatters] do not and cannot hold together" (137). Kuspit claims that this suturing or reparative operation cannot take place because avant-gardism not only results from experiencing modernity as catastrophe but also, inadvertently, perpetuates modernity's destructive or catastrophic impulses (138). In collage the body of the image and the body as image are discontinuous and fragmented (Groys 2008, 70). Such fragmentation imbues this medium with an allegorical impulse dating back to the early montage strategies of George Grosz and John Heartfield (Buchloh 1982, 43). Yet as I suggest in chapter 2, the ruinous, fragmented, and allegorical artwork in 1980s Latin America developed in a context in which modernity itself had started to crumble, and where the evocation and embodiment of broken, vulnerable bodies recalled those loved ones who had gone missing—disappeared—with the rise of dictatorial regimes. In this chapter I continue the discussion of allegorical and performative practices in which (as in Zurita's art and poetry) the body, as a surface upon which narratives of power are inscribed, speaks back through the hardened textures of its scars and the anonymous—even posthumous—resonances of its expressions of pain. I do this by focusing on Argentine artist León Ferrari's practice of collage from the 1980s onward: a visual practice that presents a complex intersection between the bidimensional picture plane and the participative and relational elements of embodied performance. Ferrari's collages during these years reveal the

artist's concern with not only the ideological content of his pieces but also their material textures and affective reception by an embodied spectator. The colleges refer primarily to Argentina's history of authoritarianism in the last quarter of the twentieth century and the role of the body in this history. Yet these works also bear the textures of texts written upon them in Braille, motivating the spectator to be touched by them as much as to directly touch or caress them. By prompting in the spectator a sentient reflection on the political and ethical possibilities of the act of touching, the collages revisit the history of political collage in Argentina. Moreover, they expose Ferrari's perspective on the role of the sense of touch in communicating (or failing to communicate) the suffering of self and Other.

Kuspit's reflections on the dermic qualities of avant-garde collage are therefore a germane point of departure to dwell on Ferrari's return to the practice of collage in the aftermath of Argentina's last military dictatorship (1976–1983). Having fled Argentina with his family in 1976 and established himself in Brazil, the artist began making periodic returns to his native country in the mid-1980s and also resumed his practice of collage. Despite Ferrari's willingness to adapt quickly to the new country, during his time in São Paulo he also experienced a feeling of displacement and a radical sense of loss. In the months following the 1976 coup, the artist had already perceived the rapid dismantling of the aesthetico-political project in which he had placed his hopes of social transformation: a project committed to the denunciation of social injustice, neo-colonialism, and structural violence, and one that embraced the idea of a coming social, and possibly communist, revolution. Between May and October 1976, while still living in Buenos Aires, the artist generated an archive of almost 400 newspaper cuttings documenting the recurrent "disappearances," the proliferation of *habeas corpus* petitions, and the discovery of bullet-riddled bodies all over the country. Ferrari's archive of disappearances was organized with the systematicity and sobriety of a bureaucratic file, and he called it *Nosotros no sabíamos* (We Did Not Know), suggesting with these words that these incidents were neither isolated nor hidden from the public eye, as some claimed. This piece shows how, in the months preceding his exile, the artist began sensing a society weakened by fear and generalized violence, one worryingly predisposed to turn a blind eye on state crimes.

Ferrari life in exile was also haunted by feelings of disquiet because his son Ariel had decided to remain in Argentina, and in February 1977 communication with him had suddenly stopped. During the two years that followed, lacking any knowledge of Ariel's whereabouts, Ferrari abandoned all figurative art. His creative practice shifted toward the sheer act of drawing minute lines, lines that seemed merely to register the passage of time, or rather shakily to scratch the paper to break free from it (Giunta 2009, 10). The artist eventually received the news of his son's death at the hands of the military and the ensuing disappearance of his body. His shock and sorrow came to be expressed through drawings of deformed, twisted, and dismembered signs, signs that only timidly related to one another and refused

to belong to a language or to surrender their difference. These turbulent drawings ended up constituting entire series of works, such as *Códigos* (1979), which Giunta (2011, 192) describes as an attempt to deconstruct language, and *Escrituras* (1979), in which sign languages are rendered in the light of their ambiguity and incompleteness. An evocation of the difficulties to express or represent grief likely motivated these series.

Despite the artist's inevitable immersion in the work of mourning, in the early 1980s he joined Brazil's experimental art scene, collaborating with numerous local artists who were not only enduring this country's own version of bureaucratic authoritarianism, but were also going through a period of intense formal and technical innovation (Shtromberg 2016, 5). Through his dialogue and collaboration with Regina Silveira, Julio Plaza, Carmela Gross, Alex Fleming, Marcelo Nietsche, Hudinilson Júnior, and Paulo Bruscky, among others, Ferrari began exploring a multiplicity of new media, including xerography, mail art, heliography, and performance. His large-scale *Heliografías* (c.1981–1987) were formally innovative and ludic sketches of the absurdities of urban life. Conceived of as impossible architectures and urban plans, they exacerbated spatial strategies of ordering and compartmentalization to the point of saturation and insanity. The artist developed these works using standardized *Letraset* to lay out urban environments, and large-scale xerography (100 × 100 cm) to reproduce them at low-cost; he then sent them, folded, to friends and other artists, as mail art postings. According to artist Roberto Jacoby, in Ferrari's *Heliografías* "the standardization of life could be seen in a brutal manner, due to the insistent, indiscriminate use of *Letraset,* an industrial system of figuration" (Jacoby 1987, 72). Crucially, adds Jacoby, Ferrari's dystopian urbanism resulted in situations that were not only tragic but also, at times, jocular. For Brazilian art critic Aracy Amaral, these works show, above all else, how *um artista inquieto* (a restless artist) is the one able to appropriate the technologies of his or her time (1980, n.p.). This same awareness of the technologies and problems of the present took the artist in a different direction on his return to Argentina in the 1980s. At this time, he saw himself moving, on the one hand, from a reflection on urbanism and the spaces of modernity to a reflection on the political uses of religion and personal suffering, and on the other, from an investigation of technology to an investigation of embodiment. Both of these shifts are visible in the artist's late collages.

In her discussion on Ferrari's return to collage in the 1980s—a practice that had been purportedly surpassed by the rise of conceptualism and the alleged "dematerialization of art" in the previous decade—Giunta argues that "this was a resistant return, in which rescuing the image involved, above all else, the protection and restauration of meaning" (2008b, 62). In other words, Giunta suggests that, as Ferrari's returned to "the languages of the sixties," he did not leave them "untouched" (62). My discussion of Ferrari's late collages will center precisely on a renewed relationship between collage and tactility. This involves various forms

FIGURE 3.1. León Ferrari, *Cuadro escrito*, December 17, 1964. India ink on paper. Eduardo F. Costantini Collection, Buenos Aires. Courtesy of Fundación Augusto y León Ferrari Archivo y Acervo (FALFAA) in partnership with Centro de Estudios Legales y Sociales (CELS).

of contact both between (cut-out) images and between the embodied spectator and the image.

To develop this argument I will first reflect on Argentina's last military regime as an intervention in the human sensorium, which had palpable effects on the distribution of the visible and the invisible, the said and the silenced, and the touchable and the untouchable. Then I will make a brief historical revision of 1960s collage and assemblage in this country, focusing on the importance of the work of Antonio Berni and on Ferrari's early approach to this medium. These introductory sections will be followed by an in-depth analysis of Ferrari's series of collages entitled *Brailles*, in which the artist uses the written language for the blind both to texturize his (appropriated) images and to resignify the relationship between the practice of collage and the production of political messages. In that section I take my cue from the biblical prohibition not to touch the body of the resurrected Christ (*mē mou haptou* in Greek; *noli me tangere* in Latin) and Jean-Luc Nancy's linking of this prohibition to a given view of history and ethics. In a third and final section I link these ideas to Ferrari's illustrated version of the human rights report *Nunca más*, which also constitutes a long series of collages. In this series the artist represents the last Argentine dictatorship as belonging to a long history of punishment in the name of order and civilization—including, among other experiences, the Holocaust and the Vietnam War. The artist highlights the numbing violence of this history, yet he challenges those that deem it to be unrepresentable and instead posits that the history of representation has precisely been marked by attempts to aestheticize such extreme experiences of suffering. In his efforts to thematize suffering and loss, Ferrari therefore explores the critical and ethical possibilities of an art inviting the spectator to engage corporeally with the image and its materiality.

A POLITICAL MEDIUM?

Approaching Ferrari's collages from the perspective of an understanding of collage as a chiefly political artistic medium would lead us to believe that the artist's return to collage in the 1980s reinstates aesthetic strategies that prevailed in the production of political art during the 1960s. During this decade, this medium became the bearer of *messages* to be understood by the anonymous gaze of the masses, preferably outside traditional art venues—namely, in "the street" (Longoni and Mestman 2000, 258). I suggest that, while close in form and technique to John Heartfield's iconic anti-fascist collages, in which the juxtaposition and fusion of images serve to convey a "clear and direct" message for the masses (a position that contrasts with the "nonsensical juxtaposition" of images in Dadaist and Surrealist collage) (Ades 1976, 43–44; Foster et al. 2011, 176)—and despite bearing certain resemblances to his own denunciative works of the 1960s—Ferrari's late approach to collage does not search to *reveal* a message or an idea as much as to

make the (participant) spectator *feel*, touch, and question the nature of the image before his or her eyes and body. The making of these collages and their display involves an interpellation not primarily to the spectator's intellect, but to his or her senses. As I show in the following sections, this foregrounding of the sensuous, particularly of haptic experience responds to the artist's reflections on the question of the (un)representability of historical trauma. Daniel Link writes that in each of Ferrari's late collages one can sense the words "I don't understand anything" (*no entiendo nada*), "there is nothing to be understood" (*hay nada que entender*), or "nothingness is to be understood" (*hay que entender la nada*), phrases that come from one of his earliest written drawings, *Cuadro escrito* (Written Painting) (1964) (Figure 3.1).[1] These variations on the idea of nothingness, says Link, lie behind each of Ferrari's images, "but not like a god revealing his word through the image, or a voice that dictates shapes and shades, but like a gentle hand that may touch us, or not" (Link 2012, 19). Moreover, Link suggests that the image that touches and invites touch "can no longer be understood as either form or representation," but must be seen "as force, as immemorial survival (*pathos*), as a form of life (not as cadaver or mummy, ashes or dust); [for] it becomes a pure area of contact" (2012, 18).

Conceived of as contact areas, Ferrari's late collages bridge the gap produced by the distancing and reifying power of the gaze, which Jacques Lacan understood as a function of the desire of the seeing subject, that is to say, a way of seeing that leaves the seeing subject unaffected (Lacan 1981, 84). In these works, the artist invited the viewer to touch the works and be touched by them, privileging the haptic experience over the communication of a visual message. To the spectator's gaze, Ferrari returned encrypted messages, messages that remained open to be deciphered by perceptive bodies and "blinded eyes." In this rendering of collage into an aesthetics of caressing encounters, rejecting the institutional character of the museum or the art gallery—as previous avant-garde and political artists had done—became secondary to the capacity of these spaces to foster a renewed form of relationality between the viewer and the work, in an atmosphere of relative intimacy. Ferrari's exploration of the critical potentiality of collage in the aftermath of Argentina's most recent historical catastrophe thus tested the possibilities and limits of an "ethics of blindness."[2]

A TORTURED ERA

The political landscape of mid-1980s Argentina—the period in which, as I mention at the start of this chapter, the artist began settling down back in Buenos Aires, first doing periodic trips until he moved his house and workshop there in 1991—differed from the agitated 1960s in many ways: the Vietnam War, which prompted Ferrari to become politically involved, had ended; Juan Domingo Perón, the legendary populist leader who shaped political life in Argentina during most

of the twentieth century, had died, and a great part of Perón's left-wing following (the *Montoneros*) had either been murdered as a result of political repression or gone into exile. The Argentine, Brazilian, and Uruguayan military dictatorships had all come to an end, and even the Cold War was reaching its ideological and structural limits, as communist regimes in the East were losing political control and credibility, while countries like Chile, Argentina, and Mexico were experiencing international pressure to open their economies and liberalize their political regimes.

During the 1970s, Argentina had gone through one of the bloodiest periods of its history, one that not only transformed the country's political and economic structures, but also shredded its social fabric. The military junta that took power on March 24, 1976 vowed to institute what they described as a major "Process of National Reorganization." This was a total sociopolitical project that the generals understood as a strategy to salvage from communist subversion not only Argentina itself, but also "Western, Christian civilization" (Feitlowitz 2011, 7). According to Marguerite Feitlowitz, the Argentine military saw the country as "the theatre for 'World War III,' which had to be fought against those whose activities—and thoughts—were deemed 'subversive' [...]. The junta was particularly obsessed with the hidden enemy. Suspects were 'disappeared' in order to be exposed (and then annihilated) within a network of some 340 secret torture centers and concentration camps [...]. 'For torture to be effective, they'd tell us, it had to be limitless' [so testified one of the victims]" (7–8).

In view of the military's brutal and systematic practice of torture, along with the regime's control of everyday sociability through fear, Ferrari situated the dictatorship's most profound effects not in the realm of ideas but in the realm *aisthesis* or sense perception.[3] This aesthetic understanding of dictatorship was crucial in leading the artist to question the exceptional character of this historical moment, relating it, instead, to the broader unfolding of Western modernity—conceived as a civilizing process equally concerned with disciplining the mind, the body, and the senses. For Ferrari, the most overt expression of the regime's resolve to control sentient experience was the use of sophisticated and often medicalized technologies to inflict (physical and psychological) pain, which he refers to as "the thousand forms of torture inflicted upon combatants and non-combatants, adults or children, the rape of abducted girls" (Ferrari [1995] 2005f, 144). This political intervention in the terrain of sense perception attempted to set boundaries between the sayable and the unsayable, the visible and the invisible, the representable and the unrepresentable, the aural and its other. Diana Taylor describes the military regime's troubling involvement in what Rancière calls the distribution of "the fabric of sensory experience" (Rancière 2013a, 140) as unfolding through widespread "censorship, blacklisting, and the systematic implementation of terror," particularly against artists (Taylor 1997, 11).[4] As Taylor observes, "Writers, producers, filmmakers, actors, technicians had been threatened and at times killed

by military forces [...]. Prohibitions (euphemistically called "guidelines") against unacceptable content came down from above. Cultural content would harmonize with the *proceso*'s mission—there should be no contradictory or disturbing images, nothing against church, family, or state" (11).

Despite its totalizing aspirations, the dictatorship did not succeed in fully imposing a new sensibility on the Argentine population. To begin with, the three branches of the military (represented in the Junta from 1976 to 1978 by Jorge Rafael Videla [commander in chief of the army], Emilio Eduardo Massera [navy], and Orlando Ramón Agosti [air force]) did not actually agree on the cultural project that they were willing to impose.[5] This gave rise to various contradictions in their policies, disagreements among them, and a general lack of a sense of direction, leading to forms of extreme repression in some cases and the survival of spaces of relative freedom in others. Moreover, the population developed strategies of overt and clandestine resistance to the regime: from the organization of underground study groups, jointly known as the "university of catacombs,"[6] to the performative denunciation of human rights violations (for instance, by way of circling the Plaza de Mayo, which the organization Mothers of Plaza de Mayo started doing in 1977).

However, the consequences of the regime's ambition to discipline the senses proved to be far-reaching. Hugo Vezzetti describes the dictatorship as a "traumatic rupture [...] which subjected society to a violence without limits and hitherto unknown" (Vezzetti 2002, 38). While I will continue to analyze the breath of this violence in the rest of this chapter, I wish to return to the discussion on collage in order to suggest that this historical rupture also posed a real challenge to those artists and writers willing to imagine new, politically effective aesthetic strategies in the aftermath of the dictatorship. In the following pages, I therefore interrogate the political and ethical effects of the performative reactivation of collage in the 1980s and 1990s, by way of the direct encounter of the body of the spectator with the collage's bidimensional plane. Could an arguably traditional artistic medium truly intervene in the politically disillusioned space of post-dictatorship Argentina, given the military regime's profoundly disruptive effects on time, space, language, and sense perception? Could an aesthetics of fragmentation be employed to rethink the possibilities and limits of political art? How would those strategies of juxtaposition and distancing characteristic of political collage in the 1960s fare in relation to new—embodied and performative—ways of reflecting on physical proximity, intimacy, and haptic contact?

A GLIMPSE INTO 1960S COLLAGE

In 1960s Argentina, collage developed, primarily through the work of Antonio Berni, as a means to render visible the often-concealed underside of an industrial and socially engineered world. In Berni's art, the found object took the form of a

leftover, a residue, an excess of the process of modernization. Featuring two fictional characters (Juanito Laguna, a young boy living in a *villa* [shanty town], and Ramona Montiel, an impoverished prostitute), Berni's collages and assemblages of these years "strike out," as Laura Podalsky suggests, "against modernization's promise of a better future" (Podalsky 2004, 111). Berni imagined and portrayed Juanito and his family as coming from the province of Santiago del Estero, but having settled on the outskirts of Buenos Aires. The place was eventually specified as "el Bajo Flores," an archetypally poor and violent shanty town, where precarious housing and open refuse dumps provided the background for Berni's depiction of Juanito's daily life—as he goes to school, plays the flute, bathes among tin cans, witnesses the flooding of his neighborhood, brings food to his father (a metallurgical worker), and even receives a salute from a "cosmonaut." For Amigo, the child's life may be seen as both the reflection of an imaginary of a working-class childhood, the struggles of which will lead the youth to become an agent of social change—imaginary shared by communists and Peronists alike—and from a less optimistic perspective, as "an inventory of Latin American social ills" (Amigo 2010, 50).

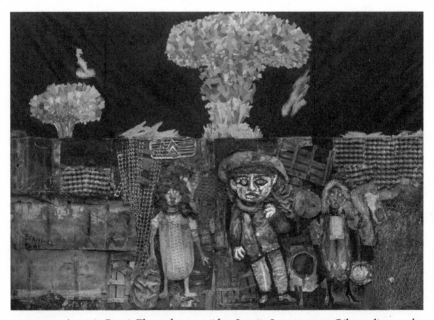

FIGURE 3.2. Antonio Berni, *El mundo prometido a Juanito Laguna,* 1962. Oil, acrylic, wood, and metals, including chicken wire, sheet metal, and trophy medals; canboard, egg cartons, and fabrics, including burlap, vegetal tow, and lace; wires, nails, and staples on wood, 280 × 400 cm. Cancillería de la República Argentina, Buenos Aires. On view at Malba—Fundación Costantini, Buenos Aires. Courtesy of Luis Emilio de Rosa and Inés Berni.

A telling example from among Berni's multifarious explorations of these themes is his work *El mundo prometido a Juanito Laguna* (The World Promised to Juanito Laguna). In this assemblage from 1962, sharply divided into an upper and lower section (corresponding to a close, walled foreground and a distant background), Berni reconstructs the precarious conditions of life in a shantytown, where two female figures look out from their cardboard houses, as Juanito passes by, carrying his scavenger's bag. The artist reproduces this impoverished milieu by pasting cans, colored paper, pieces of burlap, and other scrap materials, such as wooden fruit boxes and egg cartons, onto the work, equally using them as building blocks of the houses and parts of bodies. A notably pale Juanito gazes out of the frame, his desolate eyes lacking any sense of direction. Emerging behind this scene, two brightly colored and polychromatic mushroom clouds, equally evocative of a fireworks display and a nuclear explosion, radiate in the horizon (Figure 3.2). Read alongside the work's title, the divided composition stresses Juanito's condition of oblivion and invisibility, concealed as he is by the leftovers of a promised, yet failing, modernity.

Like other works from this period, *El mundo prometido* goes "beyond a general lament about urban poverty" (Podalsky 2004, 111). It situates Buenos Aires as "a landscape divided between the realities of poverty and the promise of riches" (111). The split canvas therefore reflects a larger class rift, coinciding with Berni's reading of capitalist modernity through the lens of dialectical materialism. A communist since the late 1920s, the artist remained loyal to this worldview throughout his life, even while becoming increasingly aware of its limitations and contradictions. The latter were particularly visible to him in relation to the possibility of articulating a program for revolutionary transformation in Argentina. He expressed them through his very choice of collage as medium in the 1960s, instead of primarily relying on the totalizing powers of painting, as he had done in the preceding decades. As Giunta suggests, during these years "Berni constructed from the fragment, not to reconstruct a mass of people united in the hope of change through joint struggle but to show the contradictions that would lead the discourse of promises to an ultimate explosion" (Giunta 2008c, 159–160).

During the 1960s Ferrari was influenced by both Berni and Surrealism as he employed collage and assemblage as means of articulating a critique of past and present forms of colonial subjection and imperial warfare. His 1965 piece, *La civilización occidental y cristiana* (Western, Christian Civilization) (1965), fuses a six-feet-high scale copy of an FH107 plane, like the ones used by the American army to bomb Vietnam, with a *santería* Christ (Figure 3.3).[7] The open arms of the crucified body lie on the missile-loaded aircraft's wings, while Christ's feet are nailed to the lower part of the front fuselage. Hung in a vertical position, as if in a nose dive, the piece suggests the imminent fall of the bombs and, with them, the rapid downfall of Western, Christian civilization. Ferrari described *La civilización* as an artwork made to oppose the fierce war on the Eastern country. Yet the work is

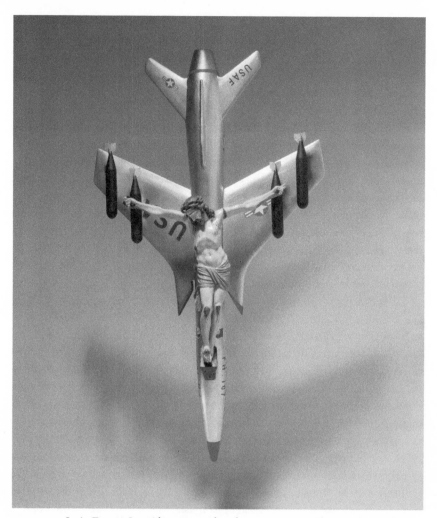

FIGURE 3.3. León Ferrari, *La civilización occidental y cristiana*, 1965. Plastic, oil, and plaster of Paris. Courtesy of FALFAA-CELS.

more largely evocative of colonial violence—in particular, violence waged in the name of a religiously imbued idea of civilization. This crucifix-shaped assemblage thus brings together a reflection on the destruction brought about by mechanized modernity, symbolized by the American bomber, and the religious dimension of colonial power.

In 1965 Ferrari sent his "image-manifesto," as Giunta calls it, to an art contest organized by the foremost modernist art critic in Argentina and head of the Visual Arts Centre at the Di Tella Institute, Jorge Romero Brest (Giunta 2008c, 277). The critic did not expect Ferrari to present such a polemical work, as this approach to art making was unprecedented in his career. Faced with the decision of whether

or not to exhibit *La civilización*, Brest decided to censor the piece on the grounds that it would offend the religious sensibilities of the institute's personnel.[8] In response to this act of censorship (and the later accusation by art critic Ernesto Ramallo that the works were mere "political libels"), in October of the same year Ferrari released one of his earliest and most important public statements in the magazine *Propósitos* (Ferrari [1965] 2005d, 13). Here he outlines his understanding of the politics of aesthetics, pouring scorn on attempts to censor critical art, particularly on the basis of its alleged difference from "true" or autonomous art, as Ramallo had done. For Ferrari, aesthetic judgment should be independent of the artwork's perceived ends; yet he also states that it is most important for an artist to avoid becoming "a manufacturer of ornaments for generals" (14). Responding to the censorship of his piece at the Di Tella contest, Ferrari adds that his art does not oppose religion but rather the political uses of it. In the context of Cold War polarization and paranoia, Ferrari was all too aware of the possibility of being blacklisted, so in his statement he also clarifies that he was neither a communist nor an anti-communist. His opposition to the war in Vietnam and to the use of force by the United States more generally was, he says, shared with Pope Paul VI (among others), who condemned the bombing of Hiroshima and Nagasaki: "My opinion [...] coincides with Paul VI's view on Truman's government when twenty years ago it threw the first atomic bomb; that is, I think Johnson and his generals are the felons of civilization, butchers of human lives" (Ferrari 2005d, 15).

For a period characteristically absorbed by the idea of a communist revolution, committed to the struggle against imperialism, and often defined by the increased militancy of artists and intellectuals, Ferrari's statement is noticeably accepting of ideas coming from the church and from Anglo-Saxon intellectuals. The artist's distance from communism and Peronism is also striking. Yet both through its contents and through its omissions, the artist's positioning reveals the political agitation of the time. Indeed, Brest's attempt to censor Ferrari's work and the artist's response are indicative of a moment of inflexion in the politicization of Argentine artists. In the years that followed, artists became increasingly involved in political militancy; a large group of them rejected the cosmopolitan version of avant-gardism sponsored by the Di Tella Institute in favor of a commitment to Third World solidarity and liberation from colonialism.

Further engaged in this process of artistic politicization, in 1968 Ferrari wrote an article entitled "El arte de los significados" (The Art of Meanings), in which he explains his "politics of montage" as being oriented toward achieving the greatest possible efficacy in the transmission of new "meanings"—meanings emerging from the critique and reorganization of existing preconceptions (Ferrari [1968] 2005b, 21). The artist also highlights art's powers of persuasion and clarity, and its capacity for making denunciatory statements, to the point of becoming "a source of transmission of scandal and perturbation" (26–27). Moreover, he provocatively claims that "art will be neither beauty nor novelty, art will be efficacy and perturbation.

The successful work of art will be the one which, within the artist's milieu, has an impact similar to a terrorist attack in a country struggling for its liberation" (27).

An emblematic work of Ferrari's "art of meanings," which has been described as situated "within the very essence of the sixties" (Giunta 2006, 346), is Ferrari's 1967 literary collage entitled *Palabras ajenas: Conversaciones de Dios con algunos hombres y de algunos hombres con algunos hombres y con Dios* (translated either as *Alien Words, Listen, Here, Now!* or, *The Words of Others*). Conceived both as a printed book and a theatrical performance, *Palabras ajenas* is entirely made up of juxtaposed quotations from 160 sources, including biblical texts, news agencies, and historical figures such as Pope Paul VI, John F. Kennedy, Lyndon Johnson, Hitler, Goebbels, several German cardinals of the Nazi period, and US generals active during the Vietnam War. Ferrari structured these quotations as a conversation with God, whose word was mainly sourced from Exodus. In the prologue, the artist explains that the work was intended to be both read (as a literary piece) and performed according to a series of guidelines that challenge dramatic conventions: "This play—wrote Ferrari—will be interpreted without any action. Without any play with lighting, without reflectors, microphones, amplifiers, curtains, etc. The spectacle will have no beginning nor ending: it will already have begun when the first spectator enters the theatre, and it will only end when the last spectator has gone" (Ferrari [1967] 2008a, 8).[9] These stage directions seek to produce a seemingly unending flow of discourse through the accumulation and juxtaposition of quotations. They also aim to generate a feeling of everlasting unity and continuity in the history of the West, where the twentieth century differs all too little from biblical times and contemporary leaders continue the immemorial practice of conducting violent wars in the name of righteousness. Since the arguments justifying warfare seem selfsame between past and present, the conversations among Johnson, Hitler, the Pope, the mass media, and the prophets develop as a flow of consensual views. In certain parts of the text, this dialogue is interrupted by descriptions of military offensives, rendering Vietnam as the continuation of a fascist saga going back to Auschwitz and before. On December 11, 1940, Hitler declares: "I always found it deplorable that peoples who could coexist peacefully had to resort to arms rather than reasonably conciliate their interests [. . .]." The Buenos Aires newspaper *La Razón* answers: "North Vietnam has been attacked." The dialogue that follows is a description of Johnson's lifeless gaze, as he announces, in March 1966, that his country would resume the bombing of Vietnam after a thirty-seven-day truce. At this point, Pope Paul VI declares "Zopus Justitiae Pax" (Peace is the work of justice) (Ferrari 2008a, 88).

Reading the play might lead one to conclude that Ferrari was attempting to expose the double discourses of corrupt political and religious figures. Yet the artist's stage directions suggest something different; in them, Ferrari indicates that the actors should be seated in rows exactly opposite the house, and the director should establish "an equivalence between public and actors [. . .] creating a

geometrical symmetry which accompanies or produces a mutual observation" (Ferrari 2008a, 7). Staging this "symmetrical" relationship between actors and public was meant to contest performatively the vision of the ruthless, populist leader who manipulates otherwise nonviolent ordinary people into supporting wars. By producing a mirror effect between "leaders" and "people," the play describes the desire to wage fiercely destructive—yet allegedly just—wars as disseminated between both groups, that is to say, as present in everyday forms of identification: if the history of the West can be seen as a continuum, it is precisely because any member of the audience can embody and potentially become a Hitler or a Johnson, and even receive the support of certain church leaders in the process. Such are the artist's claims in this immensely original and polemical work.

When seen in the light of Ferrari's late practice of collage, the role of the spectator in the conception of this piece of avant-garde performance deserves our critical attention. This full-scale rebuke of what Ferrari describes as Western, Christian civilization, which situates the spectator as a mirror reflection of characters such as Hitler and Goebbels, provides little space for the public to establish a critical distance, not to say a dialogical relationship, with the rapid and seemingly unending flow of discourse. The spectator can either enter the house and compliantly witness the civilizing bloodbath, or leave. Correspondingly, the long list of quotations that constitutes the text construes a "friend versus enemy" vision of history, aligned with Ferrari's message-oriented and communicatively effective understanding of political art during the 1960s, yet less well suited for a more complex, post-dictatorship scenario. Moreover, despite this work's performative dimension, it remains largely inattentive to the actors' gestures and their affective powers, emphasizing solely the value of the actors' discursive interventions. This stress on *meaning* that was characteristic of Ferrari's early practice of collage saw important transformations in the years that followed his exile in Brazil and his gradual return to Buenos Aires, a time when he began to read the experience of dictatorship as not merely an ideological struggle but the result of a more complex and multifaceted sensuous biopolitics. We will now turn to how this vision shaped his renewed approach to collage.

NOLI ME TANGERE

In several exhibitions of Ferrari's collages since the 1990s, spectators have been allowed, and indeed motivated, to touch or rather caress some of his works, namely, the *Brailles* series. Given the artist's meticulous reading and rereading of the Bible over several decades, this invitation to establish a haptic relationship with works that in themselves reference religious themes brings to mind the role of tactility in the Christian creed and its relevance in the history of representation. One episode from the Gospel of John proves to be exceptionally telling for this discussion: the moment Mary Magdalene recognizes the resurrected body of

Christ, and he asks her not to touch him with the words *Noli me tangere* (do not touch me). According to Jean-Luc Nancy, the biblical words *Noli me tangere* call to mind "a prohibition of contact, a question of sensuality or violence, a recoil, a frightened or modest flight" (Nancy 2008, 12). The philosopher sees this scriptural scene as an exception—a theological hapax—in the credo, for in Christianity nothing else is truly untouchable (as "even the body of God is given to be eaten and drunk") (14). Yet Nancy suggests that in the original Greek phrase *Mē mou haptou* (cease holding on to me), the verb *haptein* (to touch) can also mean "to hold back, to stop" (15). In this sense, the parable links the corporeal with temporality and history: "Don't try to seize upon a meaning for this finite and finished life, don't try to touch or to hold back what essentially distances itself and, in distancing itself, touches you with its very distance [. . .]. This uprising or insurrection is a glory that devotes itself to disappointing you and to pushing your outstretched hand [. . .]. He who says 'Do not touch me' never ceases to depart, for his presence is that of a disappearance indefinitely renewed or prolonged" (Nancy 2008, 16).

The prohibition to touch Jesus's resurrected body therefore posits an approach to history from a distant, hygienic positioning sustained by faith, in which materiality comes second to representation and narrative. It privileges the symbolic value of absence over the search for unmediated presence. It situates sensuous perception in suspect terrain, while presenting the untouchable as a revealed rather than as a discovered truth or message. As such, it pledges an untouched, distant history resistant to meddling with the ruins and the remains. This vision of history is also, necessarily, a form of ethics that distances self and Other, the sacred and the profane.

In Levinas's meditations on the senses, one can identify a similar double link between touch and history and touch and ethics. Levinas ponders, simultaneously, on the caress, the Other, and the future (Levinas 1969, 257–258; 1989, 51). The philosopher, however, claims that a history that refuses "touch" not only negates the possibility of deciphering the past from the materiality of its ruins, but also negates the significance of the embodied, lived present in the construction of a yet uncertain, nongiven future. "The caress," writes Levinas, "seeks what is not yet, a 'less than nothing,' closed and dormant beyond the *future*" (1969, 258). This position, in turn, marks a divide between knowledge and sensation, matching the experience of the caress with not-knowing and, accordingly, as Derrida suggests, with a conception of "pure temporalization": "a pure future without content" (Derrida 2005, 79). Historian Martin Jay also comments on the temporal and ethical dimension of touch in Levinas's thought, arguing that in the latter the ethical relationship does not develop through the hearing of ethical commands, or the contemplation of the world of objects through the eyes. It develops *during* the exposure between self and Other (Jay 1994, 558). Jay also highlights the extent to which, for Levinas, "real ethical responsibility" comes from "an eminently non-visual

source," privileging in particular those nonvisual experiences that "reveal the vulnerability of the self to the world": "whereas visual relations with others foster instrumental manipulation [. . .] touch allows a more benign interaction" (557).

By temporalizing the relationship between self and Other, subject and object, touch displaces a deterministic or an essentialist approach to these categories, favoring instead their relational and phenomenal understanding. This form of relationality occurs in a situation of dual exposure, demanding the self's corporeal implication and a search for proximity. Touch, in this sense, favors intimacy over publicity, an engagement with the world, its objects and its memories, over aloofness and detachment. In her discussion of Levinas's ethics, Edith Wyschograd goes as far as to argue that "touch is not a sense at all [. . .]. It is a metaphor for the impingement of the world as a whole upon subjectivity." Moreover, she adds: "to touch is to comport oneself not in opposition to the given but in proximity with it" (Wyschograd 1980, 199).

Levinas's considerations on the tactile dimensions of ethics approach ethics to the terrain of aesthetics, which I understand here not as a reflection upon beauty but as a reflection upon sense perception. The ethics of touch have been discussed in opposition to an ethics of recognition (in the Hegelian sense) and representation, yet approaches such as Levinas's and Wyschograd's suggest that embracing touch as the basis of an ethico-aesthetic relationship is distinct from refusing representability *tout court*—along the lines of Jean-François Lyotard's notion of the "unrepresentable." This category is similarly based on a refusal of sight and the visible; yet in contrast to the Levinasian caress, it hinges on a sense of radical negativity, risking to result in a homogeneous and consensual vision of the ethical, rigidly limited by unqualified and insurmountable divisions between right and wrong, good and evil, and the representable and the unrepresentable (see Rancière 2013a, 201).

To return to my interest in contrasting Ferrari's early and late collages, it is important to note that Rancière diagnoses a shift in this direction, "from politics to ethics," in late modernity's artistic practices, particularly during the 1990s. Casting a negative light on this transformation, Rancière considers that the efficacy of this turn resides in "its capacity to recode and invert the forms of thought and attitudes which yesterday aimed at bringing about radical political and/or aesthetic change" (Rancière 2013a, 201). In relation to this somber diagnosis, Ferrari's return to collage during the same period has a twofold significance. While the artist effectively brought this medium to the domain of ethics (an ethics of proximity, in which one-to-one, haptic forms of exposure gain primacy over the communication of public, or political messages) after his return from Brazil to Buenos Aires, his late works were also able to channel what Rancière calls "the ethical turn" toward the construction of a politically critical—undisciplined, "touched" and dissensual—sense of history. That is, Ferrari's practice of collage was deeply influenced by Argentina's recent experience of dictatorship, and he

acknowledged the difficulty of accounting for the suffering that it unleashed. However, he did not deem this suffering unrepresentable; and his work resists being reduced to the "endless work of mourning," or to what Rancière would call "the ethical witnessing of unrepresentable catastrophe" (2013a, 200–201).

BRAILLES

> *Escribir sobre el cuerpo es como acariciar a la mujer y además no entenderla.*
> *Acariciar, pero no entender.*
> (Writing upon the body is like caressing the woman and not understanding her.
> Caressing, but not understanding.)
>
> —León Ferrari

In the mid-1990s Ferrari began two long series of collages entitled *Nunca más* (Never Again) (1995–1996) and *Brailles* (1994–c. 2004). Both series return to the work of well-known artists in the history of European art, from Giotto to Man Ray, that are brought into dialogue with two texts of utmost importance in present-day Argentina: on the one hand, the human rights report commonly known as the *Nunca más*, and on the other, the Bible. Yet at first sight the two series appear to be starkly different. While the former intervenes heavily in the images, cutting and juxtaposing distinctively dissimilar scenes, the latter employs a light, almost invisible, strategy, in which the written language for the blind, Braille, serves to transcribe biblical texts onto photocopies of paintings and photographs.[10] The first series is visibly political in its intentions, fusing pictures of the Argentine military junta that seized power in 1976 with, among other symbols of authoritarianism, photographs of Nazi generals and Catholic leaders. The second gestures toward the unconscious and the erotic, drawing, for example, on Man Ray's Surrealist nudes of the 1930s. The former seems to be the bearer of a clear message, easily apprehended by the spectator's gaze. The latter appears to be directed at a public willing to dwell on the uncertain territories of blindness. I contend, however, that both series are deeply interrelated and part of a continuum, wherein the artist became increasingly distanced from the meaning-oriented aesthetic strategies of the 1960s, as his art underwent what I conceive of as a performative turn.

My analysis begins with the later series, *Brailles*, for although it is less direct in its references to the dictatorship, this series is the one that most clearly situates touch as the hub of its creative propositions. Composed of dozens of works,[11] it was developed, as briefly mentioned earlier, by inscribing texts written in Braille on color photocopies of religious paintings, Surrealist photographs, shunga prints, and pictures of torture instruments. Ferrari's *Brailles* thus texturize flat and mechanical reproductions of paintings, engravings, and photographs using the raised-dot patterns of a tactile language. Each pattern is an abstract visual composition, a text, and a surface of touch, the semantic value of which depends on

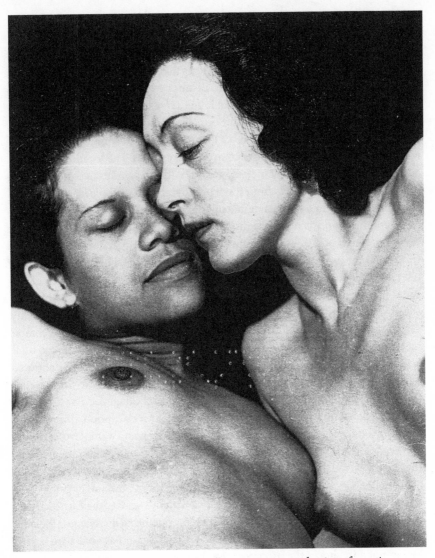

FIGURE 3.4. León Ferrari, *El amor*, 1997. Braille writing on reproduction of a section of a picture by Man Ray. 23 × 18 cm. Courtesy of FALFAA-CELS.

the spectator's sentient education. The series continues Ferrari's explorations of the materiality and gesturality of the written text, which were so heavily present in his early drawings, such as *Cuadro escrito* (1964)—a work Mari Carmen Ramírez describes as key in Latin American conceptualism for having reinstated subjectivity in a rationalist and propositional art movement (Ramírez 1999, 65). The texts encrypted in each *Braille*, in turn, originate from various sources, including the Bible, and the poetry of André Breton and Jorge Luis Borges. In this section,

I focus on those *Brailles* inscribed with biblical passages, for they allow me to suggest meaningful points of comparison with the second series, *Nunca más.*

The relationship between image and text in the *Braille* series is often ironic, if not caustic. The image never simply illustrates the text. In *El amor* (1997), Ferrari wrote in Braille the text "Dios es amor. El amor es Dios" (God is love. Love is God), partially taken from the Gospel of John (4:7–8),[12] into a depiction of homoerotic affection between the French Surrealist Nusch Éluard and Ady Fidelin, captured by May Ray in 1937 (Figure 3.4). The viewer who cannot read Braille may access the text by looking at the accompanying caption. The location and materiality of the inscribed text, however, are not without significance in relation to its meaning. Read separately from Ray's photography, the words from the gospel would likely refer to a spiritual understanding of love. They would evoke a feeling of communion arising from a disposition to love God and, according to some exegeses, to the possibility of finding God through the practice of compassion (Shuman 1999, 94). When superposed upon Ray's image, however, this biblical reference to love becomes imbued with connotations of physical contact and sensuous pleasure. Moreover, here the sacred words stand in contrast to institutionalized Christianity's historical persecution and stigmatization of homosexuality. The inscription of the biblical text on the torsos of the female bodies, accompanied by the proposition to touch the work, also invites the spectator to attend to his or her feelings toward homoerotic desire, and even to make a public endorsement of them at the moment of caressing, of failing to caress, the work. Before this picture, reading itself becomes a consciously embodied act. For those who cannot understand Braille and look away from the work's caption, this act privileges sensorial awareness over knowledge, and immediacy over interpretation.

Ferrari's *Brailles* make the spectators confront a series of predicaments: Must they publicly touch an "imagen de alto voltaje" (erotically electrifying image) (Lebenglik 1997, 29)? Is it appropriate to do this inside a museum or gallery? Is it moral to caress a photographic nude inscribed with the word of the Christian god? What operation is being performed as one attempts to bring oneself near the other and his or her desire? The answers to which the spectator has access are few, for Ferrari not only shocks the spectator with the juxtaposition of provocative images and texts, but he also situates them in a terrain of discursive and perceptive uncertainty. He invites the viewer, now tactile participant, to dwell on the possibility of not *grasping* answers from his art.

This returns us to the discussion on the Levinasian caress, which, as I mentioned previously, the philosopher describes as an act that approaches the other person without seeking to take possession of him or herself, and as a disposition to dwell on the unknown, as one awaits sensibly and expectantly for an uncertain future. This is "the opposite of the grasp, which takes possession of what it holds" (Jay 1994, 558): "The seeking of the caress constitutes its essence by the fact that the caress does not know what it seeks. This 'not knowing,' this fundamental

disorder, is the essential. It is like a game with something slipping away, a game absolutely without project or plan, not with what can become ours or us, but with something other, always other, always inaccessible, and always still to come (*à venir*)" (Levinas 1989, 51).

Ferrari intensifies that experience of disorientation—an uncertain *à venir*—by incorporating in the same series images that interrupt any possible continuity between haptic and visual pleasure. *Darle tormento y llanto* (So Much Torment and Sorrow Give Her) (1997) and *Espíritu inmundo* (Filthy Spirit) (2003) are two *Brailles* using as visual supports photographs of medieval torture instruments—a collar of iron thorns and a chair covered in sharp metal spikes, respectively (Figs. 3.5). In these works, the sourced images do not come from the tradition of Surrealist photography, like in the case of *El amor*; they were extracted from a bilingual guide to torture instruments from the Middle Ages. One can barely see the Braille dots in between the instruments' spikes. Yet on the ill-omened chair, Ferrari transcribed the command "Arrepiéntete" (Repent) (Mark 1:15), while on the collar the Braille inscription cites the punishing lines from the Apocalypse (18:7): "Dadle tormento y llanto" (So much torment and sorrow give her). These works

FIGURE 3.5. León Ferrari, *Dadle tormento y llanto*, 1997. Braille writing on reproduction of a photograph by Marcelo Bertoni taken from Robert Held's *Inquisition: Bilingual Guide to the Exhibition of Torture Instruments from the Middle Ages to the Industrial Era* (1985). Reads: "Dadle tormento y llanto" (Apocalypse 18:7). 20 × 26.3 cm. Courtesy of FALFAA-CELS.

depart both visually and textually from the evocation of (spiritual) love and worldly desire we saw in *El amor*.

In the transition from Man Ray's amatory shot to the injurious instruments the spectator is left un-grasped, unsustained, propelled across a mercurial affective terrain, and rapidly moving from longing to dread. The question further arises as to whether the collar or the chair should also be caressed: Is there pleasure or knowledge to be derived from the flattened spikes, softly retextured through the Braille inscriptions? One, in turn, wonders whether the difference between the blind and the sighted spectator resides in the fact that the sighted would immediately withdraw from touching what is deemed or *seen* as dangerous, immoral, or unpleasant (perhaps often a bit too quickly)?

According to Lebenglik, in *Brailles*, "Ferrari positions himself on a dark edge: that constituted by the two most extreme forms of physical relations between two people, sex and torture" (Lebenglik 1997, 29). This "dark edge" arguably speaks back to a *noir* aesthetic, concerned in this case with extreme affective experiences. Yet more important to me is to consider the fact that it is precisely the notion of an edge, a border, a threshold the artist is seeking to investigate—with and alongside the sense of touch. As Derrida writes, "All one ever does touch is a limit. To touch is to touch a limit, a surface, a border, an outline" (Derrida 2005, 103). Touching, therefore, in its inability to reach an "inside" ("of anything whatsoever," for one is always in contact with "the borderline of a spatiality exposed to the outside" [103]), invites us to reflect on the side of the border on which we stand. In this light, Ferrari's *Brailles* return to an old *topos*: the borderline between pleasure and pain, and their shared mechanism of affecting the body through contact. These works aim not so much at offering the spectator a moral idea or a message to be known or grasped, but to awaken what Levinas describes as both an ethical and an aesthetic capacity for unknowing. For the artist, only the unknowing, sensually awakened spectator is able to sense the pain that traverses the history of beauty, and the infamous pleasures that have sustained the forms of torture that continue through our era.

This rationale is clearly at work in *Consolación* (Consolation) (1997), a Braille in which the artist writes on a detail from Luca Signorelli's fresco *The Damned* (1500–1502), located at the Chapel of San Brizio in the Cathedral of Orvieto, Italy (Figure 3.6).[13] In Signorelli's fresco, a winged demon holds a sensual, naked woman from behind as he bites her left ear; she is located behind another woman, whom she hugs and whom is also being brusquely grasped by a horned demon. The first woman is raising her chin in a gesture evocative of both agony and extreme pleasure; the second looks down, disturbed by the horrific tortures being inflicted upon her and upon the scores of women and men around her who have been condemned to infernal fire. Located on the face of the first woman, Ferrari's Braille transcription reads: "Bienaventurados los que lloran, porque ellos recibirán consolación" (Blessed are those who mourn, / for they will be comforted) (Matt. 5:4).

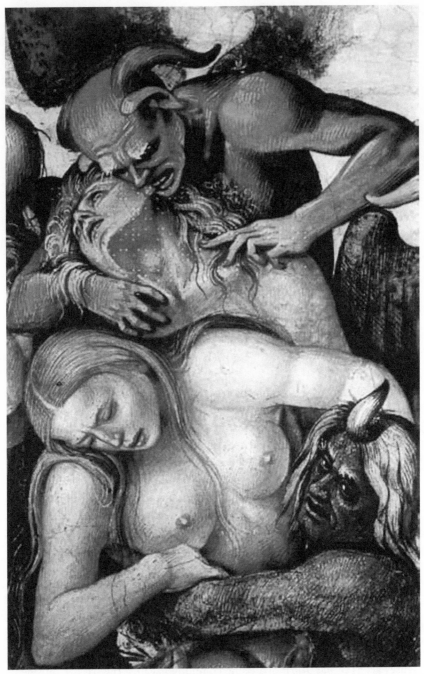

FIGURE 3.6. León Ferrari, *Consolación*, 1997. Braille writing on reproduction of
The Damned (detail) by Luca Signorelli, 32.5 × 20.9 cm. Courtesy of FALFAA-CELS.

This biblical excerpt comments on the redemptive conception of suffering in Christianity; yet Ferrari's composition plays on the double meaning of the word "consolation" as, on the one hand, finding (spiritual) solace and, on the other, being alleviated, comforted, pleased. The spectator who touches the raised chin of this female body will hence dwell on the limen between these clashing emotions, while pondering the extent to which the very act of touching this work incites pleasure or discomfort.

THE HAPTIC GAZE

Images of disembowelment and dismemberment, together with cut-out and dismembered images, have occupied center stage in the history of the avant-garde. As one analyzes Ferrari's attempts to rupture, decontextualize, appropriate, and inscribe the biblical corpus, one cannot but be reminded of statements by the likes of Boris Groys, who argues that "The [historical] avant-garde is nothing other than a staged martyrdom of the image that replaced the Christian image of martyrdom" (Groys 2008, 70). "After all," he says, "the avant-garde abuses the body of the traditional image with all manner of torture utterly reminiscent of the torture inflicted on the body of Christ in the iconography of medieval Christianity" (70). Marcia Brennan additionally suggests that Ferrari's attacks on the Catholic Church seem to carry too the violence of Inquisitional justice (Brennan 2014, 7).[14]

When Groys traces this singular genealogy of the avant-garde, he emphasizes one of the many ways in which Christian and avant-garde art are intimately interlocked. They have shaped, he claims, an iconographic imagination that "does not hesitate to recognize victory in the image of defeat" or annihilation (Groys 2008, 47). From a contrastingly different perspective, in *Compulsive Beauty* Hal Foster suggests that broken and often also impaired bodies in avant-garde art do not thematize punishment or disability; they project unconscious desire (Foster 1993, 125). He argues that when the avant-garde artist stages a broken body this becomes the mirror of a desiring—spectatorial and artistic—gaze. Ferrari continues this Surrealist fascination with the exposed body and the complex unconscious impulses that it triggers. However, he also resists the fetishism of the (dismembered) image by metaphorically disabling or blinding the spectator with the use of Braille.

Haptic experience lies at the heart of other expressions of neo-avant-garde art in Latin America, notably in the work of Brazilian Neoconcrete artists Hélio Oiticica and Lygia Clark. According to Paulo Herkenhoff, for these artists, "the senses act as *corpus delicti* of a crime committed against the passive musing or gazing at art" (Herkenhoff 2004, 328). In the late 1950s, in close dialogue with Brazilian art critic Mario Pedrosa, and deeply influenced by Maurice Merleau-

Ponty's *Phenomenology of Perception* ([1945] 2012), Clark and Oiticica endeavored to provoke and incite a "haptic gaze" among their publics (Herkenhoff 2004, 328). They understood this gaze as geared toward textures and heat; and in continuous search for contact. They also saw it as resulting from the association of sight and touch, perceived as capable of liberating the rational dimension of seeing and intensifying the subject's "awareness of the body's position and movement" (334). Clark attempted to awaken the haptic gaze by using certain objects, such as her *Sensorial Masks* (1967), which consisted of cloth hoods incorporating "eyepieces, ear coverings, and a small nose bag," in order to fuse "optical, aural and olfactory sensations" (Brett 1994, 62). "In the sensorial phase of my work, which I called 'nostalgia of the body,'" wrote Clark, "the object still is [. . .] a fundamental medium between the sensation and the participant. The person becomes fully aware of what his or her own body implies by means of tactile sensations realized in objects exterior to the self" (quoted by Herkenhoff 2004, 334).

What is crucial about the way in which perception is mobilized in Brazilian Neoconcretism is that the senses are not understood as being in opposition to reason or knowledge. On the contrary, they are seen as a means of gaining knowledge of the self and the other. Knowledge itself is deemed equally rational and sensual, in the same way that Brazilian modernity is perceived to be hybrid and anthropophagic, that is to say, intrinsically and simultaneously primitive and modern. Oiticica believed that the "body's experience originates in the sense of touch" (Herkenhoff 2004, 333); his *Parangolés* (1964) were a series of colored capes used to perform animated and turbulent dances. They "refused to exist as spectacle"; they were neither a second skin nor a visual garment, but "a sort of exposed viscera" in which "sensoriality is readily apparent" (333). Simone Osthoff therefore argues that Brazilian Neoconcretism fused a "Western aesthetic canon that privileges vision and metaphysical knowledge" with "Afro-Indigenous oral traditions in which knowledge and history are encoded in the body and ritual is profoundly concrete" (Osthoff 2000, 157).

Ferrari's works therefore share with Clark's and Oiticita's an interest in haptic perception and its relationship to knowledge. They interpellate the spectator as an embodied subject (rather than a purely rational being in search of concepts) and situate the body at the center of a larger reflection on history, memory, and trauma. Ferrari's approach to the haptic is, however, also accompanied by a reflection on the affective and material dimensions of writing. In his *Brailles*, as Claudia Laudano points out, "The fragments of limbs, organs and other body parts are organized through a double writing of image and text, where they become interchangeable." For the viewer, the experience of seeing is intensified by that of touching, and "reading becomes dense, as the body is said [*se dice*] in many ways" (Laudano 1997, 29).

NEVER AGAIN

Nunca más (Never Again) is the second series of collages that I discuss in this chapter. Some of the works in this series juxtapose Nazi iconography with portraits of the Argentine generals in power during the dictatorship—an association of the dictatorship with the Holocaust that is not uncommon. For Andreas Huyssen, "the Holocaust has provided a prism through which to read other cases of genocide, State violence, specters of destruction" (Huyssen 2009, 18).[15] Yet the reading of the Argentine experience in the light of the Holocaust has not only been common, it has also had major consequences for the way the dictatorship has been memorialized: rather than accounting for the actions and failings of competing groups, narratives about the last Argentine military regime have tended to focus on the repressive actions of a fascist state, the experiences of its victims, and the voices of those who witnessed horror (Vezzetti 2009, 22). In this section, I interrogate whether Ferrari's *Nunca más* attempts to situate the suffering provoked by that regime in the terrain of the "unrepresentable," or what Lyotard (after Adorno) calls the "'Auschwitz' model" (Lyotard 1983, 88). I also examine how this series of collages contributes to Ferrari's larger reading of the military dictatorship in the light of its "aesthetic" or sensuous effects on bodies.

Lyotard discusses "Auschwitz"—his metonym for the Holocaust—in relation to his concept of *différend*, namely, as "the unstable state and instant of language wherein something which must be able to be put into phrases cannot yet be. This state includes silence, which is a negative phrase." The impossibility of presenting Auschwitz "according to the rules of the cognitive genre" (Bennington 2008, 148)—thus making it "unrepresentable"—results from the senselessness of the concentration camps, which interrupts the possibility of experience, in its Hegelian conception as the dialectical movement of conscience or History. "Nazism cannot be placed into a universal process" because it does not lead to dialectical synthesis and cannot be positioned within a general logic of representation (151). "After Auschwitz speculative discourse in the Hegelian sense is impossible," explains Geoffrey Bennington. "The deaths at Auschwitz resist all attempts to sublate them into an economy according to which they would have paid for a crime or achieved sanctity by martyrdom" (149). This impossibility of situating the camps within a sacrificial logic in which the finite is offered in the name of the infinite (Lyotard 1983, 157), or put differently, within the *telos* of a grand narrative, turns Auschwitz into "the name of a silence" (Bennington 2008, 153): "'Auschwitz' is the forbiddance of the beautiful death [. . .]. Sacrifice is not available to the deportee, nor for that reason accession to an immortal, collective name. One's death is legitimate because one's life is illegitimate [. . .]. This death must therefore be killed, and that is what is worse than death" (Lyotard 1988, 100–101). A form of death that is worse than death, as a doubling of negativity, interrupts the representational logic of language. "There is not even a common idiom," writes

Lyotard, "in which even damages could be formulated, be they in place of a wrong" (106).[16] These last words imply that the experience of the camps does not even yield an *idea* of justice. From this perspective, the camps effaced "the very opposition between the just and the unjust," defying the "notion that injustice could be dealt with by enforcing justice" (Rancière 2013a, 187).

By describing Auschwitz as an occurrence beyond the powers of representation, Lyotard also connects this experience to the philosophical category of the "event" (Sim 2011, 71). An event is fundamentally de-rooted from history in the sense that, in Lyotard's conception of the notion, its manifestation disrupts "pre-existing theories, frameworks, models and experience through which it might otherwise be understood" (71). Yet Rancière takes issue with this consideration of Auschwitz as fundamentally ahistorical and senseless, an expression of absolute evil. He argues that to situate the Holocaust as a "world apart" enforces a silence rather than motivating debate about a past that continues to haunt the present. Furthermore, he posits that this philosophical interpretation of the Holocaust institutes silence as a site of consensus and, by so doing, "evacuates the political core" that undergirds "the symbolic structuration of the community [. . .], namely dissensus" (Rancière 2013a, 196). Solange Guénon adds: "For Rancière, as a theoretician of dissensual democracy, the Shoah is, first and foremost, an object of a dominant consensual discourse that blocks the political horizon, a depoliticizing, demobilizing, inhibiting fiction of political inventiveness and an artistic usurper of insurrectional forces" (Guénon 2009, 184).

Framed in these terms—as a model of consensus—the concept of the unrepresentable may initially seem far removed from a discussion of tactility. Rancière's understanding of consensus and dissensus is however based on the proposition that there are deep interrelations between mechanisms of representation (both aesthetic and political) and forms of sensuous perception. For him the very idea of unrepresentability seems to be articulated from the perspective of the seeing eye as it acknowledges its incapacity to imagine or cast light on certain territories of meaning, rather than the blind eye (or the haptic gaze), which seeks from the start to approach those territories perceptively, rather than representationally. The concept of the unrepresentable emphasizes the impossibility of constituting (or locating) a signifier for a given signified, be it an object or an experience. Untouchability is, in turn, primarily a problem of exclusion or prohibition. The untouchable (like the body of the resurrected Christ in depictions of *Noli me tangere*) has a presence and a materiality. Yet it enters the realm of representation as something "not to be touched" (Nancy 2008, 15). Therefore, rather than being evocative of "that which cannot be presented," it signifies the limits set by the law. It is a culturally determined (and fundamentally normative) division in the realm of perception.

In the following pages, then, I argue that, contrary to the Lyotardian narrative of unrepresentablity, Ferarri's series *Nunca más* seeks to inscribe the Argentine

dictatorship into a historical and political process that the artist not only deems representable, but also strives to render perceptible. This historical process revolves around the disciplining of the senses through notions of beauty and morality; and it can be traced back to the High Renaissance and the world-shaping experience of European colonialism. In Ferrari's view, neither the Argentine dictatorship nor the Holocaust are singular events. They belong to the long history of the Christian West, which he sees as marked by colonization, religious conversion, and (aestheticized) punishment in the name of family, morality, and nation (see Ferrari [1995] 2005c, 149–150). With this attempt to frame the dictatorship within a broader logic of Western history, Ferrari introduces an element of dissensus into one of the most canonical interpretations of the period, the human rights report *Nunca más*, which his collages were originally meant to illustrate.

Ferrari's *Nunca más* takes its title from the homonymous 1984 human rights report by the Argentine National Commission on the Disappeared (Comisión Nacional sobre la Desaparición de Personas, CONADEP). Formed by well-known members of civil society including religious authorities, and led by the writer Ernesto Sábato, CONADEP was constituted during the presidency of Raúl Alfonsín, only days after the country's return to democracy in December 1983.[17] The commission's original objectives were to establish the whereabouts of the victims of forced disappearance after the 1976 military coup,[18] receive complaints by victims of human rights violations and refer them to the judicial system, and identify children born in clandestine detention centers and illegally "appropriated" (that is, illegally taken from their parents and given up for adoption). This initial attempt at addressing those important and challenging tasks—which continue to be a pending problem in the country to this day—resulted in a five-hundred-page report containing hundreds of testimonial accounts, a provisional list of disappeared people and detention centers, an analysis of the profiles of the victims, and a detailed description of the most prevalent forms of human rights violations, including physical and psychological torture. This makes reading the document an emotional and often shocking experience.

Sábato handed the completed report to Alfonsín on live television on September 20, 1984. The text was initially rejected by the military, by members of the Peronist party, and by some human rights organizations. Peronists claimed that the report favored Alfonsín's administration, thus questioning the neutrality of the commission. Human rights organizations, in turn, opposed the report's defense of the "two demons" thesis, whereby left-wing groups, such as Montoneros and Ejército Revolucionario del Pueblo (ERP), were deemed just as responsible as the military for the violence that struck Argentina during the "Dirty War" years. Yet *Nunca más* gained notoriety and legitimacy when it formed the main corpus of evidence in the 1985 judicial trials against the three different juntas that ruled the country during the dictatorship. Indeed, regardless of its possible omissions,

biases, and flaws, the text provided the first wholesale account of the systematic violation of human rights by the military regime and, despite new and revisionist readings, it remains the most widespread narrative of those years. By 2007, the report had been edited multiple times and translated into several languages; it had also sold more than 500,000 copies in book form, reaching an outstandingly large readership for a human rights publication (Crenzel 2008, 106).[19]

Ferrari's was the first "illustrated" version of *Nunca más*, and its release took place at a time when the problem of political disappearances had acquired renewed importance. This "return" of the traumatic past responded to ex-navy captain Adolfo Scilingo's shocking confessions in March 1995. Breaching the military pact of silence for the first time since the end of the dictatorship, Scilingo, in a series of long interviews with journalist Horacio Verbitsky, described the process by which presumed political activists were kidnapped, tortured, and thrown alive from aircrafts into the River Plate. Scilingo's detailed description of the magnitude of this repressive strategy—which, evoking the experience of the Holocaust, Verbitsky published with the title "La solución final" (The Final Solution) (Verbitsky 1995)—generated public disquiet, "throwing into relief not just the day-to-day methods of the repression but also the wide spectrum of *internal* factors that enabled it" (Feitlowitz 2011, 227). For Emilio Mignone, a high-profile human rights activist and father of a *desaparecida*, the "Scilingo effect" led society at large to "confront its own denial" or "tacit approval" of clandestine state crimes, and was accompanied by a growing consciousness of the need to construct a lasting memory of the past, given the ongoing process of generational change (quoted by Feitlowitz 2011, 227).

In view of these circumstances, between July 14, 1995, and February 2, 1996, the newspaper *Página/12* offered its readers the *Nunca más* report in thirty fascicules (75,000 copies each), accompanied by Ferrari's images. This new publication not only represented the largest reprint of the report but also included materials that had been omitted after the first edition, such as the list of names of disappeared people. More importantly, according to Crenzel, the coming together of text and image in the "illustrated *Nunca más*," along with its recirculation as a portable—and touchable—publication, "resignified" the canonical text by inserting the dictatorial past into a larger history of crimes perpetrated in the name of morality and civilization. This process of historical resignification stemmed from the artist's creation of a series of images based on a "philosophy of history where present, past, and future have one and the same meaning," itself a consequence of Ferrari's singular use of what Crenzel names "historical collage" (Crenzel 2006, 94).

The *Nunca más* series effectively enacts a thought-provoking visual reworking of historical time. Before I go on to discuss the strategies through which this is achieved, it is important to note that resignifying the *Nunca más* report was not Ferrari's original or stated intention when he accepted *Página/12*'s invitation to

illustrate it. As a vocal member of the humans rights movement in Argentina, whose own son had been disappeared, the artist showed deference for this text, conceiving of it as the most authoritative account of the country's violent recent past: "I believe that the *Nunca más* is untouchable," wrote Ferrari in a newspaper article; "I'm only adding a graphic commentary" (quoted by Crenzel 2006, 88). Crafted more than a decade after the establishment of CONADEP, this graphic commentary was also meant to provide an up-to-date vision of the years of dictatorship, incorporating new knowledge—notably Scilingo's revelations—and new perspectives. "In this way," Ferrari continued, "one can produce a book that is still the original version, but add to it a contemporary perspective on what happened almost twenty years ago, indicating that despite the passing of time, we do not forget it and we bring it into the present" (96).

As he described his artistic intention and politics of memory, Ferrari did not raise the question of whether political disappearance could indeed be illustrated or whether this condition belonged instead to the realm of the unrepresentable. For him, the central problem was how to combat historical amnesia and "keep the past alive."[20] Yet in his interpretation of the series Crenzel argues that "Ferrari's intervention challenged and de-sacralized [*desacralizaba*] the supposedly 'ineffable' or 'indescribable' character of the horror in two ways; by illustrating an extreme process, in which all representation could appear insufficient or inadequate, and, at the same time, by doing this on the very text that provides the canonical narrative of this past" (2006, 88).

Ferrari's resolve to take a critical stand toward received history, to touch it, make it touchable, and thus refuse its "presence as departure" brings us back to Nancy's discussion of the Greek verb *haptein* in its meaning as stopping or holding back (Nancy 2008, 15). The injunction not to touch, to restrain from cutting, pasting, juxtaposing, distancing, and animating history institutes disappearance as the fundamental ontology of the past. With his collages, by contrast, Ferrari "touches history" as a means to take a stand against disappearance, in the double sense that the word takes in the Argentine context, as a caesura of visibility and as a sequence of abduction-torture-murder.[21] The artist's transgression of the taboo of "touching" a violent and arguably traumatic past ultimately constitutes an attempt to expose or to open images, memories, and histories to new forms of perception and interpretation.[22]

Although Ferrari did not consider his illustrated *Nunca más* as the "sufficient" or "adequate" representation of human rights abuses during the dictatorship, his collages do nonetheless critique the claim of the unrepresentability of extreme political violence. This both aesthetic and political operation develops by means of three strategies that articulate an important shift in narrative from the original *Nunca más* report. First, the works de-singularize (or de-eventify) the dictatorship by inserting it into a wider and continuous history of violence against bodies in the West. Second, they posit a close relationship between Christian moral-

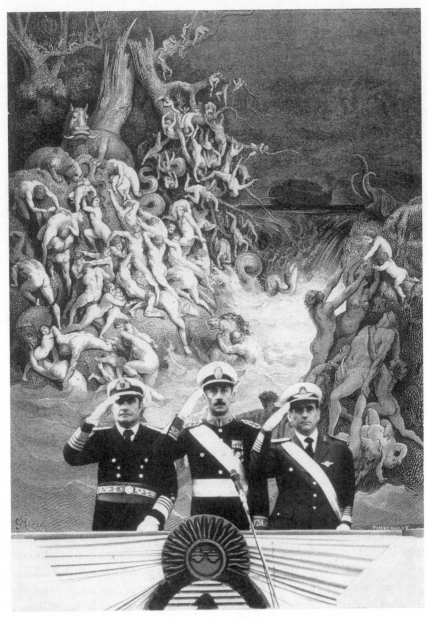

FIGURE 3.7. León Ferrari, *"Great Flood" by Doré + Military Junta*, from *Nunca más*, 1995–1996. Digital print on paper, 42 × 29.7 cm. Courtesy of FALFAA-CELS.

ity and religious art, on the one hand, and the forms of physical punishment enforced by the military, on the other. Finally, by decontextualizing and recirculating photographs originally published in the media, these works highlight the complicity between church and state during the dictatorship, while challenging the idea that this union was invisible to society at large.[23]

On the cover of the first fascicule, Ferrari fuses a photocopy of Gustave Doré's *Great Flood* (1865–1866), from the French artist's illustrated Bible engravings, with a picture of the three generals that jointly seized power in 1976 (Figure 3.7). Doré's apocalyptic image portrays a fearful and seemingly indivisible collectivity in which naked men, women, and children embrace one another to avoid falling victim to the monster-inhabited waves. This landscape of despair becomes the background against which military chiefs Emilio Eduardo Massera, Jorge Rafael Videla, and Orlando Ramón Agosti—pictured in black and white and appearing from left to right in the foreground—perform a rigid military salute in their gala uniforms. The generals turn their backs on the anguished bodies, seemingly indifferent to their cries for mercy. At the bottom of the collage, Argentina's upturned coat of arms serves as their pulpit. The organization of this image is also noteworthy for the fact that the generals' salute is directed straight at the contemporary reader of *Página/12*'s illustrated *Nunca más*. This iconographic choice to open this new version of the human rights report conveys a sense of urgency not only to come to terms with Argentina's history of state violence, but also to examine the cultural conditions that rendered repression, disappearance, and the systematic use of torture possible. Confronted anew with this military salute, how would the Argentine population respond? This appears to be the provocative gesture of Ferrari's initial collage.

Positioning Doré's anguished bodies behind those members of the army who led the dictatorship during its bloodiest, initial years produces a visual analogy between the victims of this regime and those who, according to scripture, were punished by God during the biblical Flood. This reference to the Flood narrative evokes, in particular, Silingo's confession that the disappeared were thrown alive into the River Plate from air force helicopters. Ferrari's suggested parallel between the anonymous and anguished bodies experiencing the consequences of God's rage in Doré's engraving and the victims of the military regime is not without consequences with respect to the CONADEP report's own narrative. This takes us precisely to the discussion of the (un)representability of extreme violence. For Emilio Crenzel the correspondence between Doré's drowning bodies in the initial collage and the victims of state repression "offers a representation that shatters the unrepresentable and intangible condition of the disappeared, granting to disappearance an epic and grandiose quality that is absent in the dehumanization of death implicit in this crime" (Crenzel 2006, 90).

Leaving aside the question of these images' purported epic qualities, let us recall that Ferrari is not the first to attempt to represent the disappeared. Relatives

FIGURE 3.8. Photograph of María de las Mercedes Carriquiriborde, forcibly disappeared in Córdoba on December 6, 1977. Courtesy of Alicia Carriquiriborde de Rubio.

of the disappeared and human rights organizations have used for decades passport or *carnet* pictures (4 × 4 cm) in black and white—necessarily taken before the victims' abduction—in order to represent the victims of the dictatorship in public protests and in other often more private acts of memorialization. These pictures were first used as an "herramienta de búsqueda" (literally a "search tool"), and only later gained presence in the public sphere. Today they have become the most prevalent way to "give visibility to disappearance"—that is, not only to give a human face to each victim of forced diappearance, but also to create, in Ludmila da Silva Catela's words, "a strong iconic referent for the purposes of denunciation" (2009, 337–338).

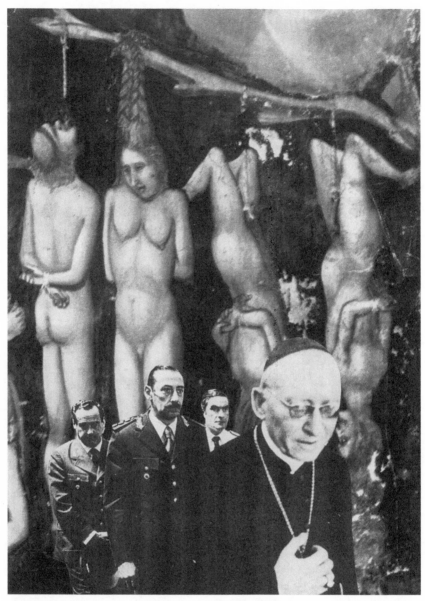

FIGURE 3.9. León Ferrari, *Videla, Massera and Agosti with Monsignor Tortolo, Vicar of the Armed Forces (Photo: A. Kacero)* + *"The Last Judgment" by Giotto, Capella degli Scrovegni, Padua 1306* from *Nunca más*, 1995–1996. Digital print on paper, 42 × 29.7 cm. Courtesy of FALFAA-CELS.

As we can appreciate in the picture of María de las Mercedes Carriquiriborde, who was forcibly disappeared in Córdoba on December 6, 1977 (Figure 3.8), each carnet picture singularizes the victim and presents him or her in a mental and physical condition entirely different from their later agony. This representational strategy contrasts with Ferrari's anonymous, clustered, and disarrayed suffering bodies. Bereft of any indicators of their identity, and mostly naked, those who are represented as victims of the dictatorship in the illustrated *Nunca más* could equally be young or old, European or Argentine, and they could have been born in the second half of the twentieth century or centuries before. As one may also observe in another collage—where Ferrari juxtaposes a detail of Giotto's *Last Judgement* with a picture of the Junta walking behind Bishop Tortolo (then vicar of the armed forces)—the types of torture that the allegorical victims of human rights abuses suffer, such as being hung by their genitals, hair, or tongue, do not even depend on modern technologies of control and punishment (Figure 3.9).

By avoiding the use of photography or any other historical documentation to represent the disappeared, Ferrari renounces realism, together with the dramatic overtones of the individual story. The *carnet* pictures are, by contrast, directly referential and evoke the tragedy of each individual abduction: giving a face to those missing, they are a harrowing reminder of their youth and vitality at the moment their lives were suddenly cut short. These pictures also precede the victims' experience of being disappeared, and therefore situate everything that happened afterward as lying outside the sphere of the visible.[24] Photographic indexicality, on the one hand, and painterly figuration, on the other, lie at the basis of these two different approaches to mimesis in relation to the disappeared. Both acknowledge the impossibility of realistically representing absence and affirm the political significance of striving to recuperate what has been made invisible. However, the effects on the workings of memory of these two mimetic regimes differ. The indexical strategy of the carnet picture leads to a demand for justice that is historically situated and must, at the very least, respond to the suffering of individual victims (and their families). Ferrari's allegorical approach seeks instead to invite reflection on the influence of long-held systems of belief on Argentina's recent political history.

Ferrari's illustrated *Nunca más*, in other words, suggests that the basis to understand the crimes committed by the Argentine military after the 1976 coup is the history of Christianity in the West and its place in the European art historical canon. He describes this vision in his 1996 text entitled *Arte y represión* (Art and Repression), which he wrote at the time that his collages were being published in *Página/12*. Here, the artist argues that in the history of art, torture has been glorified for centuries, and that this glorification is not without consequences: "The West [...] possesses an extraordinary wealth of works that depict torture as an evangelizing strategy [...]. From these artistic representations of evil, from these

paintings from a hundred, five hundred, a thousand years ago, and from the Bible verses that inspired their creators, the Armed Forces and the Episcopacy that supported them seem to have taken, whether consciously or not, ideas for the repetition of this evil: these are etchings and frescoes that could shed light upon the faces of the *Proceso*" (Ferrari [1996] 2005a, 153).

As he questions the aestheticization of punishment in Western visual culture, Ferrari ascribes equal importance to biblical and historical episodes. His narrative strategy parallels his visual and literary use of montage and leads him to argue, polemically, that some of the most atrocious crimes in Western history have been "the Flood, the Conquest, Hell, Nazism, the Apocalypse" and "the crimes of the "Western and Christian *Proceso* that are denounced in the *Nunca más* report" (Ferrari [1995] 2005c, 149). That is the strategy through which Ferrari desingularizes the brutality of the dictatorship, resisting the "model" perspective at the basis of Lyotard's theorization of Auschwitz—a perspective that also traverses the CONADEP report. While the report treats the dictatorship as an exception in Argentine history, Ferrari's emphasis on the *longue durée* and on mythical or religious history opens up a general reflection on those cultural values (from ideas of beauty to conceptions of reason) that, in different times and places, have led to the deployment of extreme violence in the name of order. The consequences of these aesthetico-political propositions for a politics of memory are noteworthy. They suggest that the work of memory should not only be oriented toward achieving discrete forms of reparative justice in relation to an exceptional and traumatic past, but also ought to examine the cultural conditions that enabled the generals to imagine and discursively justify some of the most horrific forms of violence.

This leads me to identify another of the main points of divergence between the illustrated *Nunca más* and the human rights report, namely, the artist's challenge to CONADEP's claim that political disappearance constitutes a breach of "the ethical principles upheld by the great religions and the most high-minded philosophies for millennia" (CONADEP 1984, 7). Such words by Sábato were part of the report's original prologue and suggest that disappearance and torture are inherently incompatible with the fundamental teachings of all major religious traditions. According to Ferrari, by contrast, Christian conceptions of just punishment and their visual rendering in various masterpieces were the ultimate ideological—and aesthetic—justification for the generals' murderous acts against so-called subversion. To give an example, the artist describes Doré's *Great Flood* as the West's "first extermination" (*primer exterminio*). In the parable of the Flood as illustrated by Doré, he writes, "The crime committed by the few contaminates the rest of humanity [. . .]. That is what happened with the dictatorship. The supposed crime of the few was punished with the death of tens of thousands" (quoted by Crenzel 2006, 97).

The theme of religion is prominent not only in the artist's illustrated *Nunca más*, but also throughout his work. The artist's interest in Christianity was present

from an early age. He attended a Catholic school, which he recalled as repressive (García 2008, 21), and as a young man he used to assist his architect father in the construction and renovation of churches. Later in his life he became known among friends and foes for mastering biblical texts and their exegeses better than devotees. At the basis of the artist's interest in the Bible lied a preoccupation with the Word, understood as the divine Word, the Law, and the mechanisms through which it becomes embodied. His art therefore searched to interrogate the role of religious texts and images in the development of social mores and everyday notions of good and evil. Moreover, religion became to him the entry point into a deeper exploration of the role of aestheticized punishment in the history of modernity and colonialism. This is how the religious intersects his aesthetic understanding of the last dictatorship; reducing Ferrari's work to an attack on the Catholic Church therefore overlooks how the artist ties religion to a larger aesthetics of politics.

SCENES FROM INFERNO

As I suggest in the preceding pages, Ferrari's collages are not primarily concerned with whether episodes of extreme violence and personal suffering can indeed be adequately represented; they focus instead on the history of their representation and the ways in which they have informed Western ideas of beauty. A case in point is the presence in the artist's *Nunca más* of various masterful depictions of Hell, which is also a recurring scenario in the human rights report. One of the panels in the series includes an image of Giotto's *Inferno* (1306), rendering Hell as a place where Satan physically punishes and devours sinners;[25] another panel reproduces the Limbourg brothers' *Hell* (1412–1416), where red-hot tongs serve to torture sinners for eternity. In the former, Giotto's fresco is left almost untouched, playing the role of a picture simply being contemplated by the chief commander of the navy, Admiral Massera. Between 1976 and 1978, Massera was the head of ESMA, the largest clandestine detention center during the dictatorship, and the place where the body of Ferrari's son was taken before its disappearance. With Massera's consent and direct intervention, thousands of people were tortured there, kept in conditions of extreme confinement, enslaved, and, in most cases, thrown alive into the River Plate, after having received the "blessing" of Catholic priests.[26] It is not therefore entirely surprising that Ferrari situates Massera and the devil in Giotto's *Inferno* as mirror images. In doing so, he simultaneously lays open the question of how a torturing demon can be considered one of the greatest works in the history of art. Does our aesthetic appreciation of this piece, Ferrari challenges us to ask, make us consciously or unconsciously enjoy this violence? Does the persistence of redeeming images of torture in the history of Western art influence our relationship to the suffering of the other? Are there remnants of a Christian morality in the contemporary reception of the Western artistic canon? Ferrari responds to these questions in the affirmative, even as he

remains aware of the anachronism of his comparisons. His goal is not to demonstrate historical accuracy but to expose the immense violence against bodies present in some of the best known religious art. Moreover, he seeks to shed light on the extent to which conceptions of beauty are permeated by a punitive morality and the fact that the aesthetic accomplishment of certain images often makes us forget their political use by church and state to spread fear.[27] As we remain aware of the seriousness of these claims, however, we must also bear in mind that at the background of Ferrari's critical art lies what Dawn Ades—following György Lukács—identifies as the ultimately ambiguous and jocular character of effective political photomontage. That is, the artist's images can be seen as both absurd and uncomfortably accurate, just like a good joke (Ades 1976, 57).

Cardinal Juan Carlos Aramburu, the archbishop of Buenos Aires at the time of the coup, and General Videla are the protagonists of the second collage, which portrays them as they shake hands in the midst of a blazing scenario. A well-known supporter of the military regime, Aramburu considered the state of exception imposed by the military regime to be essential in order to protect the country from communism. He also publicly denied that the practice of forced disappearance was occurring, claiming that the so-called *desaparecidos* were living in Europe (Mignone 2006, 124). The image by the Limbourg brothers, which serves as background to the encounter, allegorizes the brutal consequences of this union between church and state. The relationships between foreground and background in the panel are, however, destabilized by the fact that the greatest part of the collage is occupied by the painted background. More importantly, this background takes a certain precedence over the rest of the collage by being a thoroughly unexpected element in the narration of the Argentine dictatorship. By way of its strangeness, the image by the Limbourg brothers calls the attention of the spectator, who is prompted to question the extent to which this painting is an appropriate representation of the realities experienced in Videla's Argentina.

In a third collage involving "masterful" renderings of Hell, Aramburu and Videla shake hands once again, this time against the background of a detail of Doré's *Inferno*—taken from the artist's illustrated version of Dante's *Divine Comedy*. Other generals and clerics are also present, yet they seem to ignore the punitive ordeal occurring behind them, in which naked men and women are being whipped by demons (Figure 3.10). The uniforms of these men bear all the signs of merit, honor, and responsibility. Aramburu bows before sash-wearing Videla in a subservient gesture and seems to be offering him a gift, from which Videla averts his eyes as he maintains his characteristically serious facial expression. Although we can know little about the gift, in this context it represents unity and collaboration between the Catholic Church and the military state. Using the same image, the pair's complicit handshake leads Ferrari to suggest, in *Hitler with Christian Dignitaries + Galtieri, Lambruschini and Viola with Nuncio Calabresi and Cardinal Aramburu*, that church leaders in Argentina acted in a similar fashion to those

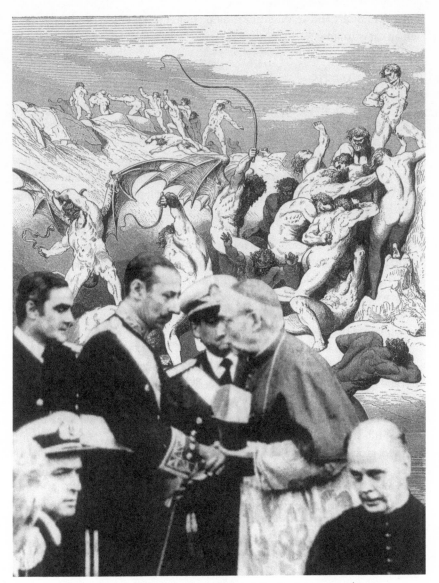

FIGURE 3.10. León Ferrari, *Videla, Massera, Agosti and Cardinal Aramburu (Photo: Loiácono) + "Dante's Inferno" by Doré, 1860*, from *Nunca más*, 1995–1996. Digital print on paper, 42 × 29.7 cm. Courtesy of FALFAA-CELS.

members of the Catholic Church who endorsed Hitler. With this last collage, Ferrari brings to the two-dimensional plane of his panels a vision of history as a series of cyclical catastrophes, whereby what Lyotard calls "Auschwitz" cannot be seen as a singular, unrepeatable event—for a parallel occurrence had actually already happened in 1970s Argentina, and could be repeated again, should we

remain politically and aesthetically indifferent to the conditions leading to these human catastrophes.

PACEM IN TERRIS

On December 1, 2004, the former archbishop of Buenos Aires, Jorge Mario Bergoglio (the current Pope Francis I), published an open letter in response to Ferrari's retrospective exhibition, which had opened at Centro Cultural Recoleta (CCR) the night before. Addressed to his dear "sons and brothers" (*hijos y hermanos*), the letter outlined concerns about certain "offences directed at our Lord Jesus Christ and the Holy Virgin Mary," resulting from public expressions against "moral and religious values." In particular, Bergoglio confessed to being "hurt" (*dolido*) by what he called a "blasphemy" being perpetrated at Recoleta on the occasion of a visual arts exhibition financed with the money of "Christian people" and the taxes of "persons of good will." Yet the archbishop added that neither he nor the Christian people should be fearful, for Jesus had already warned them such things would happen. Rather, he invited the religious community to turn the eve of the feast of the Immaculate Conception (December 7) into a day of penitence by fasting and praying, so the Lord might one day forgive their sins and those of "the city" (*la ciudad*).[28]

This letter sparked an unprecedented explosion of public outrage against Ferrari and his show, ranging from mass prayers outside Recoleta to the destruction of works by religious fanatics. A lawsuit to close down the exhibition was filed a few weeks after the opening, leading to a national and international campaign by artists, art historians, curators, and other public figures in support of the artist and in repudiation of the Catholic Church's attempt to censor a major art event. Meanwhile, a number of individuals and associations organized public demonstrations to defend freedom of expression and the right of an internationally recognized artist to exhibit his work safely and without fear of reprisal in a public institution. All in all, the Ferrari affair involved the temporary closure of the exhibition by judicial order, its later reopening following an appeal from Buenos Aires' city council, and its final closure amid an atmosphere of recurrent bomb threats.[29]

Some of the works discussed in this chapter are precisely those that ignited discontent among the clergy. One is therefore left to wonder whether, as blasphemous as the current pope considers it, Ferrari's work is fundamentally unethical. Following the artist's recent death at the age of ninety-three, a significant number of his obituaries paradoxically emphasized the opposite. In his article entitled "Cuando el arte mueve conciencias" (When Art Moves Consciences), Fabián Lebenglik (2013), art critic and columnist of *Página/12*, wrote that Ferrari's art entwined politics and poetics, as well as ethics and aesthetics. Filmmaker Gastón Duprat and curator Liliana Piñeiro also underlined the artist's "unflinching eth-

ics" (*ética inquebrantable*) (Gari 2013). The discussion of ethics in relation to Fe-rrari's work did not come as a posthumous homage, but was already common at the time of the Recoleta retrospective. On this occasion, Luis Camnitzer described the artist as a "guiding figure within twentieth-century Latin American art" and praised "his vision of an ethically committed art." For Camnitzer, Ferrari had served as a role model for various generations, helping them to escape "the empty formalism promoted by the art market" (quoted by Giunta 2008a, 17). Camnitzer's emphasis on Ferrari's ethics is significant, given his role as a pioneer theorist of the political character of conceptual art in Latin America, and consid-ering how little attention ethics has received in the scholarship on conceptualism.

The problem of situating Ferrari's ethics lies in how to define the relationship between the ethical, the aesthetic, and the political. This area of debate has gained relevance since the 1980s, when, after having been "absent from intellectual dis-cussions, or present simply as a term of abuse reserved for the bourgeoisie amid the radical anti-humanism of the 1970s," as Simon Critchley explains, ethics "returned" to academic and political agendas (Critchley 2002, 2). A "turn to ethics" (Garber et al. 2000), more or less coinciding with the 1980s "postmodern turn," has been recognized in philosophy, anthropology, aesthetics (Hoffmann and Hornung 1996), international politics (Mouffe 2005), and art (Cashell 2009). In this chapter I suggest that, if the ethical is not to be turned into another term for consensus, as Rancière critically argues, it cannot be reduced to the unrepresent-ability of certain wrongs. In my discussion of Ferrari's collages, following Levi-nas's haptic approach to ethics through ideas of exposure and contact, I have attempted to perform a shift from an understanding of ethics as a limit or a pro-hibition (of representation) to one highlighting the possibility of critical and perceptive engagement with images and narratives of history.

A haptic reading of Ferrari's *Brailles* and *Nunca más* reveals important trans-formations in the artist's practice of collage after the last experience of dictator-ship in Argentina. In these series, Ferrari resorts to a number of masterpieces in the history of art in order to inscribe the violence of the dictatorship into a larger reflection on repression and containment in Western, Christian culture. Ferrari's collages, however, do not point toward a given revolutionary message, along the lines of 1960s political collage. Their aesthetic and historical propositions are instead conceived of to arise performatively at the moment of encounter between the work and the embodied spectator. As I further discuss in the next chapter, these images are profoundly influenced by the rise of performance art in the 1970s and 1980s; they aim to awaken the body and the senses, rather than to forge a rev-olutionary consciousness. Moreover, Ferrari's late collages challenge received histories of the dictatorship by locating its most abhorrent effects on the terrain of sense perception or *aisthesis*. This reading de-singularizes and demystifies this historical process, suggesting parallels with other experiences of genocide and mass punishment.

Ferrari's flattening of history is nevertheless accompanied by an attempt to lend new volumes and textures to the representation of certain historical narratives, combining painterly figuration with photography, image with text—and inviting the spectator to understand both history and myth, the sacred and the profane, as sites of dissensus. For Rancière a "dissensus is not a conflict of interest, opinions, or values; it is a division put in the 'common sense': a dispute about what is given, about the frame within which we *see* something as given" (Rancière 2004, 304, emphasis added). Similarly, Ferrari believed that a critique of the given would not simply come in the form of new knowledge, but it would have to result from new ways of *seeing*: haptically and corporeally. The clearest example of this posture is his *Brailles* series, which sidelines the allegorical possibilities of fragmentation and juxtaposition in favor of the texturing and participatory effects of the use of Braille to inscribe texts on images.

Ferrari's *Brailles* thematize the division between the sighted and the blind spectator, inviting the former to gain greater awareness of the ocularcentrism of Western culture and the reifying effects of the gaze. They also symbolically seek to disable the sighted and prompt them to meddle with history from the subjective position of someone claiming no ultimate or unquestionable moral superiority or direct access to the Real. In other words, these works endeavor to reread the historical past with a haptic gaze, one that is intensely receptive to the body's vulnerability to pain as a transhistorical universal—thus defining the human condition as embodied and finite. In themselves, these collages do not strive for originality; they explore the significance of the act of rereading. Furthermore, these touchable works are both semantically open and materially exposed. They are made to be sullied and eroded by the hand of an undisciplined or "ignorant spectator" (to use Rancière's term [2009b]), a spectator willing to challenge museological and historical convention. Ferrari's late or performative collages are therefore indicative of the demise of a model of political art that prevailed in Latin America during the 1960s and early 1970s. They signal a shift toward a new understanding of political art cast around a performative model of subjectivity. This art is geared at perceptive and embodied participant-spectators, and it aims to confront them with a violent history that is rooted in the body and its senses.

4 · NUDITIES

La douleur, cet envers de la peau, est nudité plus nue que tout dépouillement.
(Pain, this underside of skin, is a nudity more naked than all destitution.)
— Emmanuel Levinas, *Autrement qu'être, ou au-delà de l'essence*

Each of us is constituted politically in part by virtue of the social vulnerability of our bodies—as a site of desire and physical vulnerability, as a site of publicity at once assertive and exposed.

— Judith Butler, *Precarious Life*

León Ferrari's 2003 Braille *Ausencia* (Absence) features the naked body of a young woman as she erotically bends her legs in front of the camera (Figure 4.1). Portrayed in an upward angle from her sharply focused stockings into her blurred breast and countenance, the woman, photographed by the Italian artist Tatiano Maiore, bears at the level of her tights the Braille inscription of a fragment of an early poem by Jorge Luis Borges, the title of which gave its name to Ferrari's work. If one were able to caress the picture and feel the text with the touch of one's hand, one would be confronted with a fragment of the following poem:

Habré de levantar la vasta vida
que aún ahora es tu espejo:
cada mañana habré de reconstruirla.
Desde que te alejaste,
cuántos lugares se han tornado vanos
y sin sentido, iguales
a luces en el día.
Tardes que fueron nicho de tu imagen,
músicas en que siempre me aguardabas,
palabras de aquel tiempo,
yo tendré que quebrarlas con mis manos.
¿En qué hondonada esconderé mi alma
para que no vea tu ausencia
que como un sol terrible, sin ocaso,

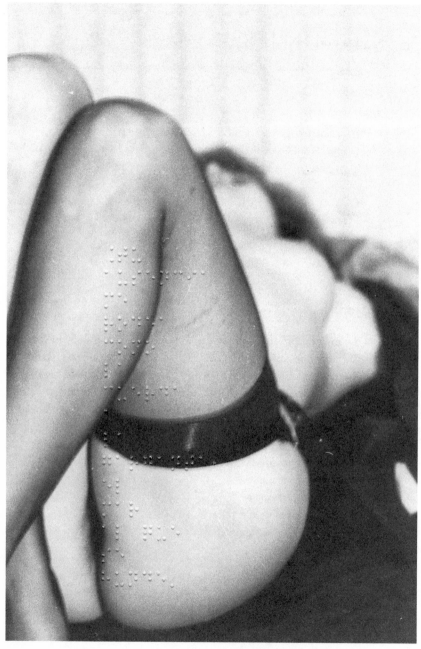

FIGURE 4.1. León Ferrari, *Ausencia*, 2003. Braille on reproduction of photograph by Tatiano Maiore, unknown dimensions. Courtesy of FALFAA-CELS.

brilla definitiva y despiadada?
Tu ausencia me rodea
como la cuerda a la garganta,
el mar al que se hunde.[1]

(I shall have to lift the vast life
that even now is your mirror:
every morning I shall have to rebuild it.
Since you have gone away,
many places have turned vain
and senseless, like
lights during the day.
Afternoons that were alcoves for your image,
songs where you waited for me,
words from yonder time,
I'll have to break them with my hands.
In which ditch shall I hide my soul
so it will not see your absence
like a terrible sun, at constant zenith,
shining calculated and ruthless?
Your absence surrounds me
like a rope around a throat,
like the sea does to someone drowning.)[2]

Literary critic Beatriz Sarlo discusses this text, alongside Borges's Ultraist poetry collection *Fervor de Buenos Aires* (Fervor of Buenos Aires) ([1923] 1970), in which it was first published, as an homage to a Buenos Aires being rapidly transformed by economic modernization—from which Borges had been absent during a seven-year stay in Europe, and to which he returned in 1921 feeling an increasing sense of alienation (Sarlo 2007, 16–17). The poem evokes an asphyxiating sense of loss, which sees meaning dissolve with the absence of a loved one, the disappearance of memories, and the difficulty of reconstructing them. As Borges's verse spatializes his nostalgia for the bygone city, one perceives the way in which the city itself also becomes a powerful symbolic machine, traversed by intense flows of erotic and mournful affect. In Borges, however, the modern city is feminized and filled with reproach, marked by dissatisfied desires and haunting absence. The poet promises to reconstruct what his eyes can no longer see, mapping a spectral, desired city over the body of the real one. This parallels Ferrari's choice of image, in which the female body lies still and submissive. The picture not only occludes the woman's gaze but also portrays her in the passive position of the receiver: her breasts waiting to be touched as the spectator

caresses the photograph; her infantilized genitalia with occluded labia remaining dutifully sealed. In both cases the female body stands as a surface for the inscription of masculine desire. The city-woman-lover is simultaneously celebrated and mistrusted, spectrally evoked and chastened. The honoring of her beauty hinges upon the negation of her gaze, her motility, and her corporeal unboundedness. As image and text converge in Ferrari's collage, the female body ends up carrying a text she cannot read; she stands as the material basis of a discourse she cannot reach, an erotic impulse that is not hers. Her portrait privileges those areas of her body that do not speak for her individuality but for what may be universal in her femininity. She is effectively absent, as subject, from the picture, incapable of responding to the spectator's caress. Her appearance is no less elusive than those mirror reflections Borges pursues amidst an excess of light in the modern city.

These considerations lead me to interrogate the role of both nudity and eroticism in what I describe as the performative turn in Latin American art during the long 1980s, comparing in particular Ferrari's performative approach to collage with the photographic performances of younger artist Liliana Maresca. In the previous chapter I discussed the centrality of the experience of absence in Ferrari's work, referring to absences produced by the politics of forced disappearance during Argentina's last dictatorship. In view of this discussion one cannot but question whether the artist's later treatment of eroticism in works like *Ausencia*, in which direct references to the country's history of authoritarianism are difficult to trace, is not a retreat from an art of memory—that is, an art seeking to bear witness to experiences of extreme suffering. Moreover, one wishes to interrogate the politics of these (erotic) images and how to read them in the context of 1980s and 1990s Argentina.

Taking into account Julia Kristeva's discussion of nudity as the moral threshold between the publicity and privacy of the body, alongside her notion of *le féminin*, in what follows I investigate the (performative) exposure of the female body in Ferrari's art in light of his own piercing critique of the violence inflicted on bodies and subjects during the last Argentine dictatorship. My decision to work with Kristeva's approach responds to its strong resonances with Ferrari's writings, and the contemporaneity of the thinker and the artist. Yet in order to situate this reflection within a larger discussion on the politics of erotic art in post-dictatorship Argentina and the role of performance in this politics, I also examine the relationships and affinities between Ferrari's art and the work of Liliana Maresca, who was a key figure in the underground art and gay scenes in 1980s Buenos Aires. This comparison unveils a little-researched relationship between both artists that cuts across a received division between so-called political art and light or erotic art. It also opens up a discussion on the public stakes of intimacy and the role of nudity, its public performance, and its control, in the formation of a field of power.

The chapter focuses on Ferrari's series of altered industrial mannequins, first exhibited at his 1994 show *Cristos y maniquíes* (Christs and Mannequins), on Maresca's photographic performance *Liliana Maresca con su obra* (1983), and on her participation in the exhibition *Mitominas II*, with the assemblage of a Christ undergoing a blood transfusion (1988). By developing a close visual and performative analysis of these works, I propose an understanding these artists' figuration of female nudity as an attempt to dissect the sensuous dynamics at work in the biopolitics of post-dictatorship Argentina. Having often confessed his "amatory passion" for women (Giunta 2006, 347), Ferrari conceives of female nudity as an impossibility. His series of appropriated mannequins reveal the female bare body as a support for the inscription of state, market, and church narratives, all of which seek to repress or manage female intimacy and desire. It is in light of this critique that Ferrari explores other forms of exposing (or rather performing) nudity, such as the caress, in which the sensuous remains open to renegotiation and resignification. This evocation of the feminine as a signifiable unsignified, "what is not yet known" (Pollock 2010, 802) but ought to be explored in (blind) corporeal proximity and exposure, sets off a double critical dynamic that, on the one hand, examines the effects of an existing symbolic system on the perception of corporeality and, on the other, identifies the system's potentially subversive excess as radically volatile and contingent. Exploring the political consequences of this volatility, I argue that Ferrari's approach to the feminine and the erotic speaks to a fluid temporality that moves both backward and forward in relation to historical time. In the first instance, it looks back on the recent past, rooting the most pervasive effects of the last Argentine dictatorship in the control of intimate desire and figuring this process as a counterrevolution against the politically and sexually liberatory impulses of the 1960s. In the second instance, it looks forward, constructing a dialogue with larger, ongoing debates in late twentieth-century Argentina about a politics of sexual discrimination corroding the country's fragile democratic agenda in the aftermath of dictatorship.

This chapter also continues my discussion on the ways in which Ferrari's late artistic practice did not staunchly repeat those strategies that turned him into one of the foremost representatives of political art in the 1960s, as some readings of his work suggest. Indeed, my analysis of distinctive changes in Ferrari's late artistic practice critiques a simplistic antagonism between political art and light art, a divide that structured the artistic field in 1990s Argentina. Light art was associated with the underground art scene and the Centro Cultural Rojas (CCR) and defined as "an art unconcerned by the affairs of the world, hedonistic, formalist." Political art, by contrast, was seen as "an art committed to its immediate, ideological sociopolitical context" (Pineau 2012, 277).[3] My reading of Ferrari specifically situates his late work alongside that of Maresca, a key figure in the underground or "light" art scene, and frequent presence at CCR. In the 1980s,

Maresca began to situate pleasure and promiscuity at the center of her critique of corporeal disciplining. Yet together with many other artists from her generation, she found herself tragically silenced by the AIDS epidemic in the early 1990s. Even as she endorsed underground festivity and carnival as means to "undiscipline" the body, her rendering of intimacy was therefore never naively liberatory, but marked by the specters of all-too-vulnerable bodies.

LE FÉMININ

Ferrari's reading of the place of Christianity in Western modernity bears telling resemblances to Kristeva's propositions in her essay "Signifying Practice and Mode of Production." Against the grain of a view of modernity as a linear and irreversible process moving from the theological imagination to the mastering of positivist reason, in this text Kristeva posits that the coming of modernity consolidated "the complicity of the family, the State and the religious discourse" (Kristeva 1976, 64). For her, in the context of increasingly consolidated capitalist economies, secularization effectively coincides with the social sublimation of Christian morality. Religion thus becomes one of the few accepted territories of excess— by managing, as Griselda Pollock adds, "the excess not allowed into representation in the tightening economies of production and reproduction" (Pollock 1998, 103).[4] Like Ferrari, therefore, Kristeva understands the place of religion in modernity as neither that of a vestige nor an ornament. Instead, she incorporates the religious into the very skeleton of the capitalist system and argues that it plays an expurgatory function. By eliminating (unrepresented) excess, says Kristeva, religion allows the perpetuation of an Oedipal/capitalist socio-symbolic system; the religious is that which monitors the boundaries between this system and its other (Kristeva 1976, 64.)

Yet in *Powers of Horror* ([1980] 1982) Kristeva suggests that there is an outside to this religiously contained socio-symbolic system. This outside is *le féminin*, an "unnamable otherness" that is also understood as "that which is not" (1982, 59). According to the French thinker, Christianity cannot process, for instance, maternal desire, so it reduces motherhood to the figure of the Madonna, a virginal mother. This repression of the erotic dimension of femininity—a primary libidinal drive—results in an unrepresentable, unspeakable excess, a site of radical negativity potentially capable of destabilizing a bourgeois and patriarchal socio-symbolic system. However, as in Lyotard's *différend*, which I discussed in the previous chapter, this understanding of *le féminin* as a realm beyond representation runs the risk of becoming a consensual category—namely, a category that evacuates the political processes at the heart of the construction of woman as Other. This is perhaps the reason why, as Butler points out, "Kristeva [...] alternately posits and denies [...] [this] emancipatory ideal": she identifies *le féminin* as a repressed dimension of language, but she also concedes that "it is a kind of lan-

guage which never can be consistently maintained," for it would lead to psychosis or even "the breakdown of cultural life itself" (Butler 1999, 102).

Ferrari not only articulated a reading of the place of religion in modernity akin to Kristeva's, but in several of his artworks and writings during the late 1980s and early 1990s, he also symbolized the aroused, desiring female subject as the Other of power. In doing so, the artist argued that the history of art in the West is marked by efforts to foreclose this emancipatory figure from representation. Using strategies of quotation and spatialized signification proper to collage, he made numerous attempts to visualize feminine *jouissance*, publically displaying it both as celebration and as a politically engaged provocation.[5] Yet in Ferrari's art the visual representation of feminine desire is almost exclusively confined to an Orientalist visual canon, via Japanese erotic prints in which women in traditional attires enjoy their bodies through both sexual encounter and self-stimulation. Partly due to these overt references to sexuality, these works contrast sharply with those collages in which Ferrari uses Christian imagery. This organizes much of the artist's visual output around binary divides, suggesting a seemingly unsurmountable opposition between East and West, masculine and feminine, (sexual) repression and emancipation. Indeed, while the artist understands the public recognition and visualization of feminine *jouissance* as a locus of resistance to the modernity-Christianity-authoritarianism triad, he also seems to symbolize this form of resistance as lying beyond representation in the West, and outside the fields of vision and political possibility in post-dictatorship Argentina. His public exposure of the female desiring body aims to challenge this foreclosure and test its limits.

FIGURE 4.2. León Ferrari, *La serpiente*, 1997. Braille writing on color reproduction of Japanese stamp, 39.8 × 49.9 cm. Reads: "La serpiente me engañó y comí" (Gen. 3:13). Museo de Arte Moderno de Buenos Aires. Photo by Viviana Gil. Courtesy of FALFAA-CELS.

In *La serpiente* (The Serpent) and *Ámate* (Love Thyself), both from 1997, Ferrari thematizes the public praise of female sexual enjoyment in Japanese shunga. The first of these Braille-inscribed prints highlights the facial expression of a woman exhibiting bliss as she engages in sexual intercourse, finding her lower body surrounded by genital fluids as her companion deploys his robust virility to give her pleasure (Figure 4.2). On the right side of the image, Ferrari wrote in Braille: "La serpiente me engañó y comí" (The serpent deceived me, and I ate; Gen 3:13). This reference to the biblical serpent that deludes Eve, accompanying an ecstatic celebration of sexuality, refuses a guilt-ridden interpretation of the Christian Fall and points toward the gratifying comfort of sexual intercourse instead. The image also insinuates what a commentator describes as an "alternative exegesis" of the sacred text, one that commends the bodily awareness that followed the biblical expulsion of humankind from Eden (Lisboa 2010, n.p.). The second work, *Ámate*, deals with the taboo subject of female masturbation. It features a detail of a print by Kitagawa Utamaro, in which a woman's genitalia is depicted in close-up so as to "demonstrate" a technique for masturbation (Figure 4.3). In this case, the artist wrote in Braille the biblical directive "Ama a tu prójimo como a ti mismo" (Love your neighbor as yourself; Mark 12:31), ostensibly underscoring the importance of giving love to oneself, as much as one loves others.

In contrast to this laudatory rendering of female pleasure in what is here understood as the "East," those erotic works among Ferrari's *Brailles* drawing from sources of Western art history fail to figure female desire. In this body of works, female subjects become voluptuous forms with little singularity, carrying in their skins imaginaries of desire effectively alien to them. The attempt to depict a feeling of desire *for* the feminine as a liberatory impulse—hailing from Surrealism—turns the erotic drives *of* women into unsignified absences. This regime of representation thus reinstates living women, "women persons," "women artists"—as Pollock puts it—into a phallically structured Symbolic that reduces them to passive and subordinated subjects (Pollock 1998, 98).[6] Recognizing this tendency in Surrealism, Gwen Raaberg points out that "'liberation,' as played out in the works of the male Surrealists," in particular in Breton's conception of *l'amour fou*, "reactivates the libido and enlists it in the passionate overthrow of repressive and oppressive bourgeois existence." Nevertheless, and more often than not, it "positions the female in the same passive and oppressed state that bourgeois culture has traditionally placed her" (Raaberg 1991, 7). As we shall see in this chapter, however, Ferrari may be considered a diasporic, allegorical, and perhaps also irreverent Surrealist, who paid homage to and drew upon the work of his European predecessors, but did not leave their work untouched.[7] Rather, he reappropriated and resignified it in a manner similar to the ways in which he attempted to resignify biblical scripture. Therefore, despite the artist's close engagement with Surrealism, particularly with the work of Breton and Man Ray, his rendering of the feminine and his public exposure of female nudity do not simply repeat a mascu-

FIGURE 4.3. León Ferrari, *Ámate*, 1997. Biblical words written in Braille on *Juego de manos* [Hand Play], print by Utamaro that shows the mokodaijuji masturbation technique, 38.5 × 29 cm. Courtesy of FALFAA-CELS.

linist poetics. These gestures performatively explore strategies to dwell upon the limits of this vision, and they align their preoccupations with a new generation of feminist, LGBT, and queer artists in Argentina (even though Ferrari did not define himself through any of these categories). The artist's erotic art and public defense of the politics of Eros therefore combine a reflection on the extent to which the

female body has been turned into a site of inscription of both religious and modernist discourses with attempts to evoke that which escapes this process, becoming "ex-scribed" in the act of writing. As Nancy suggests: "Writing *exscribes* meaning every bit as much as it inscribes significations. It exscribes meaning or, in other words, it shows that what matters—the thing itself, Bataille's 'life' or 'cry,' and finally, the existence of everything that is 'in question' in the text [. . .]—is *outside* the text, takes place outside the text" (Nancy 1993, 338).

From Nancy's perspective, it is possible to discuss the politics of Eros beyond the mere visualization of power's spaces of inscription. The philosopher sees the bare body and the forms of subjective exposure to which it is open as ultimately distinct from the history of its nudity, that is, from those discourses that have been inscribed upon nudity. This approach to the bare body as the outside of writing—its material, affective discharge—rather than as a neutral surface "to be covered by writing" (Nancy 1993, 198), is similarly present in Ferrari's exploration of the corporeality of the written word (both as Braille dots and as heavily gestural handwritten texts present in his written paintings). The corporeal thus becomes a jumbled mass to be touched, a mass that is offered, following Nancy, "without anything to articulate." As one explores these possibilities, therefore, one shall keep in mind Nancy's words when he argues that "bodies are first to be touched. Bodies are first masses [. . .]. Discharges of writing [. . .] abandonments, retreats" (197–198). In the discussion that follows, when nudity appears as pure sign or form, one ends up being confronted with hardened and empty entities; sheer (visual) reflections. The ex-scribed body, by contrast, appears as an excess, a trace, a locus of intimacy and (erotic) encounter.

CHRISTS AND MANNEQUINS

In his 1994 exhibition *Cristos y maniquíes*, organized at Álvaro Castagnino's FILO gallery in Buenos Aires, Ferrari exhibited a series of industrially produced female mannequins upon which he had either transcribed biblical texts or glued Christian imagery. The exhibition also included several of Martin Schreiber's Madonna nudes, similarly superimposed with Braille and other forms of calligraphy. Describing this series of works, Ferrari stated: "I dress the body of the woman with words, with texts, which are sometimes caresses, and sometimes not" (quoted by Lebenglik 1997, 29). *Devoción* (Devotion, 1994), like most works in the exhibition, uses as support an acrylic headless and limbless female mannequin with prominent curves, which are further highlighted by a mild backward rotation in the torso (Figure 4.4). Ferrari "dressed" this industrially shaped figuration of idealized (yet fragmented) femininity with a patchwork of little prayer cards typical of popular religiosity. Key episodes from the gospel, including the Crucifixion, as well as various saints and sacred icons, like the Sacred Heart, Our Lady of Rosary, Mary,

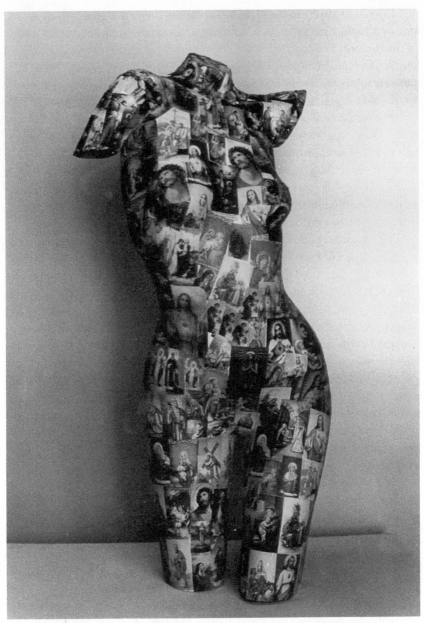

FIGURE 4.4. León Ferrari, *Devoción*, 1994, from the *Mannequins* series. Mannequin lined with religious stamps, 88 × 46 × 33 cm. Courtesy of FALFAA-CELS.

and Joseph, all feature in these cards. The motley lining that results from placing one next to the other, therefore, not only serves symbolically to hide the nudity of the bare torso but also to contrast two symbolizations of women: the virginal mother, featured in the religious imagery, and the prostitute, understood as pure object of masculine desire, embodied by the headless mannequin with voluptuous curves. Yet a suggestive contradiction disrupts the otherwise dualist vision of femininity organizing the discursive logic of the artwork: evocative of nudity and sexual excess, the mannequin is itself shaped like a crucified body; the stumps of its mutilated arms protrude from the body, forming, with the headless neck, a Romanic cross. The gesture of crucifixion, so significant in Ferrari's early approach to assemblage with *La civilización occidental y cristiana*, thus makes an eerie return in this exhibition. Such figuration impedes any easy celebration of feminine "excess" over the religious negation of corporeal desire.

Going back to Ferrari's words in his description of the process of creating these works as an act of dressing, one must also note that the artist takes the mannequins as indistinct from the (living) "cuerpo de la mujer" (body of the woman). These words fail to capture the experience of viewing the mutilated torsos. Indeed, it would be hard to imagine any of Ferrari's mannequins coming to life, rigid and dismembered as they are. *Devoción* is a fleshless, broken, and mass-produced representation of the female body, evocative of a sacrificial condition. The work stops short of being able to index the cry and the life constituting the (ex-scribed) kernel of embodiment: it is an acrylic shell without organs, a flat, lifeless, immobile screen whereupon desires of dismemberment, sexual possession, and/or sacred untouchability are projected. By intertwining the Christian narrative of sacrifice with the modern fetishization of the female body, *Devoción* does however interpellate the critical gaze, by complicating any simple construction of a liberatory or redemptive idea of *le féminin* within these discursive formations.

Deuteronomio (Deuteronomy, 1994) is a mannequin the artist dressed exclusively with text by transcribing fragments of the book of Deuteronomy onto both sides of its torso (Figure 4.5). He used the sort of jumbled calligraphy he developed in the 1960s, when he wrote (or drew) his *Carta a un general* (Letter to a General) (1963), *Cuadro escrito* (Written Painting) (1964), and various other "written drawings." This turbulent style of writing sought to reproduce, according to Ferrari, the tonal qualities of the human voice. In doing so, it rendered the materiality of writing as a locus of affect, while giving rise to an uninterrupted flow of highly expressive and deformed signs—most of which are difficult to decipher, since the irregular lines constituting them are deeply entangled, like disordered yarn. While Ferrari originally developed this form of writing in the two-dimensional plane of cotton paper, the use of a three-dimensional mannequin as support for these "vocalized" transcriptions of the Bible adds another "ex-scriptive" element to the biblical text. In Ferrari's impulse to move toward human-size, sculptural space references the cumulative nature of the sacred word, its own motion

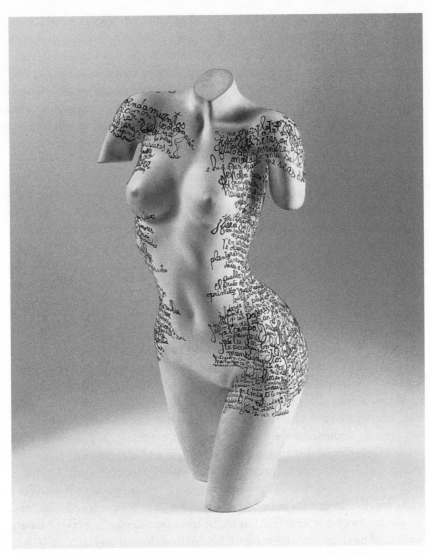

FIGURE 4.5. León Ferrari, *Deuteronomio*, 1994. From the *Mannequins* series. Plastic mannequin and acrylic paint, 104 × 43 × 39 cm. Courtesy of FALFAA-CELS.

toward excess, and continuous flight from the two-dimensional plane of the scripture into the life of real bodies. The artist's emphasis on the materiality of writing also suggests that discourse never fully captures the flesh of the text, pointing toward the extent to which the embodiment of the Word is also, always, its affective disfiguration. In *Deuteronomio*, the layer of text moves from the sides of the body toward its core, like ants eating up a corpse. Body and writing sustain a dialectical tension within which the meaning of the work is suspended. As the text

takes over the mannequin's body, its unmarked "skin" references that which lies outside of the corrosive ink, as well as that which, potentially, it cannot penetrate.

Beyond the possibility of interpreting Ferrari's transcription of the biblical text onto the female torso in the guise of an excess or an ex-scription, the artist's *Deuteronomio* is reminiscent of Giorgio Agamben's understanding of nudity in Western culture as being "inseparable from a theological signature" (Agamben 2011, 57). For Agamben, the story of the Fall conditions any visualization or experience of nudity by turning nudity into something beyond the absence of clothing. According to biblical scripture, Adam and Eve did not have any garments when they dwelled in Paradise, but they were not naked, for they were covered by a "clothing of grace, which clung to them as a garment of glory" (57). It is this clothing that the couple lost at the moment of sin, and after them, all of humanity experienced the same lack. Nudity became a negative experience: a privation of the clothing of grace, which may be similarly conceived as a post-sinful condition.

A proponent of this argument, Erik Paterson, posits in his *Theologie des Kleides* (Theology of Clothing) that "the perception of nudity is linked to the spiritual act that the Scriptures define as the 'opening of the eyes,'" which follows the Fall (quoted by Agamben 2011, 59). In Paterson's exegesis, nudity is less a corporeal condition or a form of exposure than a way of seeing: nudity does not dwell in the bare, unclothed body, but in the seeing eyes. (Agamben writes: "Nudity belongs to time and history not to being and form" [2011, 65].) This conception involves learning to accept an unfavorable idea of "the human," in which the human condition is defined by the lack of divine grace: herein lies the "theological signature" inscribed onto the bare body. From this perspective, the sacred words covering Ferrari's *Deuteronomio* are not evocative of a clothing of grace but rather reminiscent of a grid that encloses the body's flesh and impedes its formless, sensual outpouring. The chosen excerpt from Deuteronomy comes from Chapter 28, which is a long exposition of the different reasons one can receive a blessing or a curse from God. Here, the body of the (would-be) sinner is imagined as feminine, for she has a womb whose "fruit" would be cursed should she "not obey the Lord your God by diligently observing all his commandments and decrees" (Deut 28:15). Accordingly, the act of writing in this work is evocative of the setting of a moral law and its laying out on the skin of the female, fertile body—thus demarcating the limits of her flesh. Notably, the practice of torture by the Argentine military during the dictatorship has often been discussed as an act of writing—namely, as an attempt to impose a corporeal semiotics through the calligraphy of pain (Taylor 1997, 139).

Made of transparent acrylic, *Mi mujer con cabellera de llamaradas* (My Wife Whose Hair Is a Brush Fire), carries on its chest, breast, and upper belly an excerpt of Aldo Pellegrini's 1931 translation of Breton's *L'Union libre* (Free Union, 1923) written in black ink.[8] The poem's opening lines read: "Mi mujer con cabellera de

llamaradas de leño / con pensamiento de centellas de calor / con talle de reloj de arena / mi mujer con talle de nutria entre los dientes de un tigre / mi mujer con boca de escarapela y de ramillete de estrellas de última magnitud" (My wife whose hair is a brush fire / Whose thoughts are summer lighting / Whose waist is an hourglass / Whose waist is the waist of an otter caught in the teeth of a tiger / Whose mouth is a bright cockade with the fragrance of a star of the first magnitude).[9] These lines textually dismember the female body of Breton's lover, Suzanne Muzard, only to reassemble it by creating a composite of alluring objects. The use of anaphora to refer repeatedly to the woman/wife in the possessive form stresses her own passivity as her body is broken into fragments. Faced with Ferrari's transcription of these words in the mannequin, one therefore confronts the need to understand the kind of caress that may result from these lovingly violent words. Can Ferrari's gesture of proximity—which unfolds by means of a calligraphy seeking to grasp the unstable and affective sonorous variation of the word in the act of "saying," rather than transparently communicating the normative signification of "the said"—undo Breton's textual violence?[10]

Ferrari's long-standing dialogue with Surrealism is here present at multiple levels. His description of the act of dressing the mannequin with text brings to mind the scandalous 1938 International Surrealist Exhibition, in which various members of the movement (including Marcel Duchamp, André Masson, Max Ernst, Salvador Dalí, Wolfgang Paalen, and Man Ray) dressed up sixteen mannequins, each one with a different attire and thus catering to "every possible fetishistic desire" (Mahon 2005, 44). The Surrealists were memorably selective in their choice of mannequins, having rejected the first batch delivered to them in their search for a type of mannequin that could embody the "Eternal Feminine." The mannequins they eventually used were characterized by their lean bodies, slim breasts, long eyelashes, and memorably fashionable hairstyles. Alyce Mahon describes the Surrealists' artistic appropriation of these mannequins as a process of giving life to a typically passive and inanimate object (44). Similarly, Georges Hugnet argues that "The Surrealist artists [. . .] all felt the soul of Pygmalion" (Hugnet 1972, 329). Like the latter, they aimed to create beings of ideal beauty, while also rendering them as sexually provocative. For Lewis Kachur, these mannequins "were not mechanistic or stylized 'others,' but rather lifelike, active instigators/victims of an erotic or violent encounter with the viewer" (Kachur 2001, 42). Man Ray's mannequin was said to exist in "a state of metamorphosis between objectivity and subjectivity, between waxen clinical perfection and real flesh" (Mahon 2005, 44). The cold and absent expression of her still eyeballs was softened by circumventing them with long eyelids and glass tears. Its body was left entirely bare, while her feet were kept in the manufacturer's cylindrical container, suggesting this was a brand-new human-like object waiting to be clothed. Moreover, Mahon points out that despite its inanimate appearance, this mannequin

sustains "the fantasy of a living doll, her ingeniously life-like face looking as if she could cry real tears" (44).

The Surrealists perceived the eerie middle ground between the realms of life and death, flesh and appearance, subject and object, and woman and doll as evocative of the "marvelous." In the 1924 Surrealist manifesto, Breton writes: "The marvelous is not the same in every period of history: it partakes in some obscure way of a sort of general revelation only the fragments of which come down to us: they are the romantic *ruins*, the modern *mannequin*, or any other symbol capable of affecting human sensibility for a period of time" (Breton 1969, 16, original emphasis). In the same text, Breton states that "only the marvelous is beautiful" (14). The Surrealists' engagement with the mannequin through play and desire was, simultaneously, a means of directly manipulating these mysterious objects and of critiquing the trappings of consumer culture—by celebrating nudity and singularity over standardization and masquerade. The explicit sexualization of these objects is, however, puzzling. As Mahon assertively claims, "In using lifeless mannequins to evoke sexual titillation, the Surrealists paradoxically defied sexual desire, for it is the nature of the female mannequin that despite the perfect face, breast, hands and feet she is ultimately sexless, having only a flattened pubic mound" (2005, 44).

Like those exhibited in the Surrealists' 1938 exhibition, Ferrari's mannequins are traversed by opposing forces of liberation and constraint. On the one hand, they exhibit an impulse to expose female nudity in public as a challenge to a conservative and patriarchal morality willing to veil and control the female body. On the other, these works limit the idea of the feminine to being an object of fetishistic desire. The few remaining pictures of the exhibition's *vernissage* convey the second of these positions most assertively: featuring various groups of exhibition attendees distractedly talking before the still torsos, these pictures reveal the female body in a condition of continuous exposure, a docile object awaiting voyeuristic observation.[11] Deprived of subjectivity or agency, the idea of the feminine becomes pure form. As Mercado, who attended the show, suggests: "These feminine mannequins, with their inexpressivity and contingency, admissibility and moderation, are neutral supports and, if one thinks in plastic terms, the height of pure form to fulfil" (Mercado 1994, 2).

In this representation of the female body as an unwritten form or a white canvas, Ferrari fails to figure the feminine as the active, desiring subject he identified and cherished in Japanese erotic art. Referring to a transparent mannequin that Ferrari turned into an aquarium (into which he then inserted a long, dark salamander), Mercado furthermore sustains that this piece exhibits a sexual fantasy that could be described as a "zoofilia-masculino-amniótica" (amniotic-male-zoophilia). Here, the bestialized and masculinist desire for the maternal, amniotic body takes expression in "the phallic similes swimming inside the body of the transparent mannequin" (Mercado 1994, 2). This faceless, immobile, and

disemboweled body simply cannot express satisfaction. Instead, it becomes what Mercado names a "total uterus, absolute recipient femininity" (2). In this sense, rather than evoking le féminin as an excess haunting the Symbolic, Ferrari's exhibition Cristos y maniquíes renders visible the fine accommodation of three socio-symbolic systems that effectively foreclose feminine desire. The industrial mannequin, constitutive of modernity as a mode of experience, ends up providing a seductive and secure fit for Christian imagery, just as the celebration of femininity in Surrealism ends up failing to awaken the erotic doll. Yet Mercado adds that Ferrari's exhibition was not outwardly pessimistic, as it motivated the spectators to imagine a different, this time live (and not exclusively sexualized) form of female subjectivity: "The inanimate bodies, because of their incompleteness and anomie, because of their passivity and rudimentary form allow us to imagine: a woman who will not allow herself to be turned into a sign, nor dress, nor display; who will gather life from so much dying" (1994, 2).

Intertextually referencing Macedonio Fernádez's short story "El neceser del escruchante" in his Papeles de Buenos Aires (1943), Mercado's evocation of a female mannequin that would come to life through the repetitive act of dying opens up the possibility of a performative slippage from domination and docility to agency. In the short story, the awakening of Fernández's mannequin results from touch: the tickling produced by the touch of a haberdashery client, also described as the mannequin's everyday assassin. Once the mannequin gains life, the power relationships are reversed, as the mannequin goes on to become a murderer, choosing the "bad detective story novelist" Conan Doyle as victim. Having strangled Doyle, the mannequin then visits Edgar Allan Poe's grave in order to write: "You are avenged, Edgar Poe" (Estás vengado Edgardo Poe) (Fernández 1966, 128). Mercado's reference to Fernández's short story in her discussion of Ferrari's Cristos y maniquíes therefore points toward a bold awakening. Yet it may well be that for both Mercado and Ferrari the awaited awakening was not that of the female mannequins, but of the men and women situated around the works, as spectators. "How do you situate yourself before the transformation of femininity into form?" is the question that the exhibition poses as an interpellation.

DIVINE PHOBIA

The same year that Ferrari exhibited the mannequins, he attended a conference at UNAM's Instituto de Investigaciones Estéticas in San Miguel de Allende, Mexico, in which he outlined how his work since the late 1980s was a reflection on the place of eroticism in Western, Christian morality. On this occasion Ferrari claimed that "sex is the greatest enemy of the Christian West," adding that the religious obsession with the punishment of sexual pleasure (in all of its forms or presumed deviations) was the consequence of having turned human bodies into the inscriptive supports of biblical narratives (Ferrari [1994] 2005e, 94). The artist

then stated that his art was an attempt to figure bodies trapped in such narratives, while working out ways to differ with, displace, and disentangle these same writings. Such difficult unraveling, he argued, could begin by exploring the very corporeality and materiality of the written word.

During his talk, Ferrari quoted a number of biblical passages and theological exegeses, the latter going from St. Augustine's to the catechism drafted after the Second Vatican Council. Despite this wide variety of sources, Ferrari saw them as constituting a single sex-phobic and anti-feminine narrative, in which Christianity dictated punishments of greater violence toward sinners whose "faults" derived from sexual desire than toward torturers and murderers: "The hierarchy of sex as the chief of sins has been sustained through millennia: the copulation of a divorced person is a more serious crime for the Vatican than the tortures committed by a General" (Ferrari 2005e, 95).

Ferrari's talk is remembered for having spurred heated controversy. This resulted from the fact that, as in the rest of his oeuvre, the artist disavowed the division between a premodern, religious world and secular modernity. Against this perspective, Ferrari connected modernity—specifically Western modernity—with both the rationalization and the aestheticization of the division between body and mind, and the corresponding dissemination of a guilt-based system of morality, closely linked to religious belief. Cartesian dualism was in this sense to be tied to its Christian underpinnings, and to what Ferrari describes as the continuous influence of the Christian Bible in the modern history of the West. Moreover, he asserts that even in what are understood to be secular societies, discrimination against women and homosexuals,[12] accompanied by a crippling fear for the public visualization of sexual pleasure, could not be understood without recognizing the Christian grounding of Western modernity. For the artist, the Western art historical canon not only expresses this relationship—in the work of artists like Giotto, Botticelli, and Michelangelo—but must also be understood as having played a central role in normalizing and aestheticizing the most dreadful forms of violence against the aroused, desiring subject. His examples are powerful evocations of this violence:

In one of the treasures of Western culture, the Scrovegni Chapel in Padua, Giotto placed within his Hell a pair of adulterers hung over a fire, he with a cord tethered to his penis, and she with a hook in her vagina; at their side is a "fornicating" monk having his penis cut off with a large pair of pincers by a demon, an image which recalls the idea of self-castration [. . .]. Michelangelo, for his part, paints in the Sistine Chapel a homosexual man with a demon's hand inserted up his anus, so as to rip out his innards. (2005e, 113–114)

In recalling these images, Ferrari is suggesting that artistic imagination and mastery have played a role in the disciplinary repression of Eros in Western culture.

Yet his intention is not to blame artists for the punitive undertones of their creations; his criticism is rather directed toward a contemporary glorification of so-called masterpieces that lacks awareness of the context of their production and the extent to which visuality and morality are mutually reinforced. In light of this, Ferrari claims that erotic art ought to be understood as a form of political art, as it has stood "for sexual rights and against moral codes born alongside the immorality of torture" (Ferrari 2005e, 95).

Although rich in theological sources, Ferrari's argument lacks historical specificity, resulting in a simplification of both belief and scripture. The artist's perspective also dismisses internal conflicts within the Church, taking into account only the most conservative versions of Christianity. Furthermore, this reading fails to do justice to the distance between scripture and ritual, religious command and popular practice. Ferrari's approach to the "art-historical canon" is similarly reductive, as it overlooks the ways in which some of the most celebrated Renaissance artists challenged received representations of the body and desire. In his study of the art of the first half of the sixteenth century, for instance, Alexander Nagel describes the paintings of Leonardo as "destined to trouble decorum and thus to raise the question of the functions, categories, and settings of art" (Nagel 2011, 32). Similarly, Nagel speaks of an "art in a state of controversy," characterized by a multiplicity of unresolved impulses that should prevent us from reducing it to "religious art" (2). Compared with this view, Ferrari's perspective takes a sweeping and anachronistic tone. However, to dismiss the artist's view on the basis of its lack of historical and sociological specificity would involve falling prey to yet another form of anachronism. For we must remain aware that Ferrari's comparison of the differential attention given to torture and sex in the Bible is fully entrenched in his revision of Argentina's experience of dictatorship, as a regime seeking not only to control public behavior but also to reshape minds and desires. Moreover, we must remember that, as in other countries, Argentina experienced in the 1960s—the country's so-called rebel decade (Pujol 2002)—what some have termed a "sexual revolution," led by an increasingly politicized youth that often endorsed the idea of "free love" and brought to the public sphere some of the same issues that preoccupied Ferrari.

Even if in recent years scholars have questioned the actual reach of this possibly misnamed "revolution,"[13] there is some consensus around the idea that the 1960s generation boldly questioned and displaced the model of the nuclear family that had emerged in the early decades of the twentieth century, as well as the association of women with domesticity (Cosse 2006, 41). Partly in response to these changes in accepted gender and family models, the military regime sought to impose what Taylor calls "a national/gender identity" based on "strict controls on the physical body and on sexuality" (Taylor 1997, 93). According to this vision, "good women were the ones who supported the military's mission and encouraged it to exercise even more control over the public good" (78). These women

were also associated with the notions of *Patria*, motherhood, Christianity, and hygiene, and distinguished from the presumed "mothers of subversives" (i.e., the Mothers of Plaza de Mayo) who had purportedly failed to fulfill the role expected of them (83). Bad women or *guerrilleras*, in turn, were considered uncontrollable, seductive, infiltrating, and combative. And the consequences of this thoroughly artificial antagonism between "bad" and "good" women were far-reaching. As Taylor explains,

> The gendering of the enemy on a metaphoric level played itself out on the physical bodies of those detained during the junta's seven years in power. These representations are in no way separable from the experiences of flesh-and-blood people in the lived-in world. In the concentration camp known as Olimpo (Olympus), the distinction between embodied and disembodied "womanhood" ([bad] woman/ [good] Woman) was made brutally evident as military soldiers tortured female prisoners in front of the image of the Virgin Mary. The negative image of the "public" or active woman provoked and enabled the systematic assault on the reproductive organs of all female prisoners held in captivity. Women were annihilated through the metonymic reduction of their sexual "parts": wombs, vaginas, breast. Abducted women were raped as a matter of course. Testimonies repeatedly allude to guns shot into vaginas and wombs. (Taylor 1997, 83–84)

Ferrari's critique of the religiously inspired negation of female sexuality, and his interest in making (female) desire publicly visible, is fully entrenched in this history of sexualized authoritarianism, almost to the point of (antagonistically) responding to it with a purely sexualized idea of the feminine. Yet in the following sections I suggest that the artist's interest in erotica and his revision of those conceptions of morality that had been "scripted" upon female bodies also joined a larger struggle for sexual liberation (and against sexual discrimination) in late-1980s and early-1990s Argentina. Therefore the overarching and highly unspecific temporality of Ferrari's revisionist approach to the place of Eros in the history of art—akin to what Mieke Bal would call a "preposterous" quotation of Christian iconography (Bal 1999, 9)—will allow me to discuss his art not only as a critical return to Argentina's recent past but also as an attempt to look forward into a less punitive future. My reading contests the treatment of Ferrari's art as exclusively in dialogue with the political or "ideological conceptualism" of the 1960s, in order to position his later work alongside the preoccupations of a generation of younger artists, often (reductively) described as engaged in the production of "light" or hedonistic art, and among whom Maresca was a key figure. Before moving into a closer discussion of the relationship between Ferrari's "political art" and "light art," focusing on the politics of nudity in Maresca's work, I wish to conclude this reflection on Ferrari's San Miguel de Allende talk by adding that his understanding of the role of (religious) art in the Western history of punishment may also be seen

as providing a purposefully exaggerated narrative. In doing so, it expresses a certain parodic astonishment as to why, in the light of such a long history of repression on the basis of exactly the same (biblical) arguments, "things" had not yet changed.[14] Is it because our seeing eyes are in fact incapable of perceiving the prevalence of a sexually repressive ideology in some of the greatest icons of Western culture? This is the question Ferrari asks as he imagines a new art for a new (her) ethical spectator.[15]

INTIMACY REAWAKENED

> Sexual conflicts […] proved to be an important site
> […] to understand the meaning and lessons of the Holocaust.
> —Dagmar Herzog, *Pleasure, Sex, and Politics Belong Together*

While clothed bodies bear the marks of rank and class, the naked body participates in a different semiotics. For Elizabeth Grosz, the "naked European/American/African/Asian/Australian body" is far removed from being a "savage," untouched or universal territory of corporeal excess and desire, for it "is still marked by its disciplinary history" (Grosz 1994, 142). Nudity, in other words, is never only nudity. It carries the histories of race, gender, and religion. It is, to return to Mercado, an empty, "pure form" or signifier that has been invested or "clothed" in meaning.[16] For centuries, this meaning was primarily attributed by a masculine gaze that, as Lynda Nead suggests, defined the female body through an aesthetics of "wholeness and containment" (Nead 1992, 60). "One of the principal goals of the female nude" in the Western tradition of high art, writes Nead, has been "the containment and regulation of the female sexual body" (6). Born in 1951 in Buenos Aires, Maresca belongs to a richly diverse and transnational group of female artists who, since at least the late 1960s, but more intensely during the 1980s and 1990s, often suggestively used nudity in order to dismantle this "contained" ideal of the female nude, together with accompanying gender and sexual prejudices. To do so, these artists reclaimed a "right to self-representation" that broke open the imagined physical boundaries of femininity and explored forms of intimacy beyond sexuality.

Maresca began her artistic practice in the first half of the 1970s, primarily as ceramist and painter. In the early 1980s, under the mentorship of Informalist sculptor Emilio Renart, her art shifted toward the production of assembled objects, sculptures, and installations, using recycled materials she picked up from waste dumps. During those years, Maresca and her daughter also moved to a flat in the bohemian neighborhood of San Telmo, making this home a meeting place for artists from different generations who were working in a variety of media—including Marcia Schvartz (painting), Marcos López (photography), Alejandro Kuropatwa (photography), and Martín Kovensky (drawing). Adriana Lauria compares

Maresca's flat to Andy Warhol's studio in New York, known as The Factory, which served as a center for artists to get together, and where Warhol shot various films featuring nudity, same-sex relationships, and drug use. The gatherings at Maresca's flat were similarly immoderate. In 1982, as public anxiety rocketed with the Falklands-Malvinas war, both excitement and dread infused these meetings, leading to explosions of creativity, love, and self-abandonment. The flat's frequent visitors, alongside those lodging at Maresca's, became what Lauria describes as a micro-community that accompanied Maresca throughout her life. This community also became the initial locus of the artist's entanglement of her creative practice with her intimate life (Lauria 2008, 10); with them, Maresca organized semi-clandestine exhibitions and performances in often improvised spaces, encompassing theaters, galleries, and, on one occasion, a launderette. The lively events that Maresca convened blended individual and collective work, and frequently involved poetry readings and manic parties.

Carried out in collaboration with artists' collectives Puro Taller de Arte (PTA) and TAF, one of Maresca's early performances was part of a series of underground participatory events conceived of as expressions of public dissidence against the dictatorship. Entitled *Masas* (Masses) (1982), the action was originally announced by word of mouth as a theatrical play, yet once the "public" (mostly consisting of other artists) arrived, they were asked to participate in the making of a gigantic human-shaped bread with 100 kilos of dough (*masa* in Spanish, which is also used to refer to a crowd of people). According to artist Fernando Bodoya, who participated in the action, after collectively shaping the soft body, they decorated it with junk objects, like screws and broken dolls, and with little banners containing popular sayings about "bread" (*pan*)—such as "contigo pan y cebolla," meaning "together through thick and thin." TAF published an accompanying leaflet, which stressed the societal necessity for art as being similar to other vital functions, like "eating, sleeping, and making love." The leaflet then described a situation in which artists, alongside the working classes, were experiencing "hunger for knowledge" by living in a context of extensive censorship and a cultural shutdown. Their coming together in this action, they claimed, was therefore tantamount to a "clandestine orgasm" in the struggle for "a more creative and less miserable life" (March and Wain 2008, 134).

According to María Laura Rosa, Maresca, like no other figure, is associated with the "effervescence" that followed Argentina's return to democracy in 1983, with her work being characterized by a sense of joy and (sexual) liberation (Rosa 2011, 343). In *La kermesse: El paraíso de las bestias* (The Kermesse: The Paradise of the Beasts), organized in 1986 at Centro Cultural Recoleta, Maresca and Daniel Riga brought together artists, rock and punk musicians, sound designers, poets, actors, and many others to take part in a series of experiments in artistic collectivism modeled on the idea of the local *kermesse* or carnival. Participants wore costumes, played *Wheel of Fortune* and darts, took pictures of themselves next to "idols" Diego

Armando Maradona and president Raúl Alfonsín, danced uninhibitedly, and made recurrent references to sexual desire, to the point of attracting the attention of the police—which threatened to close down the show when they saw a man on stilts wearing a plush device that resembled a penis (March and Wain 2008, 139).

Longoni describes these carnivalesque gatherings "as a territory of political insubordination," capable of calling into question the processes leading to the normalization of identity and subjectivity (Longoni 2011b, 20): "The undisciplining of bodies is manifested in terms of a sexual—and political—dissidence, which questions heteronormative attributions of gender and sexuality, and even certain 'homonormative' corsés. Dancing bodies, in movement, cross-dressing; unpredictable, collective dance without rules, parties, improvised parades, these provoke bodily becomings which undo any stable identity" (20, emphasis added). The disclosure of desire in Maresca's public gatherings therefore entailed both a provocative critique of prevailing morality—seen as a constraining corset—and a parodic undoing of fixed conceptions of sexual identity. Those events belonged to what is broadly remembered as la movida under (the underground scene), consisting of "a series of [. . .] performances, recitals, and exhibitions" taking place in marginal spaces and often turning their back on moral codes (Lucena and Laboureau 2014, 59).[17] They included venues like the Parakultural Hall and Teatro Abierto, the focal points of underground theater, and much smaller salons and bars like Vértigo, Cemento, La Imprenta, Freedom, Eat and Pop, and Crash. For Jacoby, this underground scene deployed a "strategy of joy" (estrategia de la alegría) in order to respond to the conditions of dictatorship with play, sex, poetry, performance, drunkenness, and dance.[18]

That joyful and desiring strategy contrasts with the so-called political or protest strategy of the Mothers of Plaza de Mayo and other activist and human rights organizations. The Mothers constructed their public image in accordance with the Marian ideal, to the point of representing themselves in their own publications as imprisoned virgins (Amigo 2005, 220). The artists closer to the underground music, theater, and art scenes, like Maresca, often defined their (sexual) identifications in opposition to this ideal. For them the visualization of the desiring woman was central to challenging the prevailing disciplinary matrix in the aftermath of a brutally repressive (Catholic) dictatorship. Ferrari's art is situated somewhere between these clashing understandings of the subversive power of the feminine. Throughout the years, he remained a supporter of the work of the Mothers, collaborating in several of their public events and even being granted a prize by Madres-Línea Fundadora in 1997.[19] However, the artist's provocative approach to nudity and sexuality comes closer to the movida under—in which, from the early 1980s, Maresca reclaimed the importance of keeping the naked body in sight.

Crucially, Maresca preceded Ferrari in creating a series of sculptural works portraying the female body as a rigidly cast territory. Around 1982, she began using

materials she had recuperated from open dumps and the streets (including wood, wire mesh, plastic, aluminum, and rubber) to assemble corset-like prosthetic torsos with voluptuous breasts, but lacking any allusion to the body's genitalia. The following year, the artist found herself posing naked before these torsos in a photo-performance developed in collaboration with the Argentine photographer Marcos López. Named *Maresca con su obra* (Maresca with her Artworks), this series of pictures features Maresca attempting to make her bare body fit inside her own unbending creations (Figure 4.6). The artist's self-presentation within, around, and before these objects points toward a critique of the role of corporeality in the disciplining of the self. Yet the photographic performance also goes beyond this critique. Her torsos not only constrain the body, they also reimagine it as capable of being prosthetically expanded and refigured, turning corporeality into a host of alterity. Made of recycled materials, together with the dummy mask Maresca alternately wears and places to one side during the photo shoot, these torsos are evocative of a subjectivity made of recovered fragments of reality and thus capable of being performatively constituted and diluted, rather than being strictly determined by biology. This artistic operation parallels the artist's fluid gender identifications, which were central to her romantic life and artistic persona. Moreover, the photographs immerse Maresca's body within the corpus of her oeuvre, actualizing an understanding of performance art that allows for continuity and complementarity between live and object-based art.

Such bridging of practices is important to our discussion of the ways in which Maresca's work might have influenced Ferrari's performative approach to collage in the 1980s—conceiving of it, as I suggest in the previous chapter, as a practice inviting direct contact between the bidimensional image and the body of the spectator, and where the meaning of the work remains open to each singular encounter. Pointing at this possible influence to attribute greater originality to Maresca would be methodologically problematic, as there are no direct references to Maresca in Ferrari's mannequins and collages. Each body of works is, ultimately, markedly distinct. What their affinities clearly illuminate, however, is a broad cultural shift in the relationship between the physical body of the artist (and spectator), on the one hand, and his or her artistic corpus, on the other. Maresca's art was instrumental in the occurrence of this shift, which I describe as a performative turn.

It is nevertheless significant to mention that the same year in which Ferrari's exhibition *Cristos y maniquíes* took place (which is also the time when he traveled to Mexico to give his lecture and Maresca succumbed to her illness), both artists were video-recorded holding a conversation about Maresca's work. The conversation was part of a planned video-catalogue for Maresca's 1994 exhibition at Centro Cultural Recoleta, entitled *Frenesí* (Frenzy).[20] While the catalogue itself was never completed due to Maresca's death in the midst of its creation, in 2008, Adriana Miranda recuperated and edited the footage to make a film about her admired friend and collaborator. This film is key for our discussion both for being

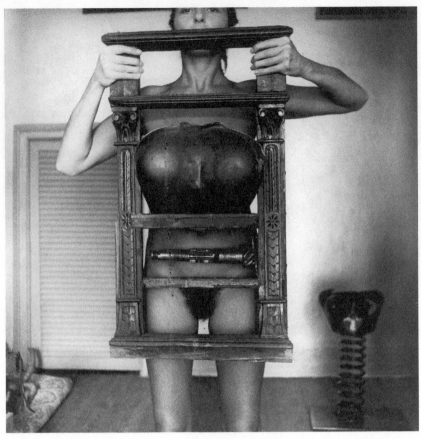

FIGURE 4.6. Liliana Maresca, *Untitled: Liliana Maresca with her Artworks*, 1983. Photo-performance photographed by Marcos López. Gelatin silver print, 50 × 60 cm. Courtesy of Rolf Art, Almendra Vilela and Marcos López.

a record of direct dialogue between Ferrari and Maresca and for the way it unveils similarities and differences between Ferrari's and Maresca's respective approaches to a politics of Eros. From what one can observe in the video, their gathering took place on a set entirely covered by a large, sky-blue cloth or canvas (Figure 4.7). In this empyrean environment, the artists begin their conversation by evoking the story of the Fall. Ferrari says: "Vos tenés que empezar desde el principio, cuando estaban Adán y Eva" (You have to start from the beginning, with Adam and Eve). As he situates the viewer's imagination in this Edenic moment, Maresca seems to embody Eve's laxity by holding a cigarette and a glass of liquor. Ferrari, in turn, carries a folded piece of paper, reminiscent of the association of masculinity with writing, knowledge, and the divine word. This contrast between desire, on the one hand, and discourse, on the other, also emerges in the course of the conversation, as Ferrari proceeds to describe Eden as characterized not only by the absence of

FIGURE 4.7. Still from the video-catalogue *Frenesí*, 1994/2013, 39:54 min. Directed by Liliana Maresca and Adriana Miranda. Available at https://vimeo.com/89182026 (accessed January13, 2015). Courtesy of Adriana Miranda.

concupiscencia (concupiscence) but also, according to biblical scripture, by general ignorance, due to God's prohibition to eat from the Tree of the Knowledge of Good and Evil. Both artists therefore express their self-identification as "fallen" creatures, but for different reasons: while Maresca's fall is the consequence of her frenetic lust, Ferrari's came as a result of his embrace of forbidden or heretical knowledge.

The exchange between both artists unfolds as a sort of biblical lesson, during which Ferrari puts his heretical theology to the service of praising Maresca's art, while she mostly listens, interjects with brief comments, and laughs. She stares at Ferrari uninterruptedly and tilts her body toward him, in a gesture revealing her respect for this true emblem of the older generation of political artists. Yet, as Ferrari's "biblical lesson" comes to a close, the gender and generational divides running through the scene—alongside the respective tensions between knowledge and desire, political art and light art, commitment and nihilism—give way to a more complex terrain in which these binaries falter. At this point, relying on his usual intermingling of history and myth, Ferrari constructs a continuum running from biblical times to the present, wherein, as he puts it, "fallen" women, like Maresca, "con la colaboración de Satanás" (with the help of Satan), have played

a primordial role in the fight against ignorance. "Tu obra," says Ferrari as the conversation concludes, "forma parte de esa necesidad del conocimiento que nos regaló Eva" (Your work is part of that need for knowledge that Eve gave us).

Maresca's passing not long after the shooting of this scene—and only weeks after the opening in November 1994 of her exhibition at Recoleta—casts a shadow over the video's joyful celebration of female sexuality and heretic belief. Her tragic affliction exposed an unspoken, ex-scripted, or perhaps repressed dimension of the two artists' conversation: the fact that sexuality in the late 1980s and early 1990s was transformed from the frenetic celebration of pleasure in the underground cultural scene during the early 1980s into what Pineau describes as "un espacio riesgoso" (a space filled with risk) (Pineau 2013, 180). Among the many artists and musicians who died during those years from AIDS-related illnesses were Federico Moura (1988), Daniel Melgarejo (1989), Batato Barea (1991), Omar Schiliro (1994), and Maresca (1994).[21] As Susan Sontag points out, at that time people with AIDS were effectively identified as members of a certain "risk group" (Sontag 1989, 25). This treatment of risk was part of a "panic logic" that proliferated through "phantasmatic sites of erotic danger" (Butler 1993b, 10). In other words, the fear of contagion intensified those "regimes centered on [controlling] [...] cultural sites of erotic exchange which threaten the hegemony of the traditional family within the political imaginary: women's bodies, pornography, prostitution, gay and lesbian sexuality" (6).

Beyond the biopolitical uses of erotic danger, the rising death toll in the midst of the epidemic and the undeniable possibility of becoming infected through sexual encounter became potent reminders of the corporeal vulnerability of the desiring subject (Butler 2004, 128). According to Jacoby, "The presence of the threat of death linked to sexuality was the dominant theme when Centro Cultural Rojas was inaugurated" in 1988 with an installation by Maresca entitled *Lo que el viento se llevó—La cochambre* (Gone with the Wind—La cochambre) (quoted by Longoni 2011a, 331).[22] Moreover, from the moment Maresca received her diagnosis in 1987, much of her art began to revolve around the theme of vulnerability, and the types of social relations resulting from this condition. In her 1993 photographic performance *Maresca se entrega a todo destino* (Maresca Gives Herself Over to Any Fate), the artist was photographed adopting a number of provocative postures while embracing nudity and self-touch with the infantilized naivety of a girl holding a teddy bear (Figure 4.8). This work was realized in collaboration with the mock advertisement agency Fabulous Nobodies, which signed one-page advertisements in underground magazines like *Revolver, Escupiendo Milagros,* and *Laberinto*.[23] Maresca's advertisement was published in *Laberinto* with the slogan "Maresca se entrega a todo destino," her phone number in large, bold letters, and the following text in small print: "la escultora Liliana Maresca donó su cuerpo a Alex Kuropatwa, fotógrafo, Sergio de Loof, trend setter y Sergio Avello, maquilladora, para este maxi aviso donde se dispone a todo" (Sculptor Liliana

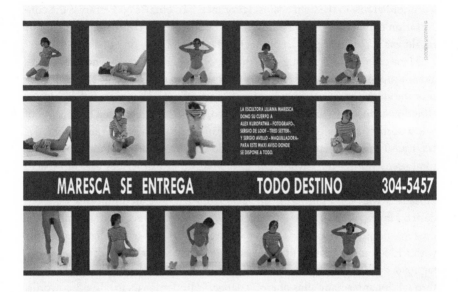

FIGURE 4.8. Fabulous Nobodies, *Maresca se entrega a todo destino*, 1993. Photo-performance shot by Alejandro Kuropatwa and printed in *El laberinto*, 8 (1993), Buenos Aires. Courtesy of Almendra Vilela.

Maresca donated her body to Alex Kuropatwa, photographer, Sergio de Loof, trend setter, and Sergio Avello, makeup artist, for this advertisement in which she's ready for all that may come).

Maresca's ad could be seen as a means to reference and critique artists' frequent need to "sell themselves" in order to enter the art market. In doing so it represents the artist as an innocent call girl having to juggle with all sorts of pressures and (sexualized) demands to stay in the business. The work anticipates more recent pieces by institutionally critical artists, like Andrea Fraser, who in 2002 videotaped a sixty-minute sexual encounter with an art collector who paid to participate in the work. However, read in the light of Maresca's personal history, her photographic performance may be seen as also going beyond a critique of the institution of art. It features the *entrega* (delivery/surrender) of one's body to any destiny, its ostensibly innocent exploration and exposure, and the willingness to surrender control of it as tantamount to entering a realm of absolute and possibly lethal uncertainty about one's future. As Pineau argues, only a year before Maresca's passing, at a time when HIV-positive patients constantly lived in fear of imminent death (since medications were poorly developed and difficult to access, while AIDS was considered a "full blown disease" [Sontag 1989, 28]), "the mention of 'destiny,' indiscriminate 'surrender,' was not accidental [. . .]. Among all possible destinies, the only certain one, and probably the most fearsome, was death" (Pineau 2013, 180). Yet *Maresca se entrega a todo destino* is far from being a desolate

work. By presenting herself as an eroticized or eroticizing being, the artist truly plays with the idea of having access to an unrestrained sexuality, a possibility likely curtailed by her disease. She also succeeds in leaving stigma to one side while offering her body for the public gaze. In the ad, each posture evokes a different destiny, and Maresca daringly presents herself as capable of performing them all.[24]

Another of Maresca's works themed around the vulnerability of the AIDS sufferer is particularly telling for the purposes of this chapter, for it has been seen as an attempt to revisit Ferrari's *La civilización occidental y cristiana* (Rosa 2011, 346; Hasper 2006, 34). The work was entitled *Cristo autotransfundiéndose* (Christ Autotransfusing Himself) (1988), and the artist made it by connecting a *santería* Christ (similar to Ferrari's) to a catheter for blood transfusion (Figure 4.9). The piece was included in the exhibition *Mitominas II: Los mitos de la sangre* (*Mitominas II: Blood Mythologies*). The show had been convened in 1988 by Monique Altschul at the Centro Cultural de la Ciudad de Buenos Aires (now Recoleta), as one of the early feminist exhibitions in the city and part of a series of gatherings and exhibitions exploring the place of myth in the social construction of femininity. Its title combined the Spanish word for myth (*mito*) with an Argentine localism for women (*mina*), yet it truly revolved around blood mythologies and brought to public attention matters like menstruation, AIDS, and gender-related violence (see Rosa 2007, 75). Within this landscape of defiant topics, Maresca's work is remembered as the exhibition's most shocking piece. Her *Cristo* had a wound at the level of the ribs, from which a blood-like fluid came out, flowing through his loincloth, legs, and feet. For María Laura Rosa, Maresca's "Christ with his bleeding sores [...] exhibits the taboos of the red liquid in the context of the AIDS epidemic" (2011, 346). In reality, the afflicted figure performs a number of roles. It references the Catholic Church's official response to the AIDS epidemic, which had been to describe the illness as a divine punishment "for those having left the good path" (346). Depicting Christ as a HIV-positive patient, the work also reclaims for the latter some of the compassion and self-identification with the suffering of the Other that some see as lying at the core of Catholic belief, that is, it presents the disease as a form of martyrdom that had received little pity from the allegedly most dutiful of people. In other words, the piece may be seen as cherishing Christianity's universalization of suffering while exposing the contradictions inherent in the Church's response to the epidemic.

Seen alongside Ferrari's 1968 piece, as a "quotation" of this much-lionized emblem of 1960s art, Maresca's assemblage enacts a shift in the public (re)presentation of suffering, going from the macropolitical concern with the torment resulting from the struggle against colonialism—present in Ferrari's work—to a micropolitical exploration of the intimacy of corporeal pain. The continuous flow of blood through Christ's body in Maresca's piece also adds a performative dimension to the stillness of Ferrari's assemblage, and cultivates a mid-terrain between the quiet permanence of sculpture and the ephemeral, live qualities of

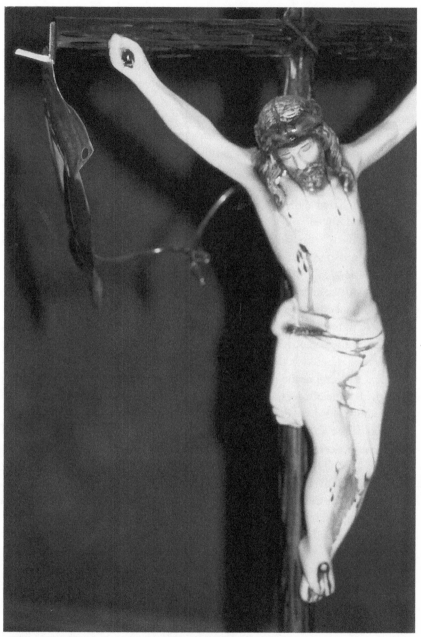

FIGURE 4.9. Liliana Maresca, *Cristo autotransfundiéndose*, 1988. Lost, unknown dimensions. Photo by Monique Altschul. Courtesy of Monique Altschul.

performance. Interestingly, the reaction of the priest of neighboring Church of Pilar to the inclusion of Maresca's work in this exhibition anticipated, too, what would happen sixteen years later, on the occasion of Ferrari's retrospective show in this same venue. The priest asked for the piece to be removed, considering it an offense to Christianity. A scandal followed, although Maresca's *Cristo* ended up simply being relocated to a "less visible" part of the show (Rosa 2011, 345–346). The work was then lost—just like Ferrari's original—and only one picture of it has been found. However, this piece is often evoked by those trying to recall those days of AIDS panic, post-dictatorship mourning, and feminist exposure.

A SCOURGE FROM GOD?

So far in this chapter I have presented a new reading of Ferrari's representation of the female body—in a state of vulnerability and exposure as it is "inscribed" with signs—in the context of post-dictatorship Argentina, focusing in particular on its relationship with the work of sculptor, performance artist, and cultural agent Liliana Maresca. I suggest that in order to understand Ferrari's attempts to intervene (provocatively) in the fabric of sensory experience through the display of female nudity, one must bear in mind not only the Surrealist overtones present in his series of collages and mannequins, but also the politics of desire during this period—when the body and, in particular "the sexed body" became a "privileged territory for poetic activation and political activism" (Badawi and Davis 2012, 92; see also Alonso 2005, 94). According to Halim Badawi and Fernando Davis, this emergent form of "sexual disobedience" led to "new forms of connection between art and politics, inscribed in a displacement of the macro-political—typical of the utopian revolutionary projects of the sixties and early seventies, and mobilized by the need to transform, in a radical and definitive manner, the conditions of existence—in favor of the micro-political, namely, the question of the production of subjectivity and the construction of 'new modes of singularizing subjectivation'" (Badawi and Davis 2012, 92).

This shift toward the micropolitical in artistic practice, which combined the use of new creative languages, such as performance art and *acciones de arte*, with political activism, took place in various places across Latin America during the 1980s, even in countries where dictatorial regimes were still in place, like Chile. The visible synchronicity of these developments has not been sufficiently investigated, yet they coincide with a profound crisis of traditional political identities across the subcontinent. Moreover, the artistic thematization of "sexual disobedience" in various Latin American countries in the 1980s responds to larger feminist, gay, and queer movements advocating for both positive and negative liberties in relation to sexual preference.[25] This nascent form of political art that sought to bring intimacy to the public domain may therefore be seen as a Latin American

instantiation of what Pollock characterized as an avant-garde moment "in, of, and from the feminine," seeking "to create knowledge about the *feminine* that existing discourses or practices could not or did not provide" (Pollock 2010, 801). Furthermore, these practices also challenged the centrality of "women" in the feminist movement, as part of a larger questioning or "queering" of essentialist forms of self-identification.

Having examined the ways in which Ferrari's treatment of feminine nudity was not only rooted in his revision of Argentina's recent disciplinary history but was also contemporaneous with the struggle for sexual rights in the post-dictatorship years, I conclude by discussing a final example that illuminates Ferrari's late approach to a politics of Eros. The year after Maresca died, Ferrari participated in *Erotizarte II* (1995), an erotica exhibition at Recoleta that claimed to pay homage to Maresca, Schirilo, and Barea, all deceased from AIDS-related illnesses. This show included some of these artists' works; however, to the surprise of many, they remained unidentified and were subsequently excluded from the catalogue. Outraged by what he deemed a case of censorship, Ferrari published an article in *Página/12* drawing a parallel between those who had supported the military regime, turning each of the regime's victims into a suspect (with the famous accusative phrase *por algo será* [there must be a reason]), with those who blamed AIDS victims for their condition (claiming: "la culpa es suya seguramente por *libertino, homosexual, drogadicto, sodomita, promiscuo*" [the guilt is surely his/hers for being a *libertine, homosexual, drug addict, sodomite, or promiscuous person*] [Ferrari 1995, n.p., original emphasis]). Moreover, the artist critiqued Christianity for providing an ideological justification for the punishment of supposedly "illicit" sexual acts, arguing that at least since the dictatorship, censorship in Argentina (in the hands of Comité Federal de Radiodifusión, COMFER) was based on a Church-authorized, therefore limiting and guilt-ridden, notion of sexuality. To this, he added that in 1987 the Latin American Episcopal Council appallingly considered AIDS "un azote de Dios" (a scourge from God).

Both the omissions of the *Erotizarte II* exhibition and Ferrari's article led to a heated debate about sexual discrimination in Argentina and, in particular, the country's failure to recognize and mourn the victims of the AIDS epidemic. As with some of his other public statements and artworks, despite the centrality of religion in the artist's intervention, its dissensual politics resulted from its capacity to construct meaningful parallels between Argentina's recent past and those problems afflicting the present. Similarly, the artist created controversy by mentioning specific people and institutions. In consequence, he demanded a response that, while not tangible, remained imaginable, and set a horizon of change rooted not in some revolutionary transformation, but in a transformation in people's attitudes and beliefs, practices, and ways of seeing—largely on an individual basis, but eventually on an institutional basis as well. All these elements in Ferrari's public intervention reveal the renewed idea of the political guiding his aesthetic

practice in the aftermath of the dictatorial experience. These reflections therefore close the arc that I began to trace in the previous chapter, by looking at the fundamental shifts in Ferrari's art in the aftermath of the dictatorship, and his relentless search for new forms of political art that would not fall hostage to a melancholic nostalgia for the "golden" sixties. As we have been able to observe in the discussion of the relationship between Ferrari's and Maresca's art, Eros played a key role in this new understanding of the political. The visualization of nudity was felt to be a necessary condition to disentangle the body's many inscriptions and the ethical relations resulting from its inescapable vulnerability. In the next chapter I broaden this discussion by examining Marcos Kurtycz's "profanatory" performances in the context of post-1968 Mexico, where destruction, exposure, institutional critique, and self-undoing became densely intertwined.

5 · RITUAL AND/OF VIOLENCE

L'intimité est la violence. (Intimacy is violence)
— Georges Bataille, *Theory of Religion*

The profanation of the unprofanable is the political task
of the coming generation.
— Giorgio Agamben, "In Praise of Profanation"

Marcos Kurtycz moved from Warsaw to Mexico City in 1968, the year Mexico saw the bloodiest repression of a student movement in its recent history. When he left Poland, Kurtycz was an amateur artist and mechanical engineer with expertise in the then-growing field of cybernetics. In the years following his transcontinental journey, he became a pioneer of performance and mail art, who developed a unique intermedial aesthetics that combined live actions with printing practices—or printing rituals, as he called many of them. Partly due to Kurtycz's foreign origin and to the great complexity and ingenuity of his approach to live performance, during the early days of his artistic career, his actions were often poorly understood by local critics. In his fleeting appearances in the press of the 1980s, the artist figured not as a radical and innovative creator but as a "shaman" (Appi 1985, 6), "exorcist" (Mariotte 1985, 3), "magician" (3), and even "cultural terrorist" (Cortés 1985, n.p.). The abundance of such striking terms in the small number of press reviews of Kurtycz's live art is symptomatic of the difficulty to locate his creative practice within prevailing conceptions of the meaning and limits of art in post-1960s Mexico. To give an example, a newspaper review of one of his actions defines performance art in general as a "mariguanada" (bunch of baloney) (Mariotte 1985, 3) while another characterizes one of Kurtycz's performances as "inaudito" (unprecedented) (Appi 1985, 6). Yet it is significant that these articles describe the spectatorial response to Kurtycz's live acts as consisting not just of curiosity but also deep emotion: "[The artist] kept everyone rapt with attention [. . .]. This attention-tension went to the essence of what prevails during rituals and ceremonies" (Mariotte 1985, 3). "We started to break out in goose pimples and the hairs on the backs of our

necks stood up"; "nobody took photos for fear that the light of the flash would freeze in mid-air" (Appi 1985, 6).

The feelings of angst and fascination that Kurtycz's live performances provoked among his audiences were triggered by the ritual unfolding of his seemingly unscripted and often violent choreographies. In these performances, the bare-chested, axe-carrying artist recurrently shocked audiences with loud gunpowder explosions that set objects on fire and put his own life at risk. During the various months I spent exploring his archive in Mexico City between 2011 and 2017, I was therefore confronted with an immensely rich body of creations that resists facile conceptualization. I was also struck by the extent to which the themes of ritual and war are present and intersected in the large majority of his creations. Having experienced the violence of Nazi-occupied Poland during his childhood, Kurtycz returned to these memories in actions like *Pasión y muerte de un impresor* (1979), *Un libro diario* (1984), *Cruz Cruz* (1984), and *Kontrol Remoto* (1987). And the artist combined these personal memories of war with an exploration of the role of death, sacrifice, and ritual in Mexican culture, returning to a theme that had fascinated such dissident Surrealists as Georges Bataille and Antonin Artaud. Moreover, Kurtycz termed several of his live performances "rituals" (such as *Ritual de Impresión* [1980], *Ritual de Raíz* [1982], and *Ritual Agreste* [1987]), and he developed an iconography that was deeply infused with local symbols, including maize, Quetzalcoatl/the feathered serpent, the skull, and tzompantli, among many others.

Kurtycz's interweaving of references to ritual and war was further bound to a critique of the conditions of artistic production in Mexico. His work was indeed permeated by a self-reflexive engagement with a struggling artistic community, both marginalized from official institutions for their critical views and collectively driven toward challenging the accepted boundaries of artistic practice. As I argue in this chapter, during the late 1970s and 1980s the artist's profane use of seemingly ritual violence was principally directed against Mexico's heavily authoritarian official art institutions, which he attacked through a series of ritualized mock-guerrilla assaults. These assaults aimed to expose the institutions' curatorial conservativism while staging new modes of relationality between artist and public. During these years, (performatively) violent attacks against the country's official art scene were also enacted by young critical artists and artists' collectives. Yet, like Kurtycz, they approached violence with an ironic distance that lent more attention to its shocking or spectacular force than to its destructive potential.

Kurtycz's performances therefore compare with the work of Mexican artists' collectives Proceso Pentágono and No Grupo, whose live actions denounced the country's authoritarianism by (playfully) simulating the language of undercover warfare, in a similar way that South American artists in the 1960s developed what Luis Camnitzer (2007) describes as a guerrilla aesthetics. Yet, as I discuss in the following pages, the way in which Kurtycz entwines the violence

of avant-gardism and institutional critique with a ritual treatment of the body and the art object is thoroughly singular. I therefore seek to disentangle what Mónica Mayer, in speaking of Kurtycz's work, identifies as "an unusual force" present in the artist's art "that could combine violence and vulnerability" (Mayer 1996, 2). Such a hybrid aesthetic played a lasting role in the renewal of Mexico's art scene during the 1970s and 1980s, triggering innovative institutional dynamics,[1] influencing younger performance artists, and creating the conditions for a larger performative turn within the country's alternative art circles.[2]

This chapter is structured as an exploration of the multiple dimensions of Kurtycz's approach to violence, which situates them in the context of what has been described as Mexico's "Dirty War" (c. 1968–1980). The latter process parallels the "dirty wars" in Chile and Argentina in the state's unlawful use of force against its own population, employing torture, forced disappearance, and other strategies to spread fear. Yet Mexico's Dirty War also differs from these experiences in that it never resulted in an outright military coup or suspension of parliamentary democracy. Indeed, the appearance of normality in Mexico's institutional life, combined with effective strategies for co-optation and silencing, led writer Mario Vargas Llosa in 1990 to describe the country as a "perfect dictatorship," characterized by the complexity of its methods of camouflage. These methods involved a proximate relationship between the state and a tactically critical intellectual elite, the veiling of social exclusion and inequality through a rhetoric of nationalism and revolution, and the careful administration of changes in the leadership to guarantee the continuity of the one-party rule of the Partido Revolucionario Institucional (PRI). That political model effectively kept the PRI in power during a seventy-year period from 1929 to 2000. Yet at the time of Kurtycz's arrival in Mexico, the country was experiencing one of its most serious political crises of the twentieth century, which showcased this regime's profound authoritarianism.[3]

THE DIRTY WAR

On October 2, 1968, days before the opening of the locally hosted Olympic Games, paramilitary police opened fire on a peaceful protest at the Plaza de las Tres Culturas in Tlatelolco, Mexico City. Scores of students were massacred, and their bodies rapidly disappeared overnight; many other students and laymen were imprisoned and tortured.[4] This brutal abuse of state power inflicted a deep wound on the country's student and labor movements, while exposing the impunity and disregard for fundamental rights that lied at the core of the PRI regime. In the wake of the student massacre, the state persecuted the remaining oppositional forces, in particular two peasant guerrilla movements that sprang up in the South of Mexico: the National Revolutionary Civic Association (ACNR), led by Genaro Vázquez, and the Party of the Poor (PDLP), led by Lucio Cabañas. According to Alexander Aviña, this rural insurgency was tied to a "long historical process of grassroots

civic activism," which the PRI regime had tried to repress with targeted assassinations, massacres, and the use of torture (Aviña 2014, 5). After years of using force primarily as a mechanism of self-defense, these groups became increasingly radicalized, to the point of collectively preparing for the "violent overthrow of the PRI regime and the radical socialist transformation of the Mexican state" (5). They mobilized *campesinos* (peasants)—in their own words—"to take over [towns] and retake the wealth of the rich [*ricos*] since that wealth actually represented the sweat of the laboring exploited poor" (142). At the start, their guerrilla tactics relied more on issuing threats against *caciques* and landowning elites than on carrying out violent assaults, since they were very poorly armed. Aviña recounts, for example, that in May 1969, the armed branch of the Army of the Poor released a communiqué recalling a massacre of peasants that had occurred two years before in Atoyac; the comuniqué announced that they had not buried their comrades, but they had "planted" them, for justice to sprout from them. Then they continued: "When we begin to kill, tyrants will die, the same tyrants that ordered the massacres of campesinos and students [. . .]. It's our generation's turn to exact demands from the Priísta government that betrayed the [1910] Revolution" (quoted by Aviña, 146). Guerrillas did occasionally kill *caciques* and ambush military and police caravans. They gradually scaled up their use of violence until kidnapping Senator Rubén Figueroa, whose rescue operation resulted in the killing of Lucio Cabañas in 1974.

The government responded to this manifest threat to the continuity of PRI hegemony by using counter-insurrectional tactics that differ little from the repressive strategies used by the Chilean and Argentinean dictatorships, which I discuss in previous chapters. These include rape, forced disappearance, strategic hamlets, death flights, massacres, and mass detentions (Aguayo 1998; Aviña 2014). The Mexican state deceptively presented them as strategies of "pacification," yet their aim was to annihilate the guerrillas, crush the rural organizations that supported them, and disappear the evidence. Subsequent governments' staunch reluctance to investigate these abuses of state power, punish those responsible, and nourish a culture of memory and retribution around the Mexican Dirty War has meant that we know little about this period of Mexican history, and certainly much less than Argentines and Chileans know of their own countries' recent histories. Yet scholars and activists have not ceased collecting oral testimonies and other sources of state repression during those years, to the point that we begin to understand the extent to which the Mexican version of authoritarianism during the 1970s also entailed serious, mass-scale human rights violations in a Cold War context in which organized guerrillas imagined the violent overthrow of the regime.

Oliver Debroise and Cuauhtémoc Medina argue that the repression of the student movement and of the Southern guerrilla insurgency also "marked the beginning of a period of cultural repression," which especially affected young artists and so-called alternative art circuits (Debroise and Medina 2006a, 23). Acts

of explicit and veiled censorship were accompanied by a blatant disregard for new media in public museums and a lack of state support for politically or institutionally critical art, resulting in what the authors describe as "institutionalized amnesia" regarding more than two decades of Mexican art—spanning from the late 1960s to the early 1990s. Recovering the history of performance art in Mexico, and in particular of the work of Marcos Kurtycz, has therefore involved digging into a number of private archives to find the remnants of that which had been deliberately excluded from official institutions. Equally, it has entailed identifying a number of cracks within official art circles that young and experimental artists managed to penetrate, leaving traces of an ongoing revolt against the state-sponsored aesthetic.

This chapter will almost fully revolve around one of Kurtycz's early performances, entitled *Potlatch* (1979) after Bataille's writings on this notion. This piece has particularly striking qualities, which involve the clandestine infiltration of an exhibition and the public destruction of a work of art. In contrast to other forms of "destructive art" practiced in Britain, Argentina, and elsewhere in the 1960s and 1970s, this performance was more than a sheer revolt against the "art institution" and the commodification of art; it incorporated various ritual elements and pointed toward the celebration of loss over accumulation, contact over confinement, and self-critique—if not self-sabotage or self-erasure—over conceited self-affirmation. The seemingly clashing intentions present in the performance therefore lead me to analyze it according to different logics that may organize the aesthetic deployment of violence, including iconoclasm, warfare, (ritual) profanation, terror, and self-critique.

I begin this discussion by situating Kurtycz's *Potlatch* within a longer history of destruction in art, and examining key episodes in the trajectories of destructive or auto-destructive art from the 1960s on. This will allow me to revisit Camnitzer's seminal thesis on the affinities between guerrilla warfare in the Southern Cone during the 1960s and 1970s and the discourses and strategies of conceptualist art in the region. I then consider the relationship between art and political violence in Mexico during the same period, focusing on the work of two collectives of young artists—Proceso Pentágono and No Grupo—that used (seemingly) violent tactics, including staged guerrilla assaults, to express their discontent with both the authoritarianism of the PRI regime and the conditions of artistic production in the country. Kurtycz's interest in ritual destruction and his singular reading of the writings of Bataille will later on take us to the specific terrain of ritual, bringing our attention to the relationship between ritual and performance art. The last two moments of this reflection on art and violence, seen through the looking glass of Kurtycz's work, will engage, first, with the arguable similarities between critical art and terror and, second, with the late twentieth-century conception of art as a self-reflexive—and possibly self-sabotaging—practice, in which the figure of the artist, too, becomes an object of scorn. The distinctions that I

make throughout the chapter about the different uses of violence in art will ultimately allow me to suggest that in Kurtycz's *Potlatch* the political critique of the art institution, the affective mobilization of fear, the self-critical destruction of the artist's persona, and the embodiment of a "secular rite" continuously "look back" upon each other. As I intend to show, the artist's destruction, or more precisely ritual transformation, of his painted canvas during *Potlatch* is not only an attack on an art object but also an intervention in a particular artistic regime and constitutive prohibitions.

POTLATCH

On the evening of November 1, 1979 (the "Day of the Dead"), while a group of artists celebrated the opening of the exhibition "Muertos en el Foro" (Dead at the Forum) at the Forum of Contemporary Art (FCA) in Mexico City, Kurtycz made a semi-clandestine entry into the gallery in order to destroy publicly an abstract, unframed painting that he had made in his workshop over the past months. As detailed in the script of this action—which the artist wrote using a typewriter and then kept in his personal archive—Kurtycz understood this live action as a *potlatch*, or what Bataille, following Marcel Mauss, conceptualized as a "gift of rivalry" (Bataille 1988, 63). The script reads: "The work, manifestly gothic, involves the ritual destruction of an object that is significant to the author by way of a ritual that puts both performer and audience at risk. This is a certain form of sacrifice known by the name of potlatch. This particular sacrifice is analyzed by Salvador Elizondo and George [*sic*] Bataille in the prologues to Bataille's *Madame Edwarda*."[5]

It was not Bataille but Elizondo who included Bataille's comments on sacrifice, in particular Aztec sacrifice, in the prologue to his translation of the former's erotic novella, *Madame Edwarda*—which was published under the pseudonym "Pierre Angélique" in 1937. The story describes the encounter of a man, the narrator, with a prostitute, who, as the text unfolds, reveals herself as God. As Petra Dierkes-Thrun suggests, in this text "Bataille proposes inextricable links between physical excess and sublimity, on the one hand, and outright horror, on the other" (Dierkes-Thrun 2011, 49). Elizondo's further inclusion of references to Aztec sacrifice in the Mexican edition of the novella intersects Bataille's treatment of Eros with his (skewed) fascination for Aztec culture, in particular with what Bataille describes as the "movement of violence that animated Aztec society" and the forms of "intimacy" that it generated (Bataille 1988, 55). Bataille derived his understanding of what he called the Aztecs' "worldview" from Franciscan friar Bernardino de Sahagún's sixteenth-century *La historia universal de las cosas de Nueva España* (General History of the Things of New Spain), an ethnographic study of Mesoamerican cultures, also known as the *Florentine Codex*. Bataille argued, based on Sahagún's account of Aztec sacrifices, that this culture was "singularly and diametrically opposed to the activity-oriented perspective of"

modern European societies: while the former celebrated *dépense*, or useless consumption, the latter focused on work and production; while the former practiced rituals of excess, deploying "uncalculated violence," the latter privileged a rationale of accumulation and containment (46). "Sacrifice is heat, in which the intimacy of those who make up the system of common works is rediscovered. Violence is its principle," writes Bataille in his discussion of these rituals (59).

This same understanding of a ritually imbued sacrificial or gift economy traverses Kurtycz's live action at the FCA. The score specifies that *Potlatch* was carefully divided into eight steps or moments, beginning with Kurtycz's abrupt and bare-chested entry into the venue. His arrival was not just sudden and unforeseen but also involved carrying a series of objects, including an axe, a bunch of marigold flowers (*flores de cempazuchitl*), and a *petate*, whose presence in a *vernissage* could only seem strange, if not openly dangerous.[6] The artist then proceeded to prepare the setting for his ritual. In perpendicular alignment to one of the gallery's empty walls, he unrolled the *petate* on the floor and used soil to outline a human silhouette on its surface. Focused and silent, he continued by placing one plinth on top of another and climbed onto them in order to hang and fully unfurl what would become the sacrificial offering: a large abstract painting featuring formless white stains on a very long and unframed dark canvas (400 × 120 cm).

This painting, in itself, is intriguing. In the score, the artist mentions working on it for several months, using a "sophisticated solar technique" that combined the application of chlorine directly on the canvas with long periods of solar exposure.[7] The process of preparing the "offering," like the live performance, therefore involved coupling the use of corrosive elements and the (seemingly ritual) wait for their effects to become visible. Moreover, Kurtycz's interest in Bataille's writings invites a perhaps coincidental but no less meaningful association of this solar technique with Bataille's *L'anus solaire* (The Solar Anus, 1927). In this text the French writer dwells on the destructive powers of the sun, a symbol that he associates with the violence of erotic desire and with the corporeal function of excretion. Furthermore, Bataille describes the world as being purely parodic, each thing being "the parody of another, or [. . .] the same thing in a deceptive form [. . .]. Air is the parody of water. The brain is the parody of the equator. Coitus is the parody of crime" (Bataille 1985, 5). Kurtycz's "offering" was clearly the parody of a painting, and possibly the parody of a performance and/or ritual too. The artist located his interest in live art precisely in the possibility of exploring the aesthetic effects of this undecidability.

Upon hanging the canvas on the gallery wall, the artist tautened its lower edges with two rocks to secure the fabric at an angular incline. He then attached the bunch of flowers to the canvas' uppermost edge, concealing a bottle of corrosive acid behind them. His vertical and horizontal movements unfolded like a care-

fully choreographed dance, wherein various objects associated with death and repose were carefully laid out, so as to create an ephemeral "Day of the Dead" offering or installation. Meanwhile, a number of people started to form a circle around him. They were certainly unaware of the artist's intention to pull an axe from his belt and firmly smash the hidden bottle, causing the burning substance to spill over the canvas and slowly turn it into shreds. By exposing (*déchirant*)[8] the painting's debased materiality, the fall of the acid marked a break in time and a spectacle of definitive destruction in which a painting that had been ritually produced was "sacrificed" to fill its loss and ephemerality with meaning, while collectivizing it as a shared experience. The *cempazuchitl* flowers fell on the *petate* after receiving the stroke of the axe, landing on a now-disfigured and pierced human (soil) silhouette. According to the timing recorded in the score, this ritualized dance and attack lasted for roughly thirty seconds. As a whole, however, the action must have taken much longer, starting with the artist's attempt to disrupt or sabotage the exhibition opening, then unfolding as the ritual profanation of a work of art in a space usually reserved for its consecration, and finishing with the artist's direct interpellation of the public by producing a situation of uncertainty and potential danger that suddenly entailed a shared experience of witnessing loss.

Performed on the day of one of Mexico's most enthralling festivities, Kurtycz's *Potlatch* revolves around the symbolism of death and its annual celebration in this country. Yet the artist shifted the focus of this ritual from the memorialization of an individual or a group of people to the loss of an artistic object and the ephemerality of live art itself. The artist's surreptitious ritual was also uncannily akin to an undercover guerrilla operation, a significant resemblance at a time when guerrilla movements in Mexico and Latin America were an important element of the political and artistic landscapes. As I discuss later in this chapter, following Camnitzer's polemical thesis in *Didactics of Liberation* (2007), guerrilla organizations and their (often spectacular) assaults not only occupied a prominent place in the public imagination during the 1970s, but they also played a transformative role in the shaping of the languages and practices of conceptualist art. I seek to establish a dialogue between Kurtycz's live art and this genealogy of Latin American conceptualism. Yet in doing so, I take into account the extent to which Kurtycz's art also explores the preoccupations of dissident Surrealists like Bataille and Antonin Artaud. By bringing together these distinct traditions—political conceptualism and dissident Surrealism—Kurtycz's live actions enriched and enhanced the complexity of the discourses that shaped the performative turn in Latin America during the 1970s and 1980s. They also raised new and fundamental questions about the role of violence and destruction in live performance. Let us now dissect, through successive scenes, the different uses and critiques of violence that are present in this piece, alongside their relationships with the role of destruction in art.

THE SCENE OF DESTRUCTION

If one examines Kurtycz's *Potlatch* from the perspective of a larger history of icon-oclasm, it becomes clear that this performance cannot be solely understood as a destructive piece, since acts of destruction in art are closely interwoven with pro-cesses of construction: of meaning, value, social prestige, and representations.[9] Major scholarly undertakings to distinguish between iconophilia and iconoclasm have repeatedly resulted in failure, that is to say, in the impossibility of drawing a clear line between the two. In *The Destruction of Art* (2007), Dario Gamboni con-cludes that "attempts to get rid of specific images [. . .] almost inevitably lead to a proliferation of new images," to the point that the histories of iconophilia and icon-oclasm are "not only inseparable but also sometimes indistinguishable" (Gam-boni 2002, 88–89). Along the same lines, Fabio Rambelli and Eric Reinders argue that "destruction is not the end of culture but one of the conditions of its possi-bility. Destruction *is* cultural activity, and also, at times, religious activity. The destruction of objects produces new meanings [. . .] damaged things may become more precious" (Rambelli and Reinders 2007, 17, italics in original). While this is all too evident in the case of relics and archeological vestiges, the history of the conservation and restoration of art and heritage is filled with various forms (and techniques) of removal, breaking, substitution, and transformation too. Further-more, the social history of vandalism (or the "willful destruction of art") suggests that the prohibition and condemnation of this activity was a condition of possi-bility for the rise of the modern notion of "artistic value," together with a dense web of institutional relations sustaining this idea (2007, 35). For this reason, Gam-boni posits that the modern understanding of the work of art as pertaining to an autonomous sphere is essentially the result of major iconoclastic episodes—such as the English Reformation or the French Revolution—in which objects and images that used to fulfill religious and political functions came under threat of destruction. In these contexts, the emergence of discourses positing the auton-omy of art served the function of protecting these objects from becoming wreckage (Gamboni 2002, 89).

Gamboni describes the 1960s and 1970s as the "Golden Age of neo-avant-garde iconoclasm" and identifies an impulse toward destruction that was mobilized by artists' willingness to bring to a halt the transformation of the work of art into a commodity (Gamboni 2002, 114). Bearing great similarities in the use of a vio-lent and inflammatory rhetoric with the historical avant-gardes of the 1920s, this period differs from previous avant-garde moments in the self-reflexivity that char-acterizes artists' approach to destruction. In other words, during these years art-ists accompanied their critique of the art market with a rejection of the (symbolic) authority historically attributed to the (male) artist and the imagined "artistic genius." A key voice of this simultaneously anti-objectualist and self-critical tendency is the German-born artist Gustav Metzger. In his 1959 manifesto

"Auto-Destructive Art," Metzger describes this practice as "a form of public art for industrial societies" aimed at critiquing consumerism, accumulation, and the pernicious forms of speculation fueling the art market in the Cold War era. For Metzger, after a maximum time span of twenty years, auto-destructive artworks had to return to their "original state of nothingness."[10]

Metzger's manifesto was largely a formalization of his own artistic practice. Since the late 1950s, he had experimented with what John A. Walker describes as "a form of Action-painting that involved applying acid with brushes to nylon sheets laid on glass" (Walker 2009, 5).[11] In 1960, he staged in London's Southbank Centre the *First Public Demonstration of Auto-Destructive Art*, a performative piece in which he placed a series of nylon canvases on a wall and then sprayed them with acid, thus tearing apart the nylon layer, in a similar way that Kurtycz's shreds his painting in *Potlatch*. By transforming the canvases into sheer ruins or remnants of the live action, Metzger's piece references his commitment to an ephemeral, non-consumerist aesthetic, and recalls the unprecedented experience of destruction lived during the Second World War. At that time, the risk of "nuclear annihilation" remained a threatening possibility, so Metzger's piece was also a form of protest against the auto-destructive frenzy animating Cold War politics (Wilson 2008, 187). In 1966, he convened the Destruction in Art Symposium (DIAS) in London's Africa Centre in Covent Garden. This event brought together international artists, poets, and scientists, including key representatives of the counter-cultural underground, such as Welsh artist Ivor Davies, Argentine Kenneth Kemble, Zambia-born John Latham, Austrian Hermann Nitsch, and Japanese Yoko Ono, among others. The symposium also involved happenings, poetry readings, and performances all over London, and it gained significant international attention, becoming a point of reference for artists interested in destruction based in Latin America.

Yet Latin American artists had been exploring the anti-aesthetic of destruction years before this event. A milestone in this history is the *Arte Destructivo* exhibition at the Lirolay Gallery in Buenos Aires in 1961. Convened and curated by Kenneth Kemble, and including works by Kemble and by Enrique Barilari, Jorge López Anaya, Jorge Roiger, Antonio Segui, Silvia Torras, and Luis Alberto Wells, the theme of the show was the repression of violence in the human psyche and the pleasure that results from its expression—a feeling animated by deep psychological forces, such as Freud's "death drive" and Jung's archetype of the "shadow," as psychologist José M. Tubio mentions in the exhibition's leaflet (Tubio 1961). The exhibition's most memorable objects featured a smashed bathtub, a wooden chair torn into pieces, and a wrecked couch whose protruding padding was suggestive of female genitalia, among other defaced objects. Reminiscent of Dada and Surrealism, the works were exhibited in a somber gallery and immersed in a soundscape of absurd and annoying noises. In his recollections of the show, López Anaya mentions that none of the objects were attributed an author and adds

that the exhibition "showcase[d] waste and garbage, accidents and deaths, noises, almost incomprehensible parlance and 'music' produced with all kinds of objects" (López Anaya 2003, 88).

Two years later, in Paris, Argentine artist Marta Minujín publicly burned all the artworks that she had created as an art student there, explaining her *happening* as follows: "I felt and believed that art was something more important for human beings than the eternity that only a few cultured ones could attain in museums and galleries; for me art was a way of intensifying life, of having an impact on the viewer by shaking him up, rousing him from his inertia. Why, then, was I going to keep my work? [...]. So that it could die in cultural cemeteries, the eternity in which I had no interest? I wanted to live and make others live" (Minujín 2004, 59). For Minujín, this search for life, as pure immanence, was impossible to reconcile with received ideas about art, wherein the enduring object was valued over fugitive experience, and more attention was bestowed upon lasting beauty than upon pressing and unacknowledged social realities. Her interest in the experiential and propositional dimensions of artistic practice anticipated the conceptualist shift toward what Argentine theorist Oscar Masotta described in 1967 (the year before Lucy Lippard and John Chandler published their seminal article on the same notion) as the dematerialization of art.[12]

The impulse toward dematerialization is arguably without violence, yet it shares with auto-destructive art an interest in the social, experiential, and epistemological dimensions of artistic practice, above and beyond the formal qualities of discrete artworks. Masotta describes dematerialization as an "anti-optical," and "anti-visual" aesthetic, driven by "the idea of constituting 'objects' [...] with the goal of speaking not to the eyes, but to the mind" (Masotta 2004, 214). Lippard and Chandler coincide with Masotta in the nonvisual emphasis of dematerialized art. They add that "the shift of emphasis from art as product to art as idea has freed the artist from present limitations—both economic and technical [...]. The artist as thinker, subjected to none of the limitations of the artist as maker, can project a visionary and utopian art" (Lippard and Chandler [1968] 1971, 270). Kurtycz's *Potlatch* is, however, closer to Minujín's accent on the live and ephemeral qualities of the new art—geared at opening uncertain spaces of possibility—than to Masotta's emphasis on the communicative powers of postwar avant-gardism. The live performance of destruction thus becomes a way to interrupt normality and to resignify art not as a series of (transcendental) objects but as a set of processes, rituals, and social relations. Destruction also becomes a means to challenge the commodification of art, but not to escape it completely, for auto-destructive art is also bound to the kinds of cycles of artistic revaluation and reappropriation that have been historically unleashed by episodes of iconoclastic fury.

THE SCENE OF WAR

If Kurtycz's art resists a primarily communicational or propositional description, it reveals other important points of convergence with what has come to be understood as Latin American conceptualism, particularly in the writings of Luis Camnitzer. The Uruguayan artist and theorist argues in *Didactics of Liberation* that the dematerialization of the work of art in Latin America carried unmistakably political overtones and was closely informed by the strategies of communication and propaganda deployed by left-wing guerrilla organizations. Focusing in particular on the Uruguayan urban guerrilla known as the Tupamaros or the National Liberation Movement (MLN), Camnitzer polemically posits that such organizations used violence principally to produce media effects, rather than to outdo the Uruguayan state (Camnitzer 2007, 65). Additionally, he sustains that the Tupamaros constructed their public image not by using traditional revolutionary iconography but by carrying out live actions in public spaces, planning each one according to the chosen site, and using performative strategies of make-believe: "It was the design of the operations that stood out and that led observers like Régis Debray to refer to the Tupamaros as a 'cultural phenomenon,'" writes Camnitzer. Their singular guerrilla tactics "prompted descriptions of their use of time and timing more likely to be found in discussions about filmmaking." Moreover, operations were often "conceived of as theater and planned accordingly" (49).

One of these was *La toma de Pando* (The Pando Siege), which began at 1 P.M. on October 8, 1969. This operation involved one hundred militants who performed a funeral procession with the goal of taking over Pando's political and economic institutions, including the police headquarters and four banks. The procession had been publicly announced as the ritual transfer of Mr. Brugueño's corpse to Uruguay, years after his death in Argentina. Five cars and a van were hired for this purpose and made their way from Montevideo to the small city of Pando, located twenty-five miles from the capital. The solemn convoy stopped several times to pick up more "relatives," "all of whom bore an appropriately funereal demeanor, most of them crying" (53). In reality Brugueño was the name of a nonexistent corpse, or rather, it was simply the most recurring surname in Pando's cemetery. Yet the coffin was not empty, but loaded with arms. And the person who planned this spectacular yet intimidating funeral, Mauricio Rosencof, was both a playwright and member of the MLN.[13]

Compared to Uruguay, Argentina, and other Latin American countries during the same period, the intersection of art and violence in Mexico during the 1970s and 1980s has received relatively sparse attention. However, artists who were active in those years and scholars agree that the radicalization of young and so-called alternative artists was closely linked to the 1968 student movement, its brutal repression, and a growing discontent with the authoritarian structures of the Mexican state (Acha 1993, 177; Gallo 2007, 168; Hijar 2008, 10).

In the aftermath of the Tlatelolco massacre, various artists in Mexico began to organize themselves outside and often against state institutions, forming more than a dozen artists' collectives—known as Los Grupos—and political organizations like the Frente Mexicano de Trabajadores de la Cultura, a short-lived group created in 1978 with the objective of uniting "cultural production [with] proletarian and democratic struggles" [Goldman 1995, 135]). According to Alejandro Navarrete Cortés, "The majority of the so-called Groups [. . .] directly confronted the mechanisms of power that had caused the repression of the student movement in 1968, together with the implementation of state terrorism and the systematic violation of human rights in almost all of the Latin American context during the so-called 'Dirty War' [. . .]. The old dispute between [artistic] production and life seemed to drive them towards the making of a political art" (Navarrete Cortés 2006, 282).

The politicization of artistic practice in the work of Los Grupos entailed the simultaneous denunciation of a political system characterized by corruption and authoritarianism, and of a field of artistic practice that had become increasingly distanced from pressing social realities. In discussing the latter, Rita Eder describes a generalized perception among young artists that (official) art institutions had become complicit with a stagnated revolutionary rhetoric, as well as increasingly predictable and nepotistic: "Young creators were particularly critical of the art world, which they perceived as a conclave of artists and connoisseurs, hanging on the views, opinions and internal criticisms conducive to fame and the market yet virtually oblivious to the general public—which often observed works of art timidly, and remained fully outside of any form of relation with the works" (Eder 2010, 140).[14]

Mobilized by this feeling of disaffection, emerging artists felt prompted to attack or profane those museological institutions that seemed unwilling to come to terms with persistently conservative and authoritarian worldviews. As I describe in the next section, many of these artists symbolically adopted the language of guerrilla warfare, and they also rejected "the *sanctity* of the art object" to the point of its physical destruction (Oles 2013, 366). This iconoclastic impulse proved to be notoriously creative, bringing the institution of the museum closer to (the problems of) the street, triggering a profound reconfiguration of arguably obsolete divisions between different media, and giving rise to new strategies of circulation and display. A desecrating or profanatory moment, in other words, stirred up the performative turn in Mexico, rendering profanation in the sense that Levinas gives to this notion, that is, as "the revelation of the hidden as hidden" (Levinas 1969, 260). Like the Tupamaros, Mexican artists, including Kurtycz, used spectacular violence to render visible otherwise occluded forms of political and symbolic violence. These artists' approach to destruction was, however, permeated by ritual, metaphor, and play.

MEXICO'S PARODIC GUERRILLA ART

> *Acerca de los términos creativo y destructivo no hacemos diferencia entre ellos,*
> *ya que ambos producen movimiento.*
> (We do not differentiate between the terms creative and destructive,
> for both of them elicit movement.)
> —Maris Bustamante, *Secuestro Plástico*, 1978

One of the earliest instances of Los Grupos' performative "guerrilla tactics" is the simulated kidnapping that artists' collective Proceso Pentágono[15] staged in 1973 directly outside the Palacio de Bellas Artes, an iconic space of the Mexican cultural establishment. Focused more on unleashing a scandal than on attacking any one person, the live action started when one of the members of the collective mingled with the crowd, pretending to be a passerby. "Suddenly, three men (the other members of Proceso Pentágono) ran toward him, threw a sac over his head, tied him up, and carried him away from an astonished crowd" (Gallo 2007, 171). This "artistic kidnapping"—as Arden Decker (2012) calls it—was part of an exhibition of Proceso Pentágono's work being held at Bellas Artes, entitled *A nivel informativo* (On an Informational Level). Gallo describes the action as referencing the kidnappings and political disappearances that were taking place in Mexico as a consequence of the ongoing Dirty War. The title of the show refers to information as a layer, arguably distinct from other layers of the real and containing different levels (*niveles*) of truth and accuracy. This same title was possibly in dialogue with the Museum of Modern Art's (MoMA) show *Information*, which opened in September 1970, showcasing a willingness to reassess the nature of art and to approach artistic practice to contemporary social issues. The MoMA exhibition was a watershed for conceptualism. It effectively rendered information "synonymous with the work of art," a proposition that certainly influenced the work of Proceso Pentágono (Osborne 2013, 63).

A nivel informativo consisted in a series of live actions, including the kidnapping performed right outside Palacio de Bellas Artes, and various installation pieces presented inside the museum's galleries. The latter could be described as static scenes geared at generating an atmosphere of generalized alienation, pervasive bureaucratic surveillance, and media manipulation—by way of featuring, for instance, bound and gagged mannequins watching TV, and scattered pieces of office furniture. Together with the live actions, these installations were meant to elicit an interactive response on the part of the spectators, pointing toward the extent to which various forms of entertainment, from television to "high art," were directing people's attention away from Mexico's difficult political reality and thus silencing the brutal repression the government was enforcing against political dissidents. In view of the exhibition's denunciatory character, it is striking that it took place precisely in Bellas Artes, the "Palace of Fine Art." As Gallo writes:

"Bellas Artes stands in one of the liveliest and most vibrant working-class neighborhoods in the city—the Centro—but its interior is a cold, tomblike, marble gallery. Outside there are crowds of street vendors, book sellers peddling Marxist treatises [...] on the sidewalk, Indian women begging for money with their babies in tow, young couples making out [...]; inside there are empty galleries illuminated by crystal chandeliers" (2007, 170). By being installed in such a luxurious and prestigious venue this show arguably functioned like a "Trojan Horse," allowing the artists "to penetrate enemy territory in order to stage a fierce battle from within" (Gallo 2007, 175). The show also facilitated the possibility of organizing live and highly political events, like the said kidnapping, right outside the museum and before the gaze of all kinds of publics, not just connoisseurs.[16]

Proceso Pentágono's use of performative and violent tactics to infiltrate the dense symbolic and material barriers dividing Bellas Artes' cold inside from its reality-stricken outside was emulated five years later by another artists' collective, known as No Grupo.[17] This time the group performed a kidnapping that took an entirely parodic form, and that was aimed at critiquing *both* the country's culture of authoritarianism and the use of violence to attempt to outdo this culture. No Grupo defined itself as a "parodic guerrilla [organization] that took advantage of the solemnity of politically engaged art, the clumsiness of cultural institutions, and the social myths surrounding the figure of the artist" (Debroise and Medina 2006b, 226). In 1978, one year before Kurtycz's *Potlatch* and once again in Bellas Artes, the collective performed a *Secuestro plástico* (Plastic Kidnapping) by releasing a series of documents meant to announce publicly the kidnapping of Gunther Gerzso, a well-known German-born abstract painter based in Mexico City.

Gerzso gained recognition in the local art scene as a result of his critical attitude toward the place that Muralism had come to occupy in the country and for having collaborated with various generations of avant-garde artists, including the local Surrealist group comprising Leonora Carrington, Kati Horna, Wolfgang Paalen, Benjamin Péret, Alice Rahon, and Remedios Varo (Paz 1983, 3). Artist Melquiades Herrera, one of the members of No Grupo, therefore described Gerzso's kidnapping as an act of "fraternal cannibalism" (Herrera 2011, 49). The piece could be equally described as a work of media art, as conceived of by Eduardo Costa, Roberto Jacoby, and Raúl Escari in their 1966 *Anti-Happening* or *Happening for a Dead Boar*. Just like Costa, Jacoby, and Escari's anti-happening, which took place only in the media, No Grupo's kidnapping of Gerzso occurred only in its documentary dissimulation. Among these documents one finds close-up shots of Gerzso's tied-up hands and mimeographed images of his mouth sealed with tape. No Grupo also printed a notice that reads: "We hereby declare that Mr. Gunter Gerzso has been kidnapped and that, as he has decided to stay with us, we have agreed to kill him in the form of a sacrificial offering." Gerzo is also quoted as saying:

I am Gunter Gerzso. My health is fine. I am in full use of my intellectual and mental faculties. Everyone listen well: I do not wish to be rescued. I do not wish to go back to a false and impoverished world where nothing outside of programmed mediocrity ever happens. I shall remain with my captors as the sole way to trigger, by example, the emergence of the new youth, the generation that shall rescue the solid Mexico of my designs and my rocks and that will show that which lies beyond Mexico's colors, textures, and transparencies.[18]

Gerzso's mock kidnapping was presented in an exhibition held in his honor at Bellas Artes entitled *Presencia ambiente a Gunther Gerzso* (Presence-Ambience for Gunther Gerzso, 1978). The piece portrays the acclaimed artist in a situation of paralysis, kidnapped not only by the institution but also by his peers. The symbolic sacrifice of Gerzso by the artists' collective thus became an attempt to enforce pressure on official institutions to recognize and support the work of the critical youth, using entirely simulacral guerrilla tactics. In the ensuing years, the group's (parodic) engagement with the imaginaries of guerrilla warfare continued. To give an example, in 1981, the group traveled to Colombia to participate in the Primer Coloquio Latinoamericano de Arte No Objetual, which was given its impetus by Peruvian critic Juan Acha. The group then remained in Medellin, collaborating with the Colombian guerrilla organization M-19, for which they contributed a series of pieces to the "agenda artístico-política" (artistic and political day-planner) *Colombia 83*—which featured the work of forty artists and was sold in Colombia and abroad to support the organization. Members of No Grupo had been fascinated by M-19's performative gesture of stealing Simon Bolívar's sword from a public museum in 1974, leaving in its place the message: "Bolivar, your sword returns to the fight." One of their works in the agenda, signed by Herrera, references this action and presents six spade playing cards from a Spanish deck beside the message: "Bolívar's sword is missing from this page, find it in the real world, it is fighting injustice; collaborate with it . . . so that this design can be completed."[19]

Gallo and Decker discuss Proceso Pentágono's and No Grupo's "guerrilla interventions" as representing not a threat to Mexico's political or art institutions but rather an overstaging of the groups' relative weakness in relation to a muscular state, deeply implicated in the cultural realm. Their performatively belligerent actions are also symptomatic of a situation of increased antagonism between experimental and established art circles, the result of a long history of state patronage and government control over artistic production (Coffey 2012, 63). According to César Espinoza and Araceli Zúñiga, having fossilized—or rather, as they put it, "embalmed"—the Mexican school of painting, official culture in the late 1970s was inevitably implicated in legitimizing the increasingly empty revolutionary discourse of the PRI regime (Espinosa and Zúñiga 2002, 81). This regime had not only failed to guarantee the social benefits and political rights that had been constitutionally promised in 1917 but had also proved remarkably reluctant to

account for the forms of exclusion that it had generated (Aguilar Camín and Meyer 1990, 241; Aguayo 1998, 91). These exclusionary dynamics were deepened when the state began to face economic hardships in the late 1970s, leading to "the worst economic debacle since 1929" (Lomnitz-Adler 2003, 131); at this point the nascent left-wing and right-wing opposition also began to articulate alternative political programs.

According to anthropologist Claudio Lomnitz-Adler, the general situation of cultural and political crisis in the early 1980s became "a serious impediment to the production of credible images of a desired future" (131). Moreover, the "times of crisis" that characterized Mexican politics and economics during these years saw a proliferation of secular allusions to sacrificial practices, even if the forms of hardship endured by the population "could not find meaning in relation to the propitiatory effects of either Aztec or Christian sacrifice" (131). Lomnitz-Adler also posits that "secular versions of Christian self-sacrifice were highly developed in Mexico, given the nation's explosive combination of a deeply religious Catholic peasantry and a secularizing, and often Jacobin, political class" (141). These comments resonate with the sacrificial language that both Kurtycz and No Grupo used in their performances. They also invite further discussion on the relationships between the country's social realities and the politics of those symbols mobilized and attacked during live and performative practices.

It is in this sense that Kurtycz's violent and unforeseen intervention in the FCA may be understood as part of a sequence of guerrilla-like, ritualized, and sacrificial attacks on official art venues in late 1970s Mexico, in which the performance of violence became a means not of harming or terrorizing the population but of "making visible" the disciplinary and exclusionary violence of public institutions. The FCA had been founded and was run by a group of artists who had left the Instituto Nacional de Bellas Artes (INBA)-run Salón de la Plástica Mexicana in order to escape the complicit nationalistic logic of this space.[20] The Forum still depended on INBA patronage, and after a personal row with the Forum organizers—following broken promises and pending payments—Kurtycz began to perceive this institution in the same terms as the rest of Mexico's official art circles. His dissatisfaction with these spaces was rooted in their palpable nationalism, the institutionally produced distance between art and experience, and the generalized official endorsement of the division between high and popular or applied art. Following an archaeological impulse informed by Bataille's writings, Kurtycz's Potlatch therefore sought to bring together the ostensibly modern and ancient, the high and low, and the exotically Mexican and foreign, exploring the critical potential emanating from de-classification. Correspondingly, Kurtycz posited that if (his) artworks were to enter a museum or a gallery, they had to be exposed—against common practice—to the touch of the human hand, the possibility and urge for (ritual) destruction and robbery, and the witnessing, rather than the mystifying veiling, of the creative process. Kurtycz's ritual poetics of

destruction thus opened up a new terrain within the realm of non-objectualist artistic practice in Mexico. In his art, the public, the artwork, and the artist not only came into direct contact with each other (often co-producing the live "event"), but they also became immersed in rituals of artistic and institutional profanation.

THE SCENE OF RITUAL

While Kurtycz borrowed the concept of potlatch from Bataille, the latter (mis) appropriated it from Marcel Mauss's study of gift exchange among so-called archaic societies (Mauss 2002 [1925]).[21] In Chinook, the language of Chinookan peoples from North America, potlatch means "to feed" or "to consume," but its use refers to a "total system of giving" that involves a series of feasts, fairs, and rituals. Through potlatch the assembled tribe attempts to outdo rival chiefs by means of lavish splendor, turning the act of consumption into a social contract of sorts, and extending it beyond the circulation of wealth into the structuring of the community through the production of ranks and social hierarchies (Mauss 2002, 7). Yet Bataille was less interested in this aspect of Mauss's theory than in "the creative potential of 'the pleasure of expense'" (Sansi 2014, 92). In his "essay on general economy," *La Part maudite* (The Accursed Share, 1949), Bataille describes potlatch as an institution inviting the subject to explore forms of exchange and communication not primarily led by a search for accumulation. Moreover, as Roger Sansi suggests, Bataille accentuates the potential of this practice "to turn expense into public spectacle": "the ultimate outcomes of this spectacle in terms of hierarchy, ranking or fame, what it is made *for*, are less interesting than the very act of expenditure" (Sansi 2014, 92, emphasis in original).

One can observe remarkable affinities between Bataille's theory of potlatch and Kurtycz's performative appropriation of this concept. The artist situated live art in relation to an economy of (useless, yet expressive) consumption rather than accumulation and market exchange. His rejection of the market started with his dismissal of the Anglo-American concept of performance as a "linguistic miscarriage" (*aborto lingüístico*), and thus from his refusal to position himself within a hegemonic genealogy of live art. He described each of his performances as an *arte-facto* or "art-i-fact," perhaps inspired by the ideas of Polish theorist Jerzy Ludwinski, who replaced the notion of the work of art with "artistic fact" (Radomska 2011, 48). Kurtycz's neologism presents performance art as a medium that not only seeks to resist the market, but also involves various dynamics of materialization. He writes: "Art-i-fact ingeniously eludes any attempt at definition, but it has certain constants, such as, for example, its visceral sincerity. Art-i-fact is the polar opposite of commercial art (only thus could the former destroy the latter one day). The value of an event-art-i-fact consists of its multiple interpretations, according to the level and the mental state of the spectators (and/or actors)."[22] In a text about Kurtycz, the noted Polish philosopher Stefan Morawski, who exchanged letters

with the artist for more than two decades, describes this stark resistance to the market as resulting from a "spontaneous kind of anarchism [...] entirely free of doctrinal elements." In explicit admiration, Morawski also contrasts what he calls the "sham qualities of postmodern art" with the "spiritual splendor that radiates from Marcos Kurtycz's anti-art (strictly speaking, his beyond-art)."[23] I will not dwell on whether Kurtycz's art possesses spiritual qualities, but it is clear that, like in Bataille, the artist's approach to destruction goes beyond an iconoclastic passion for effacement. In his work, destruction is imbued with a ritual poetics that is both expressive and, as I discuss in the next section, declassificatory. Likewise, it would be a mistake to see Kurtycz's ritual actions as primarily focused on obtaining a set objective or end product (e.g., the effacement of a painted canvas or an attack on painting *tout court*). Rather, they were entirely process-driven pieces, attentive to the concatenated chains of actions and relationships arising and dissolving during the ritual: the act of bringing near, touching, polluting or purifying; the confusion of subjectivities; the sharing of risk and intimacy; the possible reconfiguration of subject-object relations; the ritual act as an embodied form of transgression that indulges irreverence and play.

This sort of irreverence may also be discussed in relation to Giorgio Agamben's description of profanation as the possibility of challenging the distancing (and disciplining) effects of exhibitionary display—which not only privileges the gaze but also tends to foreground the exchange value of art over its everyday or profane use value (Agamben 2007, 73). In this sense, one could argue that Kurtycz conceived of the museum and the art gallery as temple-like institutions that not only consecrate works and artists but also neutralize their social value, preventing the "sacrificial" shedding of their "sacred" aura. Yet Kurtycz's work did not simply seek to embrace the profane over the sacred; it strove for the mutual contamination of the two, in a movement that is reminiscent of Bataille's own hybrid rendering of sacred and profane. That is, alongside Joseph Libertson, I take Bataille's project to be one that privileges contamination over synthesis and sustains the tension between opposing categories, instead of seeking their fusion or obliteration (Libertson 1995, 212). It is in this sense that Bataille's writings introduce another level of complexity to an understanding of sacrifice as merely "rendering sacred" or, correspondingly, profanation as merely "rendering profane." This dissident Surrealist does not see the profane and the sacred as separate, homogeneous domains, but rather as fundamentally intertwined and heterogeneous; he conceives of the sacred as both holy and base, "entirely other yet intimate" (Bois 1997b, 52). For him, sacrifice, as potlatch or *dépense*, is neither an opening up to the transcendental nor a concept linked to André Breton's appropriation of the marvelous, but an experience of base materialism, entirely distant from organized religion and devoid of an idealist or transcendental conception of closure (53). Moreover, according to Yve-Alain Bois, the sort of "[b]ase materialism" involved in Bataille's conception of sacrificial acts "has the job of de-class(ify)ing, which is to say, simultaneously lowering and

liberating from all ontological prisons, from any '*devoir être*'" (Bois 1997b, 53). Rather than serving to create a stark line between sacrality and profanity, in Bataille, like in Kurtycz, sacrifice seeks to expose their mutual contamination. In a domain as regimented as art history this commitment to an aesthetics of "contamination" not only founds the critical potential of experimental and intermedial practices, but also posits the need to revise—or perhaps even to abandon—art historical and media genealogies. Therein lies much of the critical value of Kurtycz's ritual poetics; and this explains the important role they played in 1970s and 1980s Mexico, a time in which the postrevolutionary political and aesthetic regimes faced their own diminishing capacity to incite meaningful change.

LIMINAL PERSONAE

The declassificatory potential of ritual goes hand in hand with Victor Turner's discussion of the emergence of a condition of liminality—and its accompanying liminal *personae* ("threshold people")—through ritual (Turner 1969, 95). Following Arnold van Gennep, Turner describes the ritual dynamic as a societal process going through successive phases—"separation, margin (or *limen*, signifying 'threshold' in Latin), and aggregation"—and involving different arrangements of time and space, paired with certain subjective dispositions or states (1969, 94). The liminal phase of ritual creates possibilities for the emergence of what Jeremy Biles calls the Bataillan "sacrifice of form" or "monstrosity" (Biles 2007, 63).[24] "Liminal entities," writes Turner, "are neither here nor there; they are betwixt and between the positions assigned and arrayed by law, custom, convention and ceremonial" (Turner 1969, 95). These entities have ambiguous and hybrid attributes that situate them at the margins of established social norms, identities, and ranks. And, according to Turner, this social indeterminacy is expressed through a rich multiplicity of symbols: "liminality is frequently likened to death, to being in the womb, to invisibility, to darkness, to bisexuality" (1969, 95).

The rich symbolic imaginaries associated with a liminal state or a liminal subjectivity cannot but bring us back to the opening lines of this chapter and the multiple descriptions of Kurtycz as a Polish shaman, exorcist, magician, and even terrorist. One could argue that Kurtycz occupied all these positions and none. Above all else, he destabilized the division between the Mexican and the non-Mexican artist, for even though—as I discuss in the next chapter—the artist's earliest works date back to his life in Poland, he became a performance artist in Mexico and eventually adopted Mexican nationality (which art critics and the press generally overlooked). In *Potlatch*, Kurtycz further intensified this identity confusion by himself embodying the sacrificial disposition of the "ancient Mexican."

Given Kurtycz's access to Aztec sacrifices through Bataille, one has to acknowledge that the latter's understanding of sacrifice was, in turn, influenced by

Sahagún's sixteenth-century descriptions of Aztec sacrifices as "an apex of horror in the cruel chain of religious rites" (Bataille 1988, 49). Furthermore, Kurtycz's approach to this theme continues a tradition of avant-garde artists who had been attracted to an exoticist view of Mexican culture, a tradition that includes Breton, Bataille, and Antonin Artaud. In his text "Souvenirs du Mexique," published in 1939 in the magazine *Minotaure*, Breton describes Mexico, for instance, as a "red land, virgin land, all soaked with the most generous blood, land where man's life is priceless, yet ready as the agave (always its best expression) to consume itself in a flowering desire and danger!" (Breton [1939] 1996, 113). In a similar vein, magic and shamanism were Artaud's primal sources of fascination for Mexico, which he visited in 1936, aiming to harness the "shamanistic forces of pre-Columbian sorcery to subvert European ideology" (Hertz 2003, 13).

While Artaud pursued an arduous journey to the Tarahumara region in search of shamanic experiences, Kurtycz's interest in shamanism was more eclectic and largely self-fashioned. Indeed, his shamanic impulse approached Joseph Beuys's notion of the artist as shaman, insofar as it privileged the emotional and often strictly gestural elements of this practice (see Foster et al. 2011, 527). Kurtycz's shamanism was also entirely simulacral, for he did not claim any real mystical powers or exceptional capacities for healing. The seemingly shamanic qualities of his art were, therefore, grounded in his performative embodiment of the kind of expressive, repetitive, and solemn gesturality that is often associated with the rituals of ancient Mexico. Moreover, and delving more deeply into the primacy of gesture in Kurtycz's art, one could argue that his performances, like the experimental theater of Polish director Jerzy Grotowski, endeavored to recuperate a type of "corporeal unconscious" that seemed to have been forgotten with the onset of modernity (Schechner 1993, 12). Grotowski, too, conceived of his performances as ritual acts and paid special attention to the body's movements and "resonances" as well as to the affective intentionality of gesture (Osinski 1991, 103). The playwright and theorist (who may or may not have had a direct influence on Kurtycz), defined the "performer" as a "man of action," namely, one who does not "play another" but who, in performance, becomes "a dancer, a priest, a warrior" (quoted by Osinski 1991, 105). Even if only coincidentally, Kurtycz also deeply cherished these principles of action and becoming. On various occasions he argued that his "art-i-facts" could not be reperformed or restaged, for each of them was a lived, and thus unrepeatable, *experience*.

Beyond Kurtycz's references to the place of sacrifice in Mexican culture, and its relationship with the exoticist cosmopolitanism of figures like Breton and Artaud, the artist's exploration of his own gestural archive was deeply influenced by his experience of the violence of war in Nazi-occupied Poland. As Jennifer Burris Staton observes, Kurtycz's "long-standing preoccupation with self-destruction was [...] grounded in the traumatic experiences of his early childhood in Eastern Europe" (Burris Staton 2015, 72), where most of the artist's

relatives, including his mother, died in the Holocaust. In his numerous sketch-books (carefully organized by year and letter of the alphabet) the artist made repeated references to his mother's death, drawing her as a female figure about to be executed by a firing squad. Additionally, in the documentation accompanying the performance *Cruz-Cruz* (1984)—which was carried out in the Mexican town of Tepoztlán (known for its eclectic spiritual life) and involved burning a large-scale wooden swastika—the artist wrote: "The swastika, [. . .] the cross-over-a-cross is associated with me, since childhood I have known how to survive and escape death [. . .]. The fact is that I survived five years of war as a child, out of eighty people that constituted my family only three survived, my father, my sister, and I. For me this symbol is very alive, a reminder of a strange and terrible occurrence in our century. But in itself it is not frightening, it's funny, it's a helio-centric symbol, completely solar" (quoted in Alonso Espinosa 2014, 265).

Although these references to Kurtycz's memories of Nazism may at first glance feel far removed from the shamanic logic of his *Potlatch*, the artist per-ceived this action and *Cruz-Cruz* to be intimately associated. As one can observe in Figure 5.1, Kurtycz overwrote the title *Cruz-Cruz* on one of the few pictures of his earlier action at the FCA, as if belatedly renaming the original performance. Another connection between these pieces is Kurtycz's descrip-tion of the swastika as a solar sign—a meaningful mention given that, as I described before, he had used a solar technique to produce the painting that became his action's "sacrificial gift."

THE SCENE OF TERROR

Beyond the realms of ritual and guerrilla warfare, the description of Kurtycz in the Mexican press as a "cultural terrorist" echoes another range of important schol-arly debates on the relationship between avant-gardism and violence. As Boris Groys suggests, both the avant-garde artist and the terrorist search for visibility through shock while sharing an aspiration to radicalism (to the point that "the worst thing that can be said of an artist [is that] his or her art is 'harmless'"). Yet for Groys these social categories fall under two different understandings of radi-calism: "The terrorist, the warrior is radical—but he is not radical in the same sense as the artist is radical. He does not practice iconoclasm. Rather, he wants to reinforce belief in the image, to reinforce the iconophilic seduction, the icono-philic desire. And he takes exceptional, radical measures to end the history of icon-oclasm, to end the critique of representation" (Groys 2008, 125).[25] In this text, Groys construes a fundamentally antagonistic relationship between the avant-garde artist and the terrorist, based on a seemingly clear difference in their rela-tionship to iconicity. He defines the terrorist as the "enemy of the modern artist, because he tries to create images that have a claim to be true and real—beyond any criticism of representation" (126). The terrorist appears as striving to found

FIGURE 5.1. Marcos Kurtycz, *Potlatch*, 1979. Gelatin silver on paper, ink, 10.7 × 20.4 cm. Photograph of performance at Foro de Arte Contemporáneo, redated by the artist in 1984. Photographer unknown. Courtesy of Anna and Alejandra Kurtycz.

the social bond on fear, while the artist is seen as capable of destabilizing social conventions and entering into critical dialogue with the history of images.

This universalizing model is compelling at first sight, yet it oversees the historical singularity that art and terrorism always take, and the extent to which both categories are socially and institutionally produced. Indeed, when these notions become detached from a specific social setting, much of their value and meaning immediately disappears. In today's world, where the category of the terrorist has

gained prominence and lost almost any cultural or political particularity, similar forms of stark categorizations have reduced the notion of "terrorism" to a unilateral and highly mediatized image of pure evil, ignoring the specific meaning that terror has taken in different historical moments.[26] This perspective also overlooks the possible strategic rendering by the state of public expressions of discontent into acts of terror in order to harden control and justify repressive policies. By creating a distance between artists and terrorists, and calling them enemies, Groys's view ultimately fails to acknowledge the inherent difficulties in differentiating between "good" and "bad," real and staged (or simulacral) forms of violence.[27]

Returning to the discussion of the Tupamaros, Proceso Pentágono, and the "parodic guerilla organization" No Grupo, it becomes clear that Groys's division between artists and terrorists on the basis of their relationship to iconoclasm disregards the close dialogue and often collaboration between artists and guerrilla movements in Latin America between the late 1960s and the early 1980s. During those years, the definition of terror in the region was notoriously more complex, as states themselves practiced what has been called "state terrorism," and the police and the military tortured and disappeared citizens to instigate a deep feeling of terror in the population. Meanwhile, most acts of dissidence were labeled "terrorist" in order to criminalize freedom of expression and the right to protest. Guerrilla groups, in turn, not only carried out violent acts in public sites but also adopted increasingly performative, not to say artistic, strategies to gain visibility, crossing a line that Groys deems difficult to cross. Yet despite the great complexity accompanying the notion of terror in 1960s–1970s Latin America, the naming of Kurtycz as a cultural terrorist showcases a prevailing conservativism in the Mexican art world, accompanied by a lack of recognition of the critical and dramatic qualities of performance art. Local (mostly amateur) cultural journalists were often unable to understand Kurtycz's use of violence and the associations he established between art and warfare in his critique of art institutions. In the following section I expand this discussion by looking at yet another dimension of this critique, which proceeded through mail art as a tactic for "bombardment."

LETTER BOMBING

One of Kurtycz's most combative projects involved threatening to tear down a small portion of the outer wall of Mexico's Museum of Modern Art (MAM). Before carrying out this action, the artist sent a letter to the museum's director, Jorge Alberto Manrique (in tenure between 1987 and 1988): "The Museum is surrounded by a thick wall that drastically separates it from the real world. As a consequence I have decided not to set foot in the Museum of Modern Art until this insulting fence disappears. I demand that you remove it within three months, thus avoiding severe physical consequences [...]. I already have a mass event perfectly planned and programmed entitled: RECOVERED SPACE."[28] According to Ana

María García, the artist's partner at that time, Kurtycz's fury was triggered by a programming mistake: one of his performances was planned for (and advertised as taking place on) a bank holiday, when the museum was closed. In view of the venue's poor administrative organization, Kurtycz wrote a letter threatening the director with taking over or, as he put it, "recovering" the space by and for the public, in a democratizing move that would allow a more porous relationship between the museum's inside and outside. The artist did not follow up on his threats, and most likely he never planned to. Yet this letter served to express—and perform—his disagreement with MAM's stagnant institutional policies.

Kurtycz had carried out a similar action five years earlier, when he suddenly appeared at MAM to announce to the then-director Helen Escobedo (who held this position between 1982 and 1983) that she would be subjected to bomb attacks. Escobedo was herself a pioneering abstract sculptor who had explored the tensions and possibilities resulting from the juncture between monumentality and ephemerality, color and volume, and light and movement (Schmilchuk 2001). Kurtycz's verbal provocation was hence directed both at her institutional role and at her known intelligence and creativity, which could—as she ended up doing—redefine what was perceived as the museum's conservative vision of artistic practice (Eder 2010). Kurtycz's unexpected first appearance at Escobedo's office was subsequently followed by 365 "letter bombs" (one sent every day over a year), which encompassed a diverse array of communications sent by mail, each reflecting Kurtycz's inventive use of collage and his exploration of a wide range of printing techniques, including (as I discuss in more detail in chapter 6) directly imprinting with ink traces of his own body on the letters.

The first letter bomb, sent on October 31, 1981, reads toward the end: "It is a war. There will be no truce (unless mail rates rise)." Despite the letter's threatening tone, the closing joke reveals the duality of its intentions, endorsing spontaneity and humor as key not only to challenging but also reinvigorating the institution. Kurtycz's "bombardment" of MAM therefore truly sought to incite Escobedo to open the doors of this major art space to experimental practices. The letter bombs physically traversed the borders of the institution and embraced a clandestine and "infiltrating" aesthetic. Escobedo recalls that, absorbed as she was by her bureaucratic duties, "sometimes [she] didn't even have time to open them, they kept piling up" (Escobedo 2007, n.p.). However, even as a growing pile on the director's desk, Kurtycz's bombs did not go unnoticed. Their arresting envelopes were in themselves highly provocative: one of them, for example, juxtaposes Helen's name with the word *muerte* (death), written in capital letters (Figure 5.2). Escobedo continues: "The tone of the letter bombs was varied: sometimes poetic, sometimes angry, sometimes grotesque, never straightforward" (2007, n.p.). Rather than being directly harmful, aggressive or explosive, the bombs were meant to be affectively provocative, simultaneously triggering fear and laughter, while motivating the receiver to act (creatively) in response.

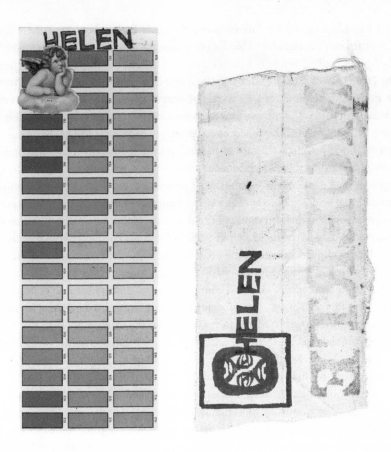

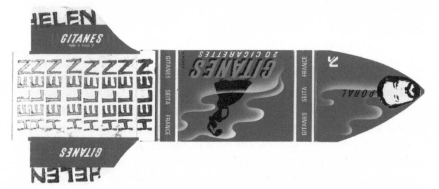

FIGURE 5.2. Marcos Kurtycz, letter bombs sent to Helen Escobedo during the yearlong bombardment of Mexico's Museum of Modern Art (1982–1983). Courtesy of Michael and Andrea Kirsebom.

I identify a significant link between Kurtycz's *Potlatch* and his letter bombs, since the latter's demand for a binding response from the receiver recalls the idea of the "gift of rivalry." While in Mauss's theory of the gift this notion is always tied to the circularity of exchange through the counter-gift (Mauss 2002, 95), in the case of Escobedo, her counter-gifts were not always visible, since she did not correspond with Kurtycz as other artists did—including Lourdes Grobet, Felipe Ehrenberg, Stelarc, among others. Moreover, during her tenure at MAM, Escobedo did not consider these letter bombs to be "art" or keep them in the museum's archive. Instead, she stored the correspondence among her personal files. However (according to Rita Eder's recently published history of the MAM during Escobedo's tenure), the sculptor quietly responded to Kurtycz's letter bombs by launching a series of major transformations in the museum: "With hindsight, it seems that Escobedo's days in the museum unfolded as a parallel encounter with this character (Kurtycz), who provoked the art world with his actions, and whose strange delicacy evoked extreme forms of collective and individual violence" (Eder 2010, 35). Closing the cycle of gifts and counter-gifts and desecration and consecration that characterized Kurtycz's relationship with Escobedo and the MAM, the artist's letter bombs returned to MAM in 2013 as part of the exhibition *Obras son amores* (Works Are Loved Ones), which revisited artistic production in Mexico from 1964 to 1992. This time, Kurtycz's letter bombs did not need to infiltrate the institution clandestinely, for they were formally displayed as "mail art," a practice that was, in turn, unproblematically described as an "established" form of art influenced by international conceptualist movements like Fluxus.[29] It is important to continue to recall the many years during which these "disobedient objects" were ignored and excluded from the same museum walls. Their visibility today is the result of years of aesthetic struggle, often by (symbolically) violent means.

THE SCENE OF THE SELF

In 1982, three years after *Potlatch*, Kurtycz printed a self-promotional triptych leaflet that further emphasized his identification with Bataille and his interest in the creative potential of sacrifice, or destruction—this time by way of self-directed violence. The leaflet's inside pages displayed six successive stages in the process of destruction of a photographic self-portrait, burned by the artist with fire (Figure 5.3). One of the outside pages included a printed summary of the artist's biography (beginning: "I was born in Poland, an important but not very pleasant fact. Look. When I was a child, I made it through the war. I was eight when my mum was killed") and another reproduced a text taken from *La Part maudite*, translated by Elizondo. Entitled *La víctima sagrada y maldita* (The Sacred and Accursed Victim), this text refers to the Aztec practice of sacrifice, stating that from the moment of being "chosen" the sacrificial victim is "destined for violent consumption." In other words, the victim becomes "the accursed share [. . .] the curse

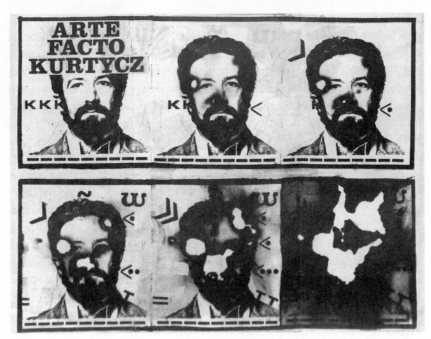

FIGURE 5.3. Marcos Kurtycz, leaflet for *Artefacto Kurtycz* (1982). Marcos Kurtycz Archive (hereafter KA). Courtesy of Anna and Alejandra Kurtycz.

tears him away from the *order of things*, it gives him a recognizable figure, which now radiates intimacy, anguish, the profundity of living beings." Bataille's writing continues by describing Aztec sacrifices as comprising "a mixture of anguish and frenzy." This results from embracing an economy of excess, but not any form of excess: "excess [...] that went beyond the bounds, and whose consumption appeared worthy of the gods." The French thinker then seals his blood-soaked primitivism by concluding that this was "the price men paid to escape their downfall and remove the weight introduced in them by the avarice and cold calculation of the real order."[30]

In this passage, the sacrificial victim escapes through ritual the state of "thing," thus renouncing any social utility and entering the unstable and Janus-faced domain of the sacred—"at once life-giving and death-dealing" (Eagleton 2005, 115). As already suggested, it was this "double condition of the sacred" (Krauss 1986, 55) that interested Bataille in his approach to Aztec sacrifices, which he referred to by evoking the "astonishingly joyous character of these horrors" (Bataille 1970, 157). Bringing together in the leaflet Bataille's text, his own bibliography, and his self-portrait, Kurtycz suggests a self-identification with the sacrificial victim.[31] There is, however, an unsettlingly controlled aspect to this practice of self-erasure, for the careful incineration of one image in six stages reveals a restrained and orderly dimension to this self-sacrificial sensibility. Rather than

referring us to a (real or imagined) Aztec excess, the artist's gradual self-immolation echoes Éli Lotar's series of pictures of the butchery at La Villette, in Paris, which accompanied the entry "Abattoir" in *Documents'* "Critical Dictionary."[32] In one of Lotar's well-known pictures, two rows of chopped cows' hooves are depicted carefully cleaned and aligned against an exterior wall, an image that visually resists Bataille's attempt to associate the butchery with "the mythic mysteries and lugubrious grandeur typical of those places in which blood flows" (1970, 205). Precisely because of their gracefully organized and hygienic qualities, Yve-Alain Bois considers these pictures as a "kind of climax, within the journal, of the iconography on horror" (Bois 1997a, 43). That is, the feeling of extreme unease that Lotar's photographs can trigger does not result from their depiction of abundant blood and indiscriminate mutilation, but from their "sinister" representation of killing as an orderly, symmetrical, fully systematic act (44). For Bois, Bataille's inclusion of this series in his magazine further suggests that it is not violence as such that interested him, "but its civilized scotomization that structures it as otherness, as heterogeneous disorder" (46). Violence thus comes to be understood as deeply entrenched in human societies, yet falsely signified as "other" through an exoticizing and fearsome veil that renders it chaotic, "primitive," or excessive. This veil, in turn, cloaks the violences of the everyday.

Read in this light, Kurtycz's sequential portrait exhibits the extent to which the description of his art-i-facts as violent acts of terror and destruction is nothing but a symptom of a societal impossibility to address other, arguably more creeping forms of violence—like the violence of the authoritarian Mexican state, at that time fully invested in the country's neoliberal opening; the violence of the museum, unaccountably entitled to exclude certain artistic languages from the established field of art; and the violence of iconography, inclined toward settling rather than opening the meanings of the visual. Furthermore, in this image the artist performs the ultimate co-dependence between acts of creation and acts of destruction, which is the founding paradox of iconoclasm and of any critique of representation.

EXPLODING TIME

This chapter offers a close reading of Kurtycz's 1979 *Potlatch* at the FCA. I discuss this piece according to a plurality of logics that may accompany the aesthetic deployment of violence. Moreover, I situate this performance in relation to the work of a series of politically critical artists' collectives in Mexico, the crisis of the Mexican state and of official art institutions in the 1970s, and a larger context of political and aesthetic radicalization in Latin America in the preceding decade. At a time in which Mexico's ruling party was undergoing a serious crisis of legitimacy, guerrilla organizations were active around the country, and the repression of the critical youth was reaching perturbing heights, Kurtycz's *Potlatch* intersected

the vocabularies and imaginaries of undercover warfare with the de-classificatory potential of ritual. In doing so, elaborating on Turner's analysis of ritual, the artist's violent entry into the FCA sought to "explode" time, space, and artwork, thus making visible the extent to which the country's political situation and the prevailing "distribution of the sensible" were both reflected and potentially transformed by the artwork's sensory effects.

Potlatch is one of the first art-i-facts in which Kurtycz performed an act of destruction in public. By doing so, he situated himself within a genealogy of artists who were iconoclastic, provocative, and deeply critical of the commodification of art. However, in this piece Kurtycz goes beyond the sheer act of iconoclasm. He embodies the roles of thespian, saboteur, and shaman, while conducting a risk-infused ritual and conceiving of it, in Richard Schechner's words, as "liminal-liminoid, unauthorized, antistructural, subjective ('if'), and subversive" (Schechner 1993, 256). This approach to performance offers new models of embodiment and social structuring, yet Kurtycz's emphasis on affective expression rather than narration reveals his own resistance to bringing these models to a state of closure. That is, instead of being an experience oriented toward the establishment of new foundations or the communication of a political program, Kurtycz's performances or art-i-facts allow the subject to experiment with new ontic possibilities.

In chapter 6, I suggest that this same search for liminality and experimentation grounds Kurtycz's critique of artistic autonomy through the practice of intermediality and the shaping of posthuman corporealities in a variety of postal and cybernetic experiments. Moreover, I argue that Kurtycz's embrace of indeterminacy, and what Morawski saw as his "anarchist" resistance to align his art with any predefined political goal, enacted a shift away from the forms of antagonism characteristic of earlier experiences of political art toward the practice of *déchirure* (using Bataille's terminology) or exposure by way of proximity. "*Déchirure* in Bataille," Didi-Huberman argues, "always begins as access, as contact. It is here that touch exposes: it is the transgression of the taboo of touch that, almost always, ends by *opening up* concepts or words" (Didi-Huberman 1995, 36).[33] In Kurtycz's ritual performances, the act of institutional profanation unfolds through direct contact with the institution, its often violent infiltration, the (expository) play with its norms and categories, and the search *in situ* for new forms of contact and organization of artist, artwork, public, and exhibition space. In this process, all these categories are closely dependent on each other, yet also mutable, reimaginable, and ultimately sacrificeable.

6 · CYBERNETICS AND FACE-OFF PLAY

If human beings have a destiny, it is rather to escape the face, to dismantle the face and facializations, to become imperceptible, to become clandestine, not by returning to animality, nor even by returning to the head, but by quite spiritual and special becomings-animal [...] that make *faciality traits* themselves finally elude the organization of the face —freckles dashing toward the horizon, hair carried off by the wind, eyes you traverse instead of seeing yourself in or gazing into those glum face-to-face encounters between signifying subjectivities.

—Gilles Deleuze and Félix Guattari, *A Thousand Plateaus*

In 1979, Marcos Kurtycz, playing with a mirror, a plain background, and a pair of teddy-bear eyes, placed himself in front of a photographic camera to start shooting a series of twenty-four self-portraits with alluring qualities. Beginning with the typical mug shots of a convict, the series moves through progressive stages of self-recognition, self-alteration, and self-undoing, passing through moments of animal-becoming via neck enlarging, self-veiling with what appears to be a *hijab*, self-touching, and doubling the face from the neck up (Figure 6.1). Evocative of a reversed Lacanian "mirror stage," the double-headed specular portraits concluding the series are telling, as at this point the reflective surface inverts the primordial identification between the self and the unitary body. Triple-eyed, double-nosed, Kurtycz's portraits evoke the visceral duplication of conjoined twins—never completely reconciled with modern imaginaries of the human. This self-deforming, if not self-dehumanizing, fluidity of the face uncannily reappeared in the artist's work toward the end of his life, in the mid-1990s, when the major agents of disfiguration became, on one hand, Kurtycz's progressive development of a partial facial paralysis and, on the other, the repeated placing and sliding of a photograph on a photocopier machine to produce a new series of self-portraits (Figure 6.2). An instrument of rapid and cheap reproduction preceding the digital era, the photocopier's blazing light bestowed aural elongations and deformities upon Kurtycz's frontal close-up images, simultaneously bifurcating his face and

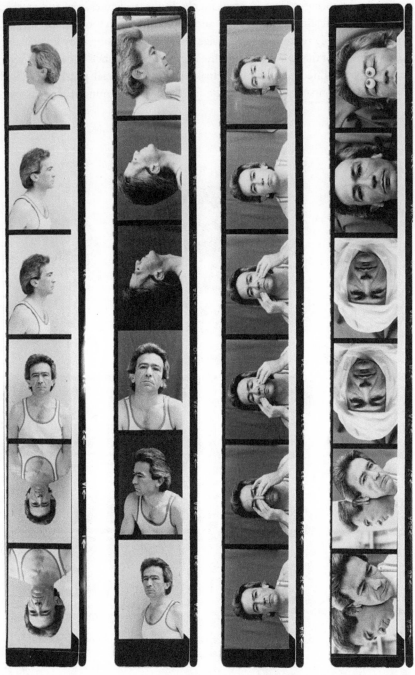

FIGURE 6.1. Marcos Kurtycz, proof sheet of untitled portraits, 1979. Gelatin silver on paper. KA. Courtesy of Anna and Alejandra Kurtycz.

physically distancing it from its own double. In these pictures, real and masked faces become indistinct, haunting one another in the search for their lost origins. The copy not only reproduces the visage, but directly acts on it by introducing the movement of the light beam into the organic countenance. One of the xerographically modified photographs cloaks the artist's facial paralysis by first inverting the nonparalyzed side of the face and then aligning it with its own

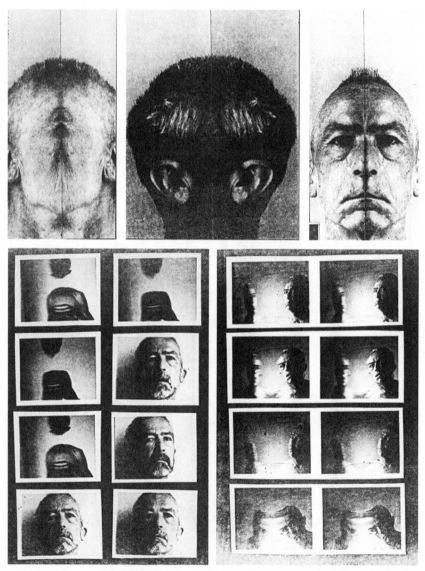

FIGURE 6.2. Marcos Kurtycz, untitled experiments with photographic self-portraits and a photocopier, 1992. Xerography. KA. Courtesy of Anna and Alejandra Kurtycz.

equal. Another one shrinks the face from left to right until the nostrils, eye open-ings, and eyebrows become three aligned and indistinct orifices with possible genital resemblances. A similar experiment with shrinking distorts the artist's facial proportions as his nose disappears, while a rotated, stand-alone mouth, visible in various pictures, gains independence from any identifiable faciality. One of the few images of the face in profile strangely resembles a sheaf of wheat, only this one is made of human hair and interrupted by the symmetrical placement of two ears mirroring one another. Working on the boundaries of recognizable portraiture, Kurtycz's deformed and disjointed facial renderings seem to participate in the dismantling of the face that Deleuze and Guattari describe in this chapter's epi-graph. As the artist's singular features escape the facial totality, they dismount the semiotic organization of the corporeal, opening up new imaginaries of the human.

Since the onset of cyborg and posthuman theories in the 1980s, the face has become a privileged locus in the critique of the ethics and biopolitics of human-ism. At the heart of Levinasian ethics, faciality has been fundamentally questioned as being culturally overdetermined, and linked to Christian and European regimes of representation. For Levinas, the human is a being that has a face, even when this concept does not involve a "plastic form" or an *eidos*, that is, an "'adequate idea' by which we could represent and grasp it" (Waldenfels 2002, 67). Rooted in a phenomenology of corporeality, Levinas's understanding of the face corresponds to a conception of the "ethical subject" as "an embodied being of flesh and blood" (Critchley 2002, 21). In other words, it is the "hungering, thirsting, enjoying, suf-fering, working, loving, murdering human being in all its corporeality (*Leibhaft-igkeit*) whose otherness is at stake" in the Levinasian face-to-face ethical relation (Waldenfels 2002, 65). And this otherness is condensed in the seen face, the *vis-age*, a fundamental "relation of exteriority," which does not belie any essential or hidden identity, but situates the Other as nakedly exposed, fragilely exhibiting his or her vulnerability through the nervous adoption of countenances and poses when confronted with another subject.[1]

For Deleuze and Guattari, however, Levinas's conception of faciality leads to the reduction of the Other to the same, an "aversion to difference" that simply propagates sameness (Bunch 2014, 45). Their perspective responds to the Levi-nasian argument that the face is universal rather than culturally determined and historically contingent. Deleuze and Guattari, by contrast, provocatively contend that "the face is not a universal," but rather "it is White Man himself, with his broad white cheeks and the black hole of his eyes. The face is Christ. The face is the typi-cal European, what Ezra Pound called the average sensual man" (Deleuze and Guattari 2004, 196).

In their attempt to construct a posthuman ethics on the basis of a post-facial epistemology, Deleuze and Guattari critique the Levinasian face's dependence on the place of the Holy Shroud in Judeo-Christian tradition. That is to say, for them,

the Levinasian face is indexical of subjectivity, "a vehicle for signification and sub-jectivation," the seat of identity, capable of acting as portrait of an inner self (Bunch 2014, 45). Yet "Primitives," they argue, "have no face and need none" (Deleuze and Guattari 2004, 195). In this primitivist spirit, Deleuze and Guattari posit that semiotic constructs of the face have been modeled after a European pro-totype that works as an abstract machine of assimilation and exclusion: "at every moment the machine rejects faces that do not conform, or seem suspicious" (197).

Hence, while Deleuze and Guattari "agree with Levinas that alterity is essen-tial to ethics, they find that faciality contradicts this effort" by acting as a totaliz-ing machinery of ruthless dissemination of sameness (Bunch 2014, 45). This machinery operates by means of a process of overcoding that involves "centering, unification, totalization, integration, hierarchization and finalization" (Deleuze and Guattari 2004, 46). That process operates an essential disarticulation of head and body, whereby the latter's "volumes," "internal cavities," "variable exterior connections and coordinates (territorialities)" become reduced to a white wall/black hole system (195). The white surface provides a set screen or a frame for sig-nifiers (186), while the black holes are a space for affective investment that allows "subjectivation [. . .] to break through" (186). Naming this operation a "horror story" (187), the authors, however, claim that (the Christian tradition of) paint-ing "has taken the abstract [. . .] machine of faciality in all directions, using the face of Christ to produce every kind of facial unit and every degree of deviance." In other words, Deleuze and Guattari suggest that "it was under the sign of the cross that people learned to steer the face and processes of facialization in all directions" (198).

Suggestively linked to Kurtycz's experiments in facial transmutation, these pas-sages situate artistic practice as a space capable of undoing the assimilating pow-ers of the faciality machine. This operation should not be confused with the mere transformation of actual forms, for it entails the more complex process of forging new virtualities, where "the virtual intercedes or penetrates the real as that which is expected, predicated, or even imagined of the real" (Rushton 2002, 226).[2] That necessity stems from the fact that the face is neither sheer actuality nor a series of shapes, meanings, or appearances. Rather, the face forges the virtual by carrying out "the prior gridding that makes it possible for the signifying elements to become discernible, and for the subjective choices to be implemented" (Deleuze and Guat-tari 2004, 199). Moreover, the faciality machine does not work as an annex to language and subjectivity. Rather, it is "subjacent to them": "a language is always embedded in the faces that announce its statements," in the same way that "a com-mon grammar is never separable from a facial education" (199).

Rooted in this conception of virtuality, Deleuze and Guattari's theorization of the face establishes a meaningful correlation between processes of subjectivation, signification, and embodiment. Nevertheless, it does not substantiate the authors' proposed transition between facial overcodification and post-facial becoming, the

fading away of the face or, to go back to this chapter's opening quotation, its dismantling or becoming clandestine. This issue has been most clearly articulated by Warwick Mules, who suggests that Deleuze and Guattari's understanding of the face as a conceptual scheme or a system fails to take into account, first, the singular specificity of *a* face, and second, the facial encounter, or the "event of the face" (Mules 2010, n.p.). Mules also posits that the problem of the ethical significance of the face, as brought up by Levinas, ought not to be reduced to a Eurocentric and "pre-critical" conception of the face as an absolute. Instead, as I shall discuss in relation to Kurtycz's work, it demands a "*critical praxis* of specific engagements with [singular] face encounters" (Mules 2010, n.p., emphasis in the original). Moreover, on the basis of Walter Benjamin's distinction between the sign, as an entity imprinted on something, and the mark, "a pure material pulse" from which something emerges (Benjamin 2000, 83), Mules considers the face as a trace or "mark of the self," which opens up "possibilities in the materiality of the medium itself for future self-configurations unseeable in current forms of self-identity" (Mules 2010, n.p.). This conceptual operation delinks the face from any presumption of self-presence, positing faciality as a contingent mechanism of encounter and mediation: "In its faciality the self withdraws from any identity assigned to it, and in this withdrawal marks itself as *a* face, as a singular, indeterminate event" (Mules 2010, n.p.). An actual face-to-face ethical relation therefore depends on the mediation of faciality only to the extent that the face, as *mark* of contingency and withdrawal, opens the possibility of "forming new self-other relations" (2010, n.p.).

According to Mules's view, even though the face in the face-to-face encounter takes a fleeting retreat, this retreat does not continue to the point of invisibility, as it does in Levinas's writings. By contrast, the face as mark carries the weight of a trace, as a presence in movement and transformation, a sign that becomes deformed and incomplete in the process of materialization, a sign in a state of impermanence. In the theory of the face as trace, the face essentially becomes a medium. This conception of faciality could be seen as responding to the increased digitalization of the corporal, where cyberspace has been discussed as a prosthetic extension of the body (Stone 1995, 12).[3] Yet even if one agrees that the face serves a primarily virtual function that frames the possibility of communication, it is unclear whether the face itself can be rendered in virtual form through networked and digital technologies. This seems to be the major challenge of what Stone describes as "prosthetic communication," given its fundamental reliance "on bodies without organs" (1995, 36). Could the mediating face take any form, or is it dependent on flesh, corporeality, viscerality? Does the face, as immanent and fleeting affectivity, need to have a materiality, a temperature, a texture, and a smell? More importantly, could the face as a site of encounter—that *something* giving rise to face-to-face recognition as it exposes the subject's fundamental vulnerability—become codified and incorporated into a cybernetic communicative circuit?

Kurtycz's treatment of the face in a variety of media throughout his career is closely related to these reflections on the conditions for communication and ethical recognition at "the close of the Mechanical Age" (Stone 1995). Increased mediatization entails dependence on pre-codified languages that not only participate in processes of "unification, totalization, [and] integration," as Deleuze and Guattari point out (2004, 46), but also remain largely alien and unreadable to the human sensorium (thus the growing and overwhelming need of computers to translate them). For the artist, the media age has been accompanied by a major and possibly irreversible redistribution of what Rancière describes as "the fabric of sensory experience" (Rancière 2013a, 140), leaving behind those forms of exposure inherent in the Levinasian face. Convinced of the importance of the possibilities for ethical relationality resulting from this conception of faciality, Kurtycz engaged in the artistic practice of searching clandestinely to incorporate them into the language of cybernetics.

The artist's youth in Poland coincided with the peak of first-order cybernetics and, having himself studied a specialized degree in this field,[4] this deeply influenced his understanding of art.[5] From the latter half of the 1960s onward, Kurtycz carried out a series of experimental works aimed at turning the desire to disembody information, which was prominent in cybernetics, into a critique of this same science, on the basis of its fundamental delinking of information from faciality. Kurtycz was well acquainted with the significance and future consequences of new developments in robotics and information technologies, and when he moved to Mexico in 1968, he continued to design, imagine, and critically incorporate mechanisms of automatization, interactivity, and networking into his artworks. He praised the ways that cybernetics opened up new possibilities for creation and communication, positively downplaying the primacy of the authorial voice. Yet he believed that, when these technologies wrest from individuals the possibility of decoding and playfully interacting with this information, the faceless and automatic network leaves no entry point for an ethics of recognition and responsibility before the Other.

The following sections correspond to three different conceptions of faciality in Kurtycz's artworks. The first situates the place of the face in his performance *Cambio de cara* (Face Change) (March 1991) and the related video-performance *Serpiente desollada* (Flayed Serpent) (1992). These ritualistic and viscerally explicit works collapse the often-made distinction between face and mask by exposing the vulnerability and mutability of the organic, visceral face. In these performances, the "true face" is rendered multiple and fragile, downplaying any attempt to represent the face as the access road to the human soul or the innerness of the psyche. This not only belies the division between self and appearance, but also opens up a meaningful space in which to explore self-reflexively the Other within the self or the self as already Other. This discussion will be followed by a closer consideration of the relationship between faciality and those mechanisms

of codification and interactivity unleashed by early developments in cybernetics. After situating Kurtycz in the context of 1960s Soviet technophilia, the analysis proceeds by examining the artist's design of cybernetic assemblages and immersive environments as explorations of the perceptive possibilities and limitations of cyborg bodies. Central to these works will be the notion of the *interface*, understood as a zone of contact between human and machine, allowing exchange between them while fostering hybridity. In the interface, the face is opened to new articulations, transcending the cultural determinism critiqued by Deleuze and Guattari. As a paradigm of communication and societal interaction, however, the interface poses significant challenges to an ethics of faciality, as it reduces forms of face-to-face recognition and exchange to a preprogrammed set of interactive possibilities. These challenges are confronted in the chapter's final section, by discussing a nine-year project entitled *Softwars*, in which the artist used the postal network as a mechanism to reclaim the possibility of intimacy and embodied communication within a networked society. Carried out roughly between 1980 and 1989, *Softwars* attempted to create a bridge between the artist's situated practice of live performance and the rapid and delocalized flows of information in the transnational postal network. The series of works that constitute this project are heavily dependent on the performativity of live art documentation. In them the (imprinted) face, understood as the trace of a withdrawal following Mules's conceptualization, takes on a new centrality, yet risks becoming the material ruin of a mode of communication moving swiftly toward its own dissolution.

THE HYBRID FACE

Filmed in an abandoned tram station in Mexico City, Kurtycz's performance *Cambio de cara* unfolds as a ritual of facial transmutation set in a space crowded with worn-down machinery and jumbled cables.[6] The work begins with the artist receiving a *hachimaki*, a Japanese headband associated with the ritual of *seppuku* and, more generally, with vigor and courage, from one of his daughters.[7] Kurtycz then kneels down by a metal steering wheel, his torso uncovered, to begin shaving the right side of his head in what he called "la rapada penitenciaria" (prison shaving). This self-disciplining act is followed by a quasi-ceremonial ablution with mud, performed in nudity. Kurtycz then uses a blowtorch to cut out a large robotlike quadrangular face from a metal sheet while "five thousand" little drawings of faces fall from the roof. This confetti-like rain of faces evokes the unrestrained and elusive multiplicity of the human face, which contrasts with the stark fixity of the metal droid-like countenance. The performance concludes with a scene of rebirth, as Kurtycz's own face emerges from the large quadrangular mouth of his recent creation, becoming the tongue of a larger countenance, whose machine-like expression could only uncannily resemble a human's facial infinitude (Figure 6.3).

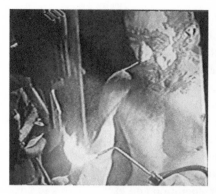

FIGURE 6.3. Marcos Kurtycz, *Cambio de cara,* 1991. Photo by Claudia Madrazo. KA. Courtesy of Anna and Alejandra Kurtycz.

The artist dedicated this performance "to those interested in seeing things as they are [...], that is to say, to see true faces." This ironic statement, handwritten on the leaflet that accompanied the live act, aimed to debunk the common evocation of a single, permanent, and true face lying underneath a person's multiple masks. The "dedication" was therefore followed by a seemingly unending list of "true faces," adding up to sixty-six and "many more": "grim face, happy face, kind face, sad face, pretty face, libidinous face, [...], etc."[8] In view of the explicit mutability and impermanence of these faces, paired with the artist's performance of a ritual of facial transformation engaging the whole of his body and a fair amount of personal risk, *Cambio de cara* resists any facile association of the human face with artifice. It was quite the contrary, according to Kurtycz; to change one's face

does not primarily involve adopting a mask or participating in a theater of deceit and representation, but it involves the recognition of self-impermanency and deformity. The artist's performance therefore partakes in an ongoing critique of what Donna Haraway calls a "coherent and masterful subjectivity" grounded in an unbridgeable division between a permanent mind or soul as the locus of being, and the body, as its mutable and masked veneer (Haraway 2004, 48). Furthermore, *Cambio de cara* opens up the possibility of the hybrid coming-together of human and machine, giving rise to a cyborg body whose existence may blur the boundaries between social and virtual realities. Yet Kurtycz's rebirth from the cold, stiff, and lipless mouth opening of a metallic countenance surrounded by broken and rusty pieces of machinery also casts a somber light on the prospects of this hybrid becoming.

A rite of passage preparing the artist for major surgery to remove an intracranial tumor (causing his left-side facial paralysis), *Cambio de cara* was followed by a series of live actions performed immediately prior to his entry into the operating theater and during surgery. In early April 1991, the Mexican painter Gilberto Aceves Navarro met Kurtycz at the entrance of Mexico's National Institute of Neurology and Neurosurgery to carry out a joint piece of body art. The few remaining pictures of the event suggest that, with his abrasive sense of figuration and vigorous lines, Aceves Navarro covered the paralyzed half of Kurtycz's face with a painted mask. Rather than veiling or cloaking the latter's expression, this mask gave it new movement and plasticity. Indeed, at first sight, Aceves Navarro's split countenance offers itself in the guise of a frenzied collision of expressive lines and bright colors. Under closer scrutiny, however, subtle figures appear, claiming a relationship of resemblance to facial traits, despite their own deformity. In this way, the artist's eyes are joined by a third oculus above his left temple, while a triangular nose and a dented mouth occupy his cheek (Figure 6.4). With these unsettling new features and his head half-shaved, Kurtycz's front and profile acquire, in their expressive asymmetry, an eerie similitude, molded by Aceves Navarro's unhinged and broken lines. Organically paralyzed by a brain tumor, Kurtycz's visage gains new vibrancy and movement through Aceves Navarro's drawing. The image of the artist's hand laid upon another artist's face, anticipating the work of the scalpel, further instantiates Kurtycz's long-held fascination for the mutability of the face, particularly when most fragile and deformed, together with the artist's embrace of bodies that are self-modified and hybrid. While Kurtycz's 1982 *Artefacto Kurtycz* is a work in which the artist aspired to facelessness by burning his own photographic portrait—as I suggest in the previous chapter—in this concatenated series of works the artist redeems the face as a site of both self-transformation and encounter with the Other. In this light, the face offers a space for unveiling the self's ultimate contingency, and it opens the human, in its interaction with other living and nonliving beings, to states of indeterminacy and change.

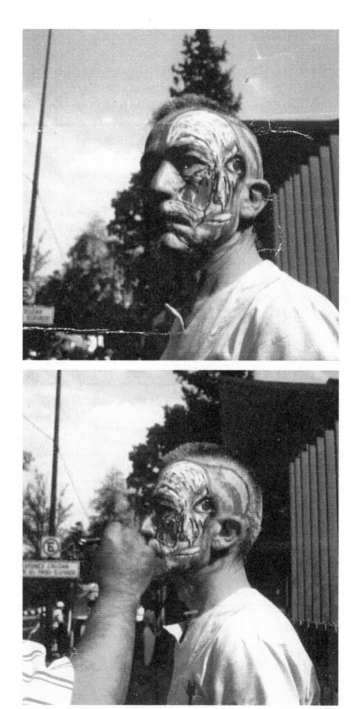

FIGURE 6.4. Work of body art by Gilberto Aceves Navarro and Marcos Kurtycz at the entrance of Mexico's National Institute of Neurology and Neurosurgery, 1991. Photo by Claudia Madrazo. KA. Courtesy of Anna and Alejandra Kurtycz.

The last stage in this long sequence of works took place in the operating room, where the entire surgery was filmed, with the footage later becoming the video *Serpiente desollada* (1992). Fixed on a close-up of the artist's face, the video centers on the moment that the surgeon's scalpel strips the artist's facial skin off. Raw, unbound, flayed, yet trapped within the surgical machinery, the artist stares vacantly at the camera, interpellating the spectator from a place of daring exposure (Figure 6.5). The skin, as threshold or limen, is here not punctured or traversed (as I discuss in relation to Diamela Eltit's *Zona de dolor* in chapter 1), but fully removed from the body, belying the division between interiority and exteriority, self and appearance. In this unfamiliar (visceral) form, the face emerges as the Other within: a mask below the mask (painted by Aceves Navarro), below the mask (of the skin). This tautological reappearance of the face as mask in the process of unveiling the artist's visage arrests any search for ultimate essences, while evoking the organic vulnerability of the mutable, human face.

In turning the operating chamber into a stage for a live performance and in the act of opening his body to (and through) the "intrusion of technology" (that of the medical equipment as well as that of the camera), Kurtycz's *Serpiente desollada* bears strong affinities with the work of French artist Orlan (Zylinska 2002, 217). Contesting "art historical equations that link constructed beauty and female identity," Orlan "has publicly de- and reconstructed her face" nine times through a series of surgical performances, in which each of the scalpel's incisions on her body is minutely planned and recorded (O'Bryan 2005, xi). The artist focuses in

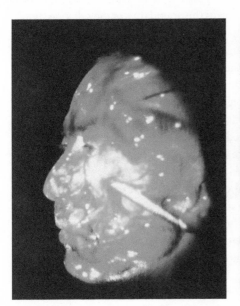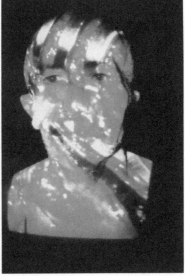

FIGURE 6.5. Photographic still of *Serpiente desollada* (1992). Unknown author. KA. Courtesy of Anna and Alejandra Kurtycz.

particular on the construction of fixed ideas of female beauty, and on the plastic surgery procedures involved in fashioning bodies to fit them. In her episodic work *La réincarnation de Sainte-Orlan* (The Reincarnation of Saint Orlan), she transforms her face into a collage of features taken from representations of women by the so-called masters of art history, acquiring "the mouth of Boucher's Europa, the chin of Botticelli's Venus, and the eyes of Gerome's Psyche" (Zylinska 2002, 222). The carefully documented bruising and swelling that follow the surgeries expose the risk and physical pain involved in the making of plastic beauty. Additionally, the resulting prosthetic attributes implanted in her face bring her appearance to disturbing, ambiguously human, and for some, posthuman, territories, which are marked by tensions and slippages between "male/female, natural/ unnatural, real/imaginary, beauty/the monstrous" (116). According to the artist, her "carnal art" seeks to traverse these divisions not only by reshaping her face and body, turning them into receptacles of prosthetic "grafts"—thus incorporating the (objectual) Other into the self—but also by exposing the plain carnality that lies below the skin, the alien or monster within.

Joanna Zylinska interprets Orlan's work in the light of the concept of prosthesis and its relevance for an ethical critique of the conception of the Other as an extension of the self "to be manipulated for the advantage of the individual and social self" (Wild 1969, 12). She observes the presence of a counter-reading of this self-centered ethical posture in Orlan's *Réincarnation*, where the prosthesis becomes a "figure of hospitality, of welcoming an absolute and incalculable alterity that challenges and threatens the concept of the bounded self" (Zylinska 2002, 217). While this piece certainly destabilizes the boundaries of the self, one should remain wary of a conception of the prosthesis as a signifier of absolute alterity, for this vision prevents a more fluid and co-constitutive relationship between self and Other, human and technology, the body and its (sensorial) extensions.[9]

One of Orlan's performances within this project parallels Kurtycz's *Serpiente desollada* in that it also involves a surgeon lifting the skin off her face. Although human faces are constituted by the skin as well as the muscles and bones beneath, C. Jill O'Bryan posits that Orlan's flayed facial skin suggests the elimination of both her face and her identity, a "bizarre phenomenon" punctuated by the use of extreme close-ups that leave all references to her identity outside the video screen (O'Bryan 2005, 103). In this unusual combination of extreme intimacy with an anonymous rendering of the body (a sort of reversed portrait), the artist becomes an "unidentifiable object, body, stuff" (103), with whom recognition by the spectator is nonetheless likely, if not inevitable—for all faces, from this "inside" perspective, independent of eye, nasal attributes, or skin color, ultimately resemble one another. "That impressive, if not abject, outpouring of flesh and blood could be me," ponders the spectator in a moment of horrifying recognition—a form of recognition that is not, however, possessive, for the vision that it encounters is shapeless, anonymous, and indecipherable (105).

Entitled *Omnipresence*, Orlan's performance was carried out in New York in 1993, two years after Kurtycz's surgery. In the visceral performances of both artists, the conception of the face as veil or mask is first made literal to then expose the impossibility of the unmasked face, its stark indecipherability, the anxiety to remask it, and the simultaneous dissolution of face and subject. The metaphysical defense of a "depth that lurks behind the surface of things" (Doane 1991, 55) is thus carnally resisted, on the one hand, by the puzzling impenetrability of the (amorphous) nonsuperficial or bidimensional face, to use Deleuze and Guattari's term, and, on the other, by the monstrous becoming of the flayed-face, its reconversion into mask. Orlan's "surgical performance," writes O'Bryan, "both ratifies and denies the existence of depth within an interior/exterior motif" (O'Bryan 2005, 106).

Beyond the surgical theater, however, Orlan's work mobilizes a technopoiesis of the body that reimagines the relationship between the human and contemporary technics, and their interdependence or interpenetration. The artist's later work, notably her computer-manipulated portraits entitled *Self-Hybridizations*, continues the practice of facial transformation using digital media, moving toward an exploration of the posthuman body—in which, according to N. Katherine Hayles, "There are no essential differences or absolute demarcation between bodily existence and computer simulation, cybernetic mechanism and biological organism, robot teleology and human goals" (Hayles 1999a, 3). These pieces are a paradoxical extension of tendencies that were already present in Orlan's earlier, viscerally explicit performances, which despite the centrality of corporeality stem from a desire to escape her own body or even break away from corporeality *tout court*.[10] The singular sense of exposure and intimacy characteristic of Orlan's surgical performances is, however, absent from her recent practices of corporeal modification through virtual reality. The artist's exploration of the vulnerability of the mortal, visceral body, offering itself in a state of outward exposure—instead of (technical) dominance and cognition—seems somewhat untranslatable to the digital medium; Orlan's computer-manipulated portraits no longer incite those deeply felt feelings of horror arising from the arguably abject qualities of her early work.[11] The artist's attempt to perform in her later work a technologically aided critique of humanism seems somewhat tamed or toned down by its own dependence on a technology that disregards the material basis of human life. In this sense, as O'Bryan suggests, "The *Self-hybridization* photographs have no interior, no texture, no body," leaving the boundaries of the facial skin untouched (2005, 134).

THE INTERFACE

Kurtycz's decision to permanently move to Mexico in the fall of 1968 coincided with his first individual exhibition, organized at the Galeria Współczesna

in Warsaw. Entirely conceived of by applying cybernetic principles and using materials involved in computational operations, the artworks on display may have seemed atypical for an art setting. Their names were no less unusual, divided as they were into *reliefy cyfrowe* (cybernetic reliefs) and *algorytmy sterowane* (controlled algorithms). In the first series, the artist used "punched tape," the chief data storage device at the onset of the computer era, to create monochrome silkscreens and textured, abstract collages, in which he glued together vertically aligned punched-tape strips. Made of hundreds of pieces of information, these alluring images remained unreadable to the human eye, beyond the sensual appreciation of their patterns and rugged textures. Alongside these medium-format reliefs, the artist exhibited other artworks evocative of cybernetic processes that served here a purely aesthetic function. This delinking of appearance from function echoes the divorce between information and medium that accompanied the rise of information theory in the wake of the Second World War. "In information theoretic terms," writes N. Katherine Hayles, "information is conceptually distinct from the markers that embody it [...]. It is a pattern rather than a presence, defined by the probability distribution of the coding elements composing the message" (Hayles 1999a, 25).

A second series of cybernetic objects entitled *Controlled algorithms* was organized around the application of a finite number of precise rules—an algorithm—to trigger the passage of light through another type of punched tape with slightly bigger holes.[12] Shaping light in a grid-like manner, and thus underscoring the physicality of cybernetic processes, these artifacts appeared equally enigmatic to the observer, given that, while cybernetic theory understands "patterning [...] as the very essence and *raison d'être* of communication," no human brain is capable of decoding these patterns without the aid of a computer (Gregory Bateson quoted by Hayles 1999a, 25). In these information-infused artworks, there are no visible signs of an authorial subjectivity, such as a characteristic voice, handwriting, style of writing, or brushstroke. The play of light and shadows formed on the panels is, however, visually striking.

Beyond the distinctive character of these pieces, all of which were lost with the artist's exile, the relevance of this early exhibition lies in its accompanying leaflet, which may be seen as a manifesto of sorts addressing some of the central topics defining the relationship between art and technology after the rise of cybernetics. Beginning with an account of what Kurtycz described as the exponential growth of information in contemporary societies, the text highlights the extent to which the capacity of digital machines to read and record data eclipses that of human beings. Yet he adds that, in the arts, a closer engagement with digital processes and digital interactivity could have the effect of further approximating artwork and viewer, by favoring the participation of the latter. The viewer, Kurtycz says, may even become involved in the making of the artwork, thus blurring the line between artist and spectator, on the one hand, and individual and collective

authorship, on the other. The artist wrote this text in a technophilic social milieu, in which cybernetics were becoming the predominant socio-scientific paradigm in the Soviet world (Crowley 2011, n.p.). However, Kurtycz resists falling into what he calls the "mystification" of the machine: the blind idolization of the nonhuman, therefore incorrupt, nature of computers. Conversely, he argues that humans will always ultimately remain in control of machines. His text therefore expresses a feeling of ambivalence toward the rapid technological transformations brought about by cybernetics—a feeling that deeply influenced Kurtycz's work while living in Mexico (Crowley 2011, n.p.).

Described as the first science capable of producing machines that uncannily resemble (and may even become a substitute for) human behaviors, cybernetics developed in the United States in the aftermath of World War II, primarily through the work of the American mathematician Norbert Wiener, in collaboration with, among others, the Mexican physiologist Arturo Rosenblueth. *Cybernetics, or Control and Communication in the Animal and the Machine* (1948) and *The Human Use of Human Beings* (1950), Wiener's major works on the subject, postulate the possibility of interpreting central human processes on the basis of information circuits, thus bringing about "a diverse set of man-machine metaphors" (Gerovitch 2002, 63). From the point of view of cybernetics, "Humans and machines were two kinds of *control systems*, which, *operating* in certain *environment*, pursue their *goals* [...] by *communicating* with this environment, that is, sending and receiving *information* about the results of their actions through *feedback*" (Gerovitch 2002, 87).

Wiener's theory was originally scorned in the Soviet world as "an ideological weapon which would deprive mankind of its humanity by turning humans into docile machines"—aiming at nothing but "the process of production realized without workers, only with machines controlled by the gigantic brain of the computer!," as a Soviet critic under the pseudonym "Materialist" wrote in 1953 (Gerovitch 2002, 128). Yet once the Scientific-Technological Revolution was launched with the purpose of shaping "a new Soviet consciousness," as Soviet premier Nikolai Bulganin announced in July 1956, cybernetics became a privileged terrain in which the relations between the state-run economy and its cultural products could be reshaped (Crowley 2011, n.p.). According to Loren Graham, "One can find no other moment in Soviet history when a particular development in science caught the imagination of Soviet artists to the degree to which cybernetics did" (Graham 2012, 90). Among the literati, interest in cybernetics came together with an effort to reshape their understanding of communicative processes, for instance, by paying renewed attention to sign systems, returning to the work of the Russian Formalists, and developing a school of structural linguistics.[13]

The expansion of cybernetics throughout the Eastern bloc by means of USSR-led, state-run research institutes is crucial to understanding Kurtycz's early induction into this science, while working as an adjunct at Warsaw's Institute for

Automation, and the techno-skepticism of his later work. Art historian David Crowley contrasts the far-reaching influence of the Scientific-Technological Revolution in the USSR with the "growing sense of the failing modernity of Polish socialism" (Crowley 2011, n.p.). Doubt and skepticism characterized the reception of the supposedly "neutral science" among Polish artists and intellectuals who, along the lines of the philosopher Leszek Kołakowski, believed that the real problems of socialism revealed after Stalin's death ought not to be obfuscated by new promises for the future. Kołakowski wrote, "We observe [. . .] the astonishing speed with which the new mythologies displace the old ones [. . .]. Thousands of people fondly imagine that the friendly inhabitants of other planets will one day solve the problems from which humans cannot extricate themselves. For others the word 'cybernetics' embodies the hope of resolving all social conflicts" (quoted by Crowley 2011, n.p.).

Similar doubts about prevailing technophilia led a number of Polish artists of what is known as the 1970s neo-avant-garde to approach new technologies with a dose of irony, or even adapt them toward goals different to those originally envisioned by the state. This involved designing unbuildable or technologically intensive (purposeless) structures, demanding the kind of excessive human efforts that were being mobilized for the similarly lofty nuclear arms and space races. Jerzy Rosołowicz's *Neutrdrom* (c. 1960), for instance, was a 100-meter tall conical tower designed to stand on its vortex. Visitors would board an elevator situated at its core and travel in absolute darkness to the top, where, "standing on a mirror, they would be bathed in a cosmic symphony of light." Ironically disregarding questions of efficiency or feasibility, the artist considered that designing this project would require the "co-operation of psychologists, physicists, physiologists, mathematicians, electronics specialists, and cybernetics specialists." For Crowley, however, it was not just irony that was at stake in Rosołowicz's *Neutrdrom*, but Theodor Adorno's concept of "negative utopia," "a condition or experience that resists the foreclosure of the possibility of a completely new way of being" (Crowley 2011, n.p.).

This sort of uncompromising entry into the future, intercepting its embedded logics from within, is similarly present in Kurtycz's design of immersive environments and cybernetic assemblages.[14] This is visible in the artist's sketchbooks from the first half of the 1970s, once he had permanently settled in Mexico. They contain a series of drawings depicting man-machine hybrids which, like cyborgs, involved the crossing of a "biological organism with a cybernetic mechanism" (Hayles 1999b, 157). The notebooks also display designs of possible and impossible cybernetic games, and a number of immersive environments incorporating sound and light elements, which the artist planned in elaborate detail despite lacking the means to construct them.[15] Kurtycz designed these projects through the use of cybernetic circuits and feedback loops. Accordingly, they involved inputs, receptors, reactions to stimuli, outputs, and noise. They also take into account time

change, kinesis, and the effects of the deployment of light and sound elements in space. In November 1971, he devised a "sound environment" that, with the aid of a microphone, a recorder, a speaker, and a storing device, would produce a sound mirror and a self-hearing machine. The project bears a strong resemblance to one of the earliest cybernetic experiments by Polish artist Krzysztof Wodiczko, who in 1969 produced his *Personal Instrument*, consisting of an electronic device worn on the head and hands that "allowed the individual to amplify or diminish the flow

FIGURE 6.6. Marcos Kurtycz, *Untitled*, c. 1969. Ink on paper. Photo by Mara Polgovsky Ezcurra. KA. Courtesy of Anna and Alejandra Kurtycz.

of sound from the environment." According to Crowley, "in wearing it, the user excluded himself or herself from the collective," evoking a situation of increased control and anomie in the People's Republic of Poland (2011, n.p.). Like many of Kurtycz's experiments, Wodiczko's *Personal Instrument* combined new technologies with a critical view of their future application and certain angst about the hasty fading away of a humanist worldview. "In its futurism," says Crowley, Wodiczko's work "pointed—perhaps darkly—to a world where the voice was no longer a *human* faculty" (2011, n.p.).

Of the various arts practiced by Kurtycz, it is in his drawings that one can most clearly sense this humanist nostalgia. When he depicts humans and machines that come together as cyborgs, the latter constitute repressive cages for the human body. They act as torturers and executioners, preventing the body's mobility and, most significantly for this discussion, erasing all facial features. Technology, in particular, exerts its vicious force on female bodies by forcing them to adopt erotic postures and render sexual favors. It also ties the human body to a specific function, thus interrupting the free flow of being and the possibility of play (Figure 6.6). As a whole, in these drawings Kurtycz depicts machines not as prostheses that potentiate or expand experience, but as instruments of isolation; for they turn humans into faceless objects and hinder their sensuous relationship to the world (Figure 6.7). In a note in the margin of one of his drawings, where a female body becomes fully embedded in a piece of machinery, the artist relates the dehumanizing experience of Nazism to the coming together of man and machine by asking: "Final solution?"

The complexity of Kurtycz's cybernetic experiments, however, does not only lie in the representation of technological dystopia, but in the way they also explore forms of resistance to it, by applying cybernetic concepts for the purposes of face-to-face encounter and enhanced sense perception. The artist's unrealized "environmental space designs" are part of a series of sound experiments and immersive environments conceived of on the basis of sustained (creative) interaction between humans and machines.[16] They are openly playful, at times erotic as well. In one of his notebooks, Kurtycz wrote—in English—that the purpose of these experiments was "to built a very special object capable of induce a kind of deep impression of outmindedness [*sic*]" (November 20, 1971). One of them is called (in shaky French) "ballet erotique avec celule fotoelectronique" and comprises a dancer on a stage whose movements are electronically captured and projected on a screen, thus converting the original corporeal gestures into a digital code that alters their visibility and amplitude.

Among the few ludic machines that the artist was able to build during the early years of his practice are what he called *Lucíferos* (1973), a series of wooden cuboid boxes whose name referred to both light (*luz* in Spanish) and Lucifer. Exhibited in various venues, including the Visual Arts School of the National Autonomous University of Mexico (UNAM), *Lucíferos* were cybernetic assemblages allowing

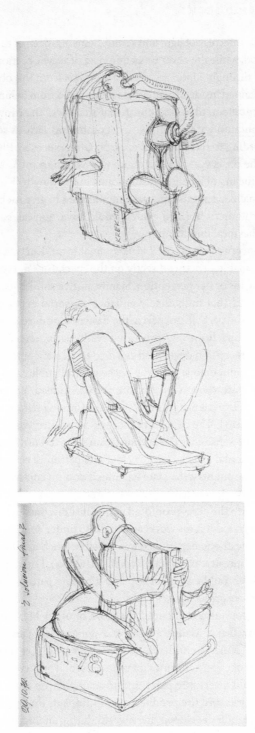

FIGURE 6.7. Marcos Kurtycz, *Untitled drawings*, 1972. Ink on paper. Photo by Mara Polgovsky Ezcurra. KA. Courtesy of Anna and Alejandra Kurtycz.

the choreographic interplay of light and sound elements. Each of the cuboid's sides was made of wood, while the cover was a fine layer of acrylic or moiré paper allowing light to pass through. Upon receiving a stimulus from the observer, objects and patterns contained inside the cube were illuminated from behind and reflected in this translucent element, as in a theater of shadows. The movement of light worked in conjunction with a soundscape, combining various sound elements (including, according to recollections, excerpts from pieces by Philip Glass) and transmitted to the observer—whose vision was as important as his or her sense of hearing—by means of a pair of headphones. According to Kurtycz's annotations, this personalized soundscape was programmed to give each participant an individual musical micro-horizon, which would have "logical, sociologic, logistic, ludic and behavioral implications."

Largely unconcerned about the *Lucíferos'* final form, Kurtycz regarded them as mechanisms capable of acting directly on the spectator's nervous system, and thus of enhancing his or her perception. Significantly, a similar search for the production of artworks that individually enhance sensorial experience characterized experimental and participatory art in the Eastern bloc during the post-Stalinist era. In Eastern Europe, however, "privatised aesthetic experiences" in which the process of artistic reception developed as a face-to-face encounter were available only rarely to the spontaneous passerby or the general public, as this entailed significant risks of state censorship for the artists. Indeed, according to Clare Bishop, "subjective experience was mostly shared among fellow artists and writers" (Bishop 2012, 130). The context of reception for Kurtycz's works in Mexico was different in the sense that the authoritarian state did not directly pursue or prosecute experimental artists.[17] Yet as chief arts patron in charge of most exhibition venues in the country, the state had much *de facto* control over artists' visibility or invisibility. During Kurtycz's early career, as a non-Mexican new media artist unaligned with the state-promoted nationalist discourses, the artist faced a constant struggle to exhibit his work, and to do so under conditions in which he felt a meaningful aesthetic experience was possible (such as allowing the public to have direct and unrestricted contact with the artworks). For most of his projects, Kurtycz lacked both public sponsorship and a private patron committed to his technology-intensive projects.

Cybernetic theory also influenced the work of other Mexican artists in the 1970s, most notably that of Manuel Felguérez. Felguérez's 1973 exhibition at Museo de Arte Moderno (MAM), entitled *Espacio múltiple* (Multiple Space), was based on the application of cybernetic principles "to present works created from a metalanguage that would insert into painting and sculpture the same conditions ruling scientific analysis and the productive ambitions of the machine" (Medina 2006b, 131). The painter developed these works during an internship at Harvard's Laboratory for Computer Graphics and Spatial Analysis and the Carpenter Centre for the Visual Arts, working in collaboration with New York-based computer

scientist Mayer Sasson. Together, they designed a digital program capable of applying the fundamental principles of Felguerez's paintings, arguably creating computers with an artificial aesthetic sensitivity (Felguérez and Sasson 1983, 10). Interestingly, looking beyond the scientific rationale motivating these creations, Octavio Paz praised their tactile dimension and their capacity to affect three-dimensional space. With this series of works, said Paz, Felguérez dissolves the division between two- and three-dimensional space, while tending toward a conceptualism that, rather than aspiring to art's dematerialization, or "dis-incarnation," is fundamentally "visual and tactile" (Paz 1974, 7, 9): "Felguérez's propositions do not enter us through the ears, but through sight and touch: they are things we can see and feel. But they are things blessed with mental properties and animated not by a mechanism but by a logic. Multiple spaces do not say: silently, they display themselves before us, and transform themselves into other spaces" (9).

Espacio múltiple featured the works of what Felguérez and Sasson named their "aesthetic machine" (*máquina estética*). The machine involved the use of cyber-netic algorithms to obtain an "n" number of compositional variants from a given number of aesthetic propositions. Therefore, as in Kurtycz's *Lucíferos*, these attempts to affect the public's sensorium—beyond the purely visual—are accom-panied by the fading away of the authorial voice. In these works' authorship becomes what Medina calls an "external mechanism," dependent on logical and automatic processes (Medina 2006b, 131). Furthermore, as Paz points out, these works' reliance on cybernetic procedures delinks their effects on perception from a narrative structure or a discourse. They are pre-discursive, if not anti-discursive machines that privilege sheer experience. Moreover, they serve as a reminder that new technologies not only entail processes of disembodiment but also lead to new configurations of space and corporeality—where proximity and direct, haptic con-tact may remain a possibility. Kurtycz's cybernetic experiments are, in turn, mechanically activated through the interaction between human and machine. This exposes the former to an array of non- or posthuman becomings, resulting from spectators'/participants' interactions with the artwork. In other words, the inter-active object produces an *interface*, "a point where two systems or objects meet and interact," "an in-between zone of prosthetic-hybridization of body and machine" (Boothroyd 2009, 334). Significantly, this notion evokes the possible existence of nonhuman facialities, delinking the "face" from the human face, par-ticularly if understood as the two-dimensional white wall/black hole system that Deleuze and Guattari propose, as previously discussed.

In the interface, faciality becomes pure skin, a surface of contact allowing the exchange of information through sensory receptors. The distinction between depth or cavity and surface, in turn, becomes insignificant, for the interface flattens all volumes by modeling them as circuits. The face thus becomes a terrain of expo-sure and variability, an entry point, independent of form—a zone of recognition

and (as well as through) self-undoing. This opens both human and machine to dynamic adaptation through recursivity and feedback. Similarly, it resignifies the human face as a sensory *response*, a haptic face, equally engaging sight and touch; a hearing face, exposed and reactive to the sounds of an immersive environment. It may be argued, however, that in this experience, the spectator/participant is reduced to an "adaptive object," one who, in Carla J. Glenn's words, "is incapable of changing reality" (Glenn 2010, 23). In an interface, the cybernetic circuits to which the spectator/participant can respond are generally fixed, therefore offering only limited and specific forms of becoming. In the process, he or she may lose the "lived experience of negotiating/creating, being/doing, in space moments of possibility" (23).

FACIAL TRACES

Besides his interest in designing cybernetic assemblages to enhance contact and interaction between the artwork and the spectator, Kurtycz brought cybernetic developments in networked communication to the terrain of mail art. Like Wiener's original cybernetic model, the artist's major mail art project, entitled *Softwars* (1980–1989), aimed at "engineering communication" circuits and producing messages that would "effectively change the behavior of the recipient" (Wiener 1950, 8). This eight-year-long "matrix," as Kurtycz called it, revolved around the notions of *software* and *war*, both understood as webs of intense and rapid exchange having potentially destructive effects but always on the verge of being pacified to foster dialogue. Kurtycz described *Softwars* as "a series of closely-articulated personal, local, national, and inter-continental acts dedicated to combating the 'microchip syndrome' on a planetary level." He then farcically defined this condition as the "acute dependency on computerized artefacts which leads individuals to believe in the limitless possibilities of the same, including the creation of artificial intelligence and art. In extreme cases of self-computerization the individual stops consuming food and/or plugs themself into the electronic network. In less serious cases, the individual gradually loses all communication with society, leaving themself at the mercy of the Great Networks"[18]

In Spanish the notion of matrix (*matriz*) evokes primarily the image of a uterus or womb. The artist's use of the term, however, referred to its meaning in electronics, computing, and even cellular biology, where it describes an array of circuit elements forming a grid, a network, or an amorphous "fibrillar material" supporting and interconnecting cells (*OED*). This conceptualization of the matrix captures Kurtycz's pursuit of "a high degree of articulation" between his works, aspiring to reach some kind of unbounded intermediality. Each matrix consisted of a series of open or unfinished works relating to each other at various levels of form and meaning, combining multiple media, moving between their boundaries, and ultimately aiming at globally interconnecting artists based in different

locations. In this regard, Kurtycz's work not only follows a matricial *structure*, by fully interrelating his performances with his drawing, printing, and mail art projects, but it also has a matricial or networking *aspiration*. The latter was realized by putting collages and various printed materials (mostly made during his live performances) in motion, drifting between distant places.

Practitioners of mail art often describe it as a horizontal social experiment promoting "spontaneous relationships" (Bazzichelli 2008, 40) and "intimate gift exchanges" (Saper 2001, xi), while bringing together established and amateur artists. "In practice," writes Tatiana Bazzichelli, "it is exercised by sending and receiving letters, cards or anything else one wants from all over the world, establishing 'virtual' ties with many other individuals" (Bazzichelli 2008, 37). Beyond this horizontal dimension, however, mail art may be seen to belong to a critical genealogy of networking cultures, contributing to the formation of collective projects aimed at hacking or intervening centralized models of social exchange and mass communication. A singular way in which this critique of networking cultures unfolds is through the formation of what Craig J. Saper calls "intimate bureaucracies," whereby artists infiltrate heavily bureaucratic organizations in order to expose their alienating anonymity and, in contrast, create "intimate aesthetic situations" (Saper 2001, 9).

Along these lines, Kurtycz's *Softwars* networks may be read as a search for intimacy in distant communicative exchanges. Counterintuitively, however, the artist's interest in unleashing a feeling of proximity, shared complicity, or familiarity in distance communication was conceived of as resulting from an initial situation of conflict, rather than a direct expression of care. The *Softwars* networks were thus created by sending "letter bombs" through the post, eliciting a response from the recipient and retaliating to it. As such, *Softwars* was primarily a postal project that structured global communication channels around the idea of an affective battlefield. It involved producing, sending, and receiving large numbers of highly varied information bundles, one of the unifying characteristics of which was the fact that no computer, regardless of its degree of sophistication, would be able to read them. Instead, the bombs were meant to be *decoded* by people's senses: with their "eyes, hands, nose, fingers, heart, and brain."[19] Their collage-like composition, combining various printing techniques, textures, and assembled elements, elicited this sensorial reception, imagined in opposition to the automatized and anonymous logic of standardized communication. In this regard, Kurtycz's letter bombs were designed as interactive objects, seeking to spark intense sensorial responses in the recipient through personal attack, provocation, and, more commonly, through sharing fragments of intimacy in the form of pictures, handwritten personal messages and, most prominently, imprinted bodily traces. The aim of Kurtycz's *Softwars* was therefore not to further intensify the flow of information in increasingly mediatized and networked societies, but to introduce a completely different tenor to distance communication by means of stamping fragments

of (corporeal) intimacy into the bureaucratized postal network. Carr describes the project as "a one-man battle against the media, high-tech, and postmodernism" (Carr 1988, n.p.). But one must bear in mind that, like Saper's "intimate bureaucracies," this battle was short of being a simple rejection of the high-tech in favor of face-to-face contact. Rather, the project involved an attempt to dwell on the shortcomings resulting from the increased standardization of communicative exchanges, reintroducing what they seemed to negate: a fundamentally corporeal ethics, best understood through the Levinasian face. That is, playing on the possible opposition between intimacy and anonymity, the project explored the possibility of being intimately exposed to the Other in networks of deterritorialized communication. Among those who were targets of Kurtycz's mail art bombardments were the Foksal art gallery in Warsaw, the journal *Artforum*, London-based Polish art historian and curator Jasia Reichardt (who in 1968 curated the exhibition *Cybernetic Serendipity* at the Institute of Contemporary Arts), Latino performance artist Guillermo Gómez-Peña, Australian performance artist Stelarc, sculptor and director of Mexico's Museum of Modern Art, Helen Escobedo, and Polish philosopher Stefan Morawski.

Although *Softwars'* main strategy was an intensive use of mail art, this practice was interconnected with a series of printing actions and public performances in which the mailings were "manufactured" using a range of experimental printing techniques. Therefore, one of the singularities of Kurtycz's *Softwars* matrix is that the objects used and produced during his live performances—objects that often bore imprinted traces of the artist's corporeal gestures and movements—became the main strategy to intervene in the bureaucratized postal system, instead of being reduced to the status of document for a putative future archive. Kurtycz's bodily imprinted low-tech mailings therefore appealed to the affective potency of a delayed encounter with the corporeal, acting like a sort of *punctum* that emanates from the traces left by certain forms of live art.[20]

Indeed, elaborating on Saper's discussion on intimate bureaucracies generated by mail art and on Philip Auslander's (2006) interest in the documentation of live events, I wish to argue that the traces of live performances may be said to "pierce" or "prick"—using Barthes's metaphors—the spectator by conjuring a sense of intimacy that points to "something outside itself" (Saper 1997, 17). This not only derives from the indexical relationship of these objects to the live event but also from what Auslander has theorized as the inherent performativity of the document (Auslander 2006, 7).[21] The significance of this problem is most vividly untangled when one considers it in relation to common analogies made with regard to the relationship between photography and the object photographed. Let us revisit, for instance, Rosalind Krauss's contention that photograms—photographs "produced by placing objects on top of light-sensitive paper, exposing the ensemble to light, and then developing the result"—"look like *footprints* in sand, or marks that have been let in dust" (Krauss 1986, 203, emphasis added).

Similarly, Susan Sontag speaks of photography not just as an image, but "also a trace, something directly stenciled off the real, like a footprint or a death mask" (Sontag 1990, 154). If the photograph is *like* a footprint, what happens when an actual footprint or death mask—turned into a work of mail art—becomes our center of attention? How are we to understand the footprint's relationship with and effects on the real? How are we to make sense of the presence of bodily marks and traces in Kurtycz's experiments in networked communication?

One may begin to answer these questions by identifying a productive parallelism between the traces imprinted in the material remains of performance art and the face as a signifying system that functions, following Mules, as the mark of a retreat. For Mules, "The face is that which withdraws from self-presence, thereby enabling the possibility of self-relation with others" (Mules 2010, n.p.). Similarly, although numerous theorists have defined performance as the art of presence, situating the ethics of performance in the face-to-face encounter (Phelan 2004, 574), one may contend that precisely the opposite is true—for it is only at the moment of the artist's retreat that the performance becomes fully available for the public's appropriation. The ethics of performance may be thus situated in time and history rather than in space and presence. It is only in the delayed encounter with performance art that the often overwhelming, if not violent, presence of the performance artist becomes ruin, opening up the relationship between artist and public to new reconfigurations. The trace of the performance, as the mark of a withdrawal, shifts the emphasis from self-presence to a materially sustained absence, whose often-vanishing physicality allows not one but successive encounters. Kurtycz's imprinted traces of his performances, turned letter bombs, are similar spaces of withdrawal and belated encounter.

Looking at the letter bombs sent to Jasia Reichardt between 1980 and 1989, which she carefully kept in her personal archive in London, one quickly notices that their most salient and recurrent element is the imprinted image of the artist's countenance. One of the earliest bombs, resembling the "Shroud of Turin" (believed to bear the imprint of Jesus's face after crucifixion), consists of a double imprint of Kurtycz's visage, which refuses in its duality—as trace of its mechanical reproduction—any claim to iconicity. While the image captures each of the artist's facial traits, including his beard and thick eyelashes, it also flattens the face, heavily deforms his nose, and truly turns his eyes into black holes, literalizing Deleuze and Guattari's semiotics of the face. In appearance, the image is closer to a death mask than to a live countenance, and as such, it stands as a site of resistance to these thinkers' critique of the bidimensionality of the face—rendering the bidimensional face as the limit of faciality, its becoming-mask or becoming-Other. Furthermore, like a negative of the body's viscera—the Other side of the dermic boundary—the mask casts a somber light on any facile celebration of the possibility of life outside one's skin. The motive of the flayed face as a liberatory impulse, aimed at unbounding the self and reaching toward the Other, is thus overshadowed by the

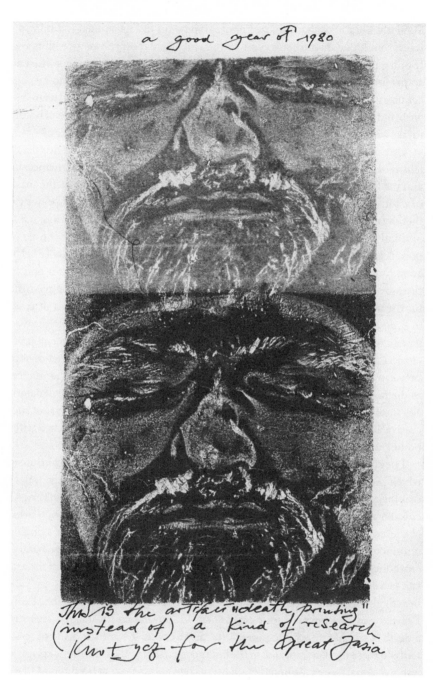

FIGURE 6.8. Marcos Kurtycz, letter bomb sent to Jasia Reichardt between 1980 and 1989. Jasia Reichardt Archive (hereafter JRA). Courtesy of Jasia Reichardt.

representation of "the negative" of the face as the limit of life. At the bottom of the image, a brief handwritten note by Kurtycz reads: "This is the artifact 'death printing' (instead of) a kind of research. Kurtycz for the great Jasia [*sic*]" (Figure 6.8).

The artist's note was most certainly aimed at framing the interpretation of his image outside of a formalist reading. The words "instead of a kind of research" are to be read as "instead of a formal or technical research." For Kurtycz, the imprinted trace of his visage ought not to be understood as an exercise of figuration but rather, in line with Auslander's propositions, as a performance. It was a delayed continuation of his live action *Pasión y muerte de un impresor* (Passion and Death of a Printer), performed in 1979 at the Annual Experimentation Section of the 1979 INBA-organized Salón Nacional de Artes Plásticas (Visual Arts National Salon). Proceeding like a penitent Passion, during which marks of the artist's bodily suffering were imprinted with artificial blood on a long sheet of paper lying on the floor, the performance (conceived of as a homage to Gutenberg as well as an act of protest against censorship) was a vivid display of the violence present in all processes of inscription: those in which an individual imprints, stamps, or engraves his or her subjectivity on a piece of paper as well as those in which this subjectivity is inscribed by a violent act or trauma. One of Kurtycz's earliest performances in Mexico and the first one carried out in a major art event, this action was so vivid and uncompromising with the make-believe codes of spectacle that, according to newspaper chronicles, someone in the audience called the Red Cross, thinking that the artist's life was at risk (*Uno más uno* 1979, 18).

Once inserted into the swift flows of information of the postal network, the imprinted image of the artist's face resulting from this and similar performances escaped a strictly representational (or visual) logic. As Georges Didi-Huberman argues, "The imprint transmits physically—and not optically—the semblance of the 'imprinted' object or being" (Didi-Huberman 1997, 38). Kurtycz's facial image, as trace, bears the marks of direct contact between the body and the surface of inscription. Just like in the case of painting and engraving, it subtly exposes the physical labor involved in the production of the trace, leaving a record of force and pressure, if not affect and intensity. The image succeeds in becoming the footprint that photography can only resemble. If one conceives of the sign, in its iconicity, as the trace of the subject's permanent death, this image stands not so much as the affirmation of presence but as the material remains of its passing. Subtly inserted into the matricially organized postal network, it speaks to the difficulty of translating the Levinasian face-to-face encounter into the logic of the network, while proposing a different rendezvous with the corporeal. Furthermore, in line with the general principles of the *Softwars* project—which intended to combat the "microchip syndrome"—this image interrogates the type of ethics that should accompany the development of a networked society, in which communication is

increasingly delinked from faciality, becoming dependent on what Beat Wyss calls the "traceless, digital sign" (Wyss 2000, 11).

Perhaps more optimistically, another of the letter bombs embraces Warhol's Pop aesthetics by offering a monochrome silkscreen of a frontal close-up of Kurtycz's face, embedded in a fluorescent background resulting from blending an image of fire with a satellite picture of moving air currents on Earth's stratosphere (Figure 6.9). As a God-like caricature printed in plotting paper, the image evokes the explicitly global ambitions of the artist's *Softwars*, while spectrally covering a networked planet with the artist's face. In relation to the previous letter bomb, however, here the face, as medium of exposure and encounter, is mere simulacrum, fully embodying an aesthetics of mechanized reproduction. Unsigned, the picture performs its anonymity; depthless, it presents itself as an impenetrable surface. The image seems to utter Warhol's famous motto: "I want to be a machine," which Hal Foster et al. read as the words of a "shocked subject, who takes on what shocks him as a mimetic defense against this very shock: I am a

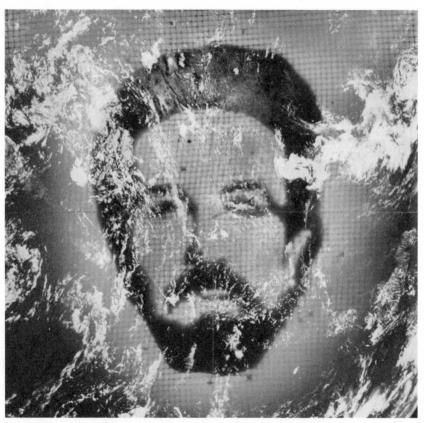

FIGURE 6.9. Marcos Kurtycz, letter bomb sent to Jasia Reichardt between 1980 and 1989. JRA. Courtesy of Jasia Reichardt.

machine too, I make (or consume) serial commodity-images too" (Foster et al. 2011, 532). Such a comparison proves significant when one begins to read Kurtycz's image as a form of identification with the cybernetic technologies that so strongly shocked and fascinated him. As with Warhol, this process leads to the compulsive repetition of an identical image, a process that results in the emptying out of its significance and meaning (534). In a third letter bomb sent to Reichardt, the artist stamped an entire cardboard sheet of a Mexican lottery game with a schematic rendering of his face that closely resembles the planet-covering monochrome silkscreen (Figure 6.10). Nine identical seals in a 3×3 grid-like alignment bury the symbols of popular culture (such as *el nopal* or *el cantarito*) depicted in each rectangular box of the lottery sheet. This kind of mechanical and compulsive repetition does not seem to aim at processing a trauma by integrating it into the symbolic order. Here, the repeated countenances sent to Reinhart—one of the people who partook in the institutional recognition of the coming together of art and cybernetics—"suggest an obsessive fixation on a lost object in melancholy" (543).

The image of the face in a state of compulsive repetition brings us back to Kurtycz's exploratory self-deforming portraits to which I referred at the beginning of this chapter. Yet while in the lottery cardboard sheet the face always remains the same, the photocopied photographs dismantle the facial organization. This seeming antagonism in Kurtycz's treatment of the face embodies a tension already entrenched in the face-to-face encounter; for, despite its manifest materiality, the facial relation entails a less-visible process of withdrawal and self-undoing. It is this simultaneous mechanism of grounding and ungrounding the self, immanent to the ethical relation, that, in Kurtycz's view, is most overtly at risk in those cybernetic attempts to displace the inevitably deformed, mutating, and incomplete human by networked automatons.

THE (POST-)FACIAL MATRIX

In this concluding chapter, I have discussed the place of faciality in Kurtycz's practice of performance, (cybernetic) assemblages, and mail art. Taking my cue from the centrality of the face in Levinasian ethics, its critique by Deleuze and Guattari, and the possibility of furthering the Levinasian perspective on the basis of these critiques, I identify three different conceptions of faciality in Kurtycz's art: first, the naked face, which collapses the distinction between face and mask; second, the interface, a zone of contact between human and machine wherein the idea of faciality becomes hybrid and prosthetic; and third, the face as trace, a sign in a state of impermanence, allowing (ethical) communication by means of its own undoing. These different conceptions of the face in Kurtycz's art respond to the challenges posed to humanist understandings of the body by the emergence of new cybernetic technologies. As such, they are symptomatic of a period characterized

FIGURE 6.10. Marcos Kurtycz, letter bomb sent to Jasia Reichardt, c. 1982. JRA. Courtesy of Jasia Reichardt.

by technological anxiety, in which the faceless and standardized network seemed to leave little space for an ethics of recognition resulting from what Levinas understood as the naked exposure to the face of the Other. In light of these developments, Kurtycz's pioneering performance practice in Mexico reclaimed the value of embodied communication and intimacy within a networked society. Yet his work also forged a critique of a humanist conception of selfhood and self-presence, by exploring the (material) impermanence of being, the incompleteness and mutability of the body, the self's visceral vulnerability, and the possibilities for hospitality provided by the self's prosthetic extensions. Furthermore, Kurtycz rendered mail art as a matricial practice. In this hybrid and distributed form, mail art allowed for the emergence of delayed, performative encounters, while transforming the (facial) trace into a sign of the self's continuous undoing.

CONCLUSION

The body implies mortality, vulnerability, agency:
the skin and the flesh expose us to the gaze of others,
but also to touch, and to violence.

—Judith Butler, *Precarious Life*

Vulnerability is unsettling; it roots us to the finitude of our bodies. As a vulnerable subject one inhabits a fallible reality, a reality that becomes unmade with the experience of pain. Being as much an individual as a social condition, vulnerability leaves us exposed not just to violence and injury, but also to the possibility of losing a loved one and becoming estranged from our political communities. Yet the expression of pain and vulnerability can take significant meaning: a cry of pain is more than a solitary act confronting us with our own grief. The cry, with its (often-nonlinguistic) sound and its gesture, is an ethical demand, a call for acknowledgement and recognition, and a recognition of the Other as interlocutor in our grief. Vulnerability, too, is a demand that falls upon us when we symbolize our world and imagine the communities to which we wish to belong. To quote Butler: "Loss and vulnerability seem to follow from our being socially constituted bodies, attached to others, at risk of losing those attachments, exposed to others, at risk of violence by virtue of that exposure" (Butler 2004, 20). Vulnerability is therefore inseparable from the causes of violence and their consequences; it also invites us to reflect on the political effects of the corporeality of the self and the significance of embodied responses to both contact and aggression.

This book discusses a series of artistic practices in 1970s and 1980s Latin America in which the representation and embodiment of vulnerable corporealities became a means of intervention in a fabric of sensory experience torn by state violence. During periods of authoritarianism in Chile, Argentina, and Mexico, and their immediate aftermath, these practices questioned, in particular, "the social utility of suffering" to the pedagogic function of power (Levinas 1988, 160). In addition, these notably experimental and intermedial practices forged an idea of the political that revised the (primarily masculinist and often violent) 1960s' model of avant-gardism. As they withdrew from this model, artists across these Latin

American countries faced the impossibility of proposing a new social or political utopia beyond an ideal of liberal democracy that rapidly lost its luster. Yet they found, in the artistic exposure, appropriation, and reshaping of the body, a terrain of political and aesthetic dissensus. I suggest that this form of dissensus proved capable of resignifying the models of vulnerability that had been inscribed in social imaginaries as a result of the biopolitics of authoritarianism. In this process, artists abandoned the quest for the "new revolutionary man" that the previous generation had imagined. They also developed a series of performative approaches to the politics of art. The latter were rooted in a complex model of subjectivity and corporeality that sought to destabilize facile divisions between pain and pleasure, the masculine and the feminine, health and disease, the sacred and the profane, the political and the ethical, and the human and the nonhuman. These artists' "touched bodies" became ethical corpora: self-reflexively positioned between self and Other, sense and matter, exposure and recoil, and corporeality and writing.

The visual and corporeal practices of the long 1980s in Latin America have received little scholarly attention, arguably as a consequence of greater curiosity toward the late 1960s, the point of origin of so-called Latin American conceptualism. A lack of rigorous scholarship on the art of this long decade has led to its simplistic association with a return to painting in the visual arts. My cross-national reading of the long 1980s on the basis of works by Diamela Eltit, Raúl Zurita, León Ferrari, Liliana Maresca, Grupo Proceso Pentágono, No Grupo, and Marcos Kurtycz, and my examination of these artists' connections with larger institutional and sociohistoric contexts, is intended as a revision of that received opinion. This book reveals synchronic similarities in artistic practice across different localities and an artistic scene characterized by the rise and popularization of intermedial performance. It also identifies two important transformations concerning the social significance of art in the 1970s and 1980s. The first is a desired and self-observing intersection between art and ethics, fueled by a reconsideration of the relationship between art and violence. The gradual displacement of the use of violence in avant-garde art in Latin America resulted from the failure of the armed struggles of the 1960s and 1970s and the ensuing disillusion with the idea of revolution as the main driver of political change and community formation. Indeed, as artists were confronted with an epochal sense of political disillusion, they explored new self-reflexive, if not self-directed, forms of aesthetic dissensus, in which the political in art became fundamentally determined by a corporeal ethics.

The second transformation signals the increased importance of live actions in artistic practice and the ways in which performative gestures animated, reenlivened, and repoliticized a range of media, including collage, poetry, sculpture, and video. As a marginal medium—often confined to the undecipherable and to the underground, yet filled with the invigorating powers of the rupture of tradition—performance art placed a politics of embodiment at the center of the field of art.

Furthermore, it expanded the signifying possibilities of more established art forms by generating a series of heterogeneous encounters between art objects and live, vulnerable, participatory, and desiring bodies. The performative turn is therefore premised on the labors of intermediality; it describes an intermedial redistribution of the order of the visible and the invisible, the touchable and the untouchable, speech and noise, numbness and feeling, detachment and proximity—a redistribution triggered by artists' commitment to the deceivingly ephemeral politics of performativity. In the years of authoritarian rule in Argentina, Chile, and Mexico, and their immediate aftermath, this intermedial reorganization of the aesthetic played a key role in influencing the public perception of the "interplay of signs," the "fragility of the procedures of reading these same signs," and the pleasure of "playing with the undecidable" (Rancière 2009a, 54). Crucially, the performative artwork did not just consist of fleeting live events or of an accumulation of traces of subjects slipping from the biopolitical norm. By contrast, performativity became a technology for aesthetic declassification, which suspended and reorganized received division between politics, ethics, and aesthetics.

TOUCHED BODIES

I understand the long 1980s as the moment of birth of what García Canclini (2010) describes as a society without a story line (*sociedad sin relato*), the societal model under which we continue to live in Latin America and the West—where we both struggle to name the direction in which our current history is unfolding and cannot imagine a different course. Therefore, the value of attending to the long 1980s does not adhere only to the possibility of shedding light on the immediate past. A different understanding of the present is also at stake. As García Canclini argues, the relationships between art and politics forged in the 1980s have largely remained unchanged. Artworks from this period lack an encompassing account of their sense of purpose, utility, identity, or history; and they actively and corporeally reject any totalizing conception of these categories. This is, in other words, the art of a society that continuously articulates "de-totalized accounts, fragments of a visuality without history" (García Canclini 2010, 21–22). From the Levinasian perspective I sustain in this book, this process of de-totalization is intimately linked to the recognition of alterity and interdependence. Yet I depart from previous scholarship in arguing that a dissensual revision of totalizing narratives cannot simply rely on an embrace of the fragment or the ruin, for these notions remain dependent on an underlying idea of the complete or the absolute. Instead, with Levinas, I raise the problem of thinking beyond totality into the realm of infinity, a realm that resists reducing the Other to the same and that allows and fosters asymmetrical encounters. "The alterity of the Infinite," writes Levinas, "can consist in not being reduced, but in becoming proximity and responsibility" (Levinas 1999, 75).

The often-unfavorable appraisal of the 1980s found in art criticism is symptomatic of a failure to attend to this relationship between "totality" and "infinity" and the ensuing emphasis that has been given to models based on fragments and ruins. When the cartography of the 1980s is figured in the guise of a landscape of ruins, the notions of defeat and trauma seem to become the loci of post-authoritarian poetics (see Avelar 1999, 69). A practice of dissensus rooted in "infinitude," by contrast, is alien to the idea of an ultimate political triumph. In this practice the notions of friend and enemy and triumph and defeat become entangled, and the very act of parody is seen as involving the "ability to identify, approximate, and draw near"—thus engaging in an intimate relationship with the parodied subject that "troubles the voice [and] the bearing" (Butler 1997a, 266). That is, artistic critique rooted in a (corporeal) ethics of infinity entails a simultaneous critique and exposure of self and Other, as the figure of the artist him- or herself, on the one hand, and the proximity between the creative voice and the discourses of power, on the other, become the subject of self-reflexive scrutiny.

I mobilize the image of the "touched body" to discuss the performative politics of Latin American art in the 1970s and 1980s. In doing so, I discuss the place of embodied artistic practices in the formation of a haptic model of ethical relationality based, first, on a critique of epistemological traditions conceiving of the body as distinct and opposed to the mind and/or the sprit, and, second, on a critique of the distancing effects of the gaze. In the two chapters devoted to Chile, the idea of "contact" figures in the guise of performative acts of writing that shatter the boundaries between the body's inside and outside, the skin and the flesh, and the ways in which subjects enjoy pleasure and endure pain. These visceral calligraphies disrupt discourses written upon vulnerable bodies by way of torture, gendering, and fear. The encounter between writing and live performance in works by Eltit and Zurita thus leads to the (intimate) erosion of structures of power from a position of self-exposure.

In the chapters concerned with Argentine art, the discussion of tactility in relation to the work of León Ferrari allows me to propose a haptic and performative analysis of his practice of collage. This reading identifies a shift in the politics of this medium from its use as a means to communicate a predetermined political message to its role as a practice geared toward the immanent undoing of received narratives. I describe the ways in which Ferrari's *Nunca más* series entwines his interest in the ethics of tactility with an approach to history that queries the idea of the unrepresentability of mass-scale violence—a notion that risks transforming this violence into a historical silence, a site of consensus. The artist's critical approach to the memory of Argentina's last military regime therefore strives for a "touched history," open to the wounding act of revisionism and the empathy and intimacy that entails approaching the suffering of the Other. In chapter 4, Liliana Maresca's celebration of nudity and eroticism in her underground gatherings and photographic performances leads me to dwell on practices that defy

voyeurism by embodying a "resistant alterity," in which the exposed body may be (visually) caressed "without a project or plan" but not grasped with a distancing gaze. This form of resistance against visual mastery over the female subject occurs through the expansion and reshaping of Maresca's body in its alliance with her own sculptures. It is also the result of Maresca's refusal to perform a victimized and abstinent image of the HIV-AIDS-afflicted subject, contesting a societal impulse to sacrifice their desire.

The last two chapters revolve around the work of performance and mixed-media artist Marcos Kurtycz. In chapter 5, the metaphor of touch leads me to discuss Kurtycz's destructive poetics in the light of Bataille's notion of *déchirement* (absolute exposure), understood as a form of critique by way of intimate, and in this case also ritually violent, proximity. This chapter reveals the Janus-faced ethics of performance art, whereby the purported ethical basis of live art (the artist's "presence" [Phelan 2004, 574]) can also be turned into a form of aggression. In chapter 6, I further discuss this dialectics of contact and withdrawal by looking at the interplay between the mask, the interface, and the traces of imprinted facial gestures in Kurtycz's photographic, postal, and live performances. In the last years of his life, after developing partial facial paralysis, Kurtycz experimented with both viscerally explicit and virtual forms of facial transformation and encounter. Opening possibilities for proximity in long-distance communication—via mail art—and revealing the face as the host of the Other, his works also articulate an early techno-skeptical critique of dematerialized, prosthetically enabled, and cybernetic forms of tactility. While this concluding chapter is acutely relevant to reflect on the place of a corporeal ethics in our digital present, it resists falling prey to a metaphysics of presence. With Nancy, I conceive of presence as the shifting movement of coming and passing, a "coming to presence" in which the subject "does not cease being born" (Nancy 1993, 2). Similarly, I describe contact as delineating a proximate coexistence that, as Laura McMahon points out, "is always already a spacing or interruption" (McMahon 2012, 2).

THE TRACE

"Histories and trajectories," writes Diana Taylor, "become visible through performance, although recognizing the challenges and limits of decipherability remains a problem" (Taylor 2003, 271). The preceding chapters examine practices that, in distinct local contexts, posed significant challenges to existing models of decipherability. The emphasis these performances placed on the body served as a means of questioning the primacy of discourse (or sense) over matter, as well as the priority of preconceived (political) projects over direct and often agonistic participation in democratic politics. These embodied performances emerged at the margins of artistic and literary practices and were repeatedly excluded from both. Eltit's *Zona de dolor* and Maresca's underground gatherings were lived and

witnessed by only a handful of people; they never entered the economy of the art market. The fact that they have circulated widely and have been exhibited in some of the most important museums of contemporary art reveals the extent to which the challenges of decipherability they once posed continue raising critical questions in the present. Similarly, Kurtycz's printing rituals were seen directly only by small audiences, even though they are rapidly gaining attention among historians, curators, and young artists—partly as a result of their glaring contemporaneity.[1] Many of Ferrari's collages were equally exhibited only on a handful of occasions and, at times, given away or lost. Today they have circulated in countless venues, including Argentina's largest detention center during the dictatorship, now turned into a site of memory.

However ephemeral, these practices have left behind rich archives of gestures and traces. The perceptive encounter with these traces and the appeal to their own performativity as historical documents has allowed me to reconstruct their histories and to begin to decipher some of the ways in which they intervened in a complex fabric of sensory experience. In addition, this encounter has led me to describe the forms of embodied knowledge they constituted, and discuss both their epistemological tenor and critical value. However, we must remain aware that a large repertoire of lived memories and experiences has been lost with the passage of time. Moreover, we should be mindful that there are multiple points of access to the archives of the remains, and these archives are always already preorganized, preselected, framed, and enclosed. The notions of the "trace," as a vestige that nurtures contact, and the "face," as that which regards and touches from a distance, have therefore not only assisted me in revisiting the corporeal marks left in Kurtycz's letter bombs in chapter 6. They have also inspired me more broadly to look beyond the visible (sur)face of any one document, examining the multiple and possibly monstrous faces that constitute it as a document of history. Exploring other readings of these materials and different entry points into these vast gestural archives remains a necessary endeavor in order to enrich our understanding of the art of the long 1980s and the ways in which the practices that shaped this period continue to touch us in their relentless passing.

ACKNOWLEDGMENTS

During the writing of this book I found myself having to face the death of my two brothers Demetrio and Eugenio, my greatest teachers and companions. If the book came to completion, if I have learned over time to signify, appropriate, and embody my grief, it is thanks to the solidarity, friendship, and love of a large number of people in Britain and across the Atlantic. The book began as a doctoral dissertation, supervised by Geoffrey Kantaris at the University of Cambridge. I am thankful to Geoffrey for his generosity, and to the members of the Centre of Latin American Studies, in particular Joanna Page, Erica Segre, Julie Coimbra, and David Lehmann, for their unwavering support both during the PhD and during my time as Junior Research Fellow at Queens' College. Queens' provided an inspiring environment to expand and deepen my doctoral research in order write this book; I am thankful to the College and in particular to Martin Crowley, John Eatwell, Or Rosenboim, and Ella McPherson for their affection and *amitiés* in times of hardship. Dear friends with whom I first crossed paths in Cambridge, and whom I thank for nesting an often-delocalized space of care, together with various rounds of proofreading, are Lucy Bell, Jordana Blejmar, Laura Caballe-Climent, Marta Cenedese, Nikolai Ssorin-Chaikov, Celia Dunne, Carlos Ezcurra, Carlos Fonseca, Lucy Foster, Mary Freedman, Niall Geraghty, Andrew Green, Alex Houen, Cecilia Lacruz, Geoff Maguire, Catriona McAllister, Chandra Morrison, Patrick O'Hare, Franco Pesce, Natasha Tanna, and Elsa Treviño. In Britain I also thank Valerie Fraser, for believing in this project, and Jasia Reichardt, for expanding my knowledge of cybernetics and of Marcos Kurtycz's "letter bombs." This research could not have been developed without the financial support of the Mexican National Council for Science and Technology (CONACYT), the Simon Bolivar Fund, and Girton College's Ruth Whaley Scholarship.

I am also very grateful to the artists whose works are the reason and motivation for this book and their families. In Chile I thank Gonzalo Díaz, Diamela Eltit, Lotty Rosenfeld, and Raúl Zurita. Their kindness was not limited to sharing their works and archives, but it also involved immersing me in a vast repertoire of memories, through interviews and various forms of dialogue. I also thank Sophie Halart for her sisterhood, Nathalie Colomer for housing me while living in Santiago, and Soledad García, for supporting my research and opening up to me the rich archival, bibliographic, and film materials of the Centro de Documentación— Artes Visuales at Centro Cultural La Moneda. Paulina Varas helped me navigate the archive of Colectivo Acciones de Arte (CADA) at Museo de la Memoria y los Derechos Humanos.

In Argentina I thank the family of León Ferrari, in particular Anna Ferrari and Julieta and Paloma Zamorano. I also thank Andrea Wain and Agustín Diez Fischer for sharing their knowledge of Argentine art and their vivid memories of León Ferrari. My gratitude also goes to Almendra Vilela, Marcos López, and the Rolf Art Gallery for authorizing the reproduction of Liliana Maresca's photographic performances. Thanks to Inés Berni for granting access to the images of Antonio Berni. My thanks are equally due to Fundación Espigas and Museo Nacional de Bellas Artes for letting me excavate their archival holdings. Carmen Ezcurra supported this research throughout, not only kindly hosting me in her house but also finding materials in various museums and libraries. The support and love of my extended family in Argentina has always been a source of inspiration and a reason to keep my heart well oriented toward the South.

In Mexico I express my sincere gratitude to Ana María García, Alejandra Kurtycz, and Anna Kurtycz. Discovering the Kurtycz's archive, on the recommendation of Mónica Mayer, was like encountering a historical treasure. And exploring with Ana, Alejandra, and Sara Schulz the infinite (and often "explosive") riches of this archive has been a life-affirming challenge, capable of uprooting countless certainties that continue to corrode art history books. I also thank Museo Universitario de Arte Contemporáneo (MUAC), Museo Carrillo Gil, Museo de Arte Moderno (MAM), Ex-Teresa Arte Actual, and Instituto de Investigaciones Estéticas at Universidad Nacional Autónoma de México (UNAM) for allowing me to access their respective libraries and archives.

My family has been the most important and unstinting source of care and affection throughout. This book is dedicated to them, and in particular to Demetrio, who died shortly after I started this project and who left me reflecting deeply about him, his art, and his joyful way of leading life while he was still with us. Demetrio's sudden departure made me realize the extent to which my mother, father, Natalia, Iván, Kati, and Milena remain my only *tierra*, my only country. And no matter where I find myself, I root my writings in this genealogy, which I honor and love. Eugenio's later departure left me clinging to the inevitability of our finitude, the depths of our vulnerability, the all-too-real value of an ethics rooted in the embodied encounter.

This book has benefited greatly from the editorial support of Kimberly Guinta at Rutgers University Press and her team of collaborators, including Jasper Chang and Gina Sbrilli. I am thankful for their commitment to this project. A previous and shorter version of chapter 1 appeared as "Zona de Dolor: Body and Mysticism in Diamela Eltit's Video-Performance Art," in the *Journal of Latin American Cultural Studies*, 21, no. 4 (2013). Excerpts of chapter 3 were included in the article "Beyond Evil: Politics, Ethics, and Religion in León Ferrari's Illustrated *Nunca más*," published in the Fall 2018 issue of the *Art Journal*. Additionally, excerpts of chapter 4 were published as "Shaman, Thespian, Saboteur: Marcos Kurtycz and the Ritual Poetics of Institutional Profanation," in my coedited volume *Sabotage*

Art: Politics and Iconoclasm in Contemporary Latin America (2016). I am grateful to the editors of these publications for their permission to reprint the material here. I am also grateful to Raúl Zurita for granting permission to reprint excerpts of his poems *Purgatorio* (1979) and *Canto a su amor desaparecido* (1985). Every effort has been made to clear the necessary permissions to reproduce images and other materials. Any omissions will be rectified in future reprints.

NOTES

INTRODUCTION

1. My translation on the basis of Alophonso Lingis's (Levinas 1994, 77). Unless indicated otherwise, all translations are my own.

2. Most prevalent and commonly evoked in the Argentine context, the practice of "forced disappearance" took place from at least the 1960s through the 1980s in various Latin American countries, including the countries under discussion in this book. Pilar Calveiro describes "forced disappearance" as a technology of power by which "at a certain moment, [a person] *disappears*, vanishes, leaving no evidence of their life nor that they had ever lived. *No body of the victim is left; nor does any trace exist of the crime*" (Calveiro 2008, 26–27, original emphasis). In chapters 2 and 3 I discuss this concept in closer detail.

3. This story is recounted in García (2005, 13).

4. In a seminal text from 1936, Berni called for a return to Realism in painting, describing New Realism as "the suggestive mirror of the great spiritual, social, political and economic reality of our century" (Berni 1936, 14). The "new" in this tendency entailed an opposition to "notions of Realism associated with academicism," and an understanding of reality not as representation but as the possibility of referencing "actual people and their things." This distances Berni's approach from the formalism of French Nouveau Réalisme (Olea 2013, 36–37).

5. The most comprehensive study of this experience is Ana Longoni and Mariano Mestman's *Del Di Tella a "Tucumán Arde"* (2000). Longoni revisits her own reading of the Tucumán Arde exhibition and sheds critical light on its current mythical status in her 2014 book *Vanguardia y Revolución*.

6. The members of Grupo Mira were Melecio Galván, Arnulfo Aquino, Jorge Perezvega, and Rebeca Hidalgo. The group was formally created in 1977, but its members began working together in the 1960s. During the years of mass student mobilization in the late 1960s, they formed graphic brigades to create, print, and distribute political posters around Mexico City. They were active members of workers' unions and were also influenced by the Chicano Movement (see Debroise and Medina 2006b, 224).

7. In her recent *Arte y feminismo latinoamericano*, Andrea Giunta writes that "the feminists of the end of the 1960s and 1970s saw the personal as political." Yet in a "situation of politicization driven by the urgency of the popular struggle and the socialist and revolutionary transformation of society, this understanding of the political had a limited scope" (Giunta 2018, 79). She adds that a personal, feminist, and embodied approach to politics gained strength when these revolutionary projects and the models of subjectivity that they forged came into crisis in the late 1970s and 1980s. The recent exhibition *Radical Women* provides a comprehensive survey of this profoundly transformative moment in feminist politics and art. See Fajardo-Hill and Giunta (2017).

8. My selection of cases is also driven by a methodological intention to expand the repertoire of practices that researchers may consider relevant to propose, on the basis of their study, a theoretically rich account of the relationship between the aesthetic and the political at the onset of neoliberalism.

9. In the first volume of his *History of Sexuality*, Michel Foucault uses the notion of biopower "to designate what brought life and its mechanisms into the realm of explicit calculations and made knowledge-power an agent of transformation of human life" (Foucault 1978, 143).

10. See, among others, Alcázar (2014); Biczel (2013); Huertas Sánchez (2004); Halart and Polgovsky Ezcurra (2016); Lewis (2010); Vidal (2012).

11. The important exhibition *Global Conceptualism: Points of Origin, 1950s–1980s* set the stage for both a decentering of conceptualist practices and a search for origins beyond the sphere of the art produced in the United States and Europe. See Camnitzer, Farver, and Weiss (1999).

12. See also Giunta (2008), who closes her in-depth study of the Argentine avant-gardes of the 1960s by narrating the process of politicization of a group of artists linked to the Di Tella Institute in Buenos Aires.

13. For a vivid description of this model of political subjectivity through carefully assembled testimonial narratives, see the three volumes of Eduardo Anguita and Martín Caparrós's *La voluntad* (2004).

14. Formed in 1968 by the Chilean Juventudes Comunistas (Communist Youth), the Brigada Ramona Parra belonged to what Pablo Oyarzún describes as a series of "organic groups organized for political propaganda." They conceived of Muralism as an "artistic solution for what they perceived as a reality in conflict, a conflict in which artists should engage" (Oyarzún 1988, 210).

15. For a close discussion of *Tucumán arde* and a related series of practices in late 1960s Argentina showcasing the increased politicization of the artistic avant-garde (collectively named by the authors "the itinerary of '68'"), see Longoni and Mestman's *Del Di Tella a "Tucumán Arde": vanguardia artística y política en el '68 argentino* (2000).

16. The "Dirty War" in Mexico involved a series of unconstitutional military counterinsurgency campaigns in which extreme violence was exercised against students, activists, organized farmers, and communities. These campaigns were principally directed against the Genaro Vázquez's and Lucio Cabañas's rural guerrilla movements in Guerrero and the Liga Comunista 23 de Septiembre (September 23rd Communist League), a Marxist-Leninist guerrilla organization founded in Guadalajara on March 15, 1973, and active until 1983 in various urban and rural parts of the country, including Guadalajara, Monterrey, and Mexico City. The former were more traditional rural guerrillas whereas the latter was composed predominantly of students. Arguably, neither of them truly threatened the hegemony of the ruling Partido Revolucionario Institutional (Institutional Revolutionary Party, PRI). See Aviña (2014) and Robinet (2012).

17. See Lechner (1992).

18. For a discussion on the difficulties in establishing these numbers and their political implications, see Brysk (1994).

19. Important analyses of the politics of cooptation and authoritarianism in post-revolutionary Mexico include Aguayo (1998), Camp (1999), and Aguilar Camín and Meyer (1990).

20. I use this category in relation to Rancière's notion of "dissensus," which I explain in the section entitled "The Aesthetics of Dissensus."

21. The "happenings" and performances that took place in the Di Tella Institute in Argentina during the 1960s are an important precedent. See King (2007), Giunta (2008c), and Fajardo-Hill and Giunta (2017).

22. Among various studies on the United States' role in the rise of dictatorial governments in Latin America from the 1960s onward, see Stella Calloni's *Los años de lobo: Operación Cóndor* (1999) and Lesley Gill's *The School of the Americas* (2004).

23. In *Arte y feminismo*, Giunta (2018, 27) develops a similar approach, looking, for instance, at the work of Colombian artist Clemencia Lucena and Argentine artist María Luisa Bemberg. Giunta mentions that this allowed her to "widen her frames of reference" and explore similar artistic conjectures at a regional level despite individual and national particularities.

24. Although I am conscious of the importance of Mosquera's call to remain aware of Latin America's cultural heterogeneity, I will still use the terms "Latin American art" and "art in Latin

America" interchangeably, as I believe that not to use a term for fear of misinterpretation would be to constrain the linguistic field without necessarily transforming it or attending to the root causes of damaging misconceptions.

25. Taylor suggests that the relationship between the archive and the repertoire is not oppositional or antagonistic; yet she stresses the historical primacy of the former over the latter. Furthermore, she argues that this primacy is deeply rooted in a logocentric epistemology, which in itself constitutes a form of exclusion, erasure, and disappearance of the nondiscursive practices that often play a central role in the cultural memory of illiterate populations and cultures historically organized around oral tradition (Taylor 2003, 36).

26. Any attempt at reenacting these performances would open up the question of whether they can retain any critical force over time. On performance and repetition, see Jones and Heathfield (2012) and Kartsaki (2017).

27. Another of Rancière's conceptual innovations is to use the notion of "police" to describe institutionalized forms of power. He defines the police as "the given distribution of social positions, hierarchies, functions, visibilities and invisibilities, characteristic of any social order." Politics thus becomes "the egalitarian disruption of such distributions" (Martín Plot 2014, 96).

28. According to Phelan, "one of the most politically radical aspects of live art is its resistance to commodity form" (Phelan 2004, 571).

29. Although I will be using Daniel Borzutzky's translation of this poem (Zurita 2010), I am providing my own translation of its title, which takes into account the gender ambiguity of the pronoun "su."

30. Elaborating on Deleuze and Guattari's (2004) discussion of faciality (*visageite*) in *A Thousand Plateaus*, Warwick Mules describes faciality as a "certain technicity of the face: its presence as a technical *infrastructure* grounded in specific face encounters through time and space" (Mules 2010, n.p.). I discuss this notion in some detail in chapter 6.

31. See Mayer (1996).

CHAPTER 1 WRITING THE BODY

1. See Comisión Nacional de Verdad y Reconciliación (1991) and Comisión Nacional sobre Prisión Política y Tortura (2005).

2. In juridical terms, the state of exception involves the sovereign's suspension of the constitutional norms that protect individual and collective liberties in the name of a purported greater good. The notion derives from the political theory of Carl Schmitt, who describes it as a paradoxical suspension of the legal order rooted in law. See Schmitt ([1922] 2005).

3. One version of this video is available in the online archive of the Hemispheric Institute of Performance and Politics: http://hidvl.nyu.edu/video/003448706.html. Accessed May 30, 2012.

4. The Vicariate of Solidarity (1976–1992) was a Catholic institution created by Cardinal Raúl Silva Henríquez, with the support of Paul VI, in order to protect the victims of state repression in Chile. It provided legal and moral support to victims of torture, political prisoners, and families of disappeared people, becoming a key player in the country's human rights movement. See Fruhling (1992, 121–141).

5. Unclassified document entitled "Colectivo Acciones de Arte," CADA Archive.

6. It has been argued that the new constitution was not designed to favor Pinochet's military presidency, but rather to institutionalize a form of "protected democracy" that would be "safeguarded" by the armed forces. Yet this did not prevent Pinochet from seeing the constitution as a vehicle for his personal ambitions, particularly because he was guaranteed an eight-year term in power before any transition to civilian rule (Barros 2002, 250).

7. Michael J. Lazzara has published a fascinating analysis of Guzmán and the specter of this figure and influence in contemporary Chile. Lazzara describes Guzmán as the "founding ideologue" of the country's neoliberal era and "Pinochet's [...] most influential collaborator" (Lazzara 2018, 53, 59). In 1991, the lawyer was assassinated by the leftist group Frente Patriótico Manuel Rodríguez, FPMR).

8. See Galende (2007, 277).

9. After the coup, the military government ordered the closing of the left-wing newspapers *El Siglo*, *Puro Chile*, and *Noticias de Última Hora*. Through economic pressure and direct intimidation, the government also censored most critical voices on TV, radio, and other public channels, thereby rapidly securing its control of the media. The Dirección Nacional de Comunicación Social (National Directorate of Social Communication, DINACOS), a special organization in charge of cultural and press censorship, was established in 1973 (Huneeus 2000, 114–116). These policies became less restrictive from the early 1980s on, when opposition journalism and other cultural practices played a central role in the gradual repoliticization of Chilean society.

10. In recent years the notion of "Avanzada" has been contested for failing to acknowledge the differences within the scene as well as its relations to previous artistic movements in Chile (Macchiavello 2011, 96).

11. "La función del video." The original document was photocopied and distributed at the video biennial organized in 1980 at the Franco-Chilean Cultural Institute. It is republished in Neustadt (2001, 139).

12. See Espinoza (2006).

13. *Por la patria* ended up being the title of Eltit's second novel, published in 1986.

14. Eltit did not refer to her piece as a performance or an art action, but she simply used the term *lectura* (reading). Bringing her text to the brothel was for her a creative experiment, part of what she calls *mis imaginarios personales* (my personal imaginaries), rather than a public spectacle (interview with the author, February 17, 2012, Santiago, Chile). In the process of transforming the performance into a video, its meaning and target audience inevitably changed.

15. Interview with the author (February 17, 2012, Santiago, Chile). Despite common confusion and misinformation in references to this work, Eltit did not engage in any act of self-wounding while at the brothel. Rather, she projected a slideshow of her act of self-injury on the brothel's outside wall.

16. Although Eltit has often been considered a marginal writer who positions herself at the edges of the literary canon (in order to contest it), she describes *Cobra* (1972), by Severo Sarduy, and the Baroque literary tradition as important influences, particularly during the writing of *Lumpérica*. In an interview with Leonidas Morales, Eltit says: "It's curious, I draw a lot on tradition. I draw on the baroque, on theatre, on acting, on *mise en scène*. For me theatre continues to be that of the Golden Age" (Morales 1998, 37).

17. It was Eltit's explicit intention to carry out the performance in one of the poorest areas of Santiago (interview with the author, February 17, 2012, Santiago, Chile).

18. A modified version of the text that Eltit reads in the video would later become chapter 4.4 of *Lumpérica*. I am quoting from the latter version because the sound of the recording is at times unclear.

19. Words from the original video (my emphasis), followed by my translation.

20. In the same vein, Foucault's discussion of the ascetic's behavior in Volume I of his *History of Sexuality* shows that the attempt to punish and forget the body may turn into a detailed and libidinalized corporeal obsession (Foucault 1978, 23, 64).

21. On this topic, see Brunner (1981) and Brunner and Catalán (1985).

22. The reading of Eltit's and Zurita's works becomes inseparable from their self-representation as injured bodies, since references to their wounds or cuts are recurrently present in their texts and accompanying metatexts. Here my main interest is to understand how these publicly exposed wounds, as signifiers of intimate and embodied suffering, took part in certain strategies of social critique. I remain aware, however, that there is nothing intrinsically critical in an act of self-harm.

23. All translations of *Purgatory* come from the bilingual edition translated by Anna Deeny (Zurita 2009b).

24. Ignacio Valente inspired the character of Sebastián Urrutia Lacroix in Roberto Bolaño's *Nocturno de Chile* (2000).

25. My translation.

26. Interview with the author, February 17, 2012, Santiago, Chile.

27. It is vital to recall that Eltit mentions mystical acts, when, in *Zona de dolor*, she interrupts the video to give a declaration of her political project.

28. In *Lumpérica* some of these scenes are narrated in the form of a film script that describes the trajectory of the camera. Like the novel, the video-performance presents a multilayered gaze in which the brothel's workers and clients (together with Eltit's friends) are depicted as observing the scene, while it is also being recorded.

29. Today the triptychs are scattered in various private collections, but they were initially exhibited in a large installation at Galería Arte Actual, entitled *Banco/Marco de Pruebas* (1988).

30. The installation in which the triptychs were first exhibited included balusters scattered on the floor. Díaz sought to project his multilayered works into the reality outside the canvas, and he saw the disorganized balusters as symbolizing the fall and decline of the authority of the museum in late twentieth-century Chile (Richard 1988, 17).

31. For a detailed reading of these symbols from a psychoanalytical and feminist perspective, see Richard (1988, 14–19).

32. The technical and thematic complexity of Díaz's series of triptychs exceeds the scope of this study. I will not discuss the third triptych, *Zulema Morandé, la escritora*, because my interest is to emphasize the encounter and confusion of Eltit and Sor Teresa, performance art and collage, in Díaz's work.

33. This model of false transgression emulates a pervert's act, in the sense that, according to Slavoj Žižek, "it fits the existing power constellation perfectly" by practicing the "secret fantasies that sustain the predominant public discourse" (2008, 292).

CHAPTER 2 LAMENTATIONS

1. Elaine Scarry writes, "Intense pain is [. . .] language-destroying: as the content of one's world disintegrates, so the content of one's language disintegrates: as the self disintegrates, so that which would express and project the self is robbed of its source and its subject" (Scarry 1985, 35).

2. Avelar's understanding of allegory is rooted in Walter Benjamin's, for whom allegory was an "image of discontinuity and deferral," different from the symbol (which suggests a harmonious mediation between sign and referent), and linked to the decaying and incomplete character of historical ruins (Richter 2002, 249).

3. The word "allegory" comes from the Greek *allôs* (other) and *agoreuein* (to speak in pubic), signifying "other speaking" (Hunter 2010, 266).

4. Zurita himself has fueled some of these controversies by, for instance, attempting to publish his first collection of poems under the title *Mein Kampf*. The publisher suggested that it be

named *Purgatorio* instead. Two subsequent texts, which became a trilogy, were named *Ante-paraíso* and *La vida nueva*, in intertextual dialogue with Dante.

5. For a discussion about CADA, see chapter 1.

6. For a broader discussion on the critical use of allegorical procedures in contemporary art, see Buchloh (1982, 44).

7. "*Ay Sudamérica*," leaflet. Reprinted in Neustadt (2001, 150).

8. Letter to the Aeronautics Ministry, June 18, 1981, signed by Lotty Rosenfeld representing CADA. Reprinted in Neustadt (2001, 147).

9. Similarly, Eltit said: "We had the bombing of La Moneda very much in mind [...]. We wanted to reference and activate the memory of that bombing with those light aircraft" (quoted in Neustadt 2001, 96).

10. For a discussion of repetitive reenactment among people who have been through a traumatic experience, and on the relationship between the compulsion to repeat and the aesthetics of memory, see Caruth (2016) and Luckhurst (2008).

11. Despite arguing for the need for radical equality between artists and workers—grounded on the levelling of art and life—the full text of the leaflets was unusually complex. An image of the leaflet can be found in Neustadt (2001, 150).

12. According to Richard, among the Avanzada artists that received official awards from the military regime were Francisco Smythe, Eugenio Dittborn, Carlos Leppe, Carlos Altamirano, Gonzalo Mezza, Lotty Rosenfeld, Diamela Eltit, and Carlos Gallardo. She adds: "Committed in their work to the dismantling of the discourses of power and authority, these artists had to negotiate the limits of acceptability of the work, ensuring not only that each work would not be censored but anticipating, furthermore, the risks of an institutional recuperation which would neutralize their critical potency or even distort their meaning and political intention" (Richard 2007, 28).

13. My translation.

14. See DeMello (2000).

15. Quotations of the poem in Spanish and translations come from the bilingual version translated by Daniel Borzutzky, published in 2010. The book is unpaginated, and the Spanish original differs slightly from the version published in 1985 by Editorial Universitaria. For the sake of consistency, I am sticking to Borzutzky's text, and I have attributed pages to it, starting in the Spanish section.

16. The Mothers of Plaza de Mayo is the main organization of victims of human rights violations during the last dictatorship in Argentina (1976–1983). It was originally formed mainly by female relatives of victims of forced disappearance, some of whom became themselves victims of this state crime as a result of their activism. Although the organization is now split into two branches, they became internationally known for their staunch resistance to the regime. Aside from being extremely vocal in Argentine political life, since 1977 they have been circling the Plaza the Mayo—where Casa Rosada, the official residence of the executive branch of government is located—every Thursday, wearing a white kerchief that symbolizes their plea for justice.

17. Borzutzky's version reads "ship," which is a possible translation of the Spanish word "nave." Yet it is unlikely for the poet to be referring to a ship or vessel in this funerary context. More likely is for him to be referring to a church's nave, where burial niches are often located. The 1985 Spanish version of the poem reads "nave y nicho remitido."

18. Here, I am providing my own translation. Borzutzky's version reads: "was stuck to the rocks, the sea and the mountains."

19. Borzutzky's translation reads: "I looked for you among the ruins."

20. Zurita's words here in a certain way prefigure Chile's participation in the 1992 Seville World Fair. On this occasion, Chilean elites attempted to rehabilitate the country's national image in

the immediate aftermath of the Pinochet regime by sending an iceberg from Patagonian waters. The costly and technologically complex process to transport this gigantic ice structure has been discussed by Gómez-Barris, among others, as a spectacle of mnemonic erasure, seeking to whiten the country's grim record of human right's violations (Gómez-Barris 2009, 4).

21. In Borzutzky's translation the poem is entitled "Song for His Disappeared Love," overlooking the gender ambiguity of the possessive pronoun "su." However, this line is translated as "Singing, oh yes, singing for *their* disappeared love" (added emphasis).

22. Susan Buck-Morss suggests that "the Baroque poets saw in transitory nature an allegory for human history, in which the latter appeared, not as a divine plan or chain of events on a 'road to salvation' but as death, ruin, catastrophe" (Buck-Morss 1989, 174). A fate-less history of ruins and fragments leads to an understanding of historical change on the basis of identifying spatial relations, rather than presupposing teleological progress.

23. In this text Benjamin dwells on the relationship between language and the biblical account of the Fall (Benjamin 1996b, 72–73).

24. The precise date remains contested (Guinan 1990, 558). Jeremiah's authorship of *Lamentations* is contested in the Christian tradition and fully rejected in Judaism.

25. See Crowley (2009, 11), who argues that finitude constitutes a "proposition of irreducible ontological equality," which results in a fundamental sense of solidarity toward those who experience pain.

26. Quotations of *Purgatorio* come from the bilingual edition translated by Anna Deeny (Zurita 2009b).

27. This is true for the poem's various editions. I worked with the first edition by Editorial Universitaria (1979), its reedition in larger format in 2007, and the bilingual edition published by Berkeley University Press in 2009.

28. For Kirkpatrick: "Dante's purgatorial journey is an Earthly Paradise which [. . .] is described in richly sensuous terms." Furthermore, although "the purpose of purgation is to recover humanity's lost innocence [. . .] for Dante this does not involve, initially, any desire to transcend or diminish the human experience" (Kirkpatrick 2006, xiii).

29. These words reference the opening stanza of Dante's *La Divina Commedia*: "Nel mezzo del cammin di nostra vita / mi ritrovai per una selva oscura, ché la diritta via era smarrita" (In the middle of the journey of our life I came to myself within a dark wood where the straight way was lost) (Dante Alighieri 2006, 2–3). Likewise, one could read Zurita's mention of Raquel as evoking the figure of Mary Magdalene.

30. Interview with the author (September 28, 2013, London).

31. This critical appropriation of the sacred to contest social and political injustice echoes the denunciatory credo of "liberation theology." While Zurita did not establish direct dialogues with this religious movement or with the work of the more directly committed priest and poet Ernesto Cardenal from Nicaragua, the possible areas of dialogue between Zurita's work and liberation theology are significant and merit further discussion. On the emergence of liberation theology in Latin America, see Smith (1991).

CHAPTER 3 TOUCH, ETHICS, AND HISTORY

1. Luis Pérez-Oramas discusses *Cuadro escrito* (a written painting using "baroque jumbled sentences to describe a potential, impossible painting") as a manifesto that speaks for one artist, rather than for a movement (Pérez-Oramas 2009, 30). According to the critic, the work enacts and calls for "an unusual return to the origins of the Western visual tradition, where the contradictions of text and image—as well as their fatal attractions, their mutual desire for each other—are always simultaneously present" (30). Bearing in mind the focus of this chapter, it

is notable that in the work Ferrari writes that he could not paint because "God had not touched him" (31).

2. This phrase refers to the name Martin Jay gives to Emmanuel Levinas's idea of the ethical (Jay 1994, 543).

3. On the subject of the political management of fear by military governments in the Southern Cone during this period, see *Fear at the Edge* (Corradi et al. 1992).

4. In view of the widespread violation of human rights and the mobilization of fear to control the population, the notion of "state terrorism" has been used to describe the repressive tactics of the Argentine dictatorial state in power between 1976 and 1983 (see Calveiro 2008).

5. On Massera's dissenting cultural project, through which he tried to position himself as Argentina's next president, see Marcelo Borrelli's *El diario de Massera* (2008, 27–33).

6. Mathematician and philosopher Gregorio Klimovsky was one of the first to describe the various, often disjointed, study groups in Argentina under dictatorship as a "university of catacombs." Popular themes in them were psychoanalysis, Marxism, and critical theory. Among those who ran them were Juan José Sebreli, Beatriz Sarlo, Ricardo Piglia, Klimovsky, and Josefina Ludmer.

7. The Spanish term *santería* has multiple meanings. In this case, it refers to a store where one can buy religious objects, including statues or models of saints.

8. An emphasis on the religious over the political aspects of the work has been characteristic of those seeking to censor Ferrari's art. His 2004 exhibition at Recoleta was temporarily closed down on the basis of similar arguments. See *El caso Ferrari* (2008, 27–33).

9. *Palabras ajenas* was staged as *Listen, Here, Now* by the Argentine artist Leopoldo Maler at the Institute of Contemporary Art in London in 1968. Ferrari celebrated the work's new title, emphasizing its sense of urgency and action. He also stipulated that the title should include "Vietnam" somewhere, so that people would know beforehand they were going to see Vietnam and "encounter God" (Katzenstein 2004, 286). Four years later, the director Pedro Asquini, known for his engagement with independent theater and "critical realism," mounted a new adaptation of Ferrari's text under the title *Pacem in terris*. Aside from some images, there are very few records of these performances. In September 2017 *Palabras ajenas* was restaged as *The Words of Others* in Los Angeles, California, as a durational performance with a cast of thirty readers, as part of Pacific Standard Time: LA/LA. The seven-to-eight-hour event was later restaged and readapted in Miami (Pérez Art Museum), Madrid (Museo Reina Sofía), and Mexico City (Museo Jumex).

10. Following the artist's terminology, I refer to these works as *Brailles*, rather than photomontages or collages.

11. The exact number remains unknown.

12. This is a partial quotation in the sense that the second sentence is absent from the Bible.

13. The virtuosity of the ensemble of Signorelli's frescoes in the Capella Nuova (commonly called the Cappella di San Brizio) in Orvieto Cathedral is well known. Jonathan B. Riess refers to them as "some of the most remarkable pictorial ensembles produced during [. . .] the High Renaissance" (Riess 1995, 7).

14. Brennan's comment derives from recalling a talk at the Rothko Chapel in which she described one of Ferrari's pieces as "a Sacred Heart that was positioned in the jaws of a metal meat grinder." Upon learning about this piece, Amy Hollywood, a reputed medievalist who was another of the speakers, immediately replied, "Wow, that's so medieval!" (Brennan 2014, 7).

15. Original text in Spanish; my translation.

16. In the realm of discourse, the Auschwitz model involves paralysis. For Lyotard, it designates: "An experience of language which brings speculative discourse to a halt [. . .]. It would be a name of the nameless [. . .], a name which designates what has no name in speculation, a

name for the anonymous. And what for speculation remains simply the anonymous" (Lyotard 1989, 364).

17. The religious figures in the commission were Carlos T. Gattinoni, bishop of the Argentine Methodist Church and active member of the human rights movement; Argentine-American rabbi Marshall T. Meyer; and Catholic monsignor Jaime de Navares.

18. By establishing this temporal boundary, the report excludes a large number of activists disappeared by paramilitary groups *before* the coup.

19. The report is also available for free online, in both Spanish and English.

20. Andreas Huyssen suggests that "combined with the ritual spell of the 'never again,' the figure of the unimaginable and the unsayable may lead to an easy amnesia" (2009, 20).

21. I use the word "caesura" to emphasize that the notion of "disappearance," as opposed to that of "murder" or "homicide," implies a sense of futurity. The *desaparecido* is one who is awaited with the hope that he or she will return alive. This term is therefore tied to an eschatological concept of justice paradoxically set in the past.

22. In *La ressemblance informe*, Georges Didi-Huberman discusses the primacy of the sense of touch in the work of Georges Bataille and the way that touching may lead to opening up (*ouvrir*) words and concepts (1995, 36). In chapter 5 I shall broaden my discussion of "touch" in this direction.

23. The proximity between high-ranking church members and the military junta, together with the collaboration of numerous priests in the process of disappearance, torture, and murder, have been topics of extensive research—as have been the cases of those priests who resisted state violence, helped members of left-wing organizations to escape from it, and were kidnapped and murdered in cold blood. Studies on the relationship between the Catholic Church and the Argentine military regime include Mignone (2006), Verbitsky (2010), and Morello (2015).

24. An extremely rare instance in which the disappeared became visible are the pictures taken by Víctor Basterra, who was clandestinely imprisoned at ESMA from 1979 to 1982. Having worked at a printer's workshop in Buenos Aires before being kidnaped by the military, Basterra was forced at ESMA to take photographs of some of the detainees and of ESMA's officers in order to make false identification documents. Taking great risks, Basterra managed to make copies of some of these pictures and smuggle them out of the torture center. See Feld (2014).

25. This work is part of Giotto di Bondone's fresco cycle at Scrovegni Chapel in Padua, Italy.

26. On Massera's involvement in the repressive apparatus and his role as head of ESMA, see Borrelli (2008).

27. See Ferrari's comments in this regard in a series of interviews edited by Andrea Wain (2016, 37).

28. Bergoglio's letter was reprinted in Giunta (2004, 55).

29. The entire affair is documented in the book *El caso Ferrari*, compiled by Andrea Giunta (2008a).

CHAPTER 4 NUDITIES

1. I am quoting the entire text because there are no records of which excerpt in particular Ferrari transcribed in Braille on the image.

2. Translation adapted from a version by Anna Schwind.

3. Art critic Jorge López Anaya coined the notion of "light art" in a newspaper article that appeared in *La Nación* on August 1, 2003. He proposed the term in relation to Jean Baudrillard's notion of the simulacrum, referring to a culture lacking in essences and caught up in the production of "reality effects." Various artists reject the binary division between light and political art as a fair description of Argentina's artistic field in the late 1980s and early 1990s. Roberto

Jacoby said, for instance, "It is not the case that you would have, on one side, those doing 'arte light,' on another those doing fashion, and on yet another those doing political art, it did not work that way" (Laboureau and Lucerna 2008, 2).

4. For Kristeva, this division between spaces of production and reproduction, on the one hand, and spaces of otherness, the sacred, and excess, on the other, will be contested by the rise of avant-gardism, situating its aesthetic potency in the possibility of redefining "the frontiers of the socio-symbolic ensembles" (Kristeva 1976, 65).

5. Mieke Bal situates the notion of "quotation" at the intersection of iconography and inter-textuality. This allows her to construct a complex concept that does not reduce the quoted (visual) text merely to "a trigger of melancholy [. . .] and source of support." Beyond these dimensions (which she also takes into account), Bal understands quotation as a means, first, to "appropriate the cultural inheritance"; second, to demonstrate the fragmentary plurality that characterizes "the visual culture of live images"; and finally, to intervene performatively in a process of materialization that stabilizes meaning over time, and which is not entirely dependent on individual intentions, but on a large cultural fabric that grounds the citational character of a text (Bal 1999, 14–15).

6. For Lacan, the paternal law structures linguistic signification, termed "the Symbolic." Fred-ric Jameson suggests that the "cornerstone of Freud's conception of the psyche, the Oedipus complex, is transliterated by Lacan into a linguistic phenomenon which he designates as the discovery by the subject of the Name-of-the-Father" (Jameson 2003, 16). It consists "in the transformation of an Imaginary relationship to that particular imago which is the physical parent into the new and menacing abstraction of the parental role as the possessor of the mother and the place of the Law" (16).

7. This mention of a diasporic Surrealism refers to Graciela Speranza's article entitled "Wan-derers," in the publication *Surrealism in Latin America: Vivísmo muerto*. Contesting the representation of Surrealism as a closed historical episode, Speranza foregrounds those "Surrealist" expressions in Latin America that go beyond the authorized voices of those who had direct contact with Breton's movement. This tale begins, she claims, with Breton's 1922 provocative invitation to "Leave everything. . . . Take to the highways" (quoted by Speranza 2012, 195). From this perspective, Surrealism may be understood as a "wandering and uprooted art eager to conjure up the intensity of life through the generative grace of change, ready to turn the negative excess of the world's pain into affirmative excess and to dissolve political boundaries along the way" (195).

8. Pellegrini was a poet himself and has been associated with having brought Surrealism to Argentina. In 1967, he organized the exhibition *Surrealismo en la Argentina* (Surrealism in Argentina) at the Di Tella Institute, which included the works *Escritura* (Writing, 1962) and *Manos* (Hands, 1964) by Ferrari.

9. Translation by David Antin (Breton 2003, 89).

10. According to the usual distinction between the saying and the said, the said is linked to the discourses of knowledge and "represents the unity and system of propositional discourse" (Ziarek 2001, 50). The saying shifts the analysis of language "from the notion of the system" to the communicative act as an exposure to the Other, and the "capacity for being affected by the Other" (51). Ziarek argues that "by situating the act of enunciation in the context of a response to the Other, the saying contests [. . .] the disembodied character of enunciation" (51).

11. These pictures are available at the Augusto y León Ferrari Archivo y Acervo (FALFAA).

12. At the time in which Ferrari was writing, more inclusive terms, such as LGBT+, were not yet common currency.

13. According to Isabella Cosse, only moderate changes in sexual practices and perceptions took place. She argues that "in the sixties people began to speak more freely about sexuality, as

premarital relations and consensual unions came to be accepted," yet these transformations were limited to the middle classes. She adds that neither the feminist movements nor sexual minorities gained significant prominence in society (Cosse 2006, 39).

14. On more than one occasion the artist stated that humor played a central role in his art. This is particularly visible in his *Heliografías*, which I discussed briefly in chapter 3. See also García Canclini (2008, 26).

15. Julia Kristeva uses the notion of "herethics" to describe "an outlaw ethics": "Herethics sets up one's obligations to the other as obligations to the self and obligations to the species. This ethics binds the subject to the other through love and not Law" (Oliver 1993, 5). Kristeva's herethics is modeled upon the ambiguity between subject and object positions during pregnancy. Although I will not elaborate further on this notion, it relates closely to a Levinasian or haptic ethical model, by foregrounding the significance of relationship over legality and by being rooted in a conception of the subject as an embodied being, whose flesh and corporeality may ultimately determine its ethical position in relation to the Other.

16. From the Latin word *investire* (to dress or clothe). Historically, the act of investing referred to enveloping a person with a garment or article of clothing.

17. On underground culture in Argentina during the transition to democracy and the years that immediately preceded it, see Garrote (2013) and Krochmalny (2013).

18. Daniel Quiles summarizes this posture by saying that what Jacoby describes as the "strategy of joy" championed "disco-era hedonism and sexual liberation as radical alternatives to authoritarian control" (Quiles 2014, 49–50). For further discussion, see Longoni (2011a).

19. Madres-Línea Fundadora emerged in January 1986 as a splinter group of Asociación Madres de la Plaza de Mayo.

20. *Frenesí* (directed by Liliana Maresca and Adriana Miranda) is available at https://vimeo .com/89182026. Accessed January 26, 2015.

21. For a discussion of how artists linked to the Centro Cultural Rojas were affected by and responded to the AIDS epidemic, see Krochmalny (2013, 7).

22. The work was made with a series of found objects, including various umbrellas, chairs, and a table, that the artist had collected in a rubbish dump in Tigre. During the opening night Batato Barea made a performance in which he recited the poem *Sombra de conchas*, by Alejandro Urdapilleta. The poem refers in various playful ways to female genitalia (Herrera 2015, n.p.).

23. The ads of the Fabulous Nobodies did not focus on selling consumer products but on giving voice to debates about AIDS and stigma. In 1994 the agency issued an edition of a T-shirts saying *Yo tengo SIDA* (I have AIDS).

24. Along the same lines, one of Maresca's poems reads: "Vete muerte / Que quiero la vida / Quiero dar fruto / Todo mi fruto jugoso / De la vida / Vivida tan intensamente" (Go death / for I want life / I want to bear fruit / All my juicy fruit / Of life / Lived so intensely) (quoted by Rosa 2011, 347–348).

25. In his "Two Concepts of Freedom," Isaiah Berlin discusses negative freedom as the possibility to perform an activity without external interference or coercion. Positive freedom, by contrast, involves expanding the possibilities for action, the freedom *to do* something, rather than freedom *from* interference (Berlin 1958, 7, 18).

CHAPTER 5 RITUAL AND/OF VIOLENCE

1. On the role of Kurtycz in the transformation of Mexico's Museum of Modern Art (MAM) in the early 1980s, see Eder (2010).

2. Other artists, in addition to Kurtycz, who were instrumental in this turn toward a general interest in performativity and intermediality in artistic practice are theater director Juan José

Gurrola, novelist, writer, and filmmaker Alejandro Jodorowski, sculptor José Luis Cuevas, painter Manuel Felguérez, and a long list of younger artists including Maris Bustamente, Adolfo Patiño, Melquiades Herrera, Felipe Ehrenberg, Mónica Mayer, Víctor Lerma, Eloy Tarcisio, Rubén Valencia, Pola Weiss, and many more.

3. For those unfamiliar with the singularities of the one-party regime that ruled Mexico during most of the twentieth century, it is important to note that the PRI rose to power in the aftermath of the 1910 Revolution, mobilizing a nationalist rhetoric and a promise of redistribution of land and wealth. As the sole party with truly national reach and principal point of confluence of the labor unions, the PRI became deeply entrenched in the structure of the Mexican state, playing a pivotal role in the implementation of all major social reforms, including the land reform and the nationalization of the oil industry during the presidency of Lázaro Cárdenas (1934–1940). However, from the onset, the PRI administration was characterized by cooptation, clientelism, and authoritarianism, leading to the repression and marginalization of dissident voices. From the 1930s on, human rights violations in the country were not only common but also left largely unpunished, as the rule of law remained an occasional privilege for the middle-classes and the metropolitan elites. Freedom of expression was tolerated, rather than guaranteed (Camp 1999). With the passage of time, the revolutionary ideals that had been turned into law in the 1917 Constitution—the first in world history to guarantee "social rights"—became increasingly devoid of meaning, as the state criminalized and repressed dissident unions, student protests, and peasant and indigenous movements.

4. The number of murdered students in 1968 remains unknown, although it is believed that between 40 and 300 victims perished during the massacre (Rodda 2012, 18; Doyle 2006). The National Security Archive and *Proceso* magazine have been able to document forty-four victims and continue investigating the identity of ten nameless victims. However, their access to witness accounts and declassified documentation is limited by the absence of a sustained state policy to find and document the truth about this historic episode. In 2002, the Mexican government created a Fiscalía Especial para Movimientos Sociales y Políticos del Pasado to investigate human rights violations committed by the PRI regime from the 1960s to 1980s. Yet the Fiscalía's final report on the "Dirty War" (2006) is believed to be heavily censored (Aviña 2014, 184). Access to the archives of the Tlatelolco Massacre and the Dirty War was partially allowed under the administration of Partido Acción Nacional (PAN) politicians Vicente Fox and Felipe Calderón. However, when the PRI came back to power in 2012, access to these documents became increasingly difficult, until they were placed, once again, under lock and key in 2015. As I conclude this chapter in March 2017, the Mexican government continues to uphold this restrictive policy.

5. Marcos Kurtycz, "Texto sobre el evento en el Foro el día 1 de noviembre de 1979," Kurtycz Archive.

6. *Petate* (from the Nahuatl *petlatl*) is a bedroll made of natural fibers, often used in Mexico and Central America to rest or sleep on the floor.

7. Kurtycz, "Texto sobre el evento en el Foro," Kurtycz Archive.

8. I am using the term "expose" in explicit reference to Bataille's notion of *déchirement*, which Patrick ffrench translates as "absolute exposure" (2007, 78).

9. The rationale underlying this typically Western and modern taboo is ambiguous and often blatantly elitist. Gamboni argues that the denunciation of iconoclasm in the work of renowned historians, such as Louis Réau—who wrote his *History of Vandalism* in 1959—is associated with the defense of a "hierarchical society in which the 'base instincts of the crowd' could be kept under control and where a high culture enjoyed the discriminating support and protection of the knowing and powerful" (Gamboni 2007, 16).

10. "Auto-Destructive Art" (2017).

11. See Wilson (2008).

12. Masotta developed this idea in his lecture "Después del Pop: Nosotros desmaterializamos," delivered on July 21, 1967, at the Instituto Di Tella in Buenos Aires. He borrowed the notion from El Lissitzky's essay "The Future of the Book," which describes the seemingly paradoxical tendency of materialist or capitalist societies to develop increasingly immaterial technologies of communication, including the telephone and the radio, both of which can be seen as strategies to overcome a print-based culture (Masotta 2004, 208).

13. Despite the initial success of the militants in seizing the city with zero casualties, the operation became a bloodbath once a police commando stopped the militants on their way back to Montevideo. One police officer and three militants died. Many others were arrested (Camnitzer 2007, 274, 31n).

14. My translation on the basis of the bilingual edition.

15. Formed in 1973 by Carlos Finck, José Antonio Hernández Amezcua, and Víctor Muñoz, Proceso Pentágono gained and lost members over the years. Felipe Ehrenberg joined the group in 1974, followed by Lourdes Grobet. The group's most active years lasted until 1980, but some collective projects continued until at least 1991. In 2015, the University Museum of Contemporary Art (MUAC) organized a retrospective exhibition of the group's works; on this occasion some past members rejoined forces to make a new piece.

16. See Decker (2012, 18).

17. Members of No Grupo also changed significantly from project to project. *Secuestro plástico* was carried out by Maris Bustamante, Melquiades Herrera, Alfredo Núñez, and Rubén Valencia (the group's most stable members), together with Hersúa, Katya Mandoki, Andrea di Castro, Sandra Isabel Llano, and Roberto Realh de León. Arden Decker mentions that "the last three artists left the group after this project" (Decker 2012, 14).

18. Document reprinted in the catalogue of the 2011 exhibition at Museo de Arte Moderno *No Grupo: Un zangoloteo al corsé artístico* (Henaro 2011, 53).

19. The work is reprinted in *No Grupo* (Henaro 2011, 93).

20. These artists included Tomás Parra, Arnold Belkin, Enrique Bostelmann, Carlos García, Carmen Parra, Nacho López, Paulina Lavista, Julia López, Zalathiel Vargas, Waldemar Sjölander, Ricardo Rocha, Luis Valsoto, Francisco Corzas, Héctor Xavier, Pedro Friedeberg, Olga Dondé, José Zúñiga, Fiona Alexander, Enrique Estrada, Graciela Iturbide, and Rogelio Naranjo.

21. The Lettrist International information bulletin, published between 1954 and 1957, was also entitled *Potlatch*.

22. "Arte Facto Kurtycz," February 26, 1982, self-publication, Kurtycz Archive.

23. Stefan Morawski, "De los recuerdos sobre Marcos Kurtycz," 1999, Kurtycz Archive.

24. According to Biles, "For Bataille, the concept of monstrosity is itself a monstrous concept, bearing the distinctive marks of what it designates—that which is ambiguous, contradictory, impure, dangerous, fearful, and often ridiculous" (Biles 2007, 63).

25. Groys's discussion focuses on post-9/11 use of video and film techniques by presumed members of Al-Qaeda, in which it becomes especially difficult to distinguish between a staged violent act, such as a mock beheading, and a real one. On the status of fiction in the wake of the events of September 11, 2001, see Houen (2004).

26. See Butler (2004, 39).

27. On the difficulty of simulating, for instance, a robbery in a store, see Baudrillard (1994, 20).

28. Letter dated "Prima Aprilis 1987" (*sic*), Kurtycz Archive.

29. The exhibition included a vitrine with Kurtycz's letter bombs and an entire wall covered by the mail art archive of Santiago Rebolledo, which he amassed between the 1970s and 1990s.

30. Leaflet, Marcos Kurtycz Archive.

31. Kurtycz circulated the leaflet as part of his letter-bombing projects.

32. In 1929, Bataille founded the review *Documents* in an attempt to develop a "war machine against received ideas" (Bradley and Ades 2006, 11). Central to this symbolic struggle was the review's "Critical Dictionary," which aimed to provide "not the meaning but the tasks of words" (12)—suggesting, for instance, that "*formless* is not only an adjective with a given meaning but a term which declassifies" (Bataille 1992, 92).

33. Agamben posits that corporeal contact (*contagione*) and physical touch have often been understood as able to return to profane use what sacrificial rituals had rendered sacred, i.e. separate (Agamben 2007, 74).

CHAPTER 6 CYBERNETICS AND FACE-OFF PLAY

1. As Butler notes, "The Levinasian face is not precisely or exclusively a human face, although it communicates what is human, what is precarious, what is injurable" (Butler 2004, xviii).

2. Constantin V. Boundas suggests that "The virtual and the actual are two mutually exclusive, yet jointly sufficient, characterizations of the real. The actual/real are states of affairs, bodies, bodily mixtures and individuals. The virtual/real are incorporeal events" with the capacity to bring about actualization. The two never coincide (Boundas 2005, 296–297).

3. Deleuze and Guattari's discussion of the faciality machine in terms of overcoding not only resonates with the coding strategies that led to the development of so-called first-order or first-wave cybernetics (the kind with which Kurtycz was most familiar), but also participates in a larger and deliberate opposition to these technoscientific developments. We might also recall the influence of second-order cybernetics in the work of these thinkers, largely through the writings of Gregory Bateson, which they reference in the title of *A Thousand Plateaus*. For Deleuze and Guattari, resisting the overcodification of the faciality machine is tantamount to resisting cybernetics as a new totality, wherein the realms of action, affectivity, cognition, and morality become fully embedded in narrowly defined and invisible (binary) codes.

4. From 1965 to 1968, Kurtycz, a mechanical engineer trained at Warsaw's Polytechnic Institute, specialized in the field of cybernetics while working at Warsaw's Institute for Automation and Instruments.

5. Hayles frames the first wave of cybernetic theories as developing between 1945 and 1960. During this period, one of the central ideas of this science was that "systems are constituted by flows of information" (Hayles 1999a, 84). This notion reconfigured the boundaries of the human body, for instance, by incorporating a blind person's cane, which gives him or her substantial information about his or her environment, into a single body-system. For Hayles, "of all of the implications that first-wave cybernetics conveyed, perhaps none is more disturbing and potentially revolutionary than the idea that the boundaries of the human subject are constructed rather than given" (84).

6. This is one of only a few works by the artist that involves significant production equipment, including professional lighting and the use of four video-cameras (two handheld and two fixed) following each of his expressions and movements. *Cambio de cara* also contains a much stronger sense of narrativity than the large majority of Kurtycz's live performances.

7. *Seppuku* or *hara-kiri* is a mode of "suicide by disembowelment, as formerly practised by the samurai of Japan, when in circumstances of disgrace" (*Oxford English Dictionary*).

8. "Cambio de cara: Acción estratégica de Marcos Kurtycz," self-published leaflet, March 1, 1991.

9. For a nonbinary and nonanthropocentric approach to the relationship between the human and the technical, see the first volume of Bernard Stiegler's *Technics and Time*. On the basis of

Leroi-Gourhan's studies on the co-constitutive relationship between the use of tools by homini and the development of the cerebral cortex, Stiegler argues, suggestively, that "the prosthesis is not a mere extension of the human body; it is the constitution of this body *qua* 'human'" (Stiegler 1998, 152–153).

10. In dialogue with a tradition of French feminism that understands both body and skin as thoroughly limiting and deceiving, Orlan repeatedly refers to the French psychoanalyst Eugénie Lemoine-Luccioni. In her essay *La Robe*, Lemoine-Luccioni posits that "the skin is deceptive [...]. I never have the skin of what I am [...] because I am never what I have" (Lemoine-Luccioni 1983, 95). In this light, Orlan's interventions on the body seek to distance corporality from being, *avoir* (having) from *être* (being): "The body as object would not embody well the subjectivity it dresses [...]. The body is that muddled and disappointing figure from which one would have to wrest away," writes Maxime Coulombe in her discussion of the artist (Coulombe 2007, 17).

11. Julia Kristeva writes: "It is [...] not lack of cleanliness or health that causes abjection but what disturbs identity, system, order. What does not respect borders, positions, rules. The inbetween, the ambiguous, the composite" (Kristeva 1982, 4).

12. An algorithm may be defined in a large sense as a set of instructions comprising a finite number of rules and procedures. Peter Wiebel distinguishes between intuitive and precise uses of algorithms in the arts. According to the author, "Beginning around 1960s, intuitive algorithms in the form of instructions for use and action began to be used in forms of analog art ranging from painting to sculpture," notably among Fluxus artists (Weibel 2007, 23). Precise mathematical algorithms were incorporated into the process of art-making with media art and digital technologies.

13. Just like in the West, the Soviet world saw in the early 1960s the convergence of cybernetics and structuralism, involving a fundamental rethinking of the role of conventions and originality (or difference) in the arts as well as a critique of the notion of artistic genius (Jackson 2010, 36).

14. The term "immersive," developed from computing terminology, describes that which provides "information or stimulation for a number of senses, not only sight and sound" (Machon 2013, 21).

15. The artist's approach to the existence of these works was similar to that of American conceptual artist Lawrence Weiner, who considered a declaration of intent a sufficient condition to talk about a work of art. In a note from October 1972, Kurtycz wrote: "Pending clarification: these projects are being described for two simple reasons: those that cannot be made (for whatever reason), become real through their sole conception, the rest have been made already" (notebook annotations, Kurtycz Archive).

16. Although most of these projects remained unrealized due to their high costs and the artist's lack of funding, their careful design remains significant. Bruce Mazlish posits that "for the history of science and technology [...] the aspirations of semi-mythical inventors can be as revealing as their actual embodiment" (Mazlish 1995, n.p.).

17. In the early 1970s, after the 1968 student massacre and the Corpus Christi massacre (another instance of fierce repression of a student demonstration), the kind of fear that led to the privatization of artistic experience in Eastern Europe was also present in Mexico, particularly among young students and visual artists. Yet in Mexico state repression tended to be less systematic and was often preceded by attempts to co-opt dissidents (Oles 2013, 354).

18. "Softwares," October 22, 1987, Kurtycz Archive.

19. Notebook annotations, Kurtycz Archive.

20. For a similar analogy between performance and photography, expanding Barthes's reflections on photography's relationship to the Real, see Auslander (2006, 1–2).

21. According to Auslander, when an individual has not witnessed a performance, the performance event occurs at the moment of sensorial encounter with those materials created during the performance for its documentation (Auslander 2006, 7, 10).

CONCLUSION

1. In September 2018, a major exhibition of Kurtycz's work opened at Museo Amparo, in the Mexican state of Puebla. The show was entitled "Contra el estado de guerra, un arte de acción total" (Against the State of War, An Art of Total Action), a title that could not but sound notoriously meaningful and provocative in a country that in recent years has been suffering from a violent war on drugs. In the show, the contemporaneity of the works of Kurtycz also became visible through his potent criticism of the art market, and in the series of reflections that his letter-bombing actions open in relation to the role of violence in artistic practice and the relationship between terror and the avant-garde.

REFERENCES

ARCHIVES

Archive of Colectivo Acciones de Arte (CADA), Museo de la Memoria y los Derechos Humanos, Santiago, Chile.

Arkheia, Museo Universitario de Arte Contemporáneo (MUAC), Mexico City, Mexico.

Documents of 20th-Century Latin American and Latino Art, International Center for the Arts of the Americas (ICAA), Museum of Fine Arts, Houston, Texas, USA.

Fundación Augusto y León Ferrari Archivo y Acervo (FALFAA), Buenos Aires, Argentina.

Fundación Espigas, Buenos Aires, Argentina.

Helen Escobedo Archive, Mexico City, Mexico.

Jasia Reichardt Archive, London, UK.

Marcos Kurtycz Archive, Mexico City, Mexico.

BIBLIOGRAPHY

Acha, Juan. 1993. "De la modernización a la posmodernidad, 1970–1990." In *Las culturas estéticas de América Latina*, 173–197. Mexico City: UNAM.

———. 2012. "Teoría y práctica no-objetualistas en América Latina." In *Ensayos y ponencias latinoamericanistas*, 183–199. Mexico City: Trillas.

Ades, Dawn. 1976. *Photomontage*. London: Thames and Hudson.

Adorno, Theodor W. 2004. *Aesthetic Theory*. Edited by Gretel Adorno and Rolf Tiedemann. Translated by Robert Hullot-Kentor. London: Continuum.

Agamben, Giorgio. 2007. "In Praise of Profanation." In *Profanations*, 73–92. New York: Zone.

———. 2011. "Nudity." In *Nudities*, 55–90. Stanford: Stanford University Press.

Aguayo, Sergio. 1998. *1968: Los archivos de la violencia*. Mexico City: Grijalbo-Reforma.

Aguilar Camín, Héctor, and Lorenzo Meyer. 1990. *A la sombra de la Revolución mexicana*. Mexico City: Cal y Arena.

Alcázar, Josefina. 2014. *Performance: un arte del yo. Autobiografía, cuerpo e identidad*. Mexico City: Siglo Veintiuno.

Alighieri, Dante. 2006. *The Divine Comedy: Inferno*. Translated by Robin Kirkpatrick. London: Penguin.

Alonso Espinosa, Ángeles. 2014. "Marcos Kurtycz." In *América Latina 1960–2013. Fotos + textos*, 264–265. Puebla-Paris: Museo Amparo-Fondation Cartier pour l'art contemporain.

Alonso, Rodrigo. 2005. "Entre la intimidad, la tradición y la herencia." In *Performance y arte-acción en América Latina*, edited by Josefina Alcázar and Fernando Fuentes, 77–94. Mexico City: CITRU-Ediciones sin nombre-Ex Teresa.

Amaral, Aracy A. 1980. "A invenção e a máquina." In *A arte de León Ferrari: Escultura gravura desenho livros*. São Paulo: Licópodio.

Amigo, Roberto. 2005. "Letanías en la Catedral. Iconografía cristiana y política en la Argentina: Cristo Obrero, Cristo Guerrillero, Cristo Desaparecido." Edited by Mario Sartor. *Studi Latinoamericani/Estudios Latinoamericanos* 1:184–227.

————. 2010. "El corto siglo de Antonio Berni." In *Berni, narrativas argentinas*, 21–61. Buenos Aires: MNBA.

Anguita, Eduardo, and Caparrós, Martín. 2004. *La voluntad: Una historia de la militancia revolucionaria en la Argentina, 1976–1978*. Buenos Aires: Norma.

Appi, Amadá. 1985. "Transborder: Marcos Kurtycs Espectáculo del Polaco." n.t., 6.

Ascoli, Albert R. 2010. "Dante and Allegory." In *The Cambridge Companion to Allegory*, edited by Rita Copeland and Peter T. Struck, 128–135. Cambridge: Cambridge University Press.

Auslander, Philip. 2006. "The Performativity of Performance Documentation." *PAJ: A Journal of Performance and Art* 84:1–10.

————. 2008. *Liveness: Performance in a Mediatized Culture*. London: Routledge.

Austin, J. L. 1962. *How to Do Things with Words*. Oxford: Clarendon Press.

"Auto-Destructive Art." n.d. *Tate: Glossary of Art Terms* (blog). Accessed March 12, 2017. http://www.tate.org.uk/learn/online-resources/glossary/a/auto-destructive-art.

Avelar, Idelber. 1999. *The Untimely Present: Postdictatorial Latin American Fiction and the Task of Mourning*. Durham, NC: Duke University Press.

Aviña, Alexander. 2014. *Specters of Revolution: Peasant Guerrillas in the Cold War Mexican Countryside*. New York: Oxford University Press.

Ayala, Matías. 2012. "The Photographic Legacy of Surrealism in Late-Twentieth-Century Chilean Poetry." In *Surrealism in Latin America: Vivísmo Muerto*, 177–191. London: Tate-Getty Research Institute.

Badawi, Halim, and Fernando Davis. 2012. "Desobediencia sexual." In *Perder la forma humana: Una imagen sísmica de los años ochenta en América Latina*, edited by Red Conceptualismos del Sur, 92–98. Madrid: Museo Reina Sofía.

Bal, Mieke. 1999. *Quoting Caravaggio: Contemporary Art, Preposterous History*. Chicago: University of Chicago Press.

Barros, Robert. 2002. *Constitutionalism and Dictatorship: Pinochet, the Junta, and the 1980 Constitution*. Cambridge: Cambridge University Press.

Basualdo, Carlos. 1999. "Viajes argentinos." *Lápiz: Revista internacional de arte*, 158/159: 156–167.

Bataille, Georges. 1970. *Oeuvres Completes: Premiers Écrits, 1922–1940*. Paris: Gallimard.

————. 1985. "The Solar Anus." In *Visions of Excess: Selected Writings, 1927–1939*, translated by Allan Stoekl, Carl R. Lovitt, and Donald M. Leslie Jr., 5–9. Minneapolis: University of Minnesota Press.

————. 1988. *The Accursed Share: An Essay on General Economy*. Translated by Robert Hurley. New York: Zone.

————. 1992. "Formless." Translated by Dominic Faccini. *Documents* 7.

Bateson, Gregory. 1987. *Steps to an Ecology of Mind: Collected Essays in Anthropology, Psychiatry, Evolution, and Epistemology*. Northvale, NJ: Jason Aronson.

Baudrillard, Jean. 1994. *Simulacra and Simulation*. Translated by Shelia Faria Glaser. Ann Arbor: University of Michigan Press.

Bazzichelli, Tatiana. 2008. *Networking: The Net as Artwork*. Aarhus: Digital Aesthetics Research Center, Aarhus University.

Bell, Vikki. 2014. *The Art of Post-Dictatorship: Ethics and Aesthetics in Transitional Argentina*. Oxon, UK: Routledge.

Benjamin, Walter. 1996a. "On Language as Such and On the Language of Man." In *Selected Writings: 1913–1926*, 1:62–74. Cambridge, MA: Harvard University Press.

————. 1996b. "The Role of Language in Trauerspiel and Tragedy." In *Selected Writings: 1913–1926*, 1:59–61. Cambridge, MA: Harvard University Press.

———. 1999. "Theses on the Philosophy of History." In *Illuminations*, edited by Hannah Arendt, translated by Harry Zorn, 245–258. London: Pimlico.

———. 2000. "On Painting, or Sign and Marks." In *Selected Writings: 1913–1926*, edited by Marcus Bullock and Michael William Jennings, 1: 83–86. Cambridge, MA: Belknap Press.

Bennington, Geoffrey. 2008. *Lyotard: Writing the Event*. Manchester: Manchester University Press and Columbia University Press.

Berlin, Isaiah. 1958. *Two Concepts of Liberty*. Oxford: Clarendon Press.

Berni, Antonio. 1936. "El nuevo realismo." *Forma*, 8, 14.

Biczel, Dorota. 2013. "Self-Construction, Vernacular Materials, and Democracy Building: Los Bestias, Lima, 1984–1987." *Buildings & Landscapes: Journal of the Vernacular Architecture Forum* 20 (2): 1–21.

Biles, Jeremy. 2007. *Ecce Monstrum: Georges Bataille and the Sacrifice of Form*. New York: Fordham University Press.

Bishop, Claire. 2012. *Artificial Hells: Participatory Art and the Politics of Spectatorship*. London: Verso.

Bois, Yve-Alain. 1997a. "Abattoir." In *Formless: A User's Guide*, edited by Yve-Alain Bois and Rosalind E. Krauss, 43–50. New York: Zone Books.

———. 1997b. "Base Materialism." In *Formless: A User's Guide*, edited by Yve-Alain Bois and Rosalind E. Krauss, 51–62. New York: Zone Books.

Bolaño, Roberto. 1999. *Estrella Distante*. Barcelona: Anagrama.

———. 2000. *Nocturno de Chile*. Barcelona: Anagrama.

———. 2005. *La literatura nazi en América*. Barcelona: Seix Barral.

Boothroyd, Dave. 2009. "Touch, Time and Technics. Levinas and the Ethics of Haptic Communications." *Theory, Culture & Society* 26 (2–3): 330–345.

Borges, Jorge Luis. (1923) 1970. *Fervor de Buenos Aires*. Buenos Aires: Emecé.

———. 2006. "Absence." Translated by Anna Schwind. http://annaschwind.com/2006/11/11/.

Borrelli, Marcelo. 2008. *El diario de Massera: Historia y política editorial de Convicción: la prensa del "Proceso."* Buenos Aires: Koyatun.

Boundas, Constantin V. 2005. "Virtual/Virtuality." In *The Deleuze Dictionary*, edited by Adrian Parr, 296–298. Edinburgh: Edinburgh University Press.

Bradley, Fiona, and Dawn Ades. 2006. "Introduction." In *Undercover Surrealism: Georges Bataille and Documents*, edited by Dawn Ades and Simon Baker, 11–16. London: Hayward Gallery; Cambridge, MA: MIT Press.

Bravo, Doris M. 2012. "The Life of the Archive: Tracing the Journey of Gonzalo Díaz's Banco/ Marco de Pruebas from Birth to Storage." Master's thesis, University of Texas at Austin.

Brennan, Marcia. 2014. "Icons without Orthodoxies: Religion and the Avant-Garde." Response paper, CAA 102nd Annual Conference, Chicago, IL, February 13.

Breton, André. 1969. *Manifestoes of Surrealism*. Translated by Richard Seaver and Helen R. Lane. Ann Arbor: University of Michigan Press.

———. (1939) 1996. "Remembrance of Mexico." In *Mexico through Foreign Eyes: Photographs, 1850–1990*, edited by Carole Naggar and Fred Ritchin, 113–114. New York: W.W. Norton.

———. 2003. *André Breton: Selections*. Edited by Mark Polizzotti. Berkeley: University of California Press.

Brett, Guy. 1994. "Lygia Clark: In Search of the Body." *Art in America*, July, 56–63.

Brito, Eugenia. 1990. *Campos minados: literatura post-golpe en Chile*. Santiago: Cuarto Propio.

Brunner, José Joaquín. 1981. *La cultura autoritaria en Chile*. Santiago: FLACSO.

———. 1985. "Cultura autoritaria y cultura escolar." In *Cinco estudios sobre cultura y sociedad*, edited by José Joaquín Brunner and Gonzalo Catalán, 415–453. Santiago: FLACSO.

Brunner, José Joaquín, and Gonzalo Catalán, eds. 1985. *Cinco estudios sobre cultura y sociedad.* Santiago: FLACSO.

Brysk, Alison. 1994. "The Politics of Measurement: The Contested Count of the Disappeared in Argentina." *Human Rights Quarterly* 16:676–692.

Buchloh, Benjamin H. D. 1981. "Figures of Authority, Ciphers of Regression: Notes on the Return of Representation in European Painting." *October* 16:39–68.

———. 1982. "Allegorical Procedures: Appropriation and Montage in Contemporary Art." *Artforum* 21 (1): 43–56.

Buck-Morss, Susan. 1989. *Dialectics of Seeing: Walter Benjamin and the Arcades Project.* Cambridge, MA: MIT Press.

Bunch, Mary. 2014. "Posthuman Ethics and the Becoming Animal of Emmanuel Levinas." *Culture, Theory and Critique* 55 (1): 34–50.

Buntinx, Gustavo. 1995. "Identidades póstumas. Un momento chamánico en Lonquén 10 años de Gonzalo Díaz." Conference paper, Beyond Identity: Latin American Art in the 21st Century, University of Texas, Austin, 1–28.

Bürger, Peter. 1984. *Theory of the Avant-Garde.* Translated by Michael Shaw. Manchester: Manchester University Press.

Burris Staton, Jennifer. 2015. "Marcos Kurtycz." In *Arqueologías de Destrucción 1959–2014,* 72. Haveford, PA: Cantor Fitzgerald Gallery.

Butler, Judith. 1990. *Gender Trouble: Feminism and the Subversion of Identity.* New York: Routledge.

———. 1993a. *Bodies That Matter: On the Discursive Limits of "Sex."* New York: Routledge.

———. 1993b. "Editor's Introduction." In *Erotic Welfare: Sexual Theory and Politics in the Age of Epidemic,* by Linda Singer, edited by Maureen MacGrogan. New York: Routledge.

———. 1997a. "Merely Cultural." *Social Text* 52/53: 265–277.

———. 1997b. *The Psychic Life of Power: Theories in Subjection.* Stanford, CA: Stanford University Press.

———. 1999. *Gender Trouble: Feminism and the Subversion of Identity.* New York: Routledge.

———. 2004. *Precarious Life: The Powers of Mourning and Violence.* London: Verso.

———. 2015. *Notes toward a Performative Theory of Assembly.* Cambridge, MA: Harvard University Press.

CADA. 1982. "Una ponencia del C.A.D.A." *Ruptura,* May, 2–3.

Calirman, Claudia. 2012. *Brazilian Art under Dictatorship: Antonio Manuel, Artur Barrio, and Cildo Meireles.* Durham, NC: Duke University Press.

Calloni, Stella. 1999. *Los años del lobo: Operación Cóndor.* Buenos Aires: Peña Lillo and Ediciones Continente.

Calveiro, Pilar. 2008. *Poder y desaparición.* Buenos Aires: Colihue.

Camnitzer, Luis. 2007. *Conceptualism in Latin American Art: Didactics of Liberation.* Austin: University of Texas Press.

Camnitzer, Luis, Jane Farver, and Rachel Weiss. 1999. "Foreword." In *Global Conceptualism: Points of Origin, 1950s–1980s,* vii–xi. New York: Queens Museum of Art.

Camp, Roderic A. 1999. *Politics in Mexico: The Decline of Authoritarianism.* Oxford: Oxford University Press.

Carr, C. 1988. "Secret Wars." *The Village Voice,* December 27, 1988.

Caruth, Cathy. 2016. *Unclaimed Experience: Trauma, Narrative, and History.* Baltimore: Johns Hopkins University Press.

Carvajal, Fernanda, Ana Longoni, Miguel A. López, Fernanda Nogueira, Mabel Tapia, and Jaime Vindel. 2013. "Introducción." In *Perder la forma humana: Una imagen sísmica de los*

años ochenta en América Latina, edited by Red Conceptualismos del Sur, 11–15. Madrid: Museo Reina Sofía.

Cashell, Kieran. 2009. *Aftershock: The Ethics of Contemporary Transgressive Art*. London: I.B. Tauris.

Coffey, Mary K. 2012. *How a Revolutionary Art Became Official Culture: Murals, Museums, and the Mexican State*. Durham, NC: Duke University Press.

Comisión Nacional de Verdad y Reconciliación. 1991. *Informe de la Comisión Nacional de Verdad y Reconciliación*. Santiago de Chile: La Nación.

Comisión Nacional sobre Prisión Política y Tortura. 2005. *Informe de la Comisión Nacional sobre Prisión Política y Tortura (Valech I)*. Santiago: La Nación.

CONADEP. 1984. *Nunca más: informe de la Comisión Nacional sobre la Desaparición de Personas*. Buenos Aires: Universitaria.

Copeland, Rita, and Peter T. Struck. 2010. "Introduction." In *The Cambridge Companion to Allegory*, edited by Rita Copeland and Peter T. Struck, 1–11. Cambridge: Cambridge University Press.

Corcoran, Steve. 2013. "Editor's Introduction." In *Dissensus. On Politics and Aesthetics*, 1–24. London: Continuum.

Corradi, Juan E., Patricia Weiss Fagen, and Manuel Antonio Garretón, eds. 1992. *Fear at the Edge: State Terror and Resistance in Latin America*. Berkeley: University of California Press.

Cortés, Ana Lilia. 1985. "Marcos Kurtycz: Un Terrorista Cultural." *El Mexicano*, July 22, 1985.

Cosse, Isabella. 2006. "Cultura y sexualidad en la Argentina de los sesenta: usos y resignificaciones de la experiencia trasnacional." *EIAL* 17 (1): 39–60.

Coulombe, Maxime. 2007. "Le Visage comme tableau." *Ciel variable: art, photo, culture* 75:17–19.

Cox, Neil. 2006. "Sacrifice." In *Undercover Surrealism: Georges Bataille and Documents*, edited by Dawn Ades and Simon Baker, 106–117. London: Hayward Gallery; Cambridge, MA: MIT Press.

Crenzel, Emilio. 2006. "El *Nunca Más* en fascículos: el infierno resignificado." *E.I.A.L* 17 (2): 87–106.

———. 2008. *La historia política del Nunca más: la memoria de las desapariciones en la Argentina*. Buenos Aires: Siglo Veintiuno.

Critchley, Simon. 2002. "Introduction." In *The Cambridge Companion to Levinas*, edited by Simon Critchley and Robert Bernasconi, 1–32. Cambridge: Cambridge University Press.

Crowley, David. 2011. "The Art of Cybernetic Communism." *Faktografia.com*, 2011. http://faktografia.com/2011/09/13/the-art-of-cybernetic-communism/.

Crowley, Martin. 2009. *L'Homme sans: politiques de la finitude*. Clemency: Lignes.

Das, Veena. 1997. "Language and Body: Transactions in the Construction of Pain." In *Social Suffering*, edited by Arthur Kleinman, Veena Das, and Margaret M. Lock, 67–92. London: University of California Press.

Davis, Oliver. 2013. "The Politics of Art: Aesthetic Contingency and the Aesthetic Effect." In *Rancière Now*, edited by Oliver Davis, 155–168. Cambridge: Polity Press.

De Andrade, Oswald. (1928) 1991. "Cannibalist Manifesto." Translated by Leslie Bary. *Latin American Literary Review* 19 (38): 38–47.

Debroise, Olivier, and Cuauhtémoc Medina. 2006a. "Genealogía de una exposición." In *La era de la discrepancia*, edited by Olivier Debroise and Cuauhtémoc Medina, 18–24. Mexico City: UNAM.

Debroise, Olivier, and Cuauhtémoc Medina, eds. 2006b. *La era de la discrepancia: arte y cultura visual en México, 1968–1997*. Mexico City: UNAM.

Decker, Arden. 2012. "Secuestros Artísticos: Abduction as Institutional Critique in the Work of Proceso Pentágono and No-Grupo." In *Synchronicity: Contacts and Divergences*, 14–21. Austin, TX: CLAVIS.

Deleuze, Gilles, and Félix Guattari. 2004. *A Thousand Plateaus: Capitalism and Schizophrenia.* Translated by Brian Massumi. London: Continuum.

DeMello, Margo. 2000. *Bodies of Inscription: A Cultural History of the Modern Tattoo Community.* Durham, NC: Duke University Press.

Derrida, Jacques. 2005. *On Touching, Jean-Luc Nancy.* Translated by Christine Irizarry. Stanford, CA: Stanford University Press.

Didi-Huberman, Georges. 1995. *La Ressemblance informe, ou, Le gai savoir visuel selon Georges Bataille.* Paris: Macula.

———. 1997. "La ressemblance par contact. Archéologie, anachronisme, et modernité de l'emprente." In *L'empreinte,* 15–192. Paris: Centre Georges Pompidou.

———. 2005. *Confronting Images: Questioning the Ends of a Certain History of Art.* University Park, PA: Penn State University Press.

Dierkes-Thrun, Petra. 2011. *Salome's Modernity: Oscar Wilde and the Aesthetics of Transgression.* Ann Arbor: University of Michigan.

Doane, Mary Ann. 1991. *Femmes Fatales: Feminism, Film Theory, Psychoanalysis.* New York: Routledge.

Donoso, Jaime. 2009. "Práctica de la Avanzada: *Lumpérica* y la figuración de la escritura como fin de la representación burguesa de la literatura y el arte." In *Diamela Eltit: redes locales, redes globales,* edited by Rubi Carreño Bolívar. Madrid: Iberoamericana.

Doyle, Kate. 2006. "The Dead of Tlatelolco." *Proceso-The National Security Archive,* January. https://nsarchive2.gwu.edu/NSAEBB/NSAEBB201/index.htm.

Eagleton, Terry. 2005. *Holy Terror.* Oxford: Oxford University Press.

Eder, Rita. 2010. *El arte contemporáneo en el Museo de Arte Moderno de México durante la gestión de Helen Escobedo (1982–1984).* Mexico City: UNAM.

Edwards, Brent Hayes. 2009. *The Practice of Diaspora: Literature, Translation, and the Rise of Black Internationalism.* Cambridge, MA: Harvard University Press.

Eltit, Diamela. 1998. *Lumpérica.* Santiago: Seix Barral.

———. 2003. "Excerpts from *Lumpérica (E. Luminata):* 'From Her Forgetfulness Project' and 'Dress Rehearsal.'" In *Holy Terrors: Latin American Women Perform,* edited by Diana Taylor and Roselyn Costantino, translated by Ronald Christ, 107–116. Durham, NC: Duke University Press.

———. 2008. *Lumpérica.* Santiago: Seix Barral.

Escobedo, Helen. 2007. "Conversación con Helen Escobedo." *Testimonios: Kurtycz* (blog). 2007. http://www.marcoskurtycz.com.mx/testimonios.htm.

Espinosa, César, and Araceli Zúñiga. 2002. *La Perra Brava: Arte, crisis y políticas culturales: Periodismo cultural (y otros textos) de los años 70 a los 90.* Mexico City: UNAM.

Espinoza, Eduardo Castillo. 2006. *Puño y letra: movimiento social y comunicación gráfica en Chile.* Santiago: Ocho Libros Editores.

Esslin, Martin. 1960. *Brecht. The Man and His Work.* New York: Doubleday and Company.

Fajardo-Hill, Cecilia, and Andrea Giunta, eds. 2017. *Radical Women: Latin American Art, 1960–1985.* Los Angeles: Hammer Museum; New York: DelMonico Books.

Feitlowitz, Marguerite. 2011. *A Lexicon of Terror: Argentina and the Legacies of Torture.* New York: Oxford University Press.

Feld, Claudia. 2014. "Making Disappearance Visible? Photographs of the Disappeared at the ESMA on Victor Basterra's Testimony." *Clepsidra* 1 (1): 28–51.

Felguérez, Manuel, and Mayer Sasson. 1983. *La máquina estética.* Mexico City: UNAM.

Fernández, Macedonio. 1966. *Papeles de recienvenido: Poemas: relatos, cuentos, miscelánea.* Buenos Aires: Centro Editor de América Latina.

Ferrari, León. 1995. "Sobre sexo, SIDA y censura." *Página 12,* March 28, 1995.

————. (1996) 2005a. "Arte y represión." In *León Ferrari: Prosa Política*, 151–158. Buenos Aires: Siglo XXI.

————. (1968) 2005b. "El arte de los significados." In *Prosa Política*, 20–27. Buenos Aires: Siglo Veintiuno.

————. (1995) 2005c. "Imágenes en el *Nunca más*." In *Prosa Política*, 149–150. Buenos Aires: Siglo XXI.

————. (1965) 2005d. "La respuesta del artista." In *Prosa Política*, 13–16. Buenos Aires: Siglo XXI.

————. (1994) 2005e. "Sexo y violencia en el arte cristiano." In *Prosa Política*, 94–142. Buenos Aires: Siglo Veintiuno.

————. (1995) 2005f. "Sobre ESMA, hostias y obispos." In *Prosa Política*, 143–144. Buenos Aires: Siglo Veintiuno.

————. 2008a. *Palabras ajenas*. Buenos Aires: Licopodio.

ffrench, Patrick. 2007. *After Bataille: Sacrifice, Exposure, Community*. Leeds: Legenda.

Foster, Hal. 1993. *Compulsive Beauty*. Cambridge, MA: MIT Press.

————. 2013. "What Is the Problem with Critical Art?" *London Review of Books* 35 (19): 14–15.

Foster, Hal, Rosalind Krauss, Yve-Alain Bois, Benjamin H. D. Buchloh, and David Joselit. 2011. *Art since 1900: Modernism, Antimodernism, Postmodernism*. London: Thames & Hudson.

Foucault, Michel. 1978. *The History of Sexuality*. Volume I. New York: Pantheon Books.

————. 1979. *Discipline and Punish: The Birth of the Prison*. Translated by Alan Sheridan. New York: Vintage Books.

Franco, Jean. 1989. *Plotting Women: Gender and Representation in Mexico*. New York: Columbia University Press.

————. 2002. *The Decline and Fall of the Lettered City: Latin America in the Cold War*. Cambridge, MA: Harvard University Press.

Fruhling, Hugo. 1992. "Resistance to Fear in Chile. The Experience of the Vicaría de La Solidaridad." In *Fear at the Edge: State Terror and Resistance in Latin America*, edited by Juan E. Corradi, Patricia Weiss Fagen, and Manuel Antonio Garretón, 121–141. Berkeley: University of California Press.

Fusco, Coco. 2015. *Dangerous Moves: Performance and Politics in Cuba*. London: Tate.

Galaz, Gaspar, and Milan Ivelić. 1988. *Chile, arte actual*. Valparaíso: Ediciones Universitarias de Valparaíso.

Galende, Federico. 2007. *Filtraciones I: Conversaciones sobre arte en Chile (de los 60's a los 80's)*. Cuarto Propio.

Gallo, Rubén. 2007. "The Mexican Pentagon: Adventures in Collectivism during the 1970s." In *Collectivism after Modernism: The Art of Social Imagination after 1945*, 165–192. Minneapolis: University of Minnesota.

Gamboni, Dario. 2002. "Image to Destroy: Indestructible Image." In *Iconoclash: Beyond the Image Wars in Science, Religion, and Art*, edited by Bruno Latour and Peter Weibel, 88–135. Karlsruhe: ZKM; Cambridge, MA: MIT Press.

————. 2007. *The Destruction of Art: Iconoclasm and Vandalism since the French Revolution*. London: Reaktion.

Garber, Marjorie B., Beatrice Hanssen, and Rebecca L. Walkowitz, eds. 2000. *The Turn to Ethics*. New York: Routledge.

García Canclini, Néstor. 2008. "El caso raro de León Ferrari." In *León Ferrari: Obras/Works 1976–2008*, 24–40. Mexico City: Instituto Nacional de Bellas Artes.

————. 2010. *La sociedad sin relato: Antropología y estética de la inminencia*. Madrid: Katz.

García, Fernando. 2005. *Los ojos: vida y pasión de Antonio Berni*. Buenos Aires: Planeta.

———. 2008. *León Ferrari: Todavía quedan muchos creyentes por convencer*. Buenos Aires: Capital Intelectual.

Gari, Facundo. 2013. "Voces para homenajear a un gigante." *Página/12*, July 26, 2013.

Garrote, Valeria. 2013. "La estrategia de la alegría en los colectivos artísticos de la dictadura y post-dictadura en España y Argentina (1973–1989)." PhD thesis, Rutgers University.

Garza Usabiaga, Daniel. 2011. *La máquina visual: una revisión de las exposiciones del Museo de Arte Moderno, 1964–1988*. Mexico City: CONACULTA and INBA.

Geiger, Jeffrey, and Karin Littau. 2013. "Introduction: Cinematicity and Comparative Media." In *Cinematicity in Media History*, edited by Jeffrey Geiger and Karin Littau, 1–20. Edinburgh: Edinburgh University Press.

Gerovitch, Slava. 2002. *From Newspeak to Cyberspeak: A History of Soviet Cybernetics*. Cambridge, MA: MIT Press.

Gill, Lesley. 2004. *The School of the Americas: Military Training and Political Violence in the Americas*. Durham, NC: Duke University Press.

Giunta, Andrea, ed. 2004. *León Ferrari: Retrospectiva: Obras 1954–2004*. Buenos Aires: Centro Cultural Recoleta and Malba.

———. 2006. "Disturbing Beauty." In *Léon Ferrari. Retrospectiva: Obras 1954–2006*, edited by Andrea Giunta, 345–348. São Paulo: Cosac Naify.

———. ed. 2008a. *El caso Ferrari: Arte, censura y libertad de expresión en la retrospectiva de León Ferrari en el Centro Cultural Recoleta, 2004–2005*. Buenos Aires: Licopodio.

———. 2008b. "Líneas, planos y el dibujo del sonido: León Ferrari, Sao Paulo, 1979–1986." In *León Ferrari: Obras / Works 1976–2008*, 62–80. Mexico City: Instituto Nacional de Bellas Artes.

———. 2008c. *Vanguardia, internacionalismo y política: arte argentino en los años sesenta*. Buenos Aires: Siglo Veintiuno.

———. 2009. "León Ferrari: Textura del dibujo." In *León Ferrari–Henri Michaux: Un diálogo de signos*, 7–11. Buenos Aires: Jorge Mara–La Ruche.

———. 2011. "Experimentación y supervivencia. Consecuencias sociopolíticas del dibujo." In *Escribir las imagines: Ensayos sobre arte argentino y latinoamericano*, 175–196. Buenos Aires: Siglo Veintiuno.

———. 2018. *Arte y feminismo latinoamericano: Historias de artistas que emanciparon el cuerpo*. Buenos Aires: Siglo Veintiuno Editores Argentina.

Glenn, Carla J. 2010. "Inter-Facing Reflexive Pedagogy." *SFU Educational Review* 4:13–25.

Goldberg, RoseLee. 1988. *Performance Art: From Futurism to the Present*. London: Thames and Hudson.

Goldman, Shifra M. 1995. *Dimensions of the Americas: Art and Social Change in Latin America and the United States*. Chicago: University of Chicago Press.

Gómez-Barris, Macarena. 2009. *Where Memory Dwells: Culture and State Violence in Chile*. Berkeley: University of California Press.

Government Junta of the Armed Forces and Carabineros of Chile. 2014. "In the Eyes of God and History." In *The Chile Reader: History, Culture, Politics*, edited by Elizabeth Q. Hutchison, Thomas Miller Klubock, Nara B. Milanich, and Peter Winn, 450–453. Durham, NC: Duke University Press.

Graham, Loren R. 2012. "Cybernetics." In *Science and Ideology in Soviet Society: 1917–1967*, edited by George Fischer, Loren R. Graham, and Herbert S. Levine, 83–106. New York: Routledge.

Green, Mary. 2007. *Diamela Eltit: Reading the Mother*. Woodbridge, UK: Tamesis Books.

Groïs, Boris. 2008. *Art Power*. Cambridge, MA: MIT Press.

Grosz, Elizabeth. 1994. *Volatile Bodies: Toward a Corporeal Feminism*. Bloomington: Indiana University Press.

Groys, Boris. 2008. *Art Power*. Cambridge, MA: MIT Press.

Guénoun, Solange M. 2009. "Jacques Rancière's Ethical Turn and the Thinking of Discontents." In *Jacques Rancière: History, Politics, Aesthetics*, edited by Gabriel Rockhill and Philip Watts, 176–192. Durham, NC: Duke University Press.

Guinan, Michael D. 1990. "Lamentations." In *The New Jerome Biblical Commentary*, edited by Raymond Edward Brown, Joseph A. Fitzmyer, and Roland E. Murphy, 558–562. London: Geoffrey Chapman.

Halart, Sophie, and Mara Polgovsky Ezcurra, eds. 2016. *Sabotage Art: Politics and Iconoclasm in Contemporary Latin America*. London: I.B. Tauris.

Haraway, Donna J. 2004. "Ecce Homo, Ain't (Ar'n't) I a Woman, and Inappropriate/d Others: The Human in a Post-Humanist Landscape." In *The Haraway Reader*, 47–61. New York: Routledge.

Harvey, David. 2006. *Spaces of Global Capitalism*. London: Verso.

Hasper, Graciela. 2006. *Liliana Maresca: Documentos*. Buenos Aires: Libros del Rojas.

Hayles, N. Katherine. 1999a. *How We Became Posthuman: Virtual Bodies in Cybernetics, Literature, and Informatics*. Chicago: University of Chicago Press.

———. 1999b. "The Life Cycle of Cyborgs: Writing the Posthuman." In *Cybersexualities: A Reader on Feminist Theory Cyborgs and Cyberspace*, edited by Jenny Wolmark, 157–173. Edinburgh: Edinburgh University Press.

Hegel, Georg Wilhelm Friedrich. 1977. *Phenomenology of Spirit*. Translated by Arnold V. Miller. Oxford: Clarendon Press.

Henaro, Sol, ed. 2011. *No Grupo: Un zangoloteo al corsé artístico*. Mexico City: Museo de Arte Moderno.

Herkenhoff, Paulo. 2004. "The Hand and the Glove." In *Inverted Utopias: Avant-Garde Art in Latin America*, edited by Mari Carmen Ramírez and Héctor Olea, 327–337. New Haven, CT: Yale University Press.

Herrera, María José. 2015. "El Rojas, semillero de los '90." *Página/12*, January 27, 2015. http://www.pagina12.com.ar/diario/suplementos/espectaculos/6-34568-2015-01-27.html.

Herrera, Melquiades. 2011. "El secuestro plástico, 1978." In *No Grupo: Un zangoloteo al corsé artístico*, edited by Sol Henaro, 49. Mexico City: Museo de Arte Moderno.

Hertz, Uri. 2003. "Artaud in Mexico." *Fragmentos* 25:11–17.

Hijar, Cristina. 2008. *Siete grupos de artistas visuales de los años setenta*. Mexico City: UAM and Conaculta.

Hillers, Delbert. 1992. *The Anchor Bible Commentary on Lamentations*. Garden City, NY: Doubleday.

Hirsch, Marianne. 2012. *The Generation of Postmemory: Writing and Visual Culture After the Holocaust*. New York: Columbia University Press.

Hobsbawm, Eric J. 1995. *Age of Extremes: The Short Twentieth Century 1914–1991*. London: Abacus.

Hoffmann, Gerhard, and Alfred Hornung, eds. 1996. *Ethics and Aesthetics: The Moral Turn of Postmodernism*. Heidelberg: C. Winter.

Holst-Warhaft, Gail. 2002. *Dangerous Voices: Women's Laments and Greek Literature*. London: Routledge.

Houen, Alex. 2004. "Novel Spaces and Taking Place(s) in the Wake of September 11." *Studies in the Novel* 36 (3): 419–437.

Huertas Sánchez, Miguel Antonio. 2004. *El largo instante de la percepción: Los años setenta y el crepúsculo del arte en Colombia*. Bogotá: Universidad Nacional de Colombia.

Hugnet, Georges. 1972. *Pleins et déliés, souvenirs et témoignages 1926–72*. La Chapelle-sur-Loire: Guy Authier.

Huidobro, Vicente. 1981. *Altazor, Temblor de Cielo*. Edited by René de Costa. Madrid: Cátedra.

Huneeus, Carlos. 2000. *El régimen de Pinochet*. Santiago: Sudamericana.

Hunter, Lynette. 2010. "Allegory Happens: Allegory and the Art Post-1960." In *The Cambridge Companion to Allegory*, edited by Rita Copeland and Peter T. Struck, 266–280. Cambridge: Cambridge University Press.

Huyssen, Andreas. 2009. "Prólogo: Medios y memoria." In *El pasado que miramos: memoria e imagen ante la historia reciente*, edited by Claudia Feld and Jessica Stites Mor, 15–24. Buenos Aires: Paidós.

Jackson, Matthew Jesse. 2010. *The Experimental Group: Ilya Kabakov, Moscow Conceptualism, Soviet Avant-Gardes*. Chicago: University of Chicago Press.

Jacobson, Jeremy. 1983. "Introduction to 'Desert' from *Purgatorio* by Raúl Zurita." *Latin American Literary Review* 11 (23): 85.

Jacoby, Roberto. 1987. "Las herejías de León Ferrari." *Crisis*, January, 71–73.

Jameson, Fredric. 2003. "Jacques Lacan. Critical Evaluations in Cultural Theory." In *Imaginary and Symbolic in Lacan: Marxism, Psychoanalytic Criticism, and the Problem of the Subject*, edited by Slavoj Žižek, vol. 3: Society, Politics, Ideology, 3–43. London: Routledge.

Jay, Martin. 1994. *Downcast Eyes: The Denigration of Vision in Twentieth-Century French Thought*. Berkeley: University of California Press.

Jelin, Elizabeth. 2003. *State Repression and the Labors of Memory*. Minneapolis: University of Minnesota Press.

Jones, Amelia. 1998. *Body Art/Performing the Subject*. Minneapolis: University of Minnesota Press.

Jones, Amelia, and Adrian Heathfield, eds. 2012. *Perform, Repeat, Record: Live Art in History*. Chicago: Intellect.

Kachur, Lewis. 2001. *Displaying the Marvelous: Marcel Duchamp, Salvador Dalí, and Surrealist Exhibition Installations*. Cambridge: MIT Press.

Kartsaki, Eirini. 2017. *Repetition in Performance: Returns and Invisible Forces*. London: Palgrave Macmillan.

Katzenstein, Inés, ed. 2004. *Listen, Here, Now! Argentine Art of the 1960s: Writings of the Avant-Garde*. New York: Museum of Modern Art.

Kay, Ronald, ed. 1975. *Manuscritos*. Santiago: Departamento de Estudios Humanísticos.

King, John. 2007. *El Di Tella y el desarrollo cultural argentino en la década del sesenta*. Buenos Aires: Asunto Impreso.

Kirkpatrick, Robin. 2006. "Introduction." In *The Divine Comedy 2: Purgatorio*, by Dante Alighieri, xi–lxii. London: Penguin.

Krauss, Rosalind E. 1986. *The Originality of the Avant-Garde and Other Modernist Myths*. Cambridge, MA: MIT Press.

Kristeva, Julia. 1975. "Pratique signifiante et mode de production." In *La Traversée des signes*, edited by Julia Kristeva, 11–30. Paris: Éditions du Seuil.

———. 1976. "Signifying Practice and Mode of Production." Translated by Geoffrey Nowell-Smith. *Edinburgh Magazine* 1:64–76.

———. (1980) 1982. *Powers of Horror: An Essay on Abjection*. Translated by Leon Roudiez. New York: Columbia University Press.

———. 1995. "Bataille, Experience and Practice." In *On Bataille: Critical Essays*, edited by Leslie Anne Boldt-Irons, 237–264. Albany: State University of New York Press.

Krochmalny, Syd. 2013. "La Kermesse: arte y política en el Rojas." *Caiana* 2 (August): 1–15.

Kuspit, Donald B. 2000. *Psychostrategies of Avant-Garde Art*. Cambridge: Cambridge University Press.

Laboureau, Gisela, and Daniela Lucerna. 2008. "Cuestiones de amor y de muerte: Contextos ana-crónicos del arte en Argentina (1998–2008): Entrevista a Roberto Jacoby." *ramona* 87:1–7.

Lacan, Jacques. 1981. *The Four Fundamental Concepts of Psychoanalysis*. Edited by Jacques Alain Miller. Translated by Alan Sheridan. New York: W.W. Norton.

Langton, Rae. 1993. "Speech Acts and Unspeakable Acts." *Philosophy and Public Affairs* 2 (4): 293–330.

Latour, Bruno. 1993. *We Have Never Been Modern*. Translated by Catherine Porter. Cambridge, MA: Harvard University Press.

Laudano, Claudia. 1997. "Cuerpos Transferidos." *Artinf* 97:29.

Lauria, Adriana. 2008. "Liliana Maresca. Transmutaciones." In *Transmutaciones*, 9–25. Rosario: Museo Municipal de Bellas Artes Juan B. Castagnino.

Lazzara, Michael J. 2018. *Civil Obedience: Complicity and Complacency in Chile since Pinochet*. Madison: University of Wisconsin Press.

Lebenglik, Fabián. 1997. "Tormentas sobre el cuerpo: León Ferrari." *Página/12*, March 12, 1997.

———. 2013. "Cuando el arte mueve conciencias." *Página/12*, July 26, 2013. http://www.pagina12.com.ar/diario/elpais/1-225347-2013-07-26.html.

Lechner, Norbert. 1992. "Some People Die of Fear: Fear as a Political Problem." In *Fear at the Edge: State Terror and Resistance in Latin America*, edited by Patricia Weiss Fagen, Juan E Corradi, and Manuel Antonio Garretón, 26–37. Berkeley: University of California Press.

Lemoine-Luccioni, Eugénie. 1983. *La Robe: essai psychoanalytique sur le vêtement*. Paris: Éditions du Seuil.

Levinas, Emmanuel. 1969. *Totality and Infinity: An Essay on Exteriority*. Pittsburgh: Duquesne University Press.

———. 1978. *Autrement qu'être, ou au-delà de l'essence*. Paris: Kluwer Academic.

———. 1988. "Useless Suffering." In *The Provocation of Levinas: Rethinking the Other*, edited by Robert Bernasconi and David Wood, 156–167. London: Routledge.

———. 1989. "Time and the Other." In *The Levinas Reader*, edited by Seán Hand, 37–58. Oxford: Blackwell.

———. 1994. *Otherwise than Being or Beyond Essence*. Translated by Alphonso Lingis. Dordrecht: Kluwer Academic Publishers.

———. 1999. *Alterity and Transcendence*. London: Athlone Press.

Lewis, Vek. 2010. *Crossing Sex and Gender in Latin America*. New York: Palgrave Macmillan.

Libertson, Joseph. 1995. "*Bataille and Communication*: Savoir, Non-Savoir, Glissement, Rire." In *On Bataille: Critical Essays*, edited by Leslie Anne Boldt-Irons, 209–230. Albany: State University of New York Press.

Linafelt, Tod. 2000. *Surviving Lamentations: Catastrophe, Lament, and Protest in the Afterlife of a Biblical Book*. Chicago: University of Chicago Press.

Link, Daniel. 2012. "León Ferrari, la experiencia exterior." In *León Ferrari: Brailles y Relecturas de la Biblia*, 11–28. Buenos Aires: Malba.

Lippard, Lucy R., and John Chandler. (1968) 1971. "The Dematerialization of Art." In *Changing: Essays in Art Criticism*, 255–276. New York: Dutton.

Lisboa, Victor. 2010. "O alfabeto umedecido de León Ferrari." *Minha Distopia* (blog). July 3, 2010. http://www.minhadistopia.com/o-alfabeto-umedecido-de-leon-ferrari/.

Lomnitz-Adler, Claudio. 2003. "Times of Crisis: Historicity, Sacrifice, and the Spectacle of Debacle in Mexico City." *Public Culture* 15 (1): 127–147.

Longoni, Ana, ed. 2011a. *El deseo nace del derrumbe: Roberto Jacoby: Acciones, conceptos, escritos*. Barcelona: La Central.

———. 2011b. "Experimentos en las inmediaciones del arte y la política." In *El deseo nace del derrumbe: Roberto Jacoby: Acciones, conceptos, escritos*, edited by Ana Longoni, 6–29. Madrid: La Central.

———. 2014a. "El mito de Tucumán Arde." *Artelogie 6* (June): 1–5.

———. 2014b. *Vanguardia y Revolución: Arte e izquierdas en la Argentina de los sesenta-setenta.* Buenos Aires: Ariel.

Longoni, Ana, and Mariano Mestman. 2000. *Del Di Tella a "Tucumán Arde": Vanguardia artística y política en el '68 argentino.* Buenos Aires: El Cielo por Asalto.

López Anaya, Jorge. 1992. "El absurdo y la ficción en una notable muestra." *La Nación*, January 8, 1992.

———. 2003. *La vanguardia informalista: Buenos Aires 1957–1965.* Buenos Aires: Alberto Sendrós.

Lorde, Audre. 1984. "Uses of the Erotic: The Erotic as Power." In *Sister Outsider: Essays and Speeches*, 53–59. Freedom, CA: Crossing Press.

Luckhurst, Roger. 2008. *The Trauma Question.* London: Routledge.

Lyotard, Jean-François. 1983. *Le différend.* Paris: Editions de Minuit.

———. 1984. *The Postmodern Condition: A Report on Knowledge.* Manchester: Manchester University Press.

———. 1988. *The Differend: Phrases in Dispute.* Minneapolis: University of Minnesota Press.

———. 1989. "Discussions, or Phrasing 'after Auschwitz.'" In *The Lyotard Reader*, edited by Andrew E. Benjamin, translated by Georges Van Den Abbeele, 360–392. Oxford: Basil Blackwell.

Macchiavello, Carla. 2011. "Vanguardia de exportación: la originalidad de la 'Escena de Avanzada' y otros mitos chilenos." In *Ensayos sobre Artes Visuales. Prácticas y discursos en los años '70 y '80 en Chile*, 89–117. Santiago: LOM.

Machon, Josephine. 2013. *Immersive Theatres: Intimacy and Immediacy in Contemporary Performance.* London: Palgrave Macmillan.

Mahon, Alyce. 2005. *Surrealism and the Politics of Eros, 1938–1968.* London: Thames & Hudson.

Manning, Erin. 2007. *Politics of Touch: Sense, Movement, Sovereignty.* Minneapolis: University of Minnesota Press.

Manovich, Lev. 2002. *The Language of New Media.* Cambridge, MA: MIT Press.

March, Natalia, and Andrea Wain. 2008. "Cronología biográfico artística." In *Transmutaciones*, by Adriana Lauria, 131–155. Rosario: Museo Municipal de Bellas Artes Juan B. Castagnino.

Mariotte, Corinee. 1985. "Kurticz, un polaco mágico." n.t., 1985.

Martín Plot. 2014. *The Aesthetico-Political: The Question of Democracy in Merleau-Ponty, Arendt, and Rancière.* New York: Bloomsbury Academic.

Masiello, Francine. 2001. *The Art of Transition: Latin American Culture and Neoliberal Crisis.* Durham, NC: Duke University Press.

Masotta, Oscar. 2004. "After Pop, We Dematerialize." In *Listen Here Now! Argentine Art of the 1960s: Writings of the Avant-Garde*, edited by Inés Katzenstein and Oscar Masotta, 208–216. New York: MoMA.

Mauss, Marcel. 2002. *The Gift: The Form and Reason for Exchange in Archaic Societies.* Oxon, UK: Routledge Classics.

Mayer, Mónica. 1996. "Marcos Kurtycz (1934–96)." *El Universal*, March 19, 1996.

Mazlish, Bruce. 1995. "Constructions of the Mind: The Man-Machine and Artificial Intelligence." *Stanford Electronic Humanities Review* 4 (2): unpaginated.

McMahon, Laura. 2012. *Cinema and Contact: The Withdrawal of Touch in Nancy, Bresson, Duras and Denis.* London: Legenda.

Medina, Cuauhtémoc. 2006a. "Mundo pánico." In *La era de la discrepancia/Age of Discrepancies*, edited by Olivier Debroise and Cuauhtémoc Medina, 90–149. Mexico City: UNAM.

———. 2006b. "Systems (Beyond So-Called 'Mexican Geometrism')." In *La era de la discrepancia: arte y cultura visual en México, 1968–1997*, edited by Olivier Debroise and Cuauhtémoc Medina, 128–133. Mexico City: UNAM.

Mercado, Tununa. 1994. "Cristos y maniquíes." FILO Art Gallery, Buenos Aires, August.

Merleau-Ponty, Maurice. 2012. *Phenomenology of Perception*. Translated by Donald A. Landes. London: Routledge.

Mignone, Emilio Fermín. 2006. *Iglesia y dictadura: el papel de la Iglesia a la luz de sus relaciones con el régimen militar*. Buenos Aires: Colihue.

Minujín, Marta. 2004. "Destruction of My Works in the Impasse Ronsin, Paris." In *Listen, Here, Now! Argentine Art of the 1960s: Writings of the Avant-Garde*, edited by Inés Katzenstein, 59–61. New York: Museum of Modern Art.

Morales T., Leonidas. 1998. *Conversaciones con Diamela Eltit*. Santiago: Cuarto Propio.

Morello, Gustavo. 2015. *The Catholic Church and Argentina's Dirty War*. New York: Oxford University Press.

Mosquera, Gerardo, ed. 2006. *Copiar el edén: arte reciente en Chile*. Santiago: Puro Chile.

———. 2010. "Against Latin American Art." In *Contemporary Art in Latin America*, edited by Gerardo Mosquera, 12–23. London: Black Dog Publishing.

Mouffe, Chantal. 2005. *On the Political*. Milton Park, Abingdon: Routledge.

Mules, Warwick. 2010. "This Face: A Critique of Faciality as Mediated Self-Presence." *Transformations* 18. http://www.transformationsjournal.org/journal/issue_18/article_01.shtml.

Munder, Heike, ed. 2015. *Resistance Performed: An Anthology on Aesthetic Strategies Under Repressive Regimes in Latin America*. Zurich: Migros Museum für Gegenwartskunst.

Nagel, Alexander. 2011. *The Controversy of Renaissance Art*. Chicago: University of Chicago Press.

Nancy, Jean-Luc. 1993. *The Birth to Presence*. Stanford, CA: Stanford University Press.

———. 2008. *Noli Me Tangere: On the Raising of the Body*. New York: Fordham University Press.

Navarrete Cortés, Alejandro. 2014. "La producción simbólica en México durante los años ochenta." In *La era de la discrepancia: arte y cultura visual en México, 1968–1997*, edited by Olivier Debroise and Cuauhtémoc Medina, 284–297. Mexico City: UNAM.

Nead, Lynda. 1992. *The Female Nude: Art, Obscenity, and Sexuality*. London: Routledge.

Neustadt, Robert. 2001. *Cada día: La creación de un arte social*. Santiago: Cuarto Propio.

———. 2003. "Diamela Eltit: Performing Action in Dictatorial Chile." In *Holy Terrors: Latin American Women Perform*, edited by Diana Taylor and Roselyn Constantino, 117–134. Durham, NC: Duke University Press.

Nietzsche, Friedrich. 1989. *On the Genealogy of Morals and Ecce Homo*. Translated by Walter Kaufmann. New York: Vintage.

O'Bryan, C. Jill. 2005. *Carnal Art: Orlan's Refacing*. Minneapolis: University of Minnesota Press.

O'Donnell, Guillermo A. 1999. *Counterpoints: Selected Essays on Authoritarianism and Democratization*. Notre Dame, IN: University of Notre Dame Press.

Olea, Héctor. 2013. "Berni and His Reality without 'Isms.'" In *Antonio Berni: Juanito and Ramona*, edited by Mari Carmen Ramírez and Héctor Olea, 33–51. Houston: The Museum of Fine Arts a Fundación Costantini.

Oles, James. 2013. *Art and Architecture in Mexico*. London: Thames & Hudson.

Oliver, Kelly. 1993. "Introduction: Julia Kristeva's Outlaw Ethics." In *Ethics, Politics, and Difference in Julia Kristeva's Writing*, edited by Kelly Oliver, 1–22. New York: Routledge.

Osborne, Peter. 2013. *Anywhere or Not at All: Philosophy of Contemporary Art*. London: Verso.

Osborne, Thomas. 1997. "Body Amnesia: Comments on Corporeality." In *Sociology after Post-modernism*, edited by David Owen, 188–204. London: Sage.

Osinski, Zbigniew. 1991. "Grotowski Blazes the Trails: From Objective Drama to Ritual Arts." *TDR* 35:95–112.

Osthoff, Simone. 2000. "Lygia Clark and Hélio Oiticica: A Legacy of Interactivity and Participation for a Telematic Future." In *Corpus Delecti: Performance of the Americas*, edited by Coco Fusco, 156–174. London: Routledge.

Owens, Craig. 1979. "Earthwords." *October* 10:120–130.

———. 1980. "The Allegorical Impulse: Towards a Theory of Postmodernism." *October* 12:67–86.

Oyarzún Robles, Pablo. 1988. *Arte en Chile de veinte, treinta años.* Georgia: University of Georgia, Center for Latin American Studies.

Paz, Octavio. 1974. "El espacio múltiple." In *Felguérez: El espacio múltiple*, 3–9. Mexico City: Instituto Nacional de Bellas Artes y Literatura.

———. 1983. "Gerzso: La centella glacial." In *Gerzso*, by John Golding and Octavio Paz, 3–7. Neuchâtel: Editions du Griffon.

Pellegrini, Marcelo. 2001. "Poesía en/de transición: Raúl Zurita y *La vida nueva*." *Revista Chilena de Literatura*, 59:41–64.

Pérez Villalobos, Carlos. 1995. "El manifiesto místico-político-teológico de Zurita." *Revista de Crítica Cultural*, 10:55–59.

Pérez-Oramas, Luis. 2009. "León Ferrari and Mira Schendel: Tangled Alphabets." In *León Ferrari and Mira Schendel: Tangled Alphabets*, 12–45. New York: Museum of Modern Art.

Phelan, Peggy. 1993. *Unmarked: The Politics of Performance.* London: Routledge.

———. 2004. "Marina Abramovic: Witnessing Shadows." *Theatre Journal* 56 (4): 569–577.

Pineau, Natalia. 2012. "La emergencia del 'arte light' como antagonismo del 'arte politico.'" In *Synchronicity: Contacts and Divergences*, 277–285. Austin: Clavis.

———. 2013. "El feminismo en el campo de las artes visuales de Buenos Aires en la década del noventa: La exhibición *Juego de damas* como estudio de caso." *Papeles de trabajo* 7 (11): 163–187.

Plate, S. Brent. 2005. *Walter Benjamin, Religion and Aesthetics: Rethinking Religion through the Arts.* New York: Routledge.

Podalsky, Laura. 2004. *Specular City: Transforming Culture, Consumption, and Space in Buenos Aires, 1955–1973.* Philadelphia: Temple University Press.

Pollock, Griselda. 1998. "To Inscribe in the Feminine: A Kristevan Impossibility? Or Femininity, Melancholy and Sublimation." *Parallax* 4 (3): 81–117.

———. 2010. "Moments and Temporalities of the Avant-Garde 'in, of, and from the Feminine.'" *New Literary History* 41 (4): 795–820.

Pujol, Sergio Alejandro. 2002. *La década rebelde: los años 60 en la Argentina.* Buenos Aires: Emecé.

Quiles, Daniel. 2014. "Dead Boars, Viruses, and Zombies: Roberto Jacoby's Art History." *Art Journal* 73 (3): 38–55.

Raaberg, Gwen. 1991. "The Problematics of Women and Surrealism." In *Surrealism and Women*, edited by Mary Ann Caws, Rudolf E. Kuenzli, and Gwen Raaberg, 1–10. Cambridge, MA: MIT Press.

Radomska, Katarzyna. 2011. "Illustration of the Field of Art." In *Jerzy Ludwinski: Filling the Blanks*, 45–49. Wrockaw: Centre of Contemporary Art Znaki Czasu.

Rama, Angel. 1984. *La ciudad letrada.* Santiago: Tajamar Editores.

Rambelli, Fabio, and Eric Reinders. 2007. "What Does Iconoclasm Create? What Does Preservation Destroy? Reflections on Iconoclasm in East Asia." In *Iconoclasm: Contested*

Objects, Contested Terms, edited by Stacy Boldrick and Richard Clay, 15–33. Aldershot, UK: Ashgate.

Ramírez, Mari Carmen. 1999. "Tactics for Thriving on Adversity: Conceptualism in Latin America, 1960–1980." In *Global Conceptualism: Points of Origin, 1950s–1980s*, edited by Luis Camnitzer, Jane Farver, and Rachel Weiss, 53–71. New York: Queens Museum of Art.

Rancière, Jacques. 2009a. *Aesthetics and Its Discontents*. Translated by Steven Corcoran. Cambridge: Polity Press.

———. 2009b. *The Emancipated Spectator*. London: Verso.

———. 2011. "A Politics of Aesthetic Indetermination: An Interview with Frank Ruda and Jan Voelker." In *Everything Is in Everything: Jacques Rancière between Intellectual Emancipation and Aesthetic Education*, edited by Jason E. Smith and Annette Weisser, translated by Jason E. Smith, 1–33. Pasadena, CA: Art Center Graduate Press.

———. 2013a. *Dissensus: On Politics and Aesthetics*. Translated by Steven Corcoran. London: Bloomsbury.

———. 2013b. *The Politics of Aesthetics*. Translated by Gabriel Rockhill. London: Bloomsbury.

Richard, Nelly. 1988. "El género de la lectura y la lectura de los géneros." *Número Quebrado* 1: 14–19.

———. 1999. "Trama urbana y fugas utópicas." *Revista de Crítica Cultural* 19:28–33.

———. 2004. *The Insubordination of Signs: Political Change, Cultural Transformation, and Poetics of the Crisis*. Durham, NC: Duke University Press.

———. 2007. *Márgenes e instituciones: Arte en Chile desde 1973*. Santiago: Metales Pesados.

Richter, Gerhard. 2002. *Walter Benjamin and the Corpus of Autobiography*. Detroit, MI: Wayne State University Press.

Riess, Jonathan B. 1995. *Luca Signorelli: The San Brizio Chapel, Orvieto*. New York: George Braziller.

Robinet, Romain. 2012. "A Revolutionary Group Fighting Against a Revolutionary State: The September 23rd Communist League Against the PRI-State (1973–1975)." In *Challenging Authoritarianism in Mexico: Revolutionary Struggles and the Dirty War, 1964–1982*, edited by Fernando Herrera Calderón and Adela Cedillo, 129–147. New York: Routledge.

Rodda, John. 2012. "'Prensa, Prensa': A Journalist's Reflections on Mexico '68." In *Reflections on Mexico '68*, edited by Keith Brewster, 1–22. West Sussex, UK: Wiley-Blackwell.

Rodríguez Fernández, Mario. 1985. "Raúl Zurita o la crucifixión del texto." *Revista Chilena de Literatura* 25: 115–23.

Rosa, María Laura. 2007. "Transitando por los pliegues y las sombras." In *La batalla de los géneros*, 67–81. Santiago de Compostela: Centro Galego de Arte Contemporánea.

———. 2011. "Fuera de discurso. El arte feminista de la segunda ola en Buenos Aires." Universidad Complutense de Madrid.

Rowe, William. 2000. "Raúl Zurita and American Space." In *Poets of Contemporary Latin America: History and the Inner Life*, 281–326. Oxford: Oxford University Press.

Rushton, Richard. 2002. "What Can a Face Do? On Deleuze and Faces." *Cultural Critique* 51: 219–237.

Sansi, Roger. 2014. "The Pleasure of Expense: Mauss and *The Gift* in Contemporary Art." *Journal of Classical Sociology* 14 (1): 91–99.

Saper, Craig J. 1997. *Artificial Mythologies: A Guide to Cultural Invention*. Minneapolis: University of Minnesota Press.

———. 2001. *Networked Art*. Minneapolis: University of Minnesota Press.

Sarlo, Beatriz. 2007. *Borges, un escritor en las orillas*. Madrid: Siglo XXI.

Sartre, Jean-Paul. 2008. *Qu'est-ce que la littérature?* Paris: Gallimard.

Scarry, Elaine. 1985. *The Body in Pain: The Making and Unmaking of the World*. Oxford: Oxford University Press.

Schechner, Richard. 1993. *The Future of Ritual: Writings on Culture and Performance*. London: Routledge.

Schmilchuk, Graciela. 2001. *Helen Escobedo: pasos en la arena*. Mexico City: CNCA, UNAM and Turner.

Schmitt, Carl. (1922) 2005. *Political Theology: Four Chapters on the Concept of Sovereignty*. Translated by George Schwab. Chicago: University of Chicago Press.

Seeman, Don. 2004. "Otherwise than Meaning: On the Generosity of Ritual." *Social Analysis: The International Journal of Social and Cultural Practice* 48 (2): 55–71.

Seltzer, Mark. 1997. "Wound Culture: Trauma in the Pathological Public Sphere." *October* 80: 3–26.

Sequeiro, Walter. 1987. "El presupuesto da para todo. Insólita y a veces ofensiva muestra con apoyo de la comuna." *Somos*, January, 56.

Shtromberg, Elena. 2016. *Art Systems: Brazil and the 1970s*. Austin: University of Texas Press.

Shuman, Joel James. 1999. *The Body of Compassion: Ethics, Medicine, and the Church*. Boulder, CO: Westview Press.

Silva, Patricio. 1999. "Collective Memories, Fears and Consensus: The Political Psychology of the Chilean Democratic Transition." In *Societies of Fear: The Legacy of Civil War, Violence and Terror in Latin America*, edited by Kees Koonings and Dirk Krujit, 171–196. London: Zed Books.

Silva Catela, Ludmila da. 2009. "Lo invisible revelado: El uso de fotografías como (re) presentación de la desaparición de personas en la Argentina." In *El pasado que miramos: memoria e imagen ante la historia reciente*, edited by Claudia Feld and Jessica Stites Mor, 337–361. Buenos Aires: Paidós.

Sim, Stuart, ed. 2011. *The Lyotard Dictionary*. Edinburgh: Edinburgh University Press.

Smith, Christian. 1991. *The Emergence of Liberation Theology: Radical Religion and Social Movement Theory*. Chicago: University of Chicago Press.

Sontag, Susan. 1989. *AIDS and Its Metaphors*. New York: Farrar, Straus & Giroux.

———. 1990. "The Image-World." In *On Photography*, 153–180. New York: Doubleday.

———. 2003. *Regarding the Pain of Others*. London: Penguin.

Soto Riveros, Paulina, and Vicente Bernaschina Schürmann. 2011. "La épica artística de avanzada: La palabra autoritaria." In *Crítica literaria chilena actual: Breve historia de debates y polémicas: de la querella del criollismo hasta el presente*, 1–50. Santiago. www.historiacritica.cl /pdf/capitulo5final.pdf.

Speranza, Graciela. 2012. "Wanderers: Surrealism and Contemporary Latin American Art and Fiction." In *Surrealism in Latin America: Vivísmo Muerto*, edited by Dawn Ades, Rita Eder, and Graciela Speranza, 193–211. Los Angeles: Tate.

Steiner, George. 2009. "Introduction." In *The Origin of German Tragic Drama*, 7–24. London: Verso.

Stern, Steve J. 2006. *Battling for Hearts and Minds: Memory Struggles in Pinochet's Chile, 1973–1988*. Durham, NC: Duke University Press.

Stiegler, Bernard. 1998. *Technics and Time*. Translated by Stephen Barker, Richard Beardsworth, and George Collins, vol. 1, *The Fault of Epimetheus*. Stanford: Stanford University Press.

Stone, Allucquère Rosanne. 1995. *The War of Desire and Technology at the Close of the Mechanical Age*. Cambridge, MA: MIT Press.

Svampa, Maristella. 2001. *Los que ganaron: la vida en los countries y barrios privados*. Buenos Aires: Editorial Biblos.

Taylor, Diana. 1997. *Disappearing Acts: Spectacles of Gender and Nationalism in Argentina's "Dirty War."* Durham, NC: Duke University Press.

————. 2003. *The Archive and the Repertoire: Performing Cultural Memory in the Americas.* Durham, NC: Duke University Press.

————. 2016. *Performance.* Durham, NC: Duke University Press.

Terán, Oscar. 2004. "Culture, Intellectuals, and Politics in the 1960s." In *Listen, Here, Now! Argentine Art of the 1960s: Writings of the Avant-Garde,* edited by Inés Katzenstein, 262–275. New York: The Museum of Modern Art.

Tubio, José M. 1961. "Fundamentos psicológicos de un arte destructivo." Fundación Espigas.

Turner, Victor W. 1969. *The Ritual Process: Structure and Anti-Structure.* London: Routledge and K. Paul.

Uno más uno. 1979. "Kurtycz representó la muerte de un impresor en su obra 'Suceso del salón,'" March 12, 1979.

Valdés, Catalina. 2006. "Raúl Zurita." In *Copiar el edén: arte reciente en Chile/Copying Eden: Recent Art in Chile,* edited by Gerardo Mosquera, 592–594. Santiago: Puro Chile.

Valdés, Juan Gabriel. 1995. *Pinochet's Economists: The Chicago School of Economics in Chile.* Cambridge: Cambridge University Press.

Valente, Ignacio. 1979. "RZ: Purgatorio." *El Mercurio,* December 16, 1979.

Verbitsky, Horacio. 1995. "La solución final." *Página/12,* March 3, 1995.

————. 2010. *La mano izquierda de Dios:* Tomo 4. La última dictadura (1976–1983): Historia política de la iglesia católica. Buenos Aires: Sudamericana.

Vezzetti, Hugo. 2002. *Pasado y presente: guerra, dictadura y sociedad en la Argentina.* Buenos Aires: Siglo Veintiuno Editores Argentina.

————. 2009. *Sobre la violencia revolucionaria: memorias y olvidos.* Buenos Aires: Siglo Veintiuno.

Vidal, Hernán. 1987. *Poética de la población marginal: Fundamentos materialistas para una historiografía estética.* Minneapolis, MN: Prisma Institute.

————. 2000. *Chile, poética de la tortura política.* Santiago: Biblioteca Mosquito Editores.

Vidal, Sebastián. 2012. *En el principio: Arte, archivos y tecnologías durante la dictadura en Chile.* Santiago: Metales Pesados.

Vindel, Jaime, and Ana Longoni. 2010. "Fuera de categoría: la política del arte en los márgenes de su historia." *El río sin orillas* 4:300–318.

Waldenfels, Bernhard. 2002. "Levinas and the Face of the Other." In *The Cambridge Companion to Levinas,* edited by Simon Critchley and Robert Bernasconi, 63–81. Cambridge: Cambridge University Press.

Walker, John A. 2009. "Gustav Metzger, the Conscience of the Artwork," 1–37. https:// monoskop.org/images/d/d9/Walker_John_A_2009_Gustav_Metzger_the_Conscience _of_the_Artworld.pdf.

Weibel, Peter. 2007. "It Is Forbidden Not to Touch: Some Remarks on the (Forgotten Parts of the) History of Interactivity and Virtuality." In *MediaArt Histories,* edited by Olivier Grau, 21–41. Cambridge, MA: MIT Press.

Wein, Andrea, ed. 2016. *Ferrari por León.* Buenos Aires: Libraria.

Westermann, Claus. 1994. *Lamentations: Issues and Interpretation.* Edinburgh: T&T Clark.

Wiener, Norbert. 1948. *Cybernetics, or Control and Communication in the Animal and the Machine.* New York: Wiley.

————. 1950. *The Human Use of Human Beings: Cybernetics and Society.* Boston: Houghton Mifflin.

Wild, John. 1969. "Introduction." In *Totality and Infinity: An Essay on Exteriority,* by Emmanuel Levinas, translated by Alphonso Lingis, 11–20. Pittsburgh: Duquesne University Press.

Wilson, Andrew. 2008. "Gustav Metzger's Auto-Destructive/Auto-Creative Art: An Art of Manifesto, 1959–1969." *Third Text* 22 (2): 177–194.

Winn, Peter. 2004. *Victims of the Chilean Miracle: Workers and Neoliberalism in the Pinochet Era, 1973–2002*. Durham, NC: Duke University Press.

Wirshing, Irene. 2009. *National Trauma in Postdictatorship Latin American Literature: Chile and Argentina*. New York: Peter Lang.

Wyschogrod, Edith. 1980. "Doing before Hearing: On the Primacy of Touch." In *Textes pour Emmanuel Lévinas*, edited by François Laruelle, 179–203. Paris: J.-M. Place.

Wyss, Beat. 2000. "Das indexikalische Bild. Hors-texte." *Fotogeschichte. Beiträge zur Gerschichte und Ästhetik der Fotografie* 76:3–11.

Ziarek, Ewa Płonowska. 2001. *An Ethics of Dissensus: Postmodernity, Feminism, and the Politics of Radical Democracy*. Stanford: Stanford University Press.

Žižek, Slavoj. 2003. *The Puppet and the Dwarf: The Perverse Core of Christianity*. Cambridge, MA: MIT Press.

———. 2005. "The Lesson of Rancière." In *The Politics of Aesthetics*, by Jacques Rancière, 69–79. London: Continuum.

———. 2008. *The Ticklish Subject: The Absent Centre of Political Ontology*. London: Verso.

Zurita, Raúl. 1982. *Anteparaíso*. Santiago: Editores Asociados.

———. 1985. *Canto a su amor desaparecido*. Santiago: Editorial Universitaria.

———. 1979. *Purgatorio*. Santiago de Chile: Editorial Universitaria.

———. 2007. *Purgatorio*. Santiago de Chile: Editorial Universitaria.

———. 2009a. *Anteparaíso*. Santiago: Universidad Diego Portales.

———. (1979) 2009b. *Purgatory: A Bilingual Edition*. Translated by Anna Deeny. Berkeley: University of California Press.

———. 2010. *Song for His Disappeared Love*. Translated by Daniel Borzutzky. Notre Dame, IN: Action Books.

Zurita, Raúl, and Benoît Santini. 2011. "En Zurita, van a aparecer las ruinas, pedazos de poemas antiguos: Entrevista a Raúl Zurita." *Revista Chilena de Literatura* 80:253–262.

Zylinska, Joanna. 2002. "'The Future . . . Is Monstrous': Prosthetics as Ethics." In *The Cyborg Experiments: The Extensions of the Body in the Media Age*, edited by Joanna Zylinska, 214–236. London: Continuum.

INDEX

ABOUT THE AUTHOR

MARA POLGOVSKY EZCURRA is a lecturer in contemporary art at Birkbeck, University of London, in the United Kingdom.